MW00454752

The publisher gratefully acknowledges
the generous contribution to this book
provided by the Ahmanson Foundation
Humanities Endowment Fund of the
University of California Press
Foundation.

SERVANTS OF THE DYNASTY

THE CALIFORNIA WORLD HISTORY LIBRARY

SERVANTS OF THE DYNASTY

Palace Women in World History

Edited by
Anne Walthall

University of California Press Berkeley Los Angeles London

University of California Press, one of the most distinguished
university presses in the United States, enriches lives around the
world by advancing scholarship in the humanities, social sciences,
and natural sciences. Its activities are supported by the UC Press
Foundation and by philanthropic contributions from individuals
and institutions. For more information, visit www.ucpress.edu.

University of California Press
Berkeley and Los Angeles, California

University of California Press, Ltd.
London, England

© 2008 by The Regents of the University of California

Library of Congress Cataloging-in-Publication Data

Servants of the dynasty : palace women in world history / edited
by Anne Walthall.
 p. cm. — (The California world history library ; 7)
 Includes bibliographical references and index.
 ISBN: 978-0-520-25443-5 (cloth : alk. paper)
 ISBN: 978-0-520-25444-2 (pbk. : alk. paper)
 1. Courtesans—History. 2. Courts and courtiers—History.
3. Ladies-in-waiting—History. 4. Favorites, Royal—History.
5. Harems—History. I. Walthall, Anne.

HQ1122.S47 2008
306.84'109—dc22 2007051011

Manufactured in the United States of America

17 16 15 14 13 12 11 10 09 08
10 9 8 7 6 5 4 3 2 1

The paper used in this publication meets the minimum
requirements of ANSI/NISO Z39.48−1992 (R 1997) (Permanence of
Paper).

CONTENTS

ILLUSTRATIONS

Figures

Maps

TABLES

ACKNOWLEDGMENTS

This volume began at a University of California Multi-Campus Research Group in World History conference, "Gender in World Historical Studies," hosted by Susan L. Mann and abetted by Robert G. Moeller at UC Davis at the beginning of December 2001. With the encouragement of Edmund Burke III and Kenneth Pomeranz, editors of the University of California Press World History Library, in March 2004 I organized a conference at UC Irvine on palace women around the world. In addition to contributors to this volume, participants at one or both of these meetings were Katherine Crawford, Mark Elliott, Nancy Florida, Virginia Ebert, and Robert Borgen.

Funding for the conference came initially from the Center for Asian Studies, UC Irvine. Additional funds were provided by the University of California Pacific Rim Research Program, UC Multi-Campus Research Group in World History, UC Irvine Humanities Center, UC Irvine Office of Research and Graduate Studies, UCI Department of History, and Institute of Turkish Studies. In addition to participants and audience at the workshop and conference, I extend special thanks to Michael Wert, who ably assisted me in organizing the conference and served as interpreter/translator for Hata Hisako. Kathy Ragsdale, Barbara Ambrose, Rosemary Humphreys, Marc Kanda, Judy Morgan, and Julie Villarino also gave crucial support when needed. Jeroen Duindam provided incisive comments on the manuscript. At the University of California Press, Suzanne Knott and Alice Falk did outstanding work in preparing the manuscript for publication.

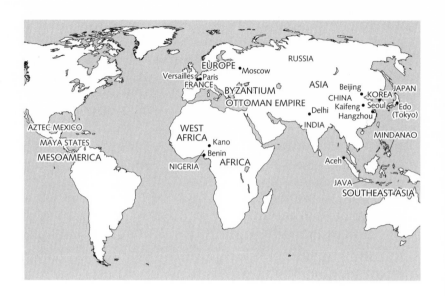

MAP 0.1.

The world.

INTRODUCING PALACE WOMEN

Anne Walthall

Mothers, wives, concubines, attendants, officials, maids, drudges. The women who worked and lived in palaces fulfilled diverse roles and served in many capacities. They might spend a lifetime behind walls in close proximity to their master, their fate tied to his, or they might stay only a few years and leave without ever having seen him. Sometimes the choice of whether to pursue a career in the palace was theirs to make; more often it was not. Regardless of their position, they enlivened an institution of remarkable persistence and ubiquity.

For most of human history in almost every corner of the globe, the most enduring form of government has been that system of rule known as monarchy. Characterized by social inequality and status hierarchies, hereditary succession, and elaborate etiquette in which the household of the ruler also encompassed the administration of the state, such systems spawned court societies whose denizens had no function other than to serve the monarch. From the monarch's point of view, his most important task was to continue his dynasty. (Female monarchs were few and far between.) For this he needed the military might, financial resources, and support most often supplied by men—but at the most basic biological level, he needed women. Although most dynasties were reckoned exclusively through the male line (Southeast Asia saw exceptions), women did far more than simply serve as borrowed wombs for the

Funding for my research on the comparative study of palace women came from the National Endowment for the Humanities.

purpose of bearing sons. The requirements of hereditary rule put women right at the center of power, with intimate access to the monarch most men could only envy. What they made of that access and how monarchs and other men tried to restrict what they could do with it provides one way to differentiate monarchical systems.

A focus on elite men and women flies in the face of scholarship in social history and cultural anthropology that examines the socially constructed meaning of ordinary lives. From a Marxist point of view, palace women are nothing but parasites on society. Yet palaces play a social role disproportionate to the number of people they contain, large though that may be. They stand at the pinnacle of nested systems of exchange through marriages, reproduction, and labor that bring commoner and elite women together; they serve as models for gender performance; they serve as instruments for projecting the ruler's authority; and they provide the structure for the everyday ongoing transactions between women, the ruler, and the outside world in which women as well as men might gain informal control over at least part of their lives and the power to influence others. The study of palaces points to the function of sexuality in hierarchical societies, what it means to be a man or a woman given pervasive status inequality, and the symbolic, economic, and political functions of palace women in the maintenance of the state.

Monarchies and the structure of palace life differ from period to period, country to country, and continent to continent. Most of the essays in this volume focus on what can broadly be called classical or premodern courts. Early examples include the Maya (250–900 C.E.) in Mesoamerica, middle Byzantium (eighth through eleventh centuries) in what is now Turkey, and Song dynasty China (960–1279). Three essays depict palace women in the sixteenth and early seventeenth centuries in Ottoman Turkey, Mughal India, and Russia. The circumstances of Aztec noble women and of concubines in the Kano palace of northern Nigeria evolved over the period from roughly 1500 to the 1700s. The essays on Chosŏn Korea, Bourbon France, and the diverse kingdoms of Southeast Asia focus on the seventeenth and early eighteenth centuries. Women inhabited the Qing dynasty's Forbidden City in China and the Tokugawa shoguns' "Great Interior" in Japan from the seventeenth through the mid- to late nineteenth centuries. Roles for royal women in modern and contemporary palaces also have undergone change, as can be seen in the studies of the nineteenth-century French royal family and the contemporary Benin monarchy in Nigeria, the latter making a conscious effort to recapitulate palace practices, especially those involving the queen mother, that originated in the fourteenth century.

This volume offers not an overview of palace women throughout time and space but rather studies focused on specific issues. Instead of arranging chapters

chronologically, I have emphasized thematic correspondences. We begin with three essays that discuss the importance of palaces in providing the setting for the theater of rule. Chapters that discuss the relations between monarch and the women closest to him highlight the importance of his mother. With few exceptions, wives and secondary wives played less prominent roles. Most women who lived in palaces, even members of the nobility, worked as servants in one capacity or another, although servants could become relatives if they bore the ruler's children. Conversely, it can also be said that all women, including mothers, served the monarchy. Concubines are often privileged in art, literature, and the popular imagination, but unless they managed to bear children, they too are best classified as servants. Four essays highlight palace women's productive rather than their reproductive roles, including their participation in the arts of entertainment and literature. We end with an essay on the connections between popular culture and the royal family in France, just one example of how monarchs and their women have fared in the court of public opinion. Taken as a whole, the essays cover divergent topics, places, and times. What is the utility of bringing them together?

Juxtaposing palace women across different settings can defamiliarize generally accepted assumptions about the structure of palaces and women's place within them. We cannot assume, for example, that being the ruler's mother or wife automatically entitled a woman to a voice in public affairs. Questions raised by the study of one monarchical system can bring a new perspective to bear on another. Research on servants is well advanced for Japan; what about for Europe? Yet making sense of comparative history is particularly challenging—for although no individual has the linguistic skills or the time to do all the in-depth studies found in this volume, no two people see historical issues in the same way. Rather than my asking the authors to address a common set of questions, they have each developed their own agendas. As a result, they have brought to this project methodologies and questions that are as diverse as the regions covered. In his study of the Maya, Takeshi Inomata has insisted on placing his theoretical discussion at the center of his argument. While historians base their conclusions on archival research, a number of contributors have woven together evidence from archaeology, linguistics, and oral histories. Heidi Nast, for example, recounts how one conversation after another uncovered different pieces of her puzzle regarding the work done by concubines in Kano, Nigeria. We hope that the volume's breadth will challenge students to engage with the histories of different parts of the world. If the diversity in approaches also stimulates future research by scholars on palace women and court societies, it will have served its purpose.

What is the point of studying palace women: to learn more about women's lives, to gain new insights into the structure of monarchies—or both? Although it is well known that sex segregation characterized many if not most palaces

in Asia, even premodern European residences provided separate apartments for dowager queens, queens, and royal female relatives, where women interacted more with each other than with men. How did women relate to other women and to the outside world? What gave meaning to their lives? Given that they inhabited the monarch's household and that (in most of the societies covered by this volume) the monarch actually ruled, we may consider a different question: what can a study of palace women contribute to our understanding of configurations of power, and indeed of the nature of political power, in a system of hereditary rule? In what follows, I suggest some of the ways in which these essays illuminate the possibilities for and limitations on women who lived in palaces, the structure of monarchies, and the nature of monarchical power.

The Setting

Although historians and anthropologists have debated the extent to which palace societies function as theater, ceremonies and processions do more than simply entertain.[1] They reproduce the kinship relations also operative in the larger society, and at the same time they dramatize the differences between ordinary families and that of the ruler. The location is important: such ceremonies either take place inside the palace or simply originate there and present the palace as a moving spectacle. In the former case, the audience may be limited; or, as in Byzantium and France, it may incorporate aristocratic men and women who normally live outside palace walls. In the latter case, spectators may be coerced to line the streets as a living wall. In the Maya city-states, for example, spectacles often took place in large plazas in front of palaces; the crowds gathered either there or in designated places from which they could watch at a distance. Wherever the locale, the performers have to be groomed, initiated, and selected to put into practice embodiments of praise for kingship specified by cultural protocols. Rituals draw most typically on religious symbols, for monarchs everywhere have justified their rule by claiming a special relationship to the divine. In the palaces analyzed in this volume, women have seldom been granted a similar aura.[2] Often women were not put on display at all; instead, their absence served to demarcate the public realm, where the authority of the state embodied in the ruler was made manifest.

For the most part, the whole notion of palace women implies their remaining largely hidden from view. Palace walls both enclose the court (the monarch plus the men and women who attend him, not all of whom live and sleep inside) and remind outsiders that they are excluded; they set up visible signifiers of hierarchy. Some palaces made less use of walls than others; Versailles, for

example, was oriented outward through windows and doors, but its location at a distance from Paris made it difficult for the ordinary Frenchman or -woman to witness its displays of power. Instead, thousands of courtiers, including men and women who inhabited its apartments, acted as both performers and spectators in daily rituals that reinforced the status hierarchy. That Versailles did not serve as a model for other European courts can be seen in the Hapsburg monarchy's quite different setting. There the king and his family appeared on public streets, but only trusted servants penetrated the royal residence. Despite having a palace in the heart of Vienna, the Hapsburg monarchs lived more secluded lives than did their counterparts at Versailles.[3] In the Maya city-states, various apertures allowed spectators to catch glimpses of women even though they did not appear at the public plaza. And as Barbara Andaya reminds us in her survey of Southeast Asian courts, in order for rulers to enact their royal status, they first need to separate themselves and their households from those over whom they rule.

Palace configurations speak first to conceptions of rule. The Tokugawa shoguns headed a military regime. They built their palace for defense, not display, and eschewed straight lines of sight (see figure 0.1). To segregate women from public ceremonies and from the shogun, they placed the "Great Interior" in the depths of the palace, behind a wall beyond the shogun's personal quarters. The Manchus, in contrast, expropriated a palace designed by their predecessors to overawe the scholar-bureaucrats who ran the government with grandiose physical structures in an ostentatious display of power (see figure 0.2). Known since well before Song times as the "Forbidden City," it centered the emperor in his cosmic, ceremonial, and familial capabilities, offering a graphic demonstration of the principles that sited him between heaven and earth: symmetry, the balance of the two opposing and complementary forces of yin and yang, and the directional hierarchy.[4] These principles also structured the spatial allotments for the empress dowager, empress, concubines, children, and servants. Korean kings built modestly scaled Chinese-style ceremonial halls facing the main entrances to each of their five palaces in Seoul as a visible sign of their subordinate position in the Sinitic world order. The interaction between Confucian principles designed to regulate the correct relations between the sexes, feng shui (geomancy), and the balance of power between king and the hereditary officials called *yangban* meant that while queens, dowager queens, and concubines had residences separate from the king's and protected by the forces of wind and water, the king had to make himself accessible to his chief supporters in ways that the Chinese emperor did not.

Perhaps nowhere were the principles of seclusion and sex segregation more marked than in Topkapi Palace in Istanbul, home to the Ottoman sultans (like the Manchu a conquest dynasty) from the mid-fifteenth to the early nineteenth

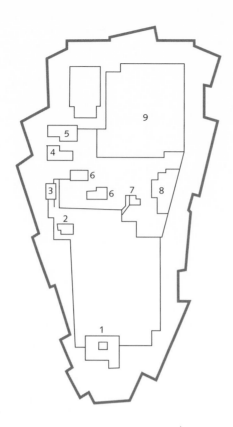

Chiyoda Castle, Tokyo

1 Main ceremonial hall
2 Shogun's personal quarters
3 Shogun's suite
4 Reception hall
5 Wife's suite
6 Female administrators' offices
7 Mother's suite
8 Male administrators' offices
9 Female staff apartments

FIGURE 0.1.
Main Enceinte, Chiyoda Castle, Tokyo, in the 1840s. The outer
ceremonial space, the area designated for the shogun's personal
use, and the Great Interior contained myriad halls, covered
walkways, buildings of all shapes and sizes, and gardens not
shown here.

centuries. In the palace's early days, only the sultan, his pages (defined as im-
mature men), and eunuchs lived at the palace, and the term *harem* defined the
area made sacred by his presence.[5] Imposing gates in thick walls at the entrances
to the second and third courts marked the approach to the audience room at the
male harem's threshold; there, the sultan allowed foreign ambassadors to view
his person (see figure 0.3). Sultans who hunted in eastern Europe as their
armies threatened the gates of Vienna carried the sacred space of the harem with
them while their women remained in seclusion in Istanbul. In other Islamic
states as well, whether in Southeast Asia, India, or Africa, ground made hallowed

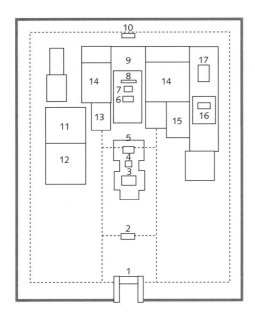

Forbidden City, Beijing

 1 Meridian gate
 2 Gate of Supreme Harmony
 3 Hall of Supreme Harmony
 4 Hall of Complete Harmony
 5 Hall of Preserving Harmony
 6 Palace of Heavenly Purity
 7 Hall of Union
 8 Palace of Earthly Tranquility
 9 Imperial Garden
10 Gate of Martial Spirit
11 Hall of Worshipping Buddha
12 Palace of Compassion and Tranquil
13 Hall of Mental Cultivation
14 Concubines' quarters
15 Hall for Worshipping Ancestors
16 Palace of Tranquil Longevity
17 Hall of Pleasurable Old Age

FIGURE O.2.
The Forbidden City, Beijing. Built in the early fifteenth century
under the Ming and restored by the Qing, the palace contained
nearly ten thousand rooms. Vast courtyards surrounded awe-
inspiring audience halls.

by the ruler's presence sanctified the seclusion of women. Even a non-Islamic
state such as Benin in modern-day Nigeria treats the seclusion of women as a
signifier of the king's sacred presence. Insofar as female inviolability to the pro-
fane gaze of the public constituted a characteristic of the palace, it served to de-
marcate royal power.

Although most societies considered the deployment of power to be the pre-
rogative of male rulers, the setting for that deployment had to implicate
women. Bloodletting done by a Maya queen, with her husband, priests, and
scribes as observers, had as its object the ordering of the cosmos so as to pro-
mote the fertility of land and people. Byzantine weddings permitted important
nobles to witness the ruler's performance of his sacred duty in providing for the
future of dynasty and realm. Commoners too joined together in (simple) mar-
riage rites, but the effect was entirely private. After the sultan retreated to Top-
kapi Palace, his mother, sisters, and daughters took his place in providing offi-
cial sanction for weddings and the circumcisions of his adult sons, albeit always

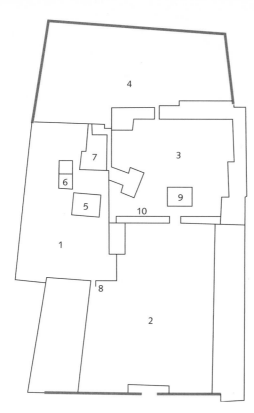

Topkapi Palace, Istanbul

1 Female harem
2 Second courtyard
3 Third courtyard
4 Fourth courtyard
5 Sultan's mother's courtyard and chambers
6 Sultan's chambers
7 Favorites' courtyard and chambers
8 Tunnel Gate
9 Audience chamber
10 White eunuchs' quarters

FIGURE O.3.
Topkapi Palace, Istanbul. In contrast to the open parks dotted with kiosks that marked the second, third, and fourth court-yards, the female harem contained a warren of rooms; some—for example, the favorites' chambers—were multistoried.

behind screens. Their invisible presence at public ceremonies reminded on-lookers that behind palace walls lived their ruler, all the more powerful for re-maining hidden. Court architecture and ceremony, etiquette and ritual, were all intended to create "the 'illusion' of power."[6]

Power

For commentators around the world, women and power constitute an unholy mix. Women, it is assumed, do not know how to use power; they play favorites, corrupt officials if not the king, squander the state's financial resources, and lack

the courage to resist enemies. In not a few countries, such as France, women were barred from rule. There, as Jo Burr Margadant points out, even queens rarely escaped censure. The few women in other countries who, for lack of a better (read male) alternative, managed to seize the throne received ample criticism no matter how hard they strove to emulate their male predecessors and contemporaries. For her efforts to hold onto her throne and acquire a successor, Queen Juana of Spain was deemed mad.[7] Despite functioning as a dynasty of female rulers, the begums of Bhopal in India faced constant complaints regarding everything from their choice of husbands to their educational and social welfare policies.[8] Kathryn M. Ringrose notes that what we know about the exploits of Byzantium's queens is filtered through the gaze of male critics, a process that inevitably taints their reputation. Especially notorious is Catherine the Great of Russia, whose efforts to expand the Russian empire are often overshadowed by gossip about her numerous lovers, Potemkin among them. Male rulers too were criticized for policies that inevitably displeased someone, but attacks on female rulers tend to be much more personal and tied directly to their (weaker) sex.

Few women ruled in their own right. The more common pattern was for a mother to step in as regent for an underage king. As JaHyun Kim Haboush and Flora Kaplan point out for Korea and Benin, respectively, mothers offered several advantages over ministers. First, they cared about the dynasty's future. Unlike a minister whose first concern was likely to be for himself, a mother's interest was supposed to be identical with her son's.[9] A male regent might usurp the throne, but not a mother—although Maria Theresa of Austria postponed turning power over to her son for what some observers thought was an unseemly length of time. In Russia as well, female regents beginning with the reign of Sofia (1682–89) displayed considerable reluctance to relinquish power to a man. When female regents in other countries resisted setting a policy favored by one faction at court, they bore the brunt of criticism that attacked not their position but their persons. Most vilified of all was Cixi of the late nineteenth century, blamed not only for the demise of the Qing dynasty but also for China's disintegration.

In the long and diverse histories of monarchies, women who ruled in their own right or even as female regents are few and far between. But does their scarcity in the historical record mean that the study of palace women must be necessarily divorced from considerations of politics and power? A number of essays in this volume suggest that analyzing the specifics of palace women's roles has much to teach us about various types of power and how they were exercised.

First, there is more to politics than making policy. So long as the monarch is also the head of the bureaucracy, decisions on who would become the next

chief minister or the next in line for the throne could be influenced by whoever had the ruler's ear, woman or man. Japanese soldiers assassinated Korea's Queen Myŏngsŏng in 1895 because she supported a chief minister inimical to Japan's interests. Mothers, and by extension wives and other palace women, had a particularly significant role to play when matters of succession were at stake. As Isolde Thyrêt points out in her study of tonsured women, both Godunov and Romanov men legitimized their claim to rule Russia through female connections to the preceding Rurikide dynasty. In Japan, women from the Great Interior intervened at critical moments to smooth the way for an adopted shogun or to lend their support to a faction opposed to the adoption of a shogun from one house rather than another.[10] In Mughal India, royal women mediated in conflicts between Akbar and his half-brothers and his son that threatened to tear the empire apart. Generally, however, palace women exerted influence in matters of appointment less often at the highest levels of state than at whatever lower levels preferment might bring prestige and status to kin.

Second, power struggles in monarchies are more likely to take place over office and income than over policy and principle. Jockeying for position takes far more time and energy than do debates over the future of the state. In order to acquire these material rewards for service, women and men pull strings. They develop informal networks based on kinship, friendship, and influence that, as Jeroen Duindam has pointed out, "can never fully be grasped, if only because most relevant communications will not have been put into writing."[11] Yet Kaplan's study of queens' roles in Benin concretely demonstrates how power circulates through people: there, a queen's ability to connect with other people makes it possible for her to have an impact on decisions taken by the ruler. Similarly, Thyrêt uses letters written by tonsured tsarinas to reveal how women locked away in monasteries used their connections to the tsar to feather their nests and provide for supporters. Kathryn Norberg shows how even women at lower ranks found themselves with the power to sell positions in the bureaucracy and military. By serving the ruler, female officials and functionaries served the state. In return, they received official titles, rank, and salaries comparable to those of male officials. They recruited clients, they sought advancement for their kin, and they competed with each other for favor and position. In that they took action to safeguard their interests, their initiatives demonstrate that they had some degree of agency.

Not only monarchs but also ministers and rivals condemned power struggles at court, especially the factional intrigue both characteristic of and inimical to hereditary rule. Ottoman sultans tried (unsuccessfully) to limit the threat of factionalism by stocking their harem with people of different ethnicities. In theory at least, exotic women a long way from home and castrated men would have

difficulty building alliances within the palace and lack connections with outside supporters. Leslie Peirce demonstrates how women in the harem overcame these obstacles. At the lower levels, the status hierarchy placed limitations on what an individual might achieve. At the upper ranks, anyone, whether male or female, whose lust for power became too blatant threatened the royal prerogative. Although kings such as Louis XIV could and did dismiss favorites, it was more difficult, though not impossible, to disgrace relatives.

Royal Women

Almost without exception, the most powerful woman in a monarch's household was his mother. In China, the emperor owed respect to his father's official widow, the empress dowager, but he remained closer to his birth mother and might even raise her to the position of empress dowager should the previous holder of that rank die.[12] The chief counterexample comes from Korea, where the king owed his father's official wife the filial piety that juniors paid to the preceding generation. If his mother were a concubine, his devotion to her had to remain private and separate from the public rituals that designated the status of queen mother.[13] When, as Haboush explains in this volume, the king treated his father's wife badly, he lost moral credibility. This type of conflict between members of different generations was less likely to arise in countries where only the monarch's biological mother could attain the position of dowager queen. In Benin as in Istanbul, the ruler typically favored a woman until she bore a son. After that, she was off-limits, out of fear that having two sons would divide her loyalties. When succession favored not the eldest but the most powerful son, a mother's influence and connections could prove decisive. Even after a monarch sat securely on his throne, his mother remained his most faithful ally. When Akbar turned to his mother to guard Delhi during his 1589 campaign in Afghanistan, he picked a supporter more trustworthy than any man.

Aside from political roles such as those played by Akbar's mother, queen mothers had quotidian duties to perform. In the Ottoman harem, they selected and trained their sons' concubines as well as supervising the staff. In Benin, they lived outside their son's residence as they served as his eyes and ears in accepting petitions and adjudicating disputes. In China, the most senior empress dowager oversaw inner palace administration. The emperor's mother provided opportunities for her son to demonstrate his grasp of the core Confucian virtue of filial piety. She and other female relatives would also pray at unauthorized shrines that were off-limits to the emperor. By giving him an excuse to donate to Buddhist temples, an act otherwise condemned by the Board of Rites, her

piety invoked the unseen world on the emperor's behalf while providing him with a cloak of deniability vis-à-vis Confucian bureaucrats.

Insofar as monarchies center on an individual, his preferences and weaknesses can lead to new rules, overturn standard practices, subvert institutional arrangements, and contradict generalizations. Following the excesses of his predecessors' mothers, the eighth Tokugawa shogun Yoshimune kept his own in the background. By the end of the Tokugawa regime, the shogun's mother counted for so little that the burial place of one of the last is unknown. The Ottoman sultan Suleiman the Magnificent so favored his concubine Hurrem that he went against precedent in making her his wife despite opposition from his ministers. The current Oba of Benin has fathered more than one son on his favorite wife and has no plans to set her aside. In establishing a separate residence for his mother, he had to overcome a break with past practice instituted by the British. In other instances, a ruler might so tire of his mother's interference that he banned her from court; that was the decision of Louis XIII. Despite these exceptions, insofar as a ruler's best ally remained his mother, she could dominate at least the female side of his household and often the male side as well.

Seldom did a monarch's wife exercise much influence. All too often her marriage functioned merely to seal an alliance, to garner support, or to gain territory. She might be older than her husband, brought into his household more as an administrator than a companion. She might be perceived as sexually unattractive or as a spy beholden to foreign interests. She might be one of several wives, forced to compete for his favor. In Benin, the senior wife was so busy running the harem that she had to leave the business of building networks to other wives and the queen mother. Wives lost out to concubines in polygynous households or to mistresses in monogamous ones. Often they commanded respect less for their personal qualities than for their powerful relatives, who might take offense were they slighted. In worst-case scenarios they might be divorced to make way for potentially more fertile women or perhaps removed to a monastery, as happened to Ivan the Terrible's wives. On the other hand, in imperial China and Tokugawa Japan, the wife ranked so far above mere concubines that she could claim their children as her own. In Korea as well, the public recognition a wife received as official spouse continued after her husband's death, and even after her own. In modern times the imposition of monogamy on societies previously polygamous, a new definition of companionate marriage, and the glare of publicity have forced royal households to become more like those of the citizenry. This change has strengthened the wife's position—although, as Margadant shows in the case of Marie-Amélie of France, not always to the monarchy's advantage.

Despite their spatial exclusion from the halls of power, women defined as widows or mothers had access to the monarch and a control over ceremony in

the inner quarters that translated into political influence on the outside. By drawing on their indisputable relations to past and present rulers, they created the grounds for intervening in a political process otherwise dominated by men. In palaces where the competition between wives and mothers continued after a ruler's death, success in justifying claims to prestige based wholly on the biological fact of motherhood depended on a number of factors, including how consorts were recruited and the extent to which wives were distinguished from concubines. The greater the status inequality between wives and concubines, the less biology mattered.

Concubines and Sexual Relations

Aside from victory in battle, the ruler's sexual potency and exuberant reproduction constituted the most visible sign of masculinized authority. For this reason, the palace was a place where his sexuality was both controlled by political, religious, and pragmatic considerations and continually demonstrated. Outside of Christendom, most monarchical systems relied either on plural marriages or on concubinage to provide opportunities for the ruler to beget offspring. From the point of view of a polygynous ruler, concubines or secondary wives had several advantages over the mistresses who comforted kings in Europe. First, although concubines did not enjoy the same status as a royal wife, they filled a fully recognized role in the dynasty's reproductive strategies. Sons fathered on mistresses were bastards and barred from the succession. Sons fathered on concubines generally suffered no such disability. (Islam mandated that concubines' sons enjoy the same status as a wife's; in Korea, they ranked below sons fathered on queens.) Second, concubines often came as gifts—as in, for example, Thailand, Benin, and Aztec Mexico—gladly bestowed on the ruler by men hoping to gain favor thereby. Whether or not they actually produced children, they played an important role in political integration by connecting the palace to powerful men outside it.

In the popular imagination, concubines congregated in harems for the ruler's pleasure. In one description of a palace in Southeast Asia provided by Andaya, the image of a monarch sitting at a window overlooking the bathing pool frequented by his women suggests that his position came with sensual rewards. European writers took delight in depicting the Ottoman sultan's harem as a place for lascivious displays of unbridled passion. Knowing that behind palace walls lived countless nubile women and only one adult man, what else was an outsider to think?

Confronted with such stereotypes, the authors in this volume have emphasized both the rules that ordered the harem and its larger function in maintaining the

state. Whether spelled *harem* or *haram*, the term referred, as we have seen, to sacred, inviolable space. Even in non-Islamic states where the term was not used, the inner quarters monopolized by women both bolstered the ruler's prestige and received protection from his relationship with the divine. In no case did having a bevy of women at his beck and call mean that the ruler could exercise free license. As Shuo Wang demonstrates, political and cultural constraints limited even Qing emperors' freedom of choice in whom to bed. Confucian norms of propriety prohibited them and Korean kings from taking women who had served in a previous generation's household.[14] In accordance with the Japanese military code of honor that declared a retainer's wife and concubines off-limits to his lord, shoguns were expected to refrain from sexual predation among their wives' chief attendants.[15] Sex was also a duty. According to the politics of reproduction in the Chakri dynasty, the king might visit his favorite as often as he wished, so long as he also impregnated as many concubines as possible. Each woman represented a powerful family who desired a blood relationship with the king, and her barrenness might have been taken as an insult.[16] Regardless of the circumstances, although concubines were responsible for reproduction, they did not control it.

Western paintings depict concubines as living a life of leisure, but the reality was often quite different. In Aztec Mexico and Kano Nigeria, concubines worked at textile-related activities; in some parts of the world, they were largely responsible for their own livelihood. Whether concubines could be differentiated from servants depended on the power structure. In the Ottoman harem, the queen mother made sure that her son bedded only women trained by and loyal to her; all other women had to keep out of sight. In some states, interested parties (especially concubines' families) tried to limit the ruler's attention to a discrete group of women, only to be confounded by a ruler's partiality for a slave or a servant. One way that emperors in China could demonstrate their absolute authority over the Forbidden City was by selecting a concubine from the women originally recruited as entertainers or drafted as maids. Beginning in the eighteenth century, the Tokugawa shoguns treated their concubines as servants unless the women bore children. Only then did they receive their own apartments and women to attend them.

Servants

Generally speaking, servants' lives are much less studied than those of queens, in part because queens are more visible and the records about them are better preserved. Queens, after all, are assumed to have a closer connection to the really important issues of power and policy. When people read history, they often

enjoy putting themselves in the place of the high and mighty. Who wants to think that in a past life they did menial labor? Social historians have tried to counter these assumptions by pointing out that most people in history were neither great nor famous. They deserve to be studied because they too had desires and projects; furthermore, their lives are more likely to expose the fundamentals of change. For both of these reasons, the women who worked in palaces figure in this book.

Faced with the paucity of conventional evidence, the authors have developed a variety of strategies to uncover information about servants' lives. Susan Toby Evans has counted spindle whorls to determine the number of women who inhabited various levels of palaces in Aztec Mexico and has drawn on pictures to prove how textile production and the structure of palace life changed after the Conquest. Heidi Nast traces transformations in palace concubines' indigo dyeing activities over half a millennium by integrating secondary source material with that collected through fieldwork. That fieldwork has involved gathering and interpreting linguistic, ethnographic, architectural, aerial photographic, and other data to create maps showing changes in the toponyms and sociospatial organization of the palace over time. Historians use paintings and documents. Kathryn Norberg sifts memoirs and the French national archives for evidence regarding female functionaries. Barbara Andaya relies on the reports of European traders who visited Southeast Asia and recorded their first shocked impressions, but she reads these texts in ways their authors never intended. Beverly Bossler likewise reads against the grain to find evidence of Song dynasty court entertainers in the disapproving records of later dynasties. JaHyun Kim Haboush adduces evidence for the subjectivity of palace matrons in their beautifully crafted lists of objects. Hata Hisako and other Japanese historians have uncovered correspondence between the palace staff and their families as well as records of service personnel in a most unlikely place—farm storehouses far removed from the shogun's capital. Although personal and fragmentary, never revealing quite as much as we want to know, these sources shed light on how women came to serve in palaces, what they did there, and what they made of their experiences.

Women entered palaces through diverse paths and for different reasons. As conquest dynasties, the Ottoman sultans stocked their harem with slaves; the Qing emperors of China drafted women designated as cultural reservoirs for Manchu identity. In neither case did women have any choice. In Benin, life behind palace walls was so feared that parents might send an unruly daughter there as a form of punishment, although in most cases she was proffered as a gift. Less powerful rulers had to rely on other inducements. In some regions women recruited other women, usually nieces and neighbors—another sign

that networks connected women inside and outside the palace at a number of different status levels. Many women sought employment in the palace either because they needed a way to support themselves or because they wanted an education. Kaplan and Evans suggest that for servants, life in the palace had to be easier than scraping a bare existence outside. Although in most cases we can only guess at why women worked in palaces or what they thought of life there, the letters by a woman in the shogun's palace found by Hata provide a glimpse of her desires and strategies for realizing them.

The vast majority of women who served in palaces left few traces of their existence. But in the aggregate, their experiences point to how they responded to changes in their immediate environment and the outside world. Aztec noblewomen found their lives transformed when the Spaniards introduced sheep and industrial spinning methods. Instead of enjoying the prestige of working at textile production indoors, they had to go outside to the common world of the marketplace. Only in their dress did they manage to retain traditional ways. Following an early-nineteenth-century reformist jihad in Kano, the palace's concubine-managed dyeing yard was abandoned; instead, Islamic reformist rulers promoted the regional commercialization of indigo dyeing by men. Nast attributes the yard's closure to changes in the economy and polity that lessened the value of fertility to the state and, hence, reduced the importance of indigo blue as a divine marker of its control by the state. In China, the emperor's effort to maintain Manchu ways at court collided with the tendency of the bannerman families who supplied his servants to mimic their Chinese neighbors, especially as the dynasty's rule stretched on. For Japanese women living in and around the shogun's city of Edo, increasing commercial activity meant that by the end of the eighteenth century, service in the Great Interior became an object of consumption. As the early modern equivalent of a finishing school, working for a few years as an attendant or a maid became a prerequisite for making a good marriage. Given the diversity of monarchical systems around the world, we cannot say that changes in the lives of women working in the harem or inner quarters led inevitably to fewer restrictions or tighter controls, to a better life or a worse one. Change can be multidirectional: it does not necessarily imply progress.

In many parts of the world, the spatial configuration that promoted sex segregation required what may be called nonsexed beings to mediate between the inner court and the outside. According to Ringrose's study of eunuchs as palace servants in Byzantium, they guarded the boundary between the sacred (the monarch) and the profane (bearded men) not only by participating in ceremonies but also by serving as trusted advisers and administrators. They performed similar functions in the Ottoman Empire and in the city-state of

Kano.[17] In Benin, eunuchs protected the sacred space around the ruler and his women.

In Japan, Java, Kano, and Thailand, women guarded the door to the inner quarters. They also did the heavy work of hauling water and carrying firewood, a duty suggesting that they were recruited for their physical prowess rather than their sexual allure. Within the Great Interior, women carried palanquins. In the Thai inner court, the guards, doctors, and judges were women, providing a space for female autonomy unmatched in other societies.[18] Fukai Masaumi has argued that in the shogun's palace, men and women who took the Buddhist tonsure became an intermediary or third sex, and thus functionally equivalent to eunuchs. Shaving the head erased status and fertility markers, thereby enabling the monks to travel between the Great Interior, the middle interior, and the outside.[19] Nonetheless, there remained a fundamental difference between monks and eunuchs: while monks may have crossed boundaries to carry messages, they lived outside and remained biological men; those who lived in the Great Interior were biological women. Eunuchs did not exist as a social category in Japan or Thailand. Instead, people with different markers of sexuality inscribed on their bodies took analogous roles, pointing to diversity in the practice of sexing beings within the context of palace life.

Producing Culture

Beyond the context that they provide for the exercise of political power, palaces offered an important setting for the production of culture. The historical sociologist Norbert Elias claimed that court societies are responsible for what he called the civilizing process, by which people learn to negotiate increasingly complex sets of interdependencies that require self-restraint and careful planning.[20] His successors have argued over whether the literary and artistic discourses as well as ceremonies and rituals that channeled this process served to trap courtiers or the monarch himself, or simply enabled the nobility to use rules of etiquette to create a sense of group identity and exclude outsiders.[21] Essays in this volume provide concrete evidence of women's roles in defining court products and the essentials of feminine self-cultivation. The Song court used performances by female entertainers to impress foreign diplomats and to reward officials. Nast argues that before 1800, palace concubines in Kano controlled the production of indigo-dyed cloth used exclusively to express state power and to shore up political relations. Its unique color, the darker the better, and its association with fertility meant that it could be used only by women. The craftsmanship that went into its production served as one means to raise the palace and ruler in the estimation of Kano's subjects. Cloth production by

women weavers in Aztec palaces contributed to the palace economy as well as defining the difference in female status between high-ranked women who wove indoors and commoner women who sold woven goods outside in the market. In both Kano and the Aztec empire, textiles originating in the palace show that the construction of female virtue was associated with productive labor.

The connection between court life, female virtue, and productive labor can be seen in other parts of the world as well. Palace women contributed to the court's civilizing mission by setting the standards for feminine accomplishments and producing works of artistic merit. As Hata points out in her essay on the shogun's women, training in the Great Interior taught women deportment and etiquette and honed their skills in calligraphy, music, dance, and song. In Thailand, the inner court educated women in domestic skills, singing, and dancing: it was a veritable "high school or university," all in the service of maintaining the palace's preeminence in the arts as well as politics.[22] So high was the court's reputation that elite families sent it their daughters to acquire polish before marriage.[23] Slaves in Topkapi Palace learned to play the harp and sing. They learned needlework so well, in fact, that they used intermediaries to sell their products outside the palace.[24] The Korean court trained the young girls who were to become attendants in etiquette, penmanship, court language, calligraphy, and literature. As Haboush points out, these skills enabled women to produce works that contributed to high culture. Some, such as the lists of items written in beautiful calligraphy, were valued for their artistic merit. One text that today would be called creative nonfiction, written by a palace woman, commented on a breakdown in the civilizing ritual order when the king violated Confucian norms of conduct by persecuting his stepmother.

What can a study of palace women bring to our understanding of how different monarchies functioned? In his study of Versailles and Vienna, Duindam focused on relations between the monarch's household and his administration as he distinguished between premodern and modern monarchies. He argued that the characteristics of early modern courts—the highly personal configuration of power around monarchs whose individual personalities gave stamp to policy and politics, the assumption that not only the monarchy but also rank should be hereditary (not true of China), the intimacy built up over generations between ruler and courtiers, and the factional strife for the ruler's favor—were intrinsically different from those found in modern regimes. Even where monarchies survived, whether in nineteenth-century France or today in Great Britain, Japan, and elsewhere, representative assemblies and bureaucracies based on some combination of education and merit took over the business of adminis-

tration, leaving only ceremonial roles to the monarch. (Kaplan's study of Benin suggests that during and after the age of empire, the continued presence of regional rulers who set policy within the limits imposed by a colonial authority or national government complicates this picture.) When the ruler's household is no longer the center of government and the ruler's favor no longer counts for more than celebrity status, why bother building factions to compete for his personal attention?[25]

Duindam's study pays scant attention to women. While we should accept his caution that if we try to include too many courts we may lose ourselves in the maze of their unending variety, attempting some generalizations is still worthwhile. For example, we might compare conquest empires such as the Ottoman and Qing and the indigenous regimes found in Korea, Japan, France, and elsewhere. The former excluded native women from the inner court in order to maintain an identity separate from that of the populace, they had the power to buy or draft consorts and servants, and the palace population was relatively homogeneous so far as the women's original status was concerned. In other countries, the rulers paid more attention to political and social integration, they often required compromises to make palace life attractive, and channels of recruitment were more diverse. All courts require bevies of courtiers; what astonished European observers of Southeast Asian realms was the overwhelming number of women that added a quantifiable dimension to the ruler's demonstration of power. Although Christian monarchs practiced monogamy (serial monogamy in the case of Ivan the Terrible), one unexpected commonality between them and other monarchs is the extent to which sex segregation structured spatial layouts and court life. Queens and queen mothers had the luxury of their own apartments, but despite the intimacy of access to the monarch, they still had to compete with male attendants and nobles. At the very least, putting palace women in the picture offers a new perspective on the enactment of kingly power.

Changes in the relationships between the monarch and women can also shed light on differences between premodern and modern courts. When the monarch no longer dominates the political process, sex segregation no longer features as prominently—perhaps because when men can seek political power through a bureaucracy located outside the court, they leave the positions in close proximity to the monarch to be filled by women. When the monarch's chief favorite becomes his wife, as in the case of Marie-Amélie of France, the institution of companionate marriage brings the royal family so close to the practice of the populace that the majesty of rule all but disappears. Having lost control over the levers of power, both women and monarch find that irresolvable contradictions between private and public roles lead all too easily to scandal.

What can a study of palace women bring to our understanding of what women did in the past? The historical record often makes it difficult to detect women's agency in the decisions that decided their fate—whether to enter the palace, whether they would procreate, what kind of support they would receive in old age. Given the pervasiveness of sex segregation, they had to live together with women of different statuses and ethnicities. In some circumstances, these differences were represented, reframed, and reinforced through daily interactions within palace walls, while in others they were moderated or transcended. Insofar as palace women participated in political integration not only by linking elite families but also by bringing a variety of social classes onto a common ground, they played a crucial if often overlooked role in the construction of the premodern polity. They furthermore participated in productive practices that over time might afford them avenues of enrichment and self-fulfillment, sometimes but not always apart from politics. Although royal courts were designed to project the authority of male rulers, they maintained themselves through the reproductive and productive activities of women.

Notes

1. See, for example, Geertz 1985 and Cannadine 1985, both essays in a volume edited by Sean Wilentz.

2. The earliest reference to Japan in Chinese chronicles states that a Queen Himiko ruled by virtue of her ability to communicate with the gods. This type of rule soon disappeared.

3. For a comparison of Vienna and Versailles, see Duindam 2003, p. 317.

4. Yu Zhuoyun 1984, pp. 25–26.

5. Peirce 1993, p. 4.

6. Strong 1973.

7. Nishikawa 2003; Aram 2005.

8. Khan 2001.

9. Not all mothers identified their sons' interests with their own. After Hōjō Masako, wife of the founder of Japan's first military regime, dethroned her two sons in order to perpetuate the influence of her natal house, no later regime appointed a female regent for an underage ruler. The infamous Wu who ruled as emperor, not empress, of China dethroned her sons in order to rule in her own right. See too Ringrose, this volume.

10. The eighth shogun Yoshimune provides an example of the first type of intervention; the fourteenth shogun Iemochi, the second type.

11. Duindam 1994, p. 313.

12. Zito 1997, p. 33; Kahn 1967.

13. Haboush 1988, pp. 46, 51, 52–53, 59–63, 182–85.

14. Haboush 1988, p. 199. Despite a chorus of criticism, emperors, kings, and shoguns occasionally violated these prohibitions.

15. Nagashima [1892] 1971, p. 99.

16. Wyatt 1982, p. 149; Chakrabongse 1960, p. 116. Despite the political pressures to show impartiality in fathering, more than half of King Mongkut's wives and concubines bore no children (Bristowe 1976, p. 20).

17. Nast (2005) adduces evidence that eunuchs in Kano did much more than assist women with dyeing: they also guarded the king, served on the state council, and ran the treasury.

18. Loos 2005.

19. Fukai 1997, p. 74.

20. Elias 1983, p. 29; 2000, p. 188.

21. Duindam 1994, pp. 100–101.

22. Chakrabongse 1960, pp. 91 (quotation), 179. Leonowens (1991, p. 109) commented that even young girls committed so many songs and poems to memory that they became "walking libraries."

23. Moffat 1961, p. 139.

24. Peirce 1993, p. 141.

25. Duindam 2003, p. 318 and passim.

WOMEN AND THE PERFORMANCE OF POWER IN EARLY MODERN SOUTHEAST ASIA

Barbara Watson Andaya

In 1666 a publisher in the Dutch city of Dordrecht printed a small book, unassumingly titled *A Javanese Journey from Batavia to the Royal Capital of Mataram via Semarang*. Attributed to a certain "Mr. N.N.," it comprised a description of the route, together with an account of "the manners, customs, and the government of the Susuhunan [Amangkurat I, r. 1646–77], the mightiest king in the island of Java." We now know that the author was Rijklof van Goens (1619–82), an employee and later governor-general of the Dutch East India Company (VOC), and that the original narrative was written in 1656 after he had made five official visits to the Mataram court.[1] The publisher presumably believed that *A Javanese Journey* would generate respectable sales. However, with stereotypes of exotic Asian women becoming standard fare in European travel writing, Dutch readers must have found the section dealing with the Susuhunan's household particularly intriguing. Indeed, Van Goens proved more than ready to invoke the titillating imagery popularly associated with male–female relations in Asian cultures. In the lingering descriptions of palace life that he offered to "curious devotees," his emphasis on the numbers and beauty of the king's women was implicitly sexual ("so delightful to see . . . their upper body completely naked except for a silk cloth two hands wide covering both breasts").[2]

Van Goens's fascination with the female presence in the Mataram court should also be considered in a context in which monogamy was an absolute prerequisite for Christian monarchs. Furthermore, while royal households in early modern Europe could include sizable female populations, responsibility

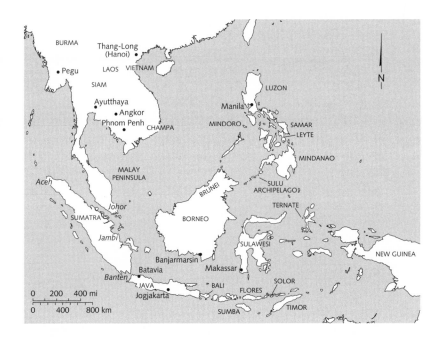

MAP I.I.
Early modern Southeast Asia.

for managing a king's wardrobe, toiletries, bedchamber, and so forth was normally the responsibility of male attendants.[3] However, in Java, wrote Van Goens, "what amazed us the most was that at night there is not a single man in this great court apart from the king; one could certainly believe that no less than ten thousand women live inside."[4] Even more extraordinary was the sight of armed women, not men, patrolling the palace and serving as the ruler's personal bodyguard. According to *A Javanese Journey*, when the king presided at an official audience he was surrounded by the 150-strong female corps, all carefully selected for their beauty and all skilled in the use of pikes, lances, blowpipes, and muskets. Flanking him was an elite group of thirty guardswomen, some of whom bore pikes and sharp daggers, while others carried the royal paraphernalia—vats of water, betel nut trays, tobacco, pipe, matches, perfume containers, umbrellas, and boxes of clothing such as jackets and slippers.[5]

While the details of court life supplied by Van Goens remain an important source for understanding the nature of kingly power in Java, in the world area we now call Southeast Asia the "femaleness" of Amangkurat's court was by no means exceptional.[6] By this period Buddhism was well established in the mainland, Chinese influence was dominant in Vietnam, and most courts in the

Malay-Indonesian archipelago had adopted Islam, but older ideas that the maintenance of many women increased male status were regionwide. It is worth remembering that a major obstacle to the acceptance of Christianity was missionary condemnation of concubinage and the insistence that high-ranking men must limit themselves to one wife. Admittedly, the female presence in the royal and chiefly households scattered across Southeast Asia rarely matched that of the Mataram court; a Buddhist king ruling in contemporary Laos, for instance, might maintain only two hundred women, while a Muslim ruler of Mindanao (southern Philippines) was said to have just thirty "women or wives."[7] Yet despite disparities of scale, the courts of early modern Southeast Asia all shared an ongoing preoccupation with the ceremonial reiteration of royal status.

The ritual restatement of authority so necessary to the maintenance of kingship forms a recurring theme in this volume, and represents a common thread in Southeast Asian history as well. The memorable phrase "theater state" so effectively deployed by Clifford Geertz in relation to Bali is eminently applicable even in places where Europeans condescendingly equated the "king" to one of their own provincial mayors. Whether in these enhanced chiefdoms or in larger courts like those of Java or Burma, ceremonial life was "an assertion of spiritual power. . . . It was an argument, made over and over again in the consistent vocabulary of ritual, that worldly status has a cosmic base, that hierarchy is the governing principle of the universe and that the arrangements of human life are but approximations, more close or less, to those of the divine."[8] In this performance of power, women were indispensable, usually in supporting roles but at times as directors and lead actors. Notwithstanding regional differences in language, culture, and historical experience, "palace women" across Southeast Asia can be considered in terms of the enactment of royal status, which, by separating a ruler from his subjects, justified and maintained the rationale on which kingship rested.

The Purpose of Royal Polygyny

The first European visitors to reach Southeast Asia in the sixteenth century often commented that whereas most men had only one wife, the region's most powerful rulers maintained numerous consorts and concubines. In seeking explanations of the phenomenon of "one man–many women," modern historians commonly stress the political alliances consolidated by the exchange of palace women. Because the dynamics of kinship were always the base on which politics and diplomacy rested, polygyny had practical advantages. Daughters of vassals and neighboring kings were brought into the palace to symbolize the conclusion of a peace treaty, the affirmation of an old contract, the swearing of a new alliance, or the surrender of some rival. In the same mode, a ruler's daughters

could also be offered as brides, strengthening established links and endorsing additional connections. A critical component was always the status of the woman, because she and her children were living signifiers of the bonds that now connected her husband and her male relatives.

Dynastic genealogies from Southeast Asia contain innumerable instances of these kinship ramifications. One striking example is provided by the life of Karaengta ri Bontojeqneq, a princess from Makassar (Sulawesi, Indonesia). According to court records, she was born in 1628, the daughter of the sultan and a commoner mother. In 1646, at the age of eighteen, she made her first marriage; by the time she died in 1669 she had been married and divorced at least four times, twice to rulers of overseas kingdoms under Makassar influence, and twice to one of Makassar's foremost nobles.[9] Through the connections of blood and marriage exemplified by Karaengta ri Bontojeqneq (herself briefly exiled because of her political involvement), palace women could acquire extraordinary influence in court diplomacy, particularly as mediators when male honor was at stake. A fragmentary text from sixteenth-century Cambodia thus mentions several instances when the women of the Khmer royal family, led by the queen grandmother, were instrumental in finding solutions to family crises that were, as O. W. Wolters notes in the case of Vietnam, state crises as well.[10]

The frequency with which women from royal and elite households were offered to European traders and officials supplies telling evidence of indigenous conviction that bonds forged by sexual relationships were critical to successful diplomacy. References to high-ranking women offered to governors and merchants are by no means unusual, and in the late seventeenth century an English sea captain could still remark that this "is a Custom used by several nations in the East-Indies, as at Pegu [southern Burma], Siam, Cochinchina, and Cambodia. . . . It is accounted a piece of Policy to do it; for the chief Factors and Captains of Ships have the great men's Daughters offered them."[11] Some Europeans were themselves willing to overlook the divides of language and religion in search of commercial profits, and could even contemplate a European woman entering an Asian household. In 1614 the English East India Company directors seriously considered the suggestion of "a gentleman of noble parentage" that his daughter, skilled in music, needlework and conversational skills, be given as a wife to "the [Muslim] ruler of Sumatra" (i.e., Aceh), because doing so would "advantage" the company.[12]

Several historians have pointed out that the absorption of lowborn women could also strengthen the position of a ruler in relation to his subjects by solidifying court–village relationships. Certainly there are many accounts of the forced abduction of young women, and across the region a common folklore

motif refers to village parents who hide or disguise a pretty daughter (for instance, by smearing her face with fish paste). Yet such stories are countered by others that tell of romantic love, of a king who is captivated by a commoner and raises her to be his queen, of the children who are born to them, and of the rewards that come to her family and community. All through Southeast Asia one still finds areas that have retained their reputation as a source of attractive maidens for palace service. No matter that they merely performed the daily chores involved in maintaining large establishments—collecting water, gathering firewood, cooking, washing, and serving as attendants to high-ranking palace women. Widespread assumptions that such women would eventually become recipients of a ruler's sexual favors reinforced fictive (and occasionally actual) blood links between ruler and village subjects and in this sense, it has been argued, transformed the ruler into an elder kinsman.[13]

As Patricia Ebrey has shown in relation to Song China, the argument that large female establishments were necessary in maintaining the ruler's position vis-à-vis his subjects, his vassal lords, and neighboring kings has been useful in exploring the influence of palace women in court affairs. Nonetheless, it does not completely explain why the largest establishments could house hundreds or even thousands of women; as Van Goens pointed out, most female residents of the Mataram court were not wives or concubines but served the queens, princesses, royal relatives, selir (the sultan's unofficial wives), and other high-ranking female residents. Furthermore, strategic marriages do not explain palace "femaleness" when the ruler was a woman, or when a queen regent governed for a minor.[14] Aceh, the devoutly Muslim court of northern Sumatra, was governed by queens for nearly sixty years (1641–99); but when the wife of a VOC envoy was entertained at court in 1661, she still spoke of noble women and their attendants "in their hundreds."[15]

Although the marriages of Southeast Asian kings could cement strategic alliances, they do not necessarily provide a personalized map of diplomatic ties and tributary relationships. For example, in the Javanese court of Mataram the ruler's first wife was almost always a relative, usually a cousin, who had grown up at court, and the selir could well be of common birth. One remarkable example concerns the daughter of a stall-keeper, who was granted a queen's title and became the mother of the future Pakubuwana IV (r. 1788–1820).[16] The elevation of such women could hardly be of great political value. Furthermore, all royal courts carefully regulated female status according to birth. The frequency of diplomatic marriages was therefore restricted, since only a limited number of high-ranking women could be successfully incorporated into the court hierarchy. Javanese kings regularly but temporarily divorced wives and married pregnant selir in order to limit their official consorts to four, the num-

ber permitted by Islam.[17] Buddhist teachings imposed no such limitations, but in 1687 Simon de La Loubère, the French ambassador to the court of Ayutthaya (Siam), noted that the king had "few mistresses, that is to say, eight or ten in all."[18] In several mainland kingdoms the candidates for chief queen were further limited because she was frequently the ruler's sister or half sister. In order to maintain this purity, a Burmese edict of 1630 specifically legalized the union of siblings born of different mothers but the same (kingly) father.[19] The most stringent restrictions on numbers of royal consorts can be found in the sinicized courts of Vietnam and became more strictly enforced as Neo-Confucianism strengthened in the fifteenth century. Thereafter scholars roundly criticized "non-Chinese" practices whereby former kings had taken two or more queens, had failed to designate a principal wife, and had even married low-ranking or non-Vietnamese women.[20]

The argument that numerous sexual partners were necessary to ensure a legitimate heir is also unconvincing in the Southeast Asian context, since direct father-to-son succession, though preferred, was not at all mandatory. Of the fifteen kings of Burma between 1597 and 1819, for example, only eight were sons of the predecessor; and in Siam the figure for the same period is seven among eighteen rulers. A young brother, an uncle, a cousin, even a daughter's husband could easily supersede the king's own sons, especially if the mother of such an individual was herself of royal birth. Despite European stereotypes of lascivious Asian potentates, genealogies suggest that kings normally limited their sexual relationships to a small group of favored women. Khmer chronicles, for instance, record that King Sattha (r. ca. 1579/80–95) had two sons and a daughter by his chief queen, a daughter from a second queen, a daughter from a third queen, and two sons and two daughters by three other consorts.[21] Nor does the often forcible recruitment of young girls to the palace necessarily indicate that royal sexuality was unrestrained, since most "inner court" attendants were selected not by kings and princes but by the senior women whom they were destined to serve.

Women's Roles at Court

In discussing the imperial court of Song China, Patricia Ebrey concludes that traditional explanations of political alliances and dynastic succession are insufficient to answer the question "why so many women." In a description reminiscent of the Geertzian "theater state," she has invoked the baggage of images that Chinese inherited about the "proper" appearance of courts, together with Daoist representations of paradise and its population of beautiful young women.[22] Most Southeast Asianists would be happy to embrace such analogies, but they

would also stress that imported ideas are better viewed as elaborations of long-standing attitudes that tied royal virility to the fertility of the land.

Long before the arrival of the world religions we find recurring evidence of a deep-seated belief that human well-being was cosmologically associated with some kind of mysterious sexual union between the ruler and the earth, often personified as a beautiful woman. An early indication of these linkages comes from 1295, when a Chinese envoy described the daily intercourse said to occur between the Cambodian king and a dragon princess.[23] With variations, this story surfaces repeatedly in sources from other Southeast Asian societies, with the *imaginaire* of the ruler–fertility motif reinforced by the king's return to a completely female world. Regardless of any actual physical relationships, the mere presence of many palace women carried cultural implications of sexuality, conception, and fruitfulness, a notion that could also be applied to queens, albeit in a more muted vein. Although the Cham peoples were conquered by the Vietnamese to their north, they continue to revere the goddess Po Nagar, personification of the nurturing earth, who had ninety-seven husbands and thirty-nine daughters.[24] Accordingly, even when the ruler was a young woman, the emphasis was not on her sexual union with men but on her allegorical role as mother of a huge family of subjects, with the royal household serving as a metaphor for female fertility. Against this background it is evident that a queen mother of the Sumatran state of Jambi who visited the VOC lodge accompanied by "all the children and grandchildren who have sprung from her loins" intended to relay a statement regarding her own fecundity.[25]

By the sixteenth century, the privileged position accorded men in imported religions and philosophies was strengthening the existing Southeast Asian preference for male authority. Two hundred years later it was rare to find a woman ruling as sovereign queen. If anything, ancient beliefs in the sexual potency of leaders had become further entrenched, because kings were commonly placed on a continuum with gods and ancestors whose supra-human status was informed by their proven masculinity. In twelfth- and thirteenth-century Angkor, the great Hindu-Buddhist capital of Cambodia, legions of heavenly maidens (*apsaras*) carved on temple reliefs thus looked on approvingly at depictions of the king's exploits in war, and were mirrored in life by the hundreds of palace women who participated in royal processions.[26] The Buddhist heritage imparted similar messages. One of Thai Buddhism's core texts, a cosmology attributed to a fourteenth-century king, asserts that India's great missionary emperor Asoka had 16,000 concubines and that the Cakravatin, the world conqueror who prepares the way for the next Buddha, is distinguished by fathering a thousand sons.[27]

Although the teachings of Islam mandated no more than four wives, no similar limit applied to the number of concubines and female slaves a man

might maintain. Descriptions of a paradise where the faithful would be served by many women, the black-eyed houris, provided a compelling model for new royal converts. Stories of the harems maintained by distant Muslim rulers in India and Turkey fostered ingrained beliefs about the relationship between temporal power, masculinity, and sexual performance; one saying attributed to the Prophet (admittedly of questionable authority) maintains that "the best of this community are those who have the largest number of wives."[28] Even in the Christianized Creole society that grew up in European-controlled towns such as Manila and Batavia, the number of retainers (especially females) in a man's household was a popular gauge of his social status. One Dutch bachelor in Batavia was said to have a "harem" of fifty slaves "assorted from the different nations of the East and combining every tinge of complexion from the sickly faded hue of a dried tobacco leaf to the shining polish of black marble."[29]

In sum, then, throughout early modern Southeast Asia the maintenance of a large female household became a mark of the wealthy and highborn, a statement of social status and superiority which in turn dictated that the ruler should have far more women than any of his subjects. Writing for a French audience, and aware that Versailles could tolerate only one queen, regardless of the king's sexual peccadilloes, the envoy La Loubère offered this perceptive assessment: "To have a great many wives [or women] is in this country [Siam] rather magnificence than debauchery. Wherefore they are very surprised to hear that so great a King as ours (i.e. Louis XIV) has no more than one wife."[30] La Loubère's observations are intriguing for other reasons. An experienced diplomat, he was fully aware that the purpose of the royal audience was to impress foreign visitors. Implicit in his remarks, therefore, and in the comments of other Europeans who visited Southeast Asian courts was the recognition that they were witnessing cultural performances of male authority and status. In these performances women became an essential accoutrement of sovereignty. As an eighteenth-century VOC official unsympathetically put it: "Indonesian kings show their greatness and power though maintaining many women in order to display their lecherous appetite."[31]

Women's Roles in the Enactment of Royal Power

As Van Goens took such pains to show, the "many women" on display in Southeast Asian courts were not an undifferentiated chorus line. From chief queen to the humblest serving girl, each had a part to play in the enactment of royal power. A thirteenth-century Chinese account of a royal audience in Cambodia

leaves no doubt as to the role of women in affirming the theatricality of the occasion:

> Distant music is heard in the place, while from outside blasts on conch shells sound forth. . . . Two girls of the palace lift up the curtain . . . and the king, sword in hand, appears standing in [a] gold window. All present, ministers and commoners, join their hands and touch the earth with their foreheads. . . . The sovereign seats himself at once on a lion's skin, which is a hereditary royal treasure. When the affairs of state have been dealt with the king turns back to the palace, the two girls let fall the curtain, and everyone rises.[32]

The writer was merely one of a succession of foreign envoys who, over the next five hundred years, documented details of their reception by Southeast Asian rulers. As one might expect, such descriptions are replete with references to impressive rooms hung with rare textiles and deferential courtiers wearing rich fabrics and valuable jewelry; at the same time, the deliberate staging of the royal appearance, often through the use of drapery and curtains, is a recurring theme. A typical visit was recorded when members of Ferdinand Magellan's crew were received by the sultan of Brunei in 1521. The great hall, said the chronicler, "was all adorned with silk hangings. . . . [A]t the end was a small hall from which a brocade curtain was drawn aside so that we could see the king seated at a table with one of his young sons[;] . . . no one but women were behind him."[33] Another example comes from Siam, where the French envoy La Loubère described how the royal audience ended with a profound silence that was finally broken by the tinkling of a timbrel and the "majestic" beating of a drum: "No person made any motion, till that the king, whose chair an invisible hand did by little and little draw back, removed himself from the window and closed the shutters thereof, and then the noise of the tinkling and the great drum ceased." A contemporary Thai mural provides visual confirmation. Seated on a raised platform framed by an ornamented window, with four of his consorts in the wings, the king looks benignly down on the prostrate courtiers and the kneeling European envoy.[34] For a Muslim queen, seclusion from public view was in keeping with religious proscriptions, but curtains and partitions could also be used to enhance dramatic effects. In Aceh, for instance, the sultana, hidden by a screen, deliberately raised and projected her voice so that all her pronouncements could be heard and understood.[35]

Producing the spectacle of royal theater in a suitable fashion required appropriate props and support actors, not just as ornamentation but as evidence of the court's ability to garner and control the strange and exotic, female as well as male. The formulaic "fifty humpbacked women" in the retinue of Burma's

legendary queens are emblematic of the unique character of royal households, and some societies mandated that albinos and identical twins be surrendered to the court.[36] Likewise, "small savage slaves" captured in the highlands might be included in the entourage of sinicized princesses in seventeenth-century Vietnam, while a Javanese court text notes the presence of a "curly-haired woman" (perhaps from Papua) in the retinue of a Cham princess.[37] Many of these unusual individuals were abducted or enslaved, like the "white women" purchased in Persia for the Thai king,[38] but the continuing demands for an unusual entourage could have more insidious consequences. In sixteenth-century Ternate (eastern Indonesia), for example, the female dwarfs who carried the king's sword and betel box were reputedly deliberately disabled as children by having their backbone broken.[39] A few years later a Dutch observer in Bali spoke of the misshapen people, often women, "who for a long time" had their arms and legs tied in such a way that they took on the appearance of the stylized figures carved on the handle of a dagger.[40]

The cultural weight attached to the ruler's assumed powers over the bizarre and unfamiliar was probably lost on most European witnesses, already accustomed to the dwarfs, African slaves, and other marks of the exotic to be found in courts at home. Like Van Goens, they would have been more intrigued by the sheer numbers of women and by such evidence of "otherness" as the gender reversal of armed guardswomen. Obviously fascinated by Mataram's elite female corps, Van Goens took particular note of their beauty; the skill with which they handled their lances, pikes, and daggers; and their refined singing and dancing. In the 1780s another VOC envoy was equally impressed by their daily training, and by the proficiency and accuracy with which they handled European musketry.[41] Like palace wardens elsewhere, the prime task of all female guards was to ensure that no male gained illegal entry into the "women's quarters"; they also guaranteed that none of the residents left without permission.

The Thai counterpart of Mataram's elite female corps may not have been formed until the eighteenth century. According to a later French account, it consisted of a battalion divided into four companies, comprising four hundred women in all. Recruited at the age of thirteen, they served as guards until they reached twenty-five or so, after which time they continued as royal attendants and supervisors. Their leaders were women of proven courage and loyalty handpicked by the king, and the corps itself was a model of organization and military prowess.[42] Examples of their vigilance are occasionally found in court chronicles; in 1783, for instance, an alert female sentry raised the alarm when two men dressed as women smuggled themselves inside. On another occasion after a palace fire, a number of escaped concubines who had sought refuge at

the homes of high-ranking officials were all apprehended and brought back by the female palace guards.[43]

Theatrical Spaces, Theatrical Performances

This type of surveillance and the words associated with the women's quarters—"inner," "closed," "forbidden"—serve as a reminder that queens, royal consorts, and princesses were rarely seen publicly. Seclusion from the outside had long been a mark of the highest female status in Southeast Asian societies, and the sequestering of marriageable princesses was widespread. The fourteen-year-old Muslim Mindanao princess who was "kept in a room and never stir[red] out," and who saw no men except her father and uncle, was representative of the invisibility that (at least in European eyes) made the influence of royal women so mysterious. French envoys wrote at length about the daughter of Ayutthaya's King Narai (r. 1656–88), who had been cloistered since puberty and whom they never met, despite her manipulation of court politics.[44]

Despite the allegedly closed and guarded world of the women's quarters, its occupants were not in fact sealed off from the outside. Through agents, and even personally, queens and princesses could be actively involved in commercial activities and in supporting religious foundations, while pilgrimages and pleasure trips were often initiated at the request of a royal favorite. In Vietnam, dowager empresses were permitted to live outside the palace in order to honor royal ancestors through visits to the mausoleums of past rulers.[45] Here and elsewhere the solemnity of these occasions—processions of palace women carried in closed palanquins, cavalcades of courtiers on elephants—served as an extension to the panoply of palace ritual.

A favorite Southeast Asian backdrop for the royal performance was always the river, with the royal barge the preferred stage. In Aceh the theatrical nature of such occasions was graphically captured by an English visitor following the installation of a new queen, Sultana Zakiyat al-Din Syah (r. 1678–88): "She went down the River of Achin in soe admirable a Grandure of Worldly State, that the like I believe was never paralleled in the Universe." Accompanied by courtiers, eunuchs, and her women, the royal procession proceeded on barges decorated with gold, as "varieties of musick, and delicate Voices . . . sange to the great Honor and Majestie of their great Virgin-Princess."[46]

Several contributors to this volume have shown that although there were numerous public arenas for the enactment of royal power, the most potent rituals were often staged in the closed theater of the palace interior, with only a select audience permitted to watch. Unfortunately, in Southeast Asia it is difficult to reconstruct the environment for these largely female occasions because the trop-

ical climate and the ravages of war have militated against the preservation of royal residences built earlier than the nineteenth century. For example, nothing remains of Lan Xang, once a dominant Lao kingdom, and we must perforce accept the assurance of an Italian Jesuit that the palace, with its spacious courtyards and "a group of houses, all of brick and roofed with tiles, in which the secondary wives usually reside," was "so extensive one would take it for a city."[47] Nor do we have much information about the architectural organization of the "Western Court," the women's quarters of the Burmese palace "where only females are allowed to work."[48]

In some cases, however, it is possible to envisage the backdrops against which palace ritual was played out. In the modern city of Aceh, for instance, one encounters the remnants of a seventeenth-century Mughal-style "garden of love" (Taman Ghairah) where sultans commonly made offerings when a wife became pregnant, and where a royal couple underwent ritual lustration. Hidden from public view, it had a symbolic force that may have been all the greater because it invoked Qur'anic accounts of the garden of paradise and because its association with sexual relationships spoke to the ideas of fertility and regeneration that lay at the very heart of kingship.[49] Probably the best example of these inner sanctums is the Javanese complex known as Taman Sari ("fragrant gardens") in contemporary Jogjakarta (central Java), built in 1758 by Sultan Hamengkubuwono I (r. 1755–92). Like the Taman Ghairah, a prominent feature was the bathing pools; two were set aside for the royal wives and concubines, and a third smaller one was reserved for the sultan and his chosen partner. Court women and their attendants could relax in the pavilions surrounding the pools, while the sultan (an audience, in effect, of one) could overlook the entire bathing area from his bedroom in a three-story tower. Far more than a playground built to satisfy some royal whimsy, the whole site was infused with immense cultural significance. In the deep recesses of the Taman Sari, it was said, a special room was reserved for periodic meetings between the sultan and the goddess of the South Sea, Ratu Kidul, and for the sexual union that would ensure the longevity of his line and the prosperity of the kingdom.[50]

The idea that the central point of a kingdom was a largely female domain, where precious objects like the regalia were housed and where secret rites were performed, was highly salient in societies where court dancing had long been seen as a conduit to the nonhuman world. For Europeans, the customs of presenting a small gift to the women as a token of appreciation probably obscured any understanding that they were witnessing far more than mere entertainment. A Dutch envoy who described the ritual Javanese dance known as the *bedhaya ketawang* was almost certainly completely unaware that it commemorated a mythical meeting between Ratu Kidul and Sultan Agung (r. 1613–46). Its potency

was such that Ratu Kidul—who could harm mortals and destroy crops when annoyed—was thought to be present when it was staged. If a dancer was ritually pure (i.e., not menstruating) Ratu Kidul might even enter her body, and she would then be taken by the ruler as his sexual partner.[51]

Although such trance-like dances apparently disappeared from the sinicized households of Vietnamese lords, the rest of Southeast Asia retained a strong belief in the mysterious powers that could be generated by court performances. A Khmer text, for instance, records that female spirit mediums, dressed in masks, were literally chased out of the palace—a symbolic purification that would protect the inhabitants from all harm.[52] Nothing of this spiritual dimension appears in the prosaic account left by a VOC envoy following his visit to the court of Banjarmasin (southeastern Borneo) in 1756. Although obviously impressed, he reported simply that he was entertained with a "comedie" about "wars and love affairs" performed in a room hung with gold tapestry, with the richly dressed and bejeweled characters played by leading court women, including the wife of the crown prince.[53]

Obviously, no performance could occur without training, direction, and organization. This was in the hands of such senior females as the two old women in the Mataram court who, said Van Goens, supervised the hundreds of attendants serving the ruler's wives and concubines. In Banjarmasin, an English sea captain who was also received by the local ruler noted that an old woman "whom I supposed to be their teacher" was in charge of the music and dancing staged for his entertainment.[54] Because the round of court ceremonies was perpetual, it provided constant demonstrations of valued learning that elevated senior women as recognized experts and a discerning audience. Their profound knowledge of history, genealogy, and custom meant that their opinion was commonly sought on a range of matters concerned with correct protocol, since the anger of ancestors or spirits at some lapse in established convention could have dire consequences. A Thai text that records the ceremonies surrounding the harvest month and describes how two queens led the court ladies out to stir the sacred rice (made into a kind of pudding) thus encodes implicit warnings of crop failure and famine that would result from any disregard for tradition.[55]

It is not surprising that the self-conscious theatricality of these occasions provides the framework of many a court text, for it was necessary to assure those who read and those who listened that tradition had been followed to the last detail. In 1808, for instance, palace advisers to a new Thai dynasty in Bangkok turned to an elderly princess to determine the procedures for the ritual shaving of the topknot of the ruler's eleven-year-old daughter. In observing precedents previously set in the court of Ayutthaya, the text describes how the procession circumambulated the palace walls, with the princess carried in a golden palan-

quin and accompanied by Buddhist monks and court Brahmans. Escorted by a noble dressed as Siva, she then ascended a representation of Mount Kailasa (renowned in Hindu myth) as an effective reincarnation of the god's spouse.[56]

Life Cycle Rituals

The inherited female knowledge of precedent and of time-honored practices underlying these staged presentations was arguably most evident in life cycle rituals—royal births, circumcisions, ear piercings, betrothals, marriages, funerals. Senior palace women were normally responsible for overseeing a royal union, from the earliest stages of reviewing possible candidates to inspecting the bride, organizing the ritual, supervising the food, and monitoring sexual relationships. Because royal virility had cosmic implications, the successful consummation of a marriage could not be in any way private, and in many instances court women were responsible for providing evidence in the form of bloodstained sheets taken from the wedding bed. In 1609 the ruler of Banten in west Java even borrowed twenty-five armed men from the English post to fire a salvo celebrating the conquest of his wife's virginity.[57]

Royal pregnancies were similarly a time of particular concern because of the possibility of infant death. An eighteenth-century Malay text devotes considerable attention to a two-day court ceremony known as "rocking the womb," intended to safeguard the well-being of the unborn child. Under the supervision of four "famous" midwives specifically summoned by the ruler, it is performed when the royal consort is seven months pregnant. The ritual commences with the application of henna to her hands and the recitation of prayers by leading Islamic officials. On the second day, the actual rocking of the womb begins. The consort lies on a mattress, while a length of cloth is slipped under her waist. Holding both ends, the midwives move the cloth from left and right, apparently to position the baby correctly. This rite is repeated seven times with different types of cloth employed, each displaying a specific design. Wearing special clothing, the ruler is ceremonially bathed with his consort the following day. Another elderly woman, presumably also a renowned midwife, pours sanctified water over the heads of the couple and processes around them seven times.[58]

The purpose of such ceremonials was not merely to provide ritual protection but also to emphasize the enormous divide between ruler and subject, a divide that could be evident even in the most mundane household tasks. Nothing should interrupt the entrance of the actors, the delivery of their lines, the timing of their exits. When some Dutchmen in Bali inadvertently blocked the path of a file of women with silver pots on their heads who were collecting river

bathwater for the king, they were told firmly by the guards that they must move out of the way.[59]

One of the most interesting accounts of indigenous attitudes toward the preservation of procedure and protocol comes from Thai chronicles of the late eighteenth century. In 1687 La Loubère had remarked that only women entered the king's chamber: "they make his bed and dress his meat; they clothe him and wait on him at Table."[60] A hundred years later, the founder of the new Bangkok dynasty, Rama I (r. 1782–1809), decided that a failure to observe the precise ritual associated with the king's person and the consequent displeasure of the deities had caused the problems that had beset the kingdom in recent times. As a result, each phase of the ruler's day became subject to strict surveillance. Women in charge of laying out his clothing were instructed to ensure that garments worn in the morning should be replaced by a new set before sundown; those used while he defecated could never be mixed with others; night clothing should be distinguished from that appropriate for daytime. Female attendants responsible for the royal bedchamber were charged with the ritual cleansing of all articles the king might touch. The water with which he cleaned his mouth and face had to be stored in a special place and covered so that none could see it, while the cloth for drying should be pure white and delicately scented. Other women were in charge of tending the plants that provided the ingredients for the royal toiletries and of mixing the sandalwood oils, roots, and flowers to make the powder for the king's face, or to perfume the wax used on his lips. Garlands of flowers should be hung near his bed, and replaced whenever they withered. Since any sudden illness could be attributed to poison, the new regulations stipulated that containers of food must be carefully sealed before being passed to the attendants who would carry them into the royal presence. En route, the seals should be inspected several times to ensure that they remained unbroken and that there had been no tampering with the contents. Only then could the containers be set before the king. After he had eaten, the remains would be taken back to the kitchens, where written notations should be made as to what and how much had been consumed. Adherence to these procedures should be strictly enforced, and any deviation punished severely.[61]

In celebrating the king's paramountcy, some occasions had special significance for palace women. At the end of the Buddhist Lent, for instance, the occupants of Burma's Western Court, carefully observing the obligatory protocol, paid homage to the king in order of seniority and status. In Vietnam a similar occasion for all courtiers took place at the New Year.[62] The inauguration of a new ruler was always a key event, and in many cases dowager queens were responsible for guarding the state paraphernalia that affirmed a legitimate succession. Such an occasion is recorded in an eighteenth-century Malay text,

as the widow of the previous ruler presided over the installation of his successor, handing over the sword, the regalia, and the royal insignia.[63] Another chronicle, a little-known Khmer work, describes the elaborate ceremonies surrounding the investiture of a new king and queen in 1614. In a hall garlanded with flowers, as conches were played and gongs and trumpets sounded, the king's new title was publicly proclaimed. After his formal acceptance, the queen took the gold inscription on which the title was written and placed it on a ceremonial tray. The music was then silenced, while the head of the Buddhist hierarchy and royal councillors chanted and gave their blessings. The royal women all made formal obeisance three times. Next, the chief minister paid homage before another gold inscription that named the new chief queen, whose title was also read aloud to the assembled company. It too was handed to the queen, who placed it on the tray with that of her husband. We are told that the state ceremonies and celebrations that followed continued for a full seven days.[64]

Throughout the region, and in different settings, this type of pageantry enacted power, authority, hierarchy, and status in a manner that Europeans could well appreciate. Perhaps the most profound sense of theater was generated by royal funerals, because ordinary subjects were so often involved as participating spectators. Without an audience the extreme demonstrations of loyalty exemplified in the ritual burning of highborn wives in Bali and pre-Muslim Java would have been pointless. Nor was the panoply of such events confined to kings; in 1633 twenty-two women also died at the cremation of a Balinese queen.[65] Sixty years later a French observer in Ayutthaya described the funeral of the ruler's mother, which was celebrated "with indescribable profusion and magnificence." All the women in the kingdom shaved their heads and wore mourning attire; the Buddhist monks, each with a specific role, paid their respects in a great display of "unprecedented ceremony." Finally, the king lit the pyre. The ashes, collected at midnight with great solemnity, were thrown into the river.[66]

The ruler's death invariably called for the most elaborate productions, and again palace women, especially queens and senior relatives, played a leading part. VOC descriptions of royal funerals in contemporary Indonesia rarely fail to mention the presence of court maidens, dressed in the appropriate mourning robes, and the elderly female courtiers who intoned the funeral chants that helped carry the soul to the future life. In the river procession after the death of a Vietnamese king, a leading vessel would carry his female kin, to be followed by a cortege of boats bearing splendid paper models of houses and other necessities that would be burned for the ruler's enjoyment in the afterlife.[67]

The Threat of Disruption

In detailing these rituals of power in Southeast Asian courts, historical records project virtually unassailable images of well-scripted, well-cast, and well-rehearsed theater. Yet in reality, of course, much could go awry—players forgot their lines, cues were ignored, leading actors failed to appear, stand-ins were disappointing. At the most pragmatic level, those who did not perform according to established standards could incur severe retribution: one Thai king was even reported to hit dancers who displeased him. In 1796 the reenactment of a battle in the Bangkok court erupted into actual fighting between two female dance-drama troupes because of the hostility between the sponsor of one group, the ruler, and his younger brother.[68]

Far more serious disruptions could occur when there was some kind of unscripted challenge to the hierarchy of rank that buttressed all aspects of court life, particularly in the women's quarters. A commoner or even a slave could become a sexual favorite, a lesser princess raised above her superiors, a son of the king and a lowborn woman preferred to his royal brothers. Since pregnancy was always a possibility and because the stakes were so high, the selection of attendants for the ruler's bedchamber had the potential to generate extreme tension. A Javanese text even claims that Amangkurat II (r. 1677–1703) had only one male heir because his wife attempted to secure the succession for her own son by causing pregnant selir to abort.[69] Friction was always a possibility when several women were vying for the ruler's affections, and humiliation could be especially galling if the favored one was a person of low social status. Even in translation, a poem attributed to a Burmese court lady conveys the despair of the repudiated lover who would never win the most coveted part in the royal drama:

> On oath you promised never to shun me
> Always to be loyal to me
> Solemnly you swore
> If I become King
> I shall make you my Queen
>
> .
> In coronation's splendid display
> I shall give to you the place of Chief Queen
> With eight Brahmans and many pages attending you
> And at the time of libation's ceremonial
> I shall cause all men to worship you
> I believed you and gave you my love
> Now . . . how different is your manner, oh Prince.[70]

The expected court scenario could also be dangerously unsettled by suspicions that a ruler had been unable to maintain the loyalty of his women. Indications of deception could take many forms; probably the most common were accusations of simple theft. In 1636, for instance, four female attendants in the Acehnese court were found guilty of stealing the silver service; as a punishment, their hands, feet, and noses were sliced off, their stomachs were cut open, their skin was torn from their body, and they were burned alive.[71] In a somewhat similar episode, the Bangkok chronicles report that several concubines were accused of stealing a chest of coins from the Royal Treasury. Those found guilty were whipped and imprisoned, and their leader, who worked in the treasury, was roasted to death.[72] But the heinous crime of sexual disloyalty was placed on a very different level, even when relations were with another woman. In the Ayutthaya court, women denounced for "playing with friends" would be lashed fifty times, tattooed on the neck, and paraded around the palace compound. As one might expect, illicit relations with a man were regarded far more seriously, being considered tantamount to treason: death by strangulation was a common penalty. In southern Vietnam a more gruesome fate awaited palace ladies accused of adultery, for according to one French observer they were "crushed underfoot" by elephants.[73]

Beyond question the greatest challenge to royal theater was evidence, real or alleged, that the lead actor, the preeminent symbol of the land's fertility, had been grossly miscast. A king who showed no interest in women was disturbing not because the land would lack a ruler (there were usually plenty of contenders) but because his lack of progeny would have cosmic implications. One striking example concerned Sultan Mahmud (r. 1685–99) from the Malay state of Johor, who had taken the sons of several nobles "by force into his palace." According to port gossip, his mother had sent a beautiful young woman to the young sultan's bed, but "he called his black guard and made them break both her arms, for offering to embrace his royal person." In this case, however, Malay histories resolved the cultural conundrum of the infertile king by providing Sultan Mahmud with a fairy wife who was jealous of any other liaison. According to these accounts, one of the palace women was required to swallow the ruler's semen, became pregnant, and gave birth to a son who was subsequently greeted as the legitimate claimant to the throne.[74]

Deviation from accepted sexual norms among the highborn was of great significance in societies in which royal incest and moral aberration could also be regarded as the cause of famine, crop failure, epidemic, or defeat in battle. Written in this mode, versions of the Ayutthaya chronicles recompiled in the early nineteenth century sometimes present past rulers in an adverse light, implicitly linking royal immorality to the kingdom's conquest by Burmese forces in 1767. King Phetracha (r. 1688–1703), for instance, was said to have consumed alcoholic

beverages and then indulged in sexual intercourse with young girls around the age of eleven or twelve, some of whom had not reached puberty. "If any girl shoved, struggled, and rolled around, the king showed his anger by striking and even killing her in the bed. If she remained still she was rewarded."[75] Female resentment at sexual indifference, ill-treatment, or physical abuse also meant that regicide of an unpopular ruler could readily be attributed to a palace conspiracy, especially as women were responsible for preparing food. Even queens were not exempt from suspicion; after the sudden death of the Malay ruler of Johor in 1685, three of his wives who had been accused of poisoning him were executed.[76]

The sexual subtext of many a court spectacle is well illustrated in the life of Krom Luang Yothathep, daughter of Ayutthaya's King Narai. Although the reports of French envoys describe Yothathep with considerable hostility, they also acknowledge that she was treated as the equivalent of a queen and that she exercised extensive political influence. At one point Narai left the kingdom under her control for a couple of days, and he even specified that she should become regent and trustee for the crown after his death. In 1688, these plans were subverted when a rival, Phetracha, seized power and shortly afterward took both Yothathep and her aunt, Narai's sister, as wives.[77]

The picture becomes more complex when French accounts are juxtaposed with later Thai chronicles. The latter present Yothathep not as vicious and scheming but as the victim of sexual exploitation. It is said that one evening, after Narai's sister had repelled Phetracha's advances, he entered Yothathep's bedchamber. Yothathep refused to accept him, uttering "cutting insults" and even seizing a sword to protect herself. A specialist in love philters was summoned, and subsequently she became infatuated with Phetracha and consented to intercourse. "Approximately seven or eight months later, she was in the third month of her pregnancy." When her baby son was born, "the earth quaked," by implication reflecting cosmic abhorrence at the circumstances of his conception. Following Phetracha's death in 1703, Yothathep and her son, together with her aunt (who was also her co-wife), took up residence in a monastery, where she subsequently died. The chronicle, however, is at pains to emphasize that her personal status was still recognized in a dramatic display of what a study of Renaissance England calls the "theater of death." Borne in a gold palanquin, the urn containing her ashes was carried up a gold tower built in the shape of the sacred Mount Meru. As many as ten thousand monks officiated in the rituals, which lasted for three days and "followed the ancient traditions handed on from one [king] to another."[78]

Generalizations are never easy when the area of research is a region rather than a single society. Southeast Asia poses specific problems because of its enormous

variety of languages and ethnicities, and because available historical sources are not equitably distributed. Nonetheless, the material presented here reaffirms the concept of a theater state so persuasively developed by Clifford Geertz in relation to Bali. Even into modern times, the ritual and ceremonial life associated with court life in Southeast Asia is a constant reminder that temporal power has supernatural and cosmological underpinnings and that rank and status are the fundamental bases for political and social relationships.[79] Nothing, therefore, about the staging of the state drama was unintentional; scripted and rehearsed according to the dictates of tradition, it was continually reperformed by different casts, in different settings, but always with the same goals and the same messages.

Inserting considerations of gender into this framework is particularly relevant in Southeast Asia, where the "high status" of women is often seen as a regional feature.[80] In undertaking a cross-cultural examination rather than focusing on a single society, this essay has argued that palace women were essential actors not merely in the proclamation of social hierarchy and royal status but also in the assertion of the ruler–fertility nexus regarded as imperative for human well-being. A telling comment on the cultural freighting of this association appears in a description provided by two Thai ambassadors during their visit to Versailles in 1686. Though court officials deliberately imitated the protocol that had been described by French envoys to Ayutthaya, one essential ingredient was lacking. French kings might well need to project their virility, but as Kate Norberg reminds us, it was the demographic dominance of men in the Versailles court that connoted rank, wealth, and power. Accordingly, Louis XIV stood on a dais surrounded only by the male members of his family rather than displaying the "many women" who for Asian kings were a metaphorical affirmation of royal potency.[81] In transposing "Asiatic luxury" into a European context, the Versailles court reprised the play but failed to recognize that the fertility arising from male–female union was the absolute justification for outward pomp, and that this core notion was always at center stage in the Southeast Asian performance of power.

Notes

1. Goens [1666] 1995.

2. Goens [1666] 1995, pp. 57–59.

3. Gomes 2003, p. 57; Norberg, this volume.

4. Goens [1666] 1995, p. 75.

5. Goens [1666] 1995, pp. 53–57, 77–79, 93.

6. Today Southeast Asia comprises Thailand, Burma, Laos, Cambodia, Vietnam, Malaysia, Singapore, Brunei, the Philippines, Indonesia, and Timor Lorosae.

7. "The Kingdom of Laos" 2002, p. 189; Dampier [1697] 1968, p. 229.

8. Geertz 1980, p. 102; see also Reid 2004, pp. 9–11.

9. Cummings 2002, pp. 109–11.

10. See further B. Andaya 2002, p. 27; Wolters 1999, p. 234.

11. Dampier [1697] 1968, p. 269.

12. B. Andaya 1993, p. 57.

13. See further B. Andaya 1993, p. 31.

14. Ebrey 2003b, p. 180.

15. L. Andaya 2004, p. 79.

16. Carey 1992, p. 403; Nagtegaal 1996, p. 56.

17. Goens [1666] 1995, pp. 78–81.

18. La Loubère [1693] 1969, p. 101; see *Dynastic Chronicles, Bangkok Era* 1978, 1:33; 2:52, 39–41.

19. La Loubère [1693] 1969, p. 52; *Royal Orders of Burma* 1983, 30.

20. J. Whitmore 2000, pp. 224–25.

21. *Phongsawadan lawaek* [1808] 1969, 44:243–44. Reference kindly supplied by Kennon Breazeale.

22. Ebrey 2003b, p. 180.

23. Chou 1967, p. 22.

24. Nguyen The Anh 1995, pp. 42–43.

25. B. Andaya 1993, p. 35.

26. Chou 1967, p. 40.

27. *Three Worlds According to King Ruang* 1982, p. 147.

28. Bouhdiba 1985, p. 90; see B. Andaya 2000.

29. Barrow [1806] 1975, 206.

30. La Loubère [1693] 1969, p. 101; see Norberg, this volume.

31. Quoted in B. Andaya 1993, p. 76.

32. Chou 1967, p. 41.

33. Nicholl 1975, p. 9.

34. La Loubère [1693] 1969, p. 100; Wyatt 2004, p. 47.

35. L. Andaya 2004, p. 71.

36. *Glass Palace Chronicle* [1923] 1960, pp. 95, 111; B. Andaya 1993, pp. 75, 240.

37. Li Tana 1998, pp. 108, 126; *Babad Tanah Djawi* 1941, p. 24.

38. La Loubère [1693] 1969, p. 28.

39. Jacobs 1971, p. 115.

40. Leupe 1856, p. 206.

41. Goens 1995, pp. 103–4; Carey 1980, p. 190.

42. Laffin 1967, pp. 46–47.

43. *Dynastic Chronicles, Bangkok Era* 1978, 1:54; 2:80, 94.

44. Dampier [1697] 1968, pp. 229, 244; Gervaise 1989, p. 186.

45. Nguyen Ngoc Huy and Ta 1987, 2:79.

46. Bowrey 1905, pp. 289, 310, 325.

47. Marini 1998, p. 9.

48. *Royal Orders of Burma* 1983, 75; see Koenig 1990, pp. 166–70.

49. Wessing 1991, p. 9.

50. Ricklefs 1974, pp. 84–85.

51. Ricklefs 1998, p. 6; Carey and Houben 1992, p. 17.

52. *Phongsawadan lawaek* [1808] 1969, 45:51–52.

53. Quoted in Paravacini 1862, p. 228; see more generally pp. 229–39.

54. Goens [1666] 1995, p. 77; Beeckman [1718] 1973, pp. 77–79 (quotation, p. 79).

55. Rutnin 1993, p. 40.

56. *Dynastic Chronicles, Bangkok Era* 1978, 1:301.

57. Purchas 1905, 2:545; Kumar 1997, p. 114.

58. *Adat Raja-Raja Melayu* 1983, pp. 56–57.

59. Leupe 1856, p. 217.

60. La Loubère [1693] 1969, p. 100.

61. *Dynastic Chronicles, Bangkok Era* 1978, 2:39–41.

62. Koenig 1990, p. 170; Cooke 2004.

63. B. Andaya 1979, p. 178.

64. *Phongsawadan lawaek* [1808] 1969, 45:9–14.

65. Creese 2004, pp. 210–44.

66. Gervaise 1989, p. 171.

67. Cadière 1916; Orband 1916.

68. Rutnin 1993, pp. 49, 53.

69. Ricklefs 1993, p. 118.

70. Lustig 1966, p. 26.

71. Ito 1984, p. 26; "Journal of a mission to Aceh" 1636, fols. 1207–8. Reference kindly supplied by Leonard Andaya.

72. *Dynastic Chronicles, Bangkok Era* 1978, 2:8.

73. Loos 2005, p. 895; Li and Reid 1993, p. 74.

74. Corfield and Morson 2001, p. 393; L. Andaya 1975, pp. 258–59.

75. *Royal Chronicles of Ayutthaya* 2000, pp. 373, 391.

76. L. Andaya 1975, p. 138.

77. Cruysse 1991, pp. 104, 392, 447, 448, 450, 456, 457, 465; de Choisy 1963, p. 184; Gervaise 1989, p. 186.

78. *Royal Chronicles of Ayutthaya* 2000, pp. 323–24, 337–38, 432; for the "theater of death," see Woodward 1997.

79. See, for example, studies of the nineteenth-century Siamese court by Loos 2005; Hong 1999.

80. See further B. Andaya 2006.

81. Norberg, this volume; Love 1996, pp. 171–98.

WOMEN IN CLASSIC MAYA ROYAL COURTS

Takeshi Inomata

Archaeologists and students working at the Classic Maya site of Aguateca in the rain forest of Guatemala were exhilarated at the sight of what they were un-earthing. As they carefully removed dirt from the remains of ancient elite resi-dences, it became clear that these buildings were full of objects that Classic Maya courtiers made and used, perhaps left behind because an enemy attack had brought Aguateca to a sudden and violent end. Among the numerous artifacts discovered during the excavations were beautiful figurines of noble women, some of them holding a child. Excavators also unearthed bone needles, spindle whorls, and grinding stones, which may have been used by women for textile production and food preparation. They provide tantalizing traces of women's life at court. Were Classic Maya court women secluded from the eyes of the pop-ulace? What kind of work did they perform? Did they have any political power? As remarkable as are the findings at Aguateca, knowledge about court women in Classic Maya society (250–900 C.E.) still remains elusive.

Our inquiry into court women needs to be guided by a theoretical framework that takes into consideration two critical issues: the internal structure and dynam-ics of a court and its external relation to the rest of society. Internally, the court is fashioned by numerous conflicting factors, including administrative necessities

Steve Houston provided thoughtful comments on earlier drafts. Houston also shared with me new interpretations of the Bonampak murals that he has been developing in collaboration with Mary Miller and Karl Taube.

demanding pragmatic efficiency and an array of symbols that defy rational explanations, along with institutional structures and shifting personal relations. As such organizational characteristics shape, and are shaped by, varying human motivations, they create dynamic political processes. Politics at court should not be perceived narrowly as a mechanics of coercive power. It is a broader, more encompassing process that takes form through individual participants' engagements in and experience of court culture, protocols, and daily routines. In this sense, human bodies are the bases through which individuals participate in political processes.

Externally, the court expresses both detachment from and connection with the rest of society. On the one hand, the court is an extraordinary sphere distinct from the ordinary business of the masses' daily lives. It claims communications with the supernatural or foreign domains and fosters exclusive culture. Its members consider themselves to be a select few endowed with special qualities distinct from others. On the other hand, the court emphasizes its role as an exemplary center of the society, and the sovereign projects his or her image as the entire society's caring father or mother. Above all, as an administrative apparatus the court has to be constantly alert to what happens outside the palace walls. The court thus is simultaneously at the center of the society and apart from it.[1]

The roles of women are crucial in shaping the internal dynamics and external relations of a court. Women's power and position are closely related to the nature of the court as the household of the ruler. Like any other household—with rare exceptions, such as the pope's court in the Vatican—the male–female relation is the central element in this organization. The gender ideologies of the society constitute and are constituted by practices at the court. In other words, the organization and operation of the court condition the power and status of women in the society, at the same time as they are being shaped by the contestation and negotiation of power relations among social agents.

Despite these underlying similarities, the forms and operations of the court vary significantly from one society to another. As Anne Walthall correctly points out in her introduction, important in this regard is the varying degree to which court women are sequestered. For example, European courts that emphasized the visibility of royal women obviously contrasted with their counterparts in China and Ottoman Turkey. In court politics, the expression and perception of body become foci where diverse interests intersect. Female bodies are the sites where female power is rooted, but their sexuality may become subject to monopolization and control by men.[2] Their visibility is a critical aspect of this process, as it conditions individuals' perceptions and actions and is manipulated by women and men alike. The issues of seclusion and visibility of court women relate to the internal and external relations of a court. Internally, the seclusion of the ruler's wives and consorts from other court members and state officials is closely tied to women's roles

and power. This connection holds whether they serve as the symbol of the power of male rulers and as material for forming alliances between competing factions or they engage actively in court politics. Externally, the visibility of court women to the populace may provide a key for understanding the contradictory processes of the court's detachment from, and its connection to, the rest of society.

The study of women in the Classic Maya court presents a serious challenge to scholars. In the absence of detailed historical accounts, individual identities, actions, and thoughts are usually beyond their reach. Yet in writing of the court's internal dynamics, I do not necessarily mean dramas of rivalry, conspiracy, or betrayal by protagonists with recognizable faces and names. Nor do "external relations" always entail articulated statements or decrees by the sovereign. I use these terms in a broader and more subtle sense, referring to processes and relations that people shape, negotiate, and contest through their ordinary and extraordinary interactions with others. These are the processes through which the structures and ideologies of the court and society are reproduced and transformed. Because bodily interactions are framed in and act on spatial and material settings, our inquiry into architectural and artifactual remains provides critical information on these issues. Glyphic texts and iconographic representations also tell us about people's perceptions and expectations of bodily presence and performance. By combining these sets of data, I examine Classic Maya court women's visibility as a window to their power and role in the court.

Classic Maya Royal Courts

The royal court was the central organ of each Classic Maya polity, organized around the hereditary ruler: k'uhul ajaw, the "holy lord," who in most cases was male. The king was surrounded by his family members and other elites, who might be called nobles, although the use of any single term disguises a great deal of variation. Many of them were probably born into privileged groups at court, but their status and power relied substantially on their achievements in learning, politics, ritual, and war. Also included in the court were people of lower status or of humble origins, such as dwarfs, hunchbacks, and servants. Many of the cross-cultural characteristics of courts apply to the Maya cases. The ruler, as well as the court, symbolized and embodied the integration of polity and the order of the universe. The Maya court also served as the ruler's household, where the many courtiers functioned more or less as support staff for the king and the royal family. Polity administration was largely an extension of royal household management.[3] In terms of spatial organization, the center of the court was a royal palace, which consisted of a living space for the royal family and constituted an important stage for political, diplomatic, and ceremonial

events. The court also included the residences of other elites, the spaces in which they worked and met.[4]

The court was clearly the main apparatus of polity administration. Yet there are few signs of a highly developed bureaucracy. Both in concept and practice, the governance of a polity merged with various other court functions, including ceremonies and aesthetic pursuits. Many courtiers spent much time producing art objects, which at once expressed political maneuvering and reflected the quest for a cultural ideal. Art pieces admired by many could significantly increase the prestige and political power of both their creators and their owners.[5] All this evidence underscores the pivotal role of fluid personal relations in the court's operations. The political and economic fortunes of individuals and factions hinged on their relationships with the ruler and with other courtiers. Internal politics affected by personal interests dictated the trajectory of the court as a whole. This description by no means implies that the court had no coherent structure. Recent developments in glyphic decipherment reveal sundry court titles, each of which defined its holder's rank and role.[6]

The Maya area was never politically unified, although a shared elite culture characterized the region. Numerous courts interacted with each other, sometimes peacefully and sometimes violently. Each court probably had a certain level of autonomy over its land and population, but rulers were not equals. Particularly powerful were the courts of Tikal and Calakmul, which significantly influenced the politics and economics of other centers such as Aguateca.[7] Relations between some courts remained fairly stable, whereas others experienced considerable change over time.

Women in Documents and Images

Among the pre-Hispanic Maya, a division of male and female economic roles was well established. Elite male concerns included court politics, polity administration, and warfare, while most non-elite men devoted themselves to agricultural work in the field.[8] Women, both elites and non-elites, appear to have been closely associated with food preparation, child rearing, and textile production.[9] Yet we need to ask how much diversity and flexibility this gender system involved. We also have to examine whether women expressed their status and power on various occasions of political interaction and, if they did so, how such acts were perceived by others.

Accounts of the Colonial-period Maya provide relevant data in this regard. In the sixteenth century Bishop Landa noted that the Maya often held large, public festivals involving the majority of the community, but women were usually not allowed at ceremonies, sacrificial rituals, or festivals held in temples. The

only exceptions were old women, who participated in certain festivals.[10] Women thus appear to have remained in less visible positions, secondary to men who occupied the central stage of civic life. These practices may also be understood as a division of male and female roles in rituals. Women conducted their own religious acts, burning incense and making offerings, often by themselves, and they danced their own dances, again separately from men. In addition, women contributed to and participated in public events by providing food and drink. Such a distinction between male and female activities may have been drawn in their daily lives as well. Landa, for example, stated that women entertained their own female guests and became drunk together. Men and women seem to have eaten separately on other occasions. Women also collaborated in certain enterprises, particularly weaving and spinning.[11] Colonial-period women had their own sphere of ceremony and performed dignified roles in various social domains, though they were subordinated to the male-centered social system.[12] We should note that Landa usually does not specify whether his descriptions are borrowed from his elite Maya informants or instead pertain to the non-elite practices he witnessed in towns and villages. Thus, in his account the specific roles of elite women in public and courtly contexts remain unclear.

As a main concern of the royal courts, theatrical performance probably had its antecedents in Classic times, though our understanding of women's roles in that period is even more limited. Stelae placed in large public plazas of Classic centers depicted rulers in ostentatious attires conducting ceremonies, presumably in front of a large audience gathered in these spaces. Such mass spectacles provided critical mechanisms that held each Maya community together as many individuals experienced their connections to the central authorities and to other community members.[13] Male rulers predominantly took center stage and were depicted on stone monuments, but a few women, such as Lady Six Sky of Naranjo and Lady Yohl Ik'nal of Palenque, assumed the position of a ruler or its equivalent and performed comparable roles in public settings.[14]

A strong emphasis on visibility is noticeable even in the more exclusive settings of royal palaces and elite residences. At most Classic Maya centers, elite residential complexes had relatively open arrangements. Many paintings on ceramic vessels, especially those depicting scenes of political and diplomatic meetings held in such buildings, show wide-open curtains at the doorways, allowing the room to be visible from outside. The activities carried out by rulers and courtiers in these settings probably had many characteristics of theatrical performance meant to be witnessed by an audience.[15] Although most protagonists in these scenes were males, a few women presented themselves in front of other elites or foreign dignitaries and participated directly. Others appear to have peeked in from behind room divisions. Whether or not these spying women officially participated in

the meetings, depictions of their presence clearly indicate women's interest in, and probably their influence on, political or diplomatic affairs, which sometimes may have been marriage negotiations with other dynasties involving their offspring.[16]

Women's secondary yet critical role in public ceremonies is also implied in a small number of other vessels. These depict the rulers preparing for ritual performance with the help of court women. Such paintings attest to the fascination of the Classic Maya with the entire process of ceremonies, as well as to the important roles that women played backstage.

Mural paintings, which are rare, bridge the highly public performances depicted in monuments and more exclusive events shown in ceramic paintings. The Bonampak murals portray a sequence of events that starts with a tribute scene, followed by a battle with another group, the sacrifice of war captives, and an elaborate dance. Among the large number of individuals shown in the murals we can identify only a handful of women. In the Room 1 murals, youths dance in a plaza or patio, as witnessed by five figures on and in front of a throne that appears to have been placed in a room. This kind of spatial positioning of people in palace-type buildings with an open area in front of them was probably common in courtly events: as mentioned above, the interior of the room was at least partially visible from outside. But the gender of these figures is uncertain. Mary Miller suggests that the central figure on the throne is the male ruler, Chan Muwaan.[17] This individual, as well as the others around the throne, nonetheless wears long garments commonly used by women. However this ambiguity might be resolved, it is safe to assume that two or more women observed this ceremony from a royal building and were viewed by other participants.

Miller persuasively argues that the sacrifice of captives depicted in Room 2 took place on a broad stairway facing a large plaza.[18] Such a stairway made an excellent theatrical stage for a presentation aimed at a large audience occupying the plaza. This highly public event likely involved numerous elite and non-elite spectators who are not depicted in the mural, and two royal women, probably the same individuals shown in the Room 1 mural, appear on the stairway among male participants.[19] The sacrificial rite was immediately followed by the solar dance shown in Room 3. Next to the ostentatious dance on the same stairway, exclusively occupied by male participants, five individuals wearing long garments conduct a bloodletting ritual on and in front of a throne, probably placed in a room. Miller originally argued that here, too, the central figure was Chan Muwaan.[20] Yet the clothes and the specific manner of bloodletting through the tongue might suggest otherwise, and Miller now favors interpreting all five individuals as women.[21] Their depiction in a mural implies that bloodletting performed by women was not totally screened from outside view.

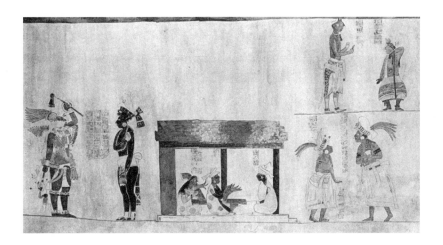

FIGURE 2.1.
Part of the Uaxactun mural. After Smith 1950, fig. 46.

In the Early Classic mural found at Uaxactun, the main theme is also a courtly event (see figure 2.1). While numerous male participants engage in ceremonial acts in an open space, three women convene in a building. Interestingly, the women sit on the floor, leaving the bench vacant. The ruler who usually occupied this throne was probably now participating in the outdoor event. These murals were painted in the interiors of buildings, and their viewers were most likely limited to a small number of elites. The lintels found over doorways of temples and palace-type buildings present comparable information. These carving were probably intended for viewers similar to those of the murals, and depict public events that took place outdoors, as well as ritual activities carried out indoors.

An important difference between stelae positioned outdoors and pictorial media viewed indoors lies in their depictions of human bodies. Many stelae tend to de-emphasize the distinctions between male and female bodies, except for the purpose of humiliating war captives. Ceramic paintings, in contrast, often exhibit realistic representations of sexual difference. Men wear loincloth and clothes around their hips, and their upper bodies are usually naked. Covered female breasts are often prominently drawn. As Rosemary Joyce has noted, gender relations may have varied from one context to another and imageries actively shaped people's notions of gender.[22] The sexuality of royal women may have been more openly expressed in images viewed by a small number of elites than in those seen by the general public.

Another factor may be that theatrical performance is conditioned by spatial setting. In the relatively small spaces of royal palaces and elite residences, participants could recognize each other's features. In mass spectacles held in open plazas, in which the attention of a large audience focused on the rulers, the facial expressions and bodily characteristics of performers were more difficult to perceive.[23] Protagonists made known their presence by donning large and colorful headdresses, backracks (large ornaments with feathers and sculptures worn on the back), and other attire clearly visible from a distance. Although the court sculptors, each with intimate knowledge of the performers and their costumes, recorded the details of ceremonial dress and facial features in monumental art, their work emphasized dress over individualized bodily features to highlight the nature of these interactions.

Despite such differences in artistic conventions, there is evidence of an unabashed appreciation of female bodies. In some palace-scene paintings, female breasts appear to be either exposed or visible through gauzelike textile, and the women in the Room 1 and Room 3 murals at Bonampak may have been similarly depicted. We should note that such an emphasis on female bodies took place in the courtly settings of rituals and diplomatic meetings. A figurine from Jaina shows a court woman exhibiting her naked upper body with elegant poise and dignity.[24] But references to sexuality were present even in public ceremonies and festivals. A number of figurines depict a male and a female—typically an ugly old man and a beautiful young woman—dancing in an amorous embrace. Karl Taube suggests that these objects represent public performances, not mythical deeds of supernatural beings. He also draws our attention to a ceramic vase painting depicting a man with an obscenely long nose (most likely a phallic reference) dancing with a young woman.[25] Similar notions of the female body and sexuality probably continued into later periods and were present among non-elite populations as well. Bishop Landa was impressed with the openness with which Maya women in Yucatán stripped off their clothes while taking baths at wells. He also described one of the dances in which both men and women participated as indecent, although he refrained from providing salacious details.[26]

In sum, various iconographic data provide critical information on the positions and roles of court women, although these pictorial representations were filtered through the point of view of males, who in many cases produced and controlled such media. Men generally took the central stage both in public ceremonies and in exclusive courtly events. Royal women usually appeared on public stages as mothers or wives of the rulers or royal heirs, thus providing assistance in ritual and helping to legitimize the royal males' claim to authority.[27] Still, the roles that court women played in ceremonial and political events were

well recognized among elites, and on some occasions women even presented themselves on public stages in front of a large audience.

Women in Architecture and Space

The spatial settings of court architecture and space at once reflected and conditioned the actions of social agents by empowering their occupants and users, males and females alike, and by constraining their acts and thoughts. The study of female spaces is arduous, however. Epigraphic and iconographic data usually do not give us specific information about the locations of female presence and action, nor does the archaeological record consistently provide traces of their activities in fine resolution. Here I focus on three cases with unusually rich information on increasingly larger spatial scales. The first includes elite residential structures at Aguateca, where rapid abandonment left numerous objects in situ. The second is the palace in Complex A-V at Uaxactun, where extensive excavations have revealed a large number of burials. The third case is the center of Yaxchilan, where lintels and other monuments provide numerous images of men and women.

Elite Residences: Aguateca

At Aguateca, as well as many other Maya centers, elite residential buildings generally consisted of multiple rooms placed in a row. I have argued elsewhere that there was a relatively clear division of male and female spaces in each residence, though they were never strictly segregated.[28] In the four excavated elite residences, the central rooms appear to have been used primarily by the male head of the household for his work and meetings with visitors. The central rooms typically contained jars for liquids and serving vessels, as well as scribal tools. A woman (or women) may have often used one of the side rooms for food storage and preparation, as well as for textile production (see Structure M8–10 in figure 2.2). The other side room served either for the male household head's scribal work or as a sleeping space. This pattern of space use may correlate with burial practices, although the available data are still minimal. In one of the elite residences (Structure M8–10), excavators uncovered a male burial under the floor of the central room. Under one of the side rooms probably used by a woman was a buried infant, who may have been reared mainly by the female occupant of that room.

In a smaller, less elaborate building in the same elite residential area we found a different pattern. In contrast to the elite residences, Structure M8–13 near Structure M8–10 contained few prestige goods, such as shell and jade ornaments, though it was equipped with its own facilities for food storage and preparation. Here excavators unearthed spindle whorls in the central room (see figure 2.2). Although this building is difficult to interpret, we might speculate that a wife or

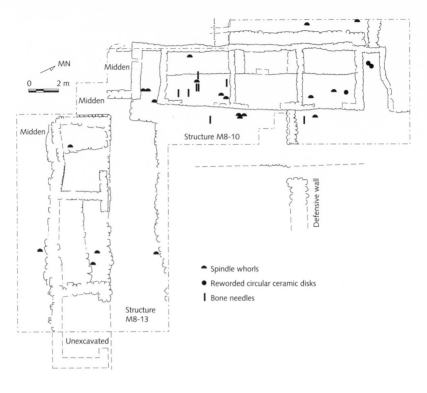

FIGURE 2.2.
The distribution of textile production tools in residential structures at Aguateca, Structures M8−10 and M8−13.

female relative of the household head of Structure M8−10 lived in Structure M8−13, and that she often used its central room to receive visitors.

The number of samples from Aguateca is small, but I hypothesize that men tended to occupy the central rooms of the central buildings, whereas women often used side rooms or the structures that flanked the main building. Though men appear to have played more visible roles in various courtly events held around the central buildings, female spaces were no more secluded than men's. Elite women who lived in these structures were easily seen by visitors and passersby. In Structure M8−4, in particular, both male and female rooms had highly visible front benches, which may have been used in meetings and receptions involving visitors.

At small to medium-size centers such as Aguateca, the royal palaces had architectural arrangements similar to those of elite residences, with multi-room buildings surrounding the central patio. The primary differences were the size

and elaborateness of architecture. At these centers, the patterns recognized in the Aguateca elite residences may also characterize the residential compounds of royal families. I have argued that the royal palace of Aguateca allowed a certain degree of visibility for its occupants.[29] If royal women lived in side rooms of the central building, Structure M7–22, they were not completely secluded from the eyes of other courtiers or sometimes even of non-elites, although Structure M7–32 on the western side provided more privacy.

The Royal Palace: Uaxactun

The royal palaces at larger centers were more complex than that at Aguateca. The intricate layout of these large buildings, which sometimes had more than one row of rooms, gave more privacy to their inhabitants. Unfortunately, we lack artifactual data on their space use comparable to those at Aguateca. Yet, if we assume a certain level of correlation between the space of primary use by an individual and the location of his or her burial, the distribution of interments may provide some clues to male and female spaces. Complex A-V in Uaxactun, where extensive excavations revealed numerous burials, probably served as a royal palace during the Late Classic period (see figure 2.3).[30]

Room 93 appears to have been the ruler's main throne room. Two male burials were discovered under its bench. Much uncertainty remains about the identities of their occupants, however. The graves were not particularly rich, containing only three or four vessels. They offer a clear contrast with the Early Classic royal tombs found in deeper layers of the same compound, which contain nineteen to thirty-five vessels. The Classic Maya custom was to bury the rulers and other highest-ranking royal personages in temple pyramids rather than under their living quarters. Although Complex A-V may have functioned originally as such a temple compound during the Early Classic period, its function became residential and administrative during the Late Classic. Those who were interred there during the Late Classic period may have been lower-ranking royal figures and other members of the court. We are still left wondering who, if not kings, were buried under this most elaborate and centrally located throne room.

Despite this problem, the distribution of female burials confirms what the Aguateca data would lead us to predict. They are found mainly under side rooms and buildings flanking the Main Court. Of particular interest are two or possibly three female interments found under Rooms 19 and 41. Unlike the buildings that faced the Main Court and guarded their occupants from public view, these rooms faced the Main Plaza, which contained numerous stelae and probably served as the primary space for public ceremonies at this center. Female court members may have watched public pageants from these rooms. The

93 Room number
▲ Adult male burial
● Adult female burial
■ Unsexed adult burial
▼ Child or infant burial

Main court

Main
plaza

South plaza

N

0 20 m

FIGURE 2.3.
Map of the A-V Palace at Uaxactun, showing the distribution of
Late Classic burials. Data from Smith 1950.

women in the rooms, like those depicted in the Bonampak and Uaxactun murals, may have been at least partially visible from the plaza.

The Cityscape: Yaxchilan

At Yaxchilan women are prominently depicted on lintels, stelae, and hieroglyphic stairways.[31] The locations of these monuments may not exactly correspond to the loci of the depicted events, particularly in the case of some early monuments reset from unknown previous locations. Still, the lasting presence of these sculptures probably had significant effects in defining and reflecting gendered spaces in the city (see map 2.1). In this study, I divide structures and stelae into four periods, according to their estimated dates of carving rather than the dates recorded in inscriptions.[32] Although early monuments mention only

the male rulers, sculptures from the reign of Itzamnaaj B'alam II (681–742) show a relatively clear spatial division in references to men and women. Monuments depicting only men are found in the West and South Acropolises on hills (Structures 41 and 44). In the area around the Main Plaza, images and references to women figured prominently, with the exception of Structure 14, a ball court. Lintels on Structure 23 designate the building a house of Itzamnaaj B'alam II's principal wife, Lady K'ab'al Xook, and they depict a series of rituals conducted by the royal couple. Discovered under the west room of this building, Tomb 2 contained a series of bone bloodletters incised with the name of Lady K'ab'al Xook, indicating that it is most likely her resting place.[33] Another wife of Itzamnaaj B'alam II, Lady Sak B'iyaan, claimed Structure 11 as her house.[34]

During the reign of Itzamnaaj B'alam II's son Bird Jaguar (752–768), the pattern is less clear. Nonetheless, a significant concentration of female images is found in the area surrounding the Main Plaza. Unlike during the reign of his father, no inscriptions define houses for specific ladies, but images of multiple women appear in single buildings. In Structure 16, Lintel 38 depicts Bird Jaguar's wife Lady Wak Tuun, whereas Lintel 40 shows a different woman. Lintels of Structure 24 list the deaths of Itzamnaaj B'alam II; his mother, Lady Pakal; and his wives, Lady K'ab'al Xook and Lady Ik' Skull. In Structure 21, Lintel 15 depicts Bird Jaguar's wife Lady Wak Tuun, and Lintel 17 refers to another of his wives, Lady Mut B'alam.[35] In its chamber, Mexican archaeologists unearthed Stela 35, with the image of the king's mother, Lady Ik' Skull.[36] Lintels 41 and 43 of Structure 42 show Lady Wak Jalam Chan Ajaw and another woman along with their husband, Bird Jaguar. At the highest hilltop complex of the South Acropolis, in contrast, the primary focus is still on the images of the male ruler. The only representation of a woman as protagonist is a retrospective reference to the king's mother, Lady Ik' Skull.

During the reign of the subsequent ruler, Itzamnaaj B'alam III (769–ca. 800), the focus of construction activities shifted to the southeast. Monuments in this section of the center repeatedly depict the king's parents, Bird Jaguar and Lady Great Skull, as well as the ruler's uncle (Lady Great Skull's brother). These images suggest that the elevated power and prestige of royal women were shaped through their relation to their husbands as rulers, to their sons as royal heirs, and to their brothers and other members of their natal groups.

The apparent prominence of women at Yaxchilan may reflect the artistic convention and the historical tradition of the Usumacinta region, which emphasized the roles of women at court as well as the personalities of individual kings and their wives. For example, royal wives are also depicted on Bonampak Stela 2.[37] At the same time, this pattern may be related to Yaxchilan's unique setting, which, unlike many other centers, lacked a clear spatial distinction between public plazas and royal palaces. For this reason, it is probably misleading to treat Yaxchilan's

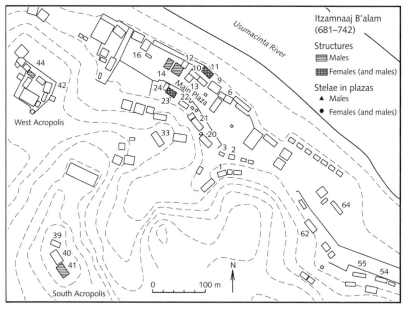

MAP 2.1.

Yaxchilan, showing buildings associated with monuments depicting or referring to men and women. The locations of some individual stelae in the Main Plaza are indicated, but other monuments with clear associations with buildings are not shown.

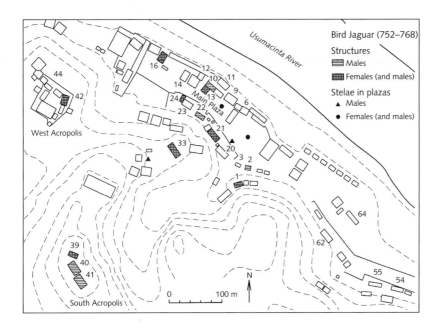

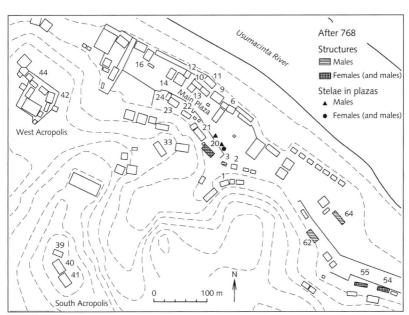

Main Plaza in the same way as public plazas at other centers. It contained at least two thrones, one in Structure 6 and another in the plaza to the north of Structure 21.[38] Although such thrones existed in the plazas of other centers, they were more typically found in royal palaces, probably used in royal audience and diplomatic events.[39] Their presence suggests that ceremonies commonly associated with royal palaces took place around Yaxchilan's Main Plaza. That the Main Plaza area functioned like a palace is also indicated by the location of the two "houses" for royal women. Although we do not know whether they lived in these buildings, the arrangement of Structure 23, with two rows of rooms containing benches placed along the side walls instead of central thrones, appears to have been concerned more with the privacy of the users than with presentations oriented toward an audience in the plaza.[40] The area around Yaxchilan's Main Plaza may thus be understood as a conflation of a royal palace and a public plaza, although we cannot pinpoint locations where the royal family routinely slept and ate.

In contrast, the hilltop compounds, particularly the South Acropolis, exhibit characteristics more akin to the public-plaza complexes at other centers. Their architectural foci, temples atop a hill, are analogous to pyramids elsewhere. Although the South Acropolis and Structure 44 of the West Acropolis lack spaces to accommodate a large audience, ceremonies associated with them appear to have emphasized their public nature by facing the open areas along the river. Monuments were placed on the northeastern side of Structure 44, not in the courtyard behind it. Stelae at the South Acropolis also faced the river. Unlike the spectators at other centers, who could gather in plazas for a relatively close view of the rulers, those at Yaxchilan may have had to remain in open areas below the hills or on the opposite side of the river, hearing the sounds and seeing smoke and banners but unable to gain clear sight of any individuals.

The spatial organization of Yaxchilan's ceremonial complexes may have reflected this center's unique cultural tradition and the personalities of its kings and queens, but it may also have been a compromise forced by its hilly topography. If this interpretation is correct, events held around the Main Plaza may have tended to be more inclusive than those held in royal palaces at other centers but more exclusive than those in public plazas. Or the early rulers may have used the Main Plaza inclusively, much as public plazas at other centers were used, while perhaps rulers in later periods increasingly restricted access to the Main Plaza as Yaxchilan's population grew. During the reigns of Itzamnaaj B'alam II and Bird Jaguar, events held in the Main Plaza may have been chiefly limited to elites. Such restrictions may explain the pervasive use of lintels at Yaxchilan, which could be viewed only by a small number of elites.[41] The organization of gendered spaces at Yaxchilan thus appears to be comparable to that at other centers. There was a loose division—not a clear segregation—between

hilltop temples (particularly the South Acropolis, which emphasized male images and public events as did public plazas elsewhere) and palace-type buildings around the Main Plaza, where kings conducted performances intended primarily for an elite audience. It was in the conflation of a plaza and a palace in the Main Plaza area that royal women conspicuously participated in ceremonies and were prominently depicted.

The pattern at Yaxchilan hints both at the potential for and at the restrictions on women's political and ceremonial ascendancy. Yaxchilan monuments show that royal women could gain considerable prominence, possibly with the help of charismatic personalities. Yet their political and ceremonial actions at Yaxchilan were not completely free from the spatial confines of the royal palace, which still retained characteristics typical of the royal household's inner space. We also need to consider the possibility that royal women at other centers took equally conspicuous political and ceremonial roles in the palace setting and that their acts were simply not recorded in stelae that focused on male performance in plazas.

Discussion

The foregoing analyses enable us to examine women's roles and visibility in the court and in relation to the masses. Inside the court, or in royal palaces and elite residences, men often took central positions. Male centrality is also reflected in ceramic paintings that show courtly interactions occurring there primarily among men. However, the spatial settings of these sites, along with iconographic records, suggest that women actively participated in many of these events. Women may also have had their own meetings and rituals, separate from those of men, as noted in Colonial-period documents. In addition, the side rooms and side buildings that may have housed women were usually not any more cut off from outside view than were male spaces. It appears that royal wives and consorts were not strictly sequestered from most male courtiers. Women's power and status were probably influenced by these durable social structures and by the inherent flexibility of personal relations. To be sure, in this system women could become victims of exploitation. For example, royal marriages often appear to have reflected men's political interests in forging alliances with other court factions and dynasties.[42] But many women probably had a vested interest in court politics. Like their Colonial-period descendants, Classic Maya women most likely possessed their own sphere of power, and their considerable visibility probably gave them ample opportunities to engage in and experience the political processes of the court. The prominence of women in Yaxchilan monuments most clearly demonstrates not only the flexibility in political dynamics that was rooted

in the unique setting of each region but also the restrictions imposed by the structural properties that the various centers shared.

Male centrality in Maya society was even more strongly emphasized in public events that involved numerous non-elite participants. Stelae placed in the public spaces primarily recorded the performance of the male rulers and reminded both the elite and non-elite of male primacy long after the event. Yaxchilan monuments, considered by many scholars the best representations of female public performance, may not demonstrate that women there were as exposed to non-elite eyes as was male performance in the plazas at other centers. Male centrality is also reflected in the predominance of male burials associated with temples around public plazas.[43] Nonetheless, women were not excluded from such public affairs. Classic court women participated in these events more actively and freely than their Colonial-period descendants did. The murals at Bonampak and Uaxactun suggest that although women were far less visible than men and often stayed indoors on those occasions, their participation was still recognized by elites and non-elites alike. It is likely that many public events even required that they contribute.[44] I should also note that events held in royal palaces may not have been completely shielded from the gaze of non-elites—particularly in small centers, whose palaces tended to have relatively open arrangements. Even commoners may have been able to glimpse royal women sitting on benches in palace buildings.

Men and women on public stages projected distinct images of the court to the populace. Public performance by elite men strongly emphasized their distinction from the masses by narrating their associations with supernatural domains.[45] Their connection with agriculture—the primary activity of non-elite men—remained figurative, in that male rulers claimed to contribute to agricultural fertility by assuming the identity of the maize god.[46] Court women— even the highest ranking—stressed more essential commonalities with non-elite women, mainly in their involvement in food preparation, child rearing, and textile production. Royal women often carried textile bundles and ceramic vessels on ritual occasions, expressing their engagement in weaving and food preparation, and some of them were buried with weaving tools.[47] Archaeological data from elite residences at Aguateca, Copán, and other centers suggest that such connections were not just symbolic and that many elite women indeed engaged in food preparation and textile production.[48]

Classic Maya court women were highly visible both to other elites and to non-elites, though typically they remained in the shadows of more prominent males. The open nature of female spaces in the Maya court is indeed striking when they are compared to those elsewhere, such as in Ottoman Turkey and China. Relatively

straightforward representations of female bodies in pictorial media that recognize their sexuality are probably not unrelated to this pattern. The visibility of elite women is not a superficial custom detached from real political mechanisms. It is an essential part of court politics. As evidenced in images of courtly scenes and textual records of royal women, the women observed face-to-face the political and ceremonial acts of men, commented on them, and at times more directly participated in them. Their presence and acts were recognized by male courtiers and non-elites. Above all, the sequence of such actions was the main process through which women and other courtiers performed and embodied otherwise abstract notions of the court, maintaining and changing its organization and operation.

Such practices at court expressed a certain level of rigidity in social relations that encompassed both male centrality and the complementary nature of male and female roles.[49] Even the remarkably prominent women at Yaxchilan did not break away from these lasting patterns. At the same time, we cannot ignore the variation and fluidity in court practices, which are evident in the differences between centers and in changes over time. The visibility of women may have contributed to such flexibility by allowing them room for active political engagement. The court's mixture of rigidity and flexibility was the stage that empowered and constrained some powerful queens recorded in monuments, as well as other women. Though many of them remain faceless and nameless to us, small fragments of their lives are still tangible.

Notes

1. Elias 1983; Geertz 1975; Inomata and Houston 2001a; Tambiah 1976.
2. Lerner 1986.
3. McAnany and Plank 2001; Sanders and Webster 1988.
4. Inomata 2001b; Webster 2001.
5. Inomata 2001c.
6. Houston and Stuart 2001; Jackson and Stuart 2001.
7. S. Martin and Grube 2000.
8. Cf. Robin 2002.
9. Joyce 1992; Hendon 1997.
10. Tozzer 1941, pp. 128, 152.
11. Tozzer 1941, pp. 127–28.
12. Restall 1997, pp. 121–40; Vail and Stone 2002.
13. Inomata 2006a, 2006b.
14. Houston 1993, p. 109; S. Martin and Grube 2000, p. 159.
15. Inomata 2001a, 2001b.
16. Reents-Budet 1994.

17. Miller 1986, p. 64.

18. Miller 1986, pp. 114–15.

19. Miller 1986, p. 129.

20. Miller 1986, p. 146.

21. Miller 2001.

22. Joyce 1992. See also Looper 2002.

23. See Hall 1966; Moore 1996.

24. Schele and Miller 1986, pl. 52.

25. Taube 1989, pp. 369–71, figs. 12–14.

26. Tozzer 1941, pp. 126–28.

27. Josserand 2002.

28. Inomata and Stiver 1998; Inomata, Triadan, Ponciano, Pinto, Terry, and Eberl 2002. Cf. Hendon 1997.

29. Inomata 2001a; Inomata, Triadan, Ponciano, Terry, and Beaubien 2001.

30. R. Adams 1974; Valdés and Fahsen 1995; Smith 1950.

31. Graham and Von Euw 1977; Mathews 1997; Schele and Freidel 1990; Tate 1992.

32. The dates are based on the studies by Tate and Mathews: see Tate 1992; Mathews 1997, table 9–3.

33. Mathews 1997, p. 276.

34. McAnany and Plank 2001; Stuart 1998.

35. Tate 1992.

36. La exposición de la civilización maya 1990; Schele and Freidel 1990, p. 274.

37. Mathews 1980.

38. Tate 1992, pp. 160, 225.

39. Kowalski 1987; Ringle and Bey 2001.

40. McAnany and Plank 2001; Tate 1992.

41. Sanchez 1997.

42. Molloy and Rathje 1974.

43. Haviland 1997; Krejci and Culbert 1995.

44. Joyce 1992, 1993.

45. Houston and Stuart 1996.

46. Taube 1985.

47. Bell 2002; Houston and Stuart 2001; Joyce 1992.

48. Inomata and Stiver 1998; Inomata, Triadan, Ponciano, Pinto, Terry, and Eberl 2002; Hendon 1997; McAnany and Plank 2001.

49. See Joyce 1992, 2000.

WOMEN AND POWER AT THE BYZANTINE COURT

Kathryn M. Ringrose

3

The Byzantine Empire is an easy target for the historian's orientalizing reflexes. Long accused of oriental decadence and overlaid by centuries of Western perceptions of the oriental harem, the Byzantine court has been stereotyped by observers as a place where women lived in harems—in oriental seclusion guarded by fierce eunuch guards. We cherish images drawn from Mozart's *Abduction from the Seraglio* and seek out sources with which to construct a thesis that affirms these expectations. It takes no effort to put Byzantium into an oriental box—the one we once used for the Ottoman harem before Leslie Peirce so thoroughly demolished it for us.[1] As we will see, the oriental harem is also a misleading image for Byzantium.

Ironically, the Byzantines themselves fell prey to such orientalizing tendencies. They believed that somewhere "in the East" there were places where women lived in seclusion guarded by powerful eunuchs. They enjoyed the tales told about Apollonius of Tyana (a teacher and philosopher from southern Turkey), available to us today in Philostratus's second-century collection of marvelous tales.[2] For the Byzantines, who regularly retold them, as for us, these tales conveyed the image of the Eastern harem popular then and now.

In one of Philostratus's stories, the philosopher Apollonius was visiting the great king at Babylon and was present when the royal guards dragged out a eunuch who worked in the women's quarters guarding the royal concubines. The senior eunuch explained that this eunuch had been unusually attentive in doing a particular lady's hair and assisting her in her toilette. Finally he had begun to

behave as if he were the lady's lover. The king asked Apollonius for advice about how he should punish the eunuch. Apollonius suggested that the king spare the eunuch's life, since, as a eunuch, he was condemned to die of frustration because he could never consummate his love.

This story recurs regularly in later Byzantine texts, especially those that speculate about whether eunuchs desire women or are able to have any sort of sexual relations with them. Yet it is a story that exists, for the Byzantines, in a foreign setting. It is as exotic and "oriental" for them as it is for us, and it does not reflect the world of the Byzantine court. For the Byzantines it is a curiosity drawn from a courtly world quite different from their own.

If eunuchs in the Byzantine court did not serve as harem guards, and women were not locked up in harems, how did these two distinctly gendered groups relate to the structure of the court and to one another? To address this issue we must first assess the state of our knowledge about women at court. Detailed information is thin indeed, as Judith Herrin notes in her recent book, *Women in Purple*.[3] In fact, the only court women we have any substantial information about are those who managed to rule autonomously or semi-autonomously—women such as Irene (r. 797–802); Theodora (r. 527–548), wife of Justinian I; Theodora, wife of Theophilos (regent, 842–856); or, later, the powerful Komnene women of the twelfth century. While the modern observer tends to be struck by how few women ruled in Byzantium, it is worth noting that several actually did so. Indeed, if one looks at the Roman or Persian worlds, or at the Middle Eastern societies around Byzantium, it becomes apparent that Byzantium is unique in the number of royal women who wielded significant autonomous power, either as empresses in their own right, as guardians of minor children, or, as in the case of Justinian's wife Theodora, as genuine co-rulers. In this essay I will show that Byzantine women's access to power was possible despite the specially gendered nature of palace space and that this access was facilitated through the mediation of eunuchs, who were uniquely able to transcend the boundaries between the gendered spaces in the palace.

Regulating the Court

Like aristocratic women elsewhere in Byzantium and in many other aristocratic societies, Byzantine court women lived in settings segregated from men. They did not, however, live in enclosed communities of wives and concubines available for the emperor's pleasure. In the first place, the Christian Byzantine emperors were, in accordance with church law, allowed to have only one wife at a time. Moreover, they could not marry more than three women in the course of

a lifetime. This limitation is illustrated by the problems of the emperor Leo VI (r. 886–912), who had the ill fortune to have married three women, each of whom died without issue. The church had disapproved of his third marriage and was scandalized when he insisted on a fourth marriage to his mistress, the beautiful Zoe Carbonopsina. Their male offspring was Constantine Porphyrogennetos or Porphyrogenitus, whose name—literally, "born in the purple"—is designed to constantly remind the world that he had been born in the purple birthing room of the imperial palace. It was a name that asserted his legitimacy. In a test of political power, the head of the Orthodox Church, the patriarch of Constantinople, declared Constantine illegitimate and denied his father, the emperor, the sacraments. Historians today often refer to the patriarch's act as a kind of Byzantine Canossa, a comparison to the much more familiar test of power in that Italian town between the Western emperor, Henry IV, and Pope Gregory VII in 1077 that ended with Henry performing penance before Gregory. His legitimacy clouded as a result of the patriarch's declaration, Constantine grew up on the edge of deposition, a Claudius-like figure who hid in the palace library and made himself invisible (Claudius survived his nephew Caligula to rule Rome from 41 to 54 C.E.). Constantine ultimately became an independent ruler in 945, but only because of a series of historical accidents. Confronted with church strictures, the Byzantine emperors learned to choose their empresses carefully and cherish each and every male offspring because ready replacements were not easily available.

Church regulation, and a growing tradition that favored imperial bloodlines descending from both the empress and emperor, made it unlikely that an illegitimate child, born of a casual alliance with a court woman, might rise to imperial office. We know that Byzantine emperors did have mistresses, and we have scattered references to illegitimate imperial children, but discretion was required. The young emperor Michael III (r. 842–867) was forced by his mother to give up his mistress, Eudokia Ingerine, so that he could make a proper marriage. Michael arranged for Eudokia to marry his best friend and confidant, Basil, so that she could continue to be available as needed. These are not the actions of emperors who keep assorted concubines stashed away in harems. On another occasion, when a son born to the emperor Romanos I (r. 920–944) and one of the court women began to show intellectual promise, Romanos had him castrated and raised as a court eunuch. Children born outside the bonds of imperial marriage simply were not eligible to reign.

In some ways, however, the imperial precinct was a harem. In fact, if we consider the term *harem* in its technical sense—as territory that is special, almost sacred, cut off, private—then the Byzantine court contained a number of such harems inhabited variously by the emperor, the reigning empress, the dowager

empress, and the imperial children. Carefully designated and rigorously controlled, these special spaces were regulated by the palace eunuchs. The emperor's private sleeping quarters (his *cubiculum*) were sacrosanct, guarded by eunuchs and supervised by a chief eunuch who was called at various times the *praepositos sacri cubiculi* or *parakoimomenos*. He was the most important eunuch official, the "one who sleeps beside the bed." The lesser bedchamber attendants under his supervision were called the bedchamber attendants, the *koitonitae*.[4]

These eunuch courtiers controlled access to the magical space around the emperor in a variety of symbolic ways. They had exclusive access to the imperial regalia, which was changed, removed, and added to in ceremonial patterns that we do not fully understand. Because of the semi-divine nature of the emperor, these changes had to be hidden from the eyes of bearded men. Rarely could bearded men receive anything directly from the imperial hand, and an object given to a bearded man by the emperor usually had to pass through the hands of an appropriate eunuch. Thus the space around the emperor was separate and distinct from the space available to bearded men. In the same way, the space occupied by the emperor and bearded men was distinct from the space inhabited by the women of the court.

Eunuch officials mediated the interaction between these spaces. The spaces themselves were not necessarily fixed in a physical sense: the symbolically defined boundaries around important individuals could move with the individuals involved. Thus, while these spaces are technically a harem, they do not restrict movement or imply the kind of constraint suggested by the stereotypical idea of "the harem."

Every step taken by people at the court, every place they went, the clothing and ornaments each wore, even the specific wording of some rituals evolved into an oral tradition. This tradition was controlled and recorded by the court eunuchs. Our most important remnant of this tradition is found in *De Ceremoniis*, or the *Book of Ceremonies*. An enormous tome, it is a compilation of ceremonial traditions sponsored by the emperor Constantine Porphyrogennetos and perhaps even compiled by him and his eunuch assistants during the years he spent hiding in the imperial library. It is a composite record of ceremonial display and legitimizing ritual that covers five centuries of Byzantine court life. As presented in these materials, the eunuchs of the imperial palace controlled the elaborate protocol that regulated the gendered spaces and ceremony of the court. They were familiar with the way things had "always been done." They educated the imperial young in the arcane traditions of the court, they stage-managed the imperial family, and they recruited and educated successive generations of eunuchs in the intricacies of court ceremonial.

Only a small part of *De Ceremoniis* refers directly to the women at court or to the empress. The language used to describe court ceremonial makes it difficult to be sure when the empress is participating or even present at a particular ceremony. In the ceremonial book the emperor is referred to as Basileus, Autokrator, or Despotes. The empress is called Augusta, Basilissa, or Despoina. In many settings where more than one member of the royal family is present, the text refers to them as Despotae, a vague plural form (rather like the modern "royals") that might include the emperor or the empress and any of their children. The empress may or may not be included among the Despotae. Occasionally it is obvious that she is not in attendance, because the attire of the Despotae is described and it is male clothing.[5] At other times the court ritual involves her directly and she is clearly present, as when the Despotae, following their marriage, go off to the marriage bed together.[6] Yet in this very same chapter the Despotae sit on their thrones while the Augusta, a specific term for the empress, is said to sit on her own throne. In the chapters that describe ceremonies during the reign of Heraclius (610–641), the emperor is called Basileus and his sons Despotae.[7] On another occasion, a reception for senators in the Circus Maximus (by the tenth century a large ceremonial building adjacent to the palace, used for chariot racing and public gatherings), the text uses gender-specific language that spells out that the Basileus is accompanied by the Augusta and the imperial daughters. Obviously the empress is present at those ceremonies that involve her directly—at her wedding or coronation, for example. She also probably appears, without a gender-specific identifier, as one of the Despotae at the ceremonies in celebration of the Easter and Christmas seasons, since these are moments when the factions of Constantinople publicly acclaim the empress and her children.

Despite the somewhat shadowy presence of the empress suggested by this linguistic ambiguity, the *De Ceremoniis* makes it clear that the empress had her own court. This "court of women"[8] made public appearances, with the empress, on ceremonial occasions when the empress was exerting her independent authority, as opposed to those occasions when she appeared as an adjunct to the emperor. The court of women was a permanent fixture in the Byzantine court. It was made up of the wives of the bearded courtiers, and each woman had a title that was a feminine equivalent of her husband's title. It was a parallel courtly world of little interest to chroniclers of events in the male domain. Its existence is confirmed by an aside about the emperor Michael II, who chose to remain a long-term widower. The "bearded men" of his court apparently complained because there was no empress to lead the women (their wives) in the court of women.[9]

Empresses in Court Ceremonial

The place of the empress at court and the role of her own court of women are best seen in the accounts of her marriage, at her coronation ceremony, and at the celebration of the birth of each of her sons. On the occasion of the marriage and coronation of the empress, the entire court assembles and changes into appropriate garments.[10] The eunuch staff places the imperial throne in the *augusteum* (a large ceremonial room in the palace often used for receptions) and hangs the transparent curtains that ritually separate the emperor and empress from those attending an audience. When the entire court is assembled, the patriarch of Constantinople is escorted in and greeted by the emperor. Behind the imperial thrones is a table that holds the imperial cloak (the *chlamys*) that is part of the empress's official regalia. The patriarch stands beside this table, and the patriarchal court enters. At a signal from the emperor, the chief eunuch leads in the empress, who is wearing a veil and royal tunic. She lights candles while the patriarch prays over the cloak. The emperor removes the empress's veil and hands it to his personal eunuch servants (his *cubicularii*). They hold the veil about her in a circle, creating a temporary magical space while the emperor dresses her in her imperial robes and fastens them with a special pin.

The act of hiding the empress behind a veil while her ceremonial clothing is changed has nothing to do with modesty. Important changes in the status of imperial persons were marked by changes in clothing, shoes, and crowns. Such costume changes could not be seen by ordinary people, and eunuch servants screened them with cloaks or, in this case, with a veil.

Following the rituals that signify the empress's change in status, the patriarch goes on to pray over the crown, which the emperor places upon the empress's head. The patriarch then prays over the ornaments that hang from the crown, and the emperor attaches them to the crown. The patriarch retires with his retinue to prepare for the marriage ceremony. A throne is brought for the new empress and the imperial couple is seated.

Next, the members of the men's court pay homage to the imperial couple. Each courtier enters through the ceremonial curtains in order of precedence: the magistrates, the patricians, the senators, the consuls, the counts, the generals, and others. All of this action is orchestrated by the principal court eunuchs. At a special signal, the men's court proclaims the imperial couple.

The men's court then leaves and the gender of the imperial space changes completely. The women's court enters and honors the new empress. As was done in the case of the court of bearded men, each woman is introduced in order of precedence using her court title, a feminized version of her husband's title. The men's court and the women's court are not in the same room at the

same time. Although the palace honors male and female space, that space is flexible space and its gendering is regulated by the corps of palace eunuchs.

Following this part of the ceremony, the women's court exits and goes to prescribed locations determined by rank. The wives of the senators, for example, go to the room of the golden hand. The empress follows them and enters with the wives of the patricians. From there, accompanied by her personal staff or *cubiculum*—which includes her ladies-in-waiting and perhaps eunuch staff members as well—the empress goes to the tribunal, where she is invested with the signs of office: the cross, scepter, and *labarum* (once a military standard, now adopted as a sign of imperial office). There the gendered spaces touch again as the men of the court greet the empress and acclaim her while she is seated with the signs of office in her lap.

The religious marriage ceremony comes next. It is preceded by an elaborately choreographed walk through the largest public rooms in the palace. As the women of the court vacate one large space, the men enter it. All honor and variously acclaim the empress as she enters their presence. The emperor and empress finally parade to an eight-sided room outside the Church of St. Stephen, which is part of the palace complex. The patriarch conducts a religious ceremony inside the church, and, when the ceremony is finished, the wedding crowns are brought in. The emperor places the wedding crown on the empress's head and the imperial couple proceeds, crowned, with much ceremonial bowing and choral singing, to the wedding chamber.

Everyone converges on the bedchamber, where the imperial regalia and imperial crowns are placed on the bed before the imperial couple goes to dinner. After dinner they arise from the table and, with friends that the emperor has invited, go to the bedchamber. The author adds some special instructions: "It is important to understand that the emperor does not sit in the bedchamber with his friends while wearing his imperial robe. Instead he wears his golden robe and lesser robe (worn underneath and perhaps flowered) and his friends wear clothes that they can recline in." Further, "The empress is not accompanied by her ceremonial guard as she parades around the palace complex."[11] This stipulation implies that she does, on occasion, process in public alone with her own personal guard. On this occasion, however, she is escorted by the emperor's personal eunuch guards.

"The ladies who are invited to the coronation should not wear hats."[12] At the Byzantine court headgear, and especially its height, is a sign of status. No woman may have a hat or coiffure that is higher than that of the empress. Because the empress's coronation is part of the ceremonial, she enters without a hat—so none of the other ladies may wear hats or elaborate coiffures. The emperor can invite selected individuals, both men and women, to attend the nuptials. The fact

that women are specified here carries the implication that women are rarely invited to court functions attended by men. Since this ceremony is intimately connected with marriage, family, and the coronation of a woman, it is considered appropriate that women be present.

On the third day after the nuptials, the empress leaves the bridal chamber and takes an elaborate ceremonial bath. Everyone in the court, men and women alike, turn out to watch her parade from the bridal chamber to the baths. Her procession is marked with music from three organs and with acclamations. On this occasion there is no mention of eunuch attendants, a requirement when the emperor takes ceremonial baths. As an afterthought, the author tells us that during the ceremonial procession the empress is escorted by dignitaries who carry three porphyry marble pomegranates encrusted with jewels. The exact significance of these items is not clear.

The empress and the women's court also appear when the emperor receives a female foreign dignitary. The most familiar case is the reception of the Russian princess Olga, who visited the court at Constantinople in 957.[13] At the time of her visit she was the regent of the Kievan state and had just converted to Christianity. The emperor is Constantine VII Porphyrogennetos; the empress is Helen, daughter of Romanos I Lecapenos. Romanos II, son and heir of the emperor, and Romanos's wife, Theophano, also play a role in the ceremony.

Olga arrives in September, attended by a large retinue of ambassadors, negotiators, and male and female relatives. After her formal reception by the emperor, Olga and her retinue go to the Triklinos of Justinian (a reception room also called the Hall of Procession), where the empress Helen sits on a high throne. The princess Olga arrives and is seated in an antechamber. Meanwhile the chief eunuch and the eunuch doorman introduce the women of the Byzantine court: first the zostae, or first ladies of the court, then the wives of the magistrates, patricians, and the various ceremonial guards in order of precedence. When all the formal ceremonial is completed and the women's court is assembled, the princess Olga—followed by her woman attendants, her female relatives, and women from selected families—enters the Triklinos, where the empress is seated. The chief eunuch, who has been orchestrating the audience, signals the princess Olga and she returns to the antechamber. The empress arises and goes to her apartment. The emperor also enters the empress's apartments and is seated with the empress and their children. Princess Olga joins them, and the emperor invites her to sit down with them. They talk freely and, according to the text, can say whatever they wish. It is highly unusual for Byzantine sources to depict men and women together in this kind of an intimate setting.

This reception is followed by two formal dinners, one for the men's court and the other for the women's court. The dinner hosted by the empress is held in

the Triklinos of Justinian. The empress sits on the throne mentioned above. The princess Olga first stands at the side of the room while her female blood relatives are introduced and bow down before the empress. Then Olga, her head bowed in submission, sits down to dinner. Her table is placed on the spot where she previously was standing, at a fixed distance from the imperial table. Her dinner companion is the first lady of the court, "even as is customary." While they dine, the church singers sing songs in praise of the family of the empress and a variety of pantomimes take place. At the same time, in the Golden Triklinos, there is a dinner for the male envoys, ambassadors, business agents, and relatives of the princess. The Russian guests at this dinner receive monetary gifts, each according to his station.

These festivities held in honor of Olga are especially interesting because they ceremonially foreground the empress rather than the emperor. The event marks an important diplomatic exchange, but it is one in which the head of the delegation is a woman. The nature of gendered space, at least at this ceremonial level, requires that the empress appear as the person formally receiving the delegation. One senses that the emperor and Olga's male courtiers are quietly negotiating in the background, but the ceremonial spotlight is on Olga and the empress and on their female courts.

Finally, we have a ceremonial that of necessity involves women's affairs, the celebration of the birth of an imperial heir.[14] On the eighth day after the birth of a male offspring in the imperial family, the empress's bedroom is hung with purple hangings and decorated with candles. The infant is brought from the church where he has been blessed by the priests and acclaimed by the urban factions. He is brought to his mother and put into his crib. Both mother and child are dressed in cloth of gold. The head of the empress's table servants, a eunuch, then summons the chief eunuchs. The latter ritually introduce the eunuchs who serve in the private imperial apartments and the other court eunuchs to the infant. Next the first ladies of the court are brought forward and introduced. Their introduction is followed by that of the wives of high officials and senators. The next people introduced are the widows of men who once held high dignities in the court. Finally, and last of all, the bearded men of the court are introduced, in order of precedence.

This ritual again makes apparent the gender segregation of the court, this time in a three-part structure that specifies separate treatment for eunuchs, women, and men. That the eunuchs appear as a separate category almost certainly signifies their distinctiveness as bridges between ritually segregated and gendered spaces in the palace.

As can be seen from these examples, the empress is most prominent in court ceremonies that involve the family and childbirth. This feature of court life

makes it easier to understand why, when female dignitaries came to court, the empress could, at least in a ceremonial way, act in the emperor's place. The princess Olga meets the emperor only informally, in the context of the empress's set of private apartments and with the imperial family present.

Eunuchs and the Configuration of the Empress's Power

Earlier we noted that a number of Byzantine empresses were able to exercise significant political power in place of or in tandem with emperors. At first glance the sharp segregation of gendered space within the palace would seem to mitigate against their capacity to do so. The cases of Olga and of the special honors addressed to the empress at the time of a "purple-born" son offer two examples of the latent ability of imperial women to exercise imperial power. To understand how empresses were able to actually rule, we have to look more closely at the place of eunuchs in the imperial court.

Court eunuchs have a history that predates the Greek and Roman empires. In that tradition, they frequently served as trusted personal servants.[15] By the middle Byzantine period (the eighth through the twelfth centuries), they were usually selected and castrated as children. Increasingly they were not of servile origin but came from freeborn, prosperous urban families. They were recruited and trained by powerful men or court eunuchs and acted as the surrogates of the men and women whom they served. Thanks to the unique capabilities they were believed to have, eunuch servants could extend the reach of those they served, their patrons, into arenas (both gendered and spiritual) that were not usually accessible to ordinary men and women. Because of their indeterminate gender status—and in this world ambiguous individuals, whether eunuchs, angels, magicians, prepubescent boys, or demons, were all presumed to have various degrees of liminal power—eunuchs were assumed to have the ability to operate across thresholds and boundaries of all kinds: theological, sexual, societal.

Eunuchs were believed to be able to bridge the gap between sacred and secular space. In a world where heaven had the same immediacy and reality as earth and where liminal figures were depicted moving on ladders and staircases from one world to the other, eunuchs could lead men to heaven but could not themselves enter heaven because, though liminal, they were still mortal. Eunuchs controlled the imperial regalia that changed individuals from mere mortals to emperors or empresses, the vice-regents of God on earth. Within the palace, eunuchs protected the rulers' sacred space from outside violation. They controlled the processional and ceremonial movements of the emperor and empress from the court out into the city, into and out of the churches of the city, and into the

countryside. In doing so they defined the geography of movable imperial space just as they defined the geography of gender in the palace. They supervised the relationship between the emperor and empress and religious authorities, including the patriarch of Constantinople. They served as doctors and confessors for cloistered women. They served as business agents for unmarried women—who else could a woman send out to negotiate the rental of an apartment?[16] Byzantine court eunuchs were clearly not harem guards—they played far more important and complex social roles, roles that were often mirrored by eunuchs serving in aristocratic households outside the court.

Having a chief court eunuch and a staff of eunuchs was an imperial prerogative. The emperor's court was staffed with eunuchs under the direction of the chief eunuch. On those rare occasions when a woman became an empress or regent and ruled in her own right or on behalf of an imperial heir, she was provided with a full complement of eunuchs for her household, including a chief eunuch. When an empress was deposed or sidelined into a back room, the first thing to happen was that the eunuchs on her staff were replaced by women.[17] Eunuch servants and especially a chief eunuch were essential to the exercise of imperial power because eunuchs bridged the divide between semi-divine imperial space and the ordinary world. Since eunuchs *also* bridged the gap between male and female spaces, we begin to see how their presence could facilitate female power in a way that was more or less compatible with tradition and custom.

Our understanding of eunuchs and their role has to do with certain ambiguities surrounding the office of the chief court eunuch. The *Book of Ceremonies* provides a number of snapshots of court ceremonial life; it is a playbook governing the day-to-day ceremonial traditions crucial to the successful workings of the court. Inevitably these ceremonials were organized and directed by palace eunuchs. But, as Michael McCormick has pointed out, one should look behind the documents themselves and see why it was necessary to write down explicit instructions and retain them in the palace archives.[18]

Chapter 39 of *De Ceremoniis* is particularly enlightening in this regard. Titled "Regarding the Patriarch and the Fact That He Had His Own Chief Eunuch in Former Times," it notes:

It is important to know that in former times the patriarch had a *praepositos* [chief eunuch] who ruled his private apartments and happened to be from among those in clerical office and counted among the clergy. This is clear from a pledge sent from the emperor Heraclius to Sergios the Patriarch, which is here contained for you to read: "We establish Thomas, *praepositos* of your honored cubiculum [apartments], third in honor among our *praepositoi*, so long as he is worthy of the diaconate [a religious office below that of the priesthood]. When

he moves into the rank of the priesthood we will establish him as second in rank among our *praepositoi*."[19]

The chief had to be a eunuch, and we have every reason to assume that the individual who served Sergios, patriarch of Constantinople from 610 to 638, was a eunuch. This passage plainly indicates that in the reign of Heraclius there were three chief eunuchs, two connected with the imperial court and another who was in charge of the patriarchal court.[20] It is also clear that the emperor was careful to guard both the right to have a chief eunuch and the authority to determine the place of each chief eunuch in the hierarchy of court ceremonial. While such attention might strike us as hairsplitting, it confirms the importance of these high eunuch officials in the life of the court and the politics of the empire.

Historians often assume that there was only one chief eunuch, yet the Book of Ceremonies often refers to them in the plural. As we see above, in the reign of Heraclius there were at least three. The second chief eunuch may have been assigned to the empress or to an imperial heir already crowned as co-emperor.[21]

That there might be multiple powerful chief eunuchs helps us understand why it would have been important to an empress to have her own chief eunuch and her own set of apartments. Having one's personal apartment staffed by eunuch servants and, perhaps more important, having one's own chief eunuch was a mark of independent power and authority in the complex world of ecclesiastical and imperial governance. Control over this office, staffed by a loyal eunuch, provided access to executive power and was assumed to be necessary if anyone—emperor, empress, or patriarch—was to rule effectively.[22] I know of no other suggestion, other than the one cited above from the reign of Heraclius, that the patriarch continued to be allowed to have his own chief eunuch.

For a number of reigns we have proof of the empress's possession of a chief court eunuch and a corresponding set of apartments, though information on this topic, as on much else pertaining to the women of the court, is murky. We know that Pulcheria, sister of the emperor Theodosius II (r. 408–450), demanded the right to have eunuch servants and a chief eunuch, and that her demands were seriously contested by the emperor.[23] By the sixth century, the empress Theodora, wife of Justinian I, had eunuch servants as well as a court of women, a power that she proudly displays in the famous mosaic on the south wall of the apse of the Church of San Vitale in Ravenna. The figure on her right (the favored side) is her chief eunuch; and next to him, in the doorway, is her first doorkeeper, another eunuch. The setting is Easter Week. Both men are beardless, but, more important, they wear the proper regalia for their respective offices. Both are dressed exactly as the Book of Ceremonies requires for these eunuch officials in the procession on Easter Week,[24] right down to the golden pins in their cloaks, which are promi-

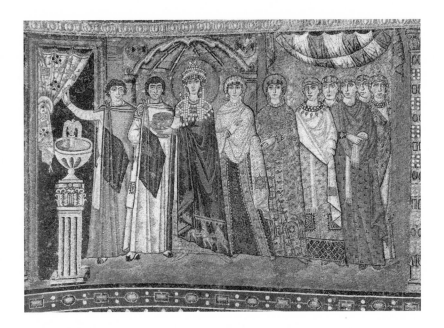

FIGURE 3.1.
The empress Theodora and her court. Mosaic in the Church of San
Vitale in Ravenna, Italy. Reproduced from Ringrose 2003, p. 166.

nently displayed in the mosaic (see figure 3.1). The historian Procopios discusses
Theodora's independent political activities at some length, dwelling on the power
of her eunuch servants. He deeply resented the fact that Justinian allowed her to
have so much independent power.[25] His very hostility, however, illustrates the
connection between eunuchs and the exercise of imperial power by an empress.

Powerful Empresses

The two most powerful women of middle period Byzantium were Irene and
Theodora. Irene (r. 797–802) has a mixed reputation in the annals of Byzan-
tine history. She ended the first period of iconoclasm and restored the venera-
tion of icons, and for this act she is honored. She decided that her only child,
Constantine VI, was not competent to rule. It may be that she did not want to
give up power and retire from court, but in any case she had him blinded and
then ruled in her own right.

Historians, both then and now, note Irene's reliance on eunuch officials, often
claiming that they were an evil influence on her. I would suggest that she had a

structural need for eunuchs. Having eunuch officials enabled her to control the palace and gave her access to the ceremonials that validated her power. It also gave her access to people outside the gendered space of the empress's household.[26]

The empress Theodora (r. 842–856) was the wife of Theophilos, the last of the iconoclastic emperors. She is honored for restoring the veneration of icons after the second period of iconoclasm. She was served by a highly educated and competent eunuch, Theoktistos. His murder seems to have been regarded as the essential first step in a plan to remove Theodora from the imperial throne.

Another powerful empress was Zoe, who shared imperial power with her sister Theodora in 1042. She first became empress in 1034 following the death of her father, Constantine VIII. On his deathbed Constantine arranged a marriage between Zoe and a high city official who ruled as Romanos III. One of our more reliable Byzantine chronicles claims that when her husband Romanos died, Zoe aspired to become empress in her own right. She therefore attempted to bring her father's eunuch staff into her household to serve her as empress. This effort was thwarted by the powerful eunuch John the Orphanotrophos. John replaced Zoe's eunuchs with women from his own family, effectively blocking her access to imperial power.[27]

These fragmentary bits of evidence reflect the problem we have with all of our evidence about Byzantine women. Because of the segregation of women at court, male chroniclers had little access to information about what royal women thought or did. For that we must wait until the twelfth century and the writings of Anna Komnene, daughter of the emperor Alexios I (r. 1081–1118). Anna offers some hints about the court and its women; but by the time she was writing, the court was very different than it had been in the eighth through the tenth centuries. The Komnene women of this later period possessed a far greater share in the power of the empire than earlier royal women had enjoyed. Moreover, because the eunuchate had been marginalized as a factor in palace organization, spatial boundaries in the palace had also changed.

In middle period Byzantium (the eighth through the twelfth centuries), society was rigidly segmented into social groups. There was an especially wide gulf between men and women. This was the context and possibly the explanation for the durability of the eunuchate, a corps of distinctively gendered individuals who constituted an integral part of Byzantine society for almost a millennium. In the imperial household, these eunuchs established and policed the traditional boundaries between men and women and between imperial power and the world of ordinary mortals. In the process they became the bridges that facilitated interaction between these segregated spaces. Spaces in the palace were highly

gendered, although not in a physically fixed manner. Male and female space was established, as needed, in accordance with ceremonial tradition. Women were a shadowy presence at court except on those occasions deemed part of the "women's sphere"—births, coronations of women, and marriage. The empress could, however, act as a substitute, at least ceremonially, for the emperor on occasions involving the reception of high dignitaries who were women.

We must not underestimate the importance of these roles. By the eighth century, "imperial blood" had become an increasingly critical issue among those aspiring to imperial office. Ceremonies that established the status of a new empress and her offspring were among the most important in the court. The "women's court" was thus more than a vestigial reflection of male authority— it was an institution essential to the stability of imperial politics.

The day-to-day activities of the empress are often hidden from our view, but the activities and identities of the women who served the empress are even more thoroughly obscured. Since the women's court was made up of the wives of bearded courtiers, and the status of each of these women was determined by her husband's status, one should be able to assume that a significant number of women served at court. Yet during the 226 years covered by the *Prosopography of the Byzantine Empire, I* (641–867),[28] a compilation that tabulates all known seals and literary references for the period, we find only thirty-six references to identifiable women serving at court. This low number does not mean that few women served at court, just that their presence was poorly documented. In fact, we have far more documentation about eunuch office holders than about women.

Because of this pattern of segregation, women in a position to rule in their own right were dependent on eunuchs if they hoped to exercise executive power. Only women who had eunuchs in their personal entourage were able to deal with men outside the sphere of the women's court. More specifically, eunuchs acted as an extension of an empress's power, allowing her to govern despite the constraints of her gender and the traditionalism of an elaborate court bureaucracy. Eunuchs were able to serve this function because of their unique ability to transcend boundaries of all kinds. Once institutionalized as mediators between otherwise separate special realms, the eunuchs enabled women to exercise power, not only within the empress' household but also on occasion as effective rulers of the empire itself.

Notes

1. Peirce 1993.
2. Philostratus 1912–50, book I, ch. 33.
3. Herrin 2001.

4. In the eighth century the terms *praepositos sacri cubiculi* and *parakoimomenos* seem to have replaced *praepositos sacri cubiculi* and *koubikoularios*, yet the latter terms seem to have been retained and used for titles reserved to eunuchs. The duties of the *praepositos* became more ceremonial, while the duties of the *parakoimomenos* centered on actually guarding and personally serving the emperor (Guilland 1967, 2:203).

5. *De Cer.*, book 1, ch. 24.

6. *De Cer.*, book 1, ch. 40.

7. *De Cer.*, book 2, chs. 27, 28.

8. *De Cer.*, book 1, ch. 9.

9. Bekker 1838, ch. 78, pp. 14–16.

10. *De Cer.*, book 1, ch. 41.

11. *De Cer.*, book 1, ch. 41. Her personal guards are eunuchs armed with ceremonial battle axes.

12. *De Cer.*, book 1, ch. 41.

13. *De Cer.*, book 2, ch. 15.

14. *De Cer.*, book 2, ch. 21.

15. Ringrose 2003.

16. "Vita of Euphrosyna" 1910, ch. 28.

17. Skylitzes 1973, p. 392.

18. McCormick 1985.

19. *De Cer.*, book 2, ch. 39.

20. There is some evidence that the Roman pope also had a *cubiculum* and a *praepositos* in the eighth century (see Martindale 2001, s.v. "Albinus" 1).

21. The plurality of chief eunuchs can be inferred from the case of the Gongylioi, brothers who were retired *praepositoi* and appear in the life of St. Basil the Younger (see Vilinskii 1911, pp. 57–58). It is also suggested in the case of two *praepositoi* who lived in a house on the Harbor of Eleutherios in the tenth century (Kazhdan and McCormick 1997, p. 185).

22. Several other important offices in the imperial bureaucracy, including the head of the chancellery and the director of the treasury, were either reserved for eunuchs or customarily held by eunuchs.

23. Theophanes the Confessor 1997, p. 153.

24. *De Cer.*, book 1, ch. 10.

25. Procopius 1962–64, vol. 3, ch. 15.

26. Herrin (2001, p. 107) shares this opinion.

27. Skylitzes 1973, 392.

28. Martindale 2001.

Ottoman Royal Women and the Exercise of Power

Leslie P. Peirce

For roughly one hundred years, from the mid-sixteenth to the mid-seventeenth centuries, women of the Ottoman royal family exercised so much influence on the political life of the empire that this period is often referred to, in both scholarly and popular writing, as "the sultanate of women." High-ranking dynastic women, especially the mother of the reigning sultan and his leading concubines, were considerably more active than their predecessors in the direct exercise of political power—in creating and manipulating domestic political factions, in negotiating with ambassadors of foreign powers, and in acting as regents to their sons. In addition, this period is notable for the important role acquired by dynastic women, the queen mother in particular, in the symbolics of sovereignty: the ceremonial demonstrations of imperial legitimacy and the patronage of artistic production.

The standard historical treatment of this salience of the imperial harem in Ottoman politics views it, in the framework of the Islamic polity and Islamic society, as an illegitimate exercise of power. The Ottomans, who established the longest-lived (ca. 1300 to 1923) and indisputably one of the greatest of Islamic states, were noted for their devotion to Islamic legal precepts and traditions.[1]

Reprinted from Leslie Peirce: "Beyond Harem Walls: Ottoman Royal Women and the Exercise of Power," from *Gendered Domains: Rethinking Public and Private in Women's History*, edited by Dorothy O. Helly and Susan M. Reverby. Copyright © 1992 by Cornell University. Used by permission of Cornell University Press.

One of the essential requirements of rulership in Islam, ideally conceived as successorship to the prophet Muhammad, is that the sovereign be male. Scholarly tradition, however, by denying the legitimacy of other channels of female political participation and influence, has taken a position with regard to the political roles of women that would have been congenial to the most conservative elements in classical Islamic and Ottoman thinking. In considering the interplay of public versus private and its role in the reading of gender in Islamic history, scholars have assumed that the segregation of the sexes, a prevalent feature of traditional urban upper-class Muslim society, created a gender-based dichotomy between easily discernible public and private spheres. Women are identified exclusively with the harem and denied any influence beyond its physical boundaries. Conversely, the harem is seen as a woman's world—domestic, private, and parochial. Its only commerce with the world of men is fundamentally sexual. Political activity by women is "meddling" in an arena to which females have no rightful access.

Within the context of Ottoman history, it has been particularly difficult to challenge this view because the rise of the imperial harem to political prominence took place principally after the death of Suleiman the Magnificent. The reign of this celebrated sultan (1520–66) has generally been accepted as the apogee of Ottoman fortunes, and the period initiated by his death one of precipitous decline from which the empire never fully recovered. The rise of the harem in the post-Suleimanic period has been attributed to the weakening in the moral fiber and institutional integrity of society traditionally accepted as the hallmark of this period. According to the conventional etiology of Ottoman decline, the "intrigue" and "meddling" of harem women is both a symptom of collapse and a principal cause of further corruption of institutions and customary practices.

Although it is certainly true that the late sixteenth and early seventeenth centuries were a period of intense difficulty for the empire—militarily, economically, and politically—only recently have scholars begun to pay attention to the means Ottomans devised to adapt to changing circumstances and the ways in which responses that had their genesis in times of crisis were resolved into permanent solutions.[2] Combined with the contributions of feminist studies, this recent challenge in Ottoman studies to traditional views of post-Suleimanic decline has created a climate hospitable for taking a new look at the imperial harem. The aim of this essay is, first, to correct certain misconceptions regarding the harem institution, and, second, to explore the networks through which royal women in this gender-segregated society exercised power in the world beyond the walls of the harem.

The Myth of the Harem

The persistence of the view that the exercise of public power by women is illegitimate derives largely from two basic misunderstandings of traditional Ottoman society. The first concerns the nature and function of the harem institution. In stark contrast to the historically persistent Western image of a group of concubines existing solely for the sexual convenience of their master, the harem of a household of means included women connected to the male head of household and to each other in an often complex set of relationships, many of which had no sexual component. The harem of a prosperous household would include the wife or wives of the male head of the household and perhaps one or more slave concubines,[3] children of the family, perhaps the widowed mother or unmarried or divorced sisters of the head of the household, and female slaves, who might be the personal property of the women or of the men of the family.

The imperial harem was similar but more extensive and its structure more highly articulated.[4] The mother of the reigning sultan was the head of the harem. The queen mother exercised authority over both family members—royal offspring; the consorts of the sultan, who might themselves acquire considerable power; and unmarried or widowed princesses—and the administrative/service hierarchy of the harem. During the second half of the sixteenth century, this latter organization grew rapidly in numbers and status.[5] High-ranking administrative officers of the harem—all of them women—received large stipends and enjoyed considerable prestige, especially the harem stewardess, chief of the administrative hierarchy. These women oversaw not only the large number of servants who performed the housekeeping tasks of the harem but also, more important, the training of select young harem women who would wait on the sultan or his mother. With the exception of the reigns of one or two notoriously uxorious sultans, few women of the imperial household occupied the sultan's bed. Indeed, as the more astute and well-informed Western observers commented, the imperial harem resembled a nunnery in its hierarchical organization and the enforced chastity of the great majority of its members.[6]

The word *harem* is one of a family of important words in the vocabulary of Islam derived from the Arabic root h-r-m. These words partake of one or both of two general—and obviously related—meanings associated with the root: "to be forbidden or unlawful" and "to declare sacred, inviolable, or taboo."[7] A harem is by definition a sanctuary or a sacred precinct and by implication a space in which certain individuals or certain modes of behavior are forbidden. Mecca and Medina, the two holiest cities of Islam, are commonly referred to as

"the two noble harems" (*haremeyn-i sherifeyn*), and in Ottoman usage the interior of a mosque is known as its harem. Because Islamic law limits open contact between the sexes to a specified degree of kinship, the private quarters of a house and by extension the female members of the household are its harem. The word *harem* is a term of respect, redolent of religious purity and honor. With the exception of its reference to the women of a family, it is not gender-specific. Indeed, the residence of the Ottoman sultan contained not one but two harems: the other, the innermost courtyard of the palace, populated exclusively by males and containing private quarters for the sultan as well as the famed school that trained youths for government service, was known as "the imperial harem" or "the honored harem" (*harem-i hümayun, harem-i muhterem*) by virtue of the presence of the sultan, "God's shadow on earth."

A second misunderstanding of the nature of Ottoman society is the erroneous assumption that the seclusion of women precluded their exercising any influence beyond the walls of the harem or that women were meant to play only a narrow role within the family, subordinate to its male members. The segregation of the sexes created for women a society that developed its own hierarchy of authority. The larger the household, the more articulated was the power structure of its harem. Women of superior status in this female society, the matriarchal elders, had considerable authority not only over other women but also over younger males in the family, for the harem was also the setting for the private life of men.[8] Furthermore, female networks sustained through formal visiting rituals provided women with information and sources of power useful to their male relatives.[9] In both its sources and its effects, the authority enjoyed by female elders transcended the bounds of the individual family. In a polity such as that of the Ottomans, in which the empire was considered the personal domain of the dynastic family and the empire's subjects the servants or slaves of the dynasty, it was natural that important women within the dynastic household—particularly the mother of the reigning sultan—would assume legitimate roles of authority in the public sphere.

A further source of women's influence beyond the family was their ownership and exploitation of property. A woman's economic independence was derived from her rights under Islamic law to the dowry provided by her husband and to specific shares of the estates of deceased kin.[10] As property owners and litigants in property, inheritance, divorce, and other legal suits, women—or at least women of means—had access to economic and social power;[11] it must be admitted, however, that at present we lack the historical evidence to determine the extent to which women of different social levels were able to exploit these theoretical rights to their advantage. That prominent women often used their wealth to benefit other women is suggested by contemporary histories and testamentary

documents, which show well-to-do individuals making provision not only for female family members and retainers but also for less fortunate women— orphans, paupers, prisoners, and prostitutes.[12] Through their practice of the charity incumbent on Muslims, women asserted the prerogative of claiming and organizing a sector of public life for their own welfare.

Thus in the Ottoman case, conventional notions of public and private are not congruent with gender. In fact, an examination of the structure of male society and the interaction of male and female networks shows that at least at the highest reaches of society, notions of public and private tend to lose meaning altogether. In many ways, male society observed the same criteria of status and propriety as did female society. The degree of seclusion from the common gaze served as an index of the status of the man as well as the woman of means. No Ottoman male of rank appeared on the streets without a retinue, just as a woman of standing could maintain her reputation for virtue only if she appeared in public with a cordon of attendants.[13] Poor men and poor women mingled in the city streets and bazaars, their cramped households and lack of servants preventing them from emulating the deportment of the well-to-do. At the highest levels of government, there were no public buildings set aside for the conduct of the state's or the people's affairs; instead, the household compound served as the locus of government. Ottoman society was thus dichotomized into spheres characterized not by notions of public/commonweal/male and private/ domestic/female but rather by distinctions between the privileged and the common, the sacred or honorable and the profane—distinctions that cut across the dichotomy of gender.[14]

Sources of Harem Power

These observations will facilitate an examination of the reasons why dynastic women acquired a substantially increased role in the exercise of political power in the sixteenth century. There were two principal features that distinguished the careers of women during the reigns of Suleiman and his successors from the careers of their predecessors: greater physical proximity to the sultan and greater status within the royal family. Both resulted from a profound change in dynastic politics, a transformation from a decentralized to a centralized style of government. In this transformation, women of the dynastic family—the sultan's mother, his principal concubines, and occasionally his sisters—gained power as princes lost it.

According to custom that had prevailed for nearly a century before Suleiman's accession in 1520, if not longer, princes, princesses, and their mothers lived apart from the sultan. The royal offspring and their mothers (by the end of the

fifteenth century virtually all slave concubines)[15] were housed in a palace separate from that of the sultan. When they reached puberty, the sultan's daughters were married to provincial governors and his sons dispatched with great ceremony to their own provincial governorates. Although the independence of princes was carefully circumscribed by the sultan, they were prominent political figures who functioned, after their father, as the most visible and important representatives of the power and charisma of the dynasty. The system of succession that prevailed in this period—all princes were considered eligible for the throne and the heir was the one who could eliminate all other claimants—inevitably rendered them rival foci of political factions. Each prince was accompanied to his provincial post by his mother, who was expected to support her son's efforts to win the throne. The practice of fratricide (whereby, in the interests of security, a new sultan executed his defeated brothers and their sons) meant that both a prince and his mother had as their highest priority his political survival. Only the mother of a victorious prince would return to the imperial capital, as queen mother to the new sultan. The fate of a royal wife or concubine thus depended almost entirely on that of her son.

The sixteenth century witnessed a reversal of this policy of dynastic decentralization, as the royal family was gradually centralized in the capital and lodged in the harem quarters of the sultan's palace. This process began with two innovations introduced by Suleiman. In a reversal later political commentators were to lament as impolitic, he married his sisters, daughters, and granddaughters to top-ranking statesmen—whenever possible, to his grand viziers.[16] Since the duties of such statesmen required them to remain in proximity to the sultan, their wives lived in the capital rather than in the provinces. Suleiman also abandoned the practice of serial concubinage, hitherto regarded as a binding tradition; this practice appears to have been aimed at ensuring that the mother of a prince would have no more than one son so that no prince would be disadvantaged in the contest for succession. Suleiman raised one of his concubines, Hurrem, to an extraordinarily privileged position: he had five sons and a daughter by her, contracted a legal marriage to her, and established in his palace a permanent residence for her, where she remained when her sons were dispatched to the provinces.

The last support in the edifice of dynastic decentralization—the princely governorate—was dismantled by Suleiman's son and grandson. With the demise of their political role, princes became faceless individuals, strictly confined to the palace; there they were kept in a perpetual state of preadulthood, denied the right to marry or to father children by concubines. By the end of the sixteenth century, no members of the royal family except the sultan left the capital. Indeed, the only members of the family to leave the palace residence were

married princesses. As a consequence, the imperial harem expanded greatly in size as it absorbed the suites of mothers and sons and acquired the requisite administrative structure.

More important, women of considerable status and political influence now pursued their careers and promoted those of their sons in close proximity to one another. The rise of the harem as the central arena of dynastic politics endowed royal women with considerably greater political leverage than they had previously enjoyed and more opportunities to exert it. In addition, women began to fill the vital role of publicly demonstrating the dynasty's legitimacy and magnificence, a role left empty by the departure of princes from the stage of royal politics. Where once princes' weddings were ceremonial occasions, the marriages of princesses were now lavishly celebrated. The sultan's mother, featured in numerous royal progresses in the capital and in surrounding provinces, became the most celebrated public figure after her son.

It is beyond the scope of this essay to do more than briefly list the factors underlying the transformation of dynastic politics outlined above. Suleiman's privileging of women has generally been seen as "indulgence," a personal weakness that opened the Pandora's box of female "lust for power" and "greed for wealth" that future generations were unable to shut. I suggest instead that his creation and exploitation of family-based networks is more properly viewed as a political strategy. This strategy was useful in building a personal base for the sultan's authority and creating a political force to oppose increasingly entrenched interests (for example, the Janissary corps) that might resist the sovereign.[17] The political roles made possible for women during the reigns of Suleiman and his successors were reinforced by a series of dynastic accidents in the first half of the seventeenth century. The six sultans who came to the throne in this period were either minors or mentally incapable of governing, and it became customary in such circumstances for the sultan's mother to act as regent. The enormous prestige enjoyed by two of these regent queen mothers, Kösem Sultan and her daughter-in-law Turhan Sultan, helped transform the queen mother's relationship with her son from an essentially private one into one that encompassed the entire empire. Evidence of this broader relationship can be seen in the attribution to the queen mother of the honorific "mother of Muslim believers" (umm al-mu'minîn), a Qur'anic title bestowed on the wives of the prophet Muhammad.

Perhaps the most broadly influential factor in the transformation of dynastic politics was the closing around the mid-sixteenth century of the great age of Ottoman conquest and expansion. Suleiman continued to campaign until the end of his reign, but his successors found it more politic to downplay the martial role heretofore a sine qua non of sovereignty. Nevertheless, the wisdom of a

peace policy was not always recognized by the sultan's subjects, who began to wonder if the sedentariness of their sultans was responsible for the problems plaguing the empire toward the end of the century. In these circumstances, it was wiser to remove princes, potential candidates for a forcible change of rulership, from the field. A further advantage of abandoning the princely governorate was freedom from the ravaging civil wars that had occurred among rival princes; the confinement of princes to the capital was soon followed by a change in the succession system to the principle of seniority (the throne henceforth went to the eldest male member of the dynasty, be he the brother, cousin, or son of the former sultan). The move from an expansionist policy to one based principally on maintaining the frontiers of the empire influenced the conduct of dynastic politics in another way: in promoting its claim to legitimate sovereignty, the dynasty now began to de-emphasize the role of warrior for the Muslim faith and to stress instead its propagation of the faith through piety and munificent support of the community of believers. Women were easily incorporated into public expressions of this latter policy.[18]

Networks of Power

Despite their often considerable influence, women of the imperial harem were inescapably confined to the palace. They left the royal residence only under the tight surveillance of the black eunuch guards of the harem. Only the queen mother appears to have had mobility outside the confines of the harem: in public ceremonials she might make herself visible from within her carriage or palanquin as she cast coins to onlookers or acknowledged their obeisances. She might also meet with high-ranking government officials in private conference if she were carefully veiled, but even she had no routine, face-to-face contact with men. Thus it was essential that harem women develop links with individuals or groups in the outside world. There was no lack of parties eager to cooperate, for as the harem came to enjoy a greater share of imperial authority, not only did its residents seek outside channels through which they might accomplish their political goals, but outsiders were anxious to form ties with potential patrons within the palace.

Like the sultans during this period, harem women built much of their networking on family-based relationships. It is crucial to recognize that the family was not limited to blood relationships but included the entire household, the vast majority of which, in the case of the dynastic family, was composed of slaves. Like the sovereigns of other Muslim states before them, the Ottomans based their authority on a military slave elite, which was recruited from outside the empire, converted to Islam and carefully trained, and instilled with loyalty

to the dynasty. From the second half of the fifteenth century on, this slave elite came to dominate the ruling class, taking over administrative positions from the native Turkish elite, with the exception of the scribal bureaucracy and the religious hierarchy. What has gone unnoticed is the remarkable parallel between male and female slaves in the ruling class: the dynasty began to rely exclusively on slave concubines for its reproduction at the same time that the highest offices of the state began to be awarded to male slaves.[19] By the reign of Suleiman (possibly by the reign of his father, Selim), the only free Muslim women in the imperial harem were the sultan's sisters, daughters, aunts, and mother (originally a slave concubine, the latter, by virtue of having borne a child to her master, was freed according to Islamic law upon his death). Toward the end of the sixteenth century, the male "harem" in the imperial palace—the third courtyard, where select young slaves were trained for the offices that would eventually be granted them—began slowly to be penetrated by native Muslims,[20] but the female harem appears to have maintained its exclusively slave nature.

For the members of the dynastic family, the harem served as residence. For female slave members of the sultan's household, it might best be described as a training institution, where the education given to young women had as its goal the provision not only of concubines for the sultan but also of wives for men near the top of military/administrative hierarchies (the highest-ranking officials would marry Ottoman princesses). Just as the third-courtyard school prepared men through personal service to the sultan within his palace for service to the dynasty outside the palace, so the harem prepared women through personal service to the sultan and his mother to take up their roles in the outer world. Once manumitted and married, these women, together with their husbands—often graduates of the palace school—would form households modeled on that of the palace. For both men and women, the palace system of training had as one of its fundamental goals the inculcation of loyalty to the ruling house. But because women as well as men sustained the ties that bound the empire's elite, the focus of the latter's loyalty was not only the sultan himself but the women of his family as well.

Within the imperial harem, the sultan's mother and favorite concubine or concubines were best positioned to build for themselves or for their sons factional support bridging the palace and the outer world. They were mothers not only of the sultan or potential sultans but of princesses as well. Moreover, their status and wealth permitted them to control the careers of a large number of personal attendants and to influence the careers of the harem's administrative officials. It was a meritorious act for a Muslim, male or female, to educate and manumit a slave. The manumission of a slave also worked practically to the benefit of the former owner, who enjoyed the loyalty of the former slave in a

clientage relationship. The seventeenth-century historian Mustafa Naima praised the generosity of the queen mother, Kösem Sultan, who appears to have taken pains to cultivate close ties of patronage with her freed slaves: "She would free her slave women after two or three years of service, and would arrange marriages with retired officers of the court or suitable persons from outside, giving the women dowries and jewels and several purses of money according to their talents and station, and ensuring that their husbands had suitable positions. She looked after these former slaves by giving them an annual stipend, and on the religious festivals and holy days she would give them purses of money."[21] Manumitted slaves might act as agents for their former mistresses, just as princess daughters, when married, could help their mothers, who remained within the imperial compound. Both princess daughters and manumitted slaves might be counted on to influence their husbands to act as advocates; for this reason, harem women strove to exert as much control as possible over the choice of husbands for their daughters or slaves.

Several incidents related in contemporary histories demonstrate the extent to which members of a harem woman's suite acted as allies within the palace and might go on to become agents for her outside. The mother of Mahmud, the eldest son of Mehmed III (r. 1595–1603), was not sufficiently circumspect in her efforts to look after her son's interests. Mahmud and his mother were executed when the queen mother, Safiye Sultan, intercepted a message sent into the palace to the prince's mother by a religious seer whom she had consulted about her son's future. The message indicated that Mahmud would succeed his father within six months. The sultan, who had grown so fat and physically unfit that his doctors warned him against campaigning, was particularly threatened by this augury because of Mahmud's popularity with the powerful Janissary troops and his pleas to be allowed to take up arms against Anatolian rebels challenging his father's authority. A substantial number of harem women were implicated in the affair and suffered the same fate as the prince's mother. Their death by drowning at sea—a form of exemplary execution whose use for women can be explained by the fact that it upheld the principle of gender segregation by preserving the female corpse from the public gaze—was reported by Henry Lello, the English ambassador to the Ottoman court: "That nighte [the mother was] with 30. more of her followers wch they supposed to be interested in the business shutt up alyve into sacks & so throwne into the sea."[22] This affair vividly illustrates the clash of two royal mothers trying to protect the interests of their sons.

Perhaps the most dramatic example of the transfer of loyalty from the palace to the outside world is found in the career of Meleki Hatun, originally a member of the suite of the queen mother Kösem Sultan. In 1648 Kösem's second sultan son was deposed for mental incompetence, an event that should have

brought her twenty-five-year career as queen mother to an end. But instead of retiring and permitting the succeeding sultan's mother to assume the position of queen mother, she was asked by leading statesmen to stay on as regent to the new sultan, her seven-year-old grandson, because of the youth of his mother, Turhan. When Turhan began to assert what she saw as her rightful authority, Kösem reportedly planned to depose the young sultan and replace him with another prince, whose mother she believed to be more tractable. At this point, Meleki deserted Kösem and betrayed her plans to Turhan, thereby enabling the latter to eliminate her mother-in-law (Kösem was murdered in a palace coup led by Turhan's chief black eunuch). Meleki became the new queen mother's loyal and favored retainer and was eventually manumitted and married to Shaban Halife, a former page in the palace training school. As a team, Meleki and Shaban were ideally suited to act as channels of information and intercessors on behalf of individuals with petitions for the palace: Shaban received male petitioners, Meleki female petitioners; Shaban exploited contacts he had presumably formed while serving within the palace, and Meleki exploited her relationship with Turhan Sultan. The political influence of the couple became so great that they lost their lives in 1656, when the troops in Istanbul rebelled against alleged abuses in government.[23]

High-ranking harem officers might establish important links outside the palace through family connections. Particularly valuable were the connections of the sultan's former wet nurse and the harem stewardess; in the stipends they received and in their ceremonial prestige, these two were the highest-ranking women in the harem after the royal family. A harem woman who lacked daughters might turn to one of these women to form a political bridge to the outside world, as did the mother of Mustafa I (r. 1617–18, 1622–23). No one had expected that Mustafa, who suffered from severe emotional problems, would become sultan. Within the imperial harem, his mother (whose name is lost to history) did not enjoy a position of much status: on the eve of her son's accession in 1617, her daily stipend was only one hundred silver pieces, while the newly deceased sultan's favorite concubine (the future queen mother Kösem) received one thousand and the former queen mother Safiye, now in retirement, two thousand.[24] When Mustafa was suddenly catapulted to the throne, one of the few political alliances that his mother was able to forge was with her son's sword-bearer, a high-ranking inner palace officer, who was brought out of the palace and awarded the prestigious and strategically vital post of governor of Egypt on condition that he marry the sultan's wet nurse.[25] Within a few months the pasha was brought back to Istanbul as grand vizier.

Probably the most important links with centers of power outside the palace were forged by harem women through the marriages of their daughters, the

princesses of the dynasty, to leading statesmen. To become a royal son-in-law was a mark of high honor, conferred generally on the highest-ranking government officers or on promising younger officers. These weddings were lavishly celebrated state occasions, serving in the sixteenth and seventeenth centuries to demonstrate imperial magnificence and munificence, as the weddings of princes, now shut up in the palace and forbidden to marry, had done in the fourteenth and fifteenth centuries. The royal son-in-law, known as *damad*, would be given an elegant palace and was likely to become grand vizier at some point in his career. Although he was not immune to dismissal or execution, he could get away with more than the non-*damad* statesman could.

The dynasty had always used the marriages of princesses for political ends; what stands out in this period is the frequency with which such marriages occurred. By the seventeenth century, serial marriages of princesses were common. The most extreme example of this practice was two daughters of Kösem Sultan and Ahmed I, Ayshe and Fatma, who were married six and seven times respectively; Ayshe was approximately fifty and Fatma sixty-one at their final betrothals.[26] Serial marriage was possible because princesses might first be married at the age of two or three; by the time a princess reached puberty she could be in her third or fourth marriage because her husbands encountered many risks in high office, including death in battle or execution. These unions could be very happy: a sixteenth-century princess, Shah Sultan, and her second husband were said to be so compatible that they fell fatally ill simultaneously, lay side by side in their deathbeds, and expired at the very same moment.

Linking important statesmen to the royal family clearly worked to the advantage of the sovereign. With the greater seclusion of the sultan in the post-Suleimanic period, the strong personal bonds that had earlier existed between the sultan and his leading subjects, fighting together and sitting in the imperial council together, were no longer possible. Providing the hand of a princess functioned to seal the loyalty of statesmen to their sovereign. Bringing a pasha into the royal family as *damad* sometimes even served to control sedition, as in the case of the rebel vizier İbshir Mustafa Pasha, who became the final husband of the six-times-married Ayshe. The importance of princess–statesman marital alliances—and the consequent strategic interest in princesses as political contacts—is seen in the care taken by foreign ambassadors to keep track of who was married to whom[27] and in the lavish gifts they bestowed on these politically key members of the dynasty.

Obviously, not just sultans but queen mothers as well benefited immensely from this practice. Married princesses enjoyed relatively easy access to the imperial harem, their parental home, and could serve as informants, couriers, and

political strategists. Because the interests of princesses and their mothers in the harem were harmonious—the goals of the former being to prolong the political careers, indeed the lives, of their husbands, and of the latter to secure loyal allies on the outside—the networks formed by the marriages of princesses were vital. It is surely no coincidence that the most powerful queen mothers were those with several daughters: Nurbanu (queen mother from 1574 to 1583) had three, Safiye (1595–1603) had two, and Kösem (1623–52) had at least three. Indeed, the efforts of queen mothers were largely responsible for the frequency of princess–statesman alliances in this period. The queen mother arranged the marriages not only of her own daughters but also of the daughters of her son and his concubines. Thus the Venetian ambassador reported in 1583 that Nurbanu planned to marry her son Murad III's second daughter to the head of the palace guards.[28] Kösem's long career gave her considerable opportunity to forge such alliances. In 1626 or thereabouts she wrote to the grand vizier proposing that he marry one of her daughters: "Whenever you're ready, let me know and I'll act accordingly. We'll take care of you right away. I have a princess ready. I'll do just as I did when I sent out my Fatma."[29] In the early 1640s, Kösem emerged victorious from a conflict with a concubine of her recently deceased son Murad IV over the marital fortunes of thirteen-year-old Kaya, daughter of the concubine and granddaughter of Kösem. The concubine was anxious for Kaya to marry one of her own political allies, the former sultan's sword-bearer, but Kösem's candidate, a pasha in his forties, won out.[30]

By creating and exploiting the variety of networks described above, a queen mother or a powerful concubine could work different sectors of public government. Through the marriages of princesses or the imperial wet nurse, alliances could be formed with the most powerful of statesmen and with the representatives of foreign powers. Through clientage ties with former slaves, contacts could be created with a wide range of middle-level public officials. It is important to recognize that this establishment of a constellation of contacts outside the palace was by no means surreptitious. Nor was it a uniquely "female" or "harem" paradigm for organizing political patronage and creating political influence. The governing class of the Ottoman Empire in this period operated not so much on the basis of institutionally or functionally ascribed authority—authority devolving from one's office—as through a complex of personal bonds and family and household connections. Functionally ascribed authority certainly existed, but more important was the web of individual relations—of patronage and clientage, of teacher and student, of kinship and marriage—that brought individuals

to their offices and that they used in the exercise of their official power. Men as well as women sustained their careers by means of such networks, and men and women played significant roles in the formation of each other's networks.

Only when the paradigm of rigidly separate public/male and private/female spheres is discarded can we begin to appreciate the ways in which the structure of the Ottoman ruling class enabled women to participate in the political life of the empire. Conversely, by understanding how women were able to acquire and exercise power, we obtain a clearer picture of the structure of Ottoman politics and society. For example, it is widely recognized that the household was the fundamental unit of Ottoman political organization in this period, but the role of women in the construction and maintenance of the household system has been ignored. Future research will demonstrate whether or not the essential role played by women in the Ottoman dynastic household was reflected in the organization and operation of households of lesser status.

Notes

1. Schacht 1964, pp. 89–90.

2. Two notable exceptions to the long-standing neglect of such questions are İnalçik 1980 and Kunt 1983.

3. Islam permits a man four wives and an unlimited number of slave concubines. For the legal and social status of slave concubines, see Marmon 1983; Brunschvig 1960. The incidence of polygyny (multiple legal wives) varied from time to time and place to place in the Islamic world; it appears to have been confined to approximately 1 to 2 percent of the Ottoman middle and upper classes in this period (Barkan 1966, pp. 13–14; Gerber 1980, p. 232).

4. Peirce 1993, pp. 113–49.

5. The size of the imperial harem was exaggerated by Western travelers and scholars: in the mid-sixteenth century it consisted of approximately 150 women; in the mid-seventeenth century, approximately 400 women (Prime Ministry Archives in Istanbul: Ali Emiri Series, Register Kanuni 24; Kamil Kepeci Series, Register 7098; Maliyeden Müdevver Series, Registers 774, 1509, 1692).

6. Withers 1905, p. 339; Baudier 1631, p. 19; Tavernier 1681, p. 541.

7. For an excellent discussion of the concept of *harem*, see Marmon 1995, pp. 6–26.

8. On the Turkish family, see Duben 1985. On the influence that Turkic tribal women today derive from their separate social organization, see Tapper 1980.

9. On the subject of visiting among the female Ottoman elite, see Montagu 1965, 347–52, 380–87; F. Davis 1986, pp. 131–56.

10. For a brief exposition of the legal position of women, see Esposito 1982.

11. See Gerber 1980; Jennings 1975.

12. Peirce 1993, pp. 201–3.

13. See the responses to queries on points of Islamic law (fetva) of the late-sixteenth-century Ottoman chief mufti Ebu Suud, in Düzdağ 1976, p. 55.

14. For discussion of the importance of the division between privileged and common (khass and 'amm), see Mottahedeh 1980, pp. 115–29, 154–55; Lewis 1988, p. 67.

15. It was common for Islamic dynasties to reproduce themselves by means of slave concubinage, either exclusively or in combination with formal marriage. On the Ottoman transition from interdynastic marriage to slave concubinage, see Peirce 1993, pp. 28–56.

16. Koçu Bey 1939, p. 61.

17. I am indebted to Roy P. Mottahedeh for suggesting a parallel in the exploitation of family-based political networks between Suleiman and the famed Abbasid caliph Hârûn al-Rashîd.

18. For a striking parallel in the incorporation of women into dynastic propaganda during a "sedentarizing" stage in the late Roman Empire, see Holum 1982. I am grateful to Peter R. Brown for drawing this work to my attention.

19. This parallel has been briefly noted by İnalcik 1973, p. 85.

20. Kunt 1983, p. 96.

21. Naima 1863–64 (A.H. 1280), 5:113.

22. Lello 1952, pp. 14–15, 57–58.

23. For the career of Meleki Hatun, see Naima 1863–64 (A.H. 1280), vols. 5 and 6.

24. Prime Ministry Archives, Maliyeden Müdevver Series, Register 397.

25. Naima 1863–64 (A.H. 1280), 2:159.

26. Uluçay 1980, pp. 50–52.

27. Alberi 1840–55, 1:117, 404–7; 2:354–58; 3:239–42, 288–93, 366–74.

28. Alberi 1840–55, 3:243.

29. Topkapi Palace Archives, Istanbul, Evrak 2457/2.

30. Barozzi and Berchet 1871–72, 1:370; Sieur du Loir 1654, pp. 124–26; Uluçay 1980, pp. 54–55.

5 | MUGHAL PALACE WOMEN

Ruby Lal

In chapter 15 of the final part of his chronicle, A'in-i Akbari, Abu-l Fazl (1551–1602), the imperial chronicler for Akbar the Great (1556–1605), recorded the regulations regarding the Mughal haram.[1] His treatment marked its institutionalization, setting forth not only its physical layout at Fatehpur-Sikri but its conceptual framework as well. Courtly and domestic spaces came, for the first time, to be distinctly separated from each other. A neatly compartmentalized haram was designed to place women in a strictly segregated space in terms of physical structures, ritual practices, and imperial regulations—for "good order and propriety," as Abu-l Fazl has it. He officially designated the women pardeh-giyan, "the veiled ones." As part of this process of institutionalization, the term haram came to be the most common description of the women's sphere and signified important changes in Mughal domestic life.

This meaning and resonance of the term haram differed from its usage in Humayun's time (1508–56). Haram, in Akbari chronicles, refers both to physical structures, the secluded quarters where royal women lived, and to the women who dwelled in them. This marks a return to the origins of the term in early Islamic history (haram as a sanctum sanctorum) and to the sanctity that extends not only to the inner quarters but also to the haram folk. It is not altogether surprising, given the divine connections now repeatedly drawn up for emperor Akbar. What are the implications of these changes?

The construction of order in different arenas and activities—what Abu-l Fazl in the preface to the A'in-i Akbari describes as the proper order of the household, army,

and empire[2]—was a major hallmark of Akbar's reign. In the drive to coordinate all aspects of imperial life, domestic life had to be carefully regulated as well. The new arrangements had a significant effect in decreasing the visibility of the royal women, now more elevated and at the same time more secluded than before. However, the theory of the new empire, which was to find tangible form in the sacred *haram*, was never so fully realized as to wipe out contradictions, tensions, human volition, or unexpected departures—that is, the stuff of human history. In the changing environment of Akbar's reign a great deal happened to alter domestic arrangements, and we have considerable evidence that shows how women and men dealt with imperial prescriptions in their everyday life. The initial part of this essay demonstrates how Abu-l Fazl established new norms by representing Akbar's domestic life. The latter half investigates how Mughal women responded to the new imperial regulations, and how women's negotiation of the new sovereign ideals became a crucial element in the making of the monarchy—at times, by rupturing those very ideals. Although Akbar's *haram* was secluded, sacred, and even inaccessible to most people, it was by no means closed off from the world, unconcerned with politics, or lacking power or interest in public affairs.

The Sacred *Haram*

His Majesty is a great friend of good order and propriety. . . . For this reason, the large number of veiled women [*pardeh-giyan*]—a vexatious question even for great statesmen—furnished his Majesty with an opportunity to display his wisdom, and to rise from the low level of worldly dependence to the eminence of perfect freedom. The imperial palace and household are therefore in the best of order. . . . His Majesty has made a large enclosure with fine buildings inside, where he reposes. Though there are more than five thousand women, he has given to each a separate apartment. He has also divided them into sections, and keeps them attentive to their duties. Several chaste women have been appointed as superintendents over each section, and one has been selected for the duties of writer. Thus, as in the imperial offices, everything is here also in proper order.[3]

Here, Abu-l Fazl describes the spatial living arrangements of the imperial women. With this public pronouncement he puts forward the veiled status, and the carefully segregated allocation of women's quarters, as a vital hallmark of the grand empire. As we will see, he uses a variety of evidence to buttress Akbar's claim to be an Islamic emperor.

In this discussion of the new sanctity that was to be created through the seclusion of women, Abu-l Fazl also refers to the arrangements for the security of the *haram* by what he calls "sober and active women." The most trustworthy

women were placed at Akbar's quarters. The eunuchs guarded the outside enclosure, and at some distance from them, the Rajputs formed another line of watchmen. "Guards of Nobles" resided on all four sides of the complex. Abu-l Fazl then gives the salaries of the women guards: the women of "highest rank" received 1,610 to 1,028 rupees per month, whereas servants' pay varied between 51 rupees and 2 rupees. If a woman wanted anything "within the limit of her salary," she had to apply to the cash keepers of the *haram*. It was the general treasurer, however, who made the payments in cash.[4]

Abu-l Fazl also records rules for visits. Whenever "the wives of the nobles, or other women of chaste character" desired to visit the *haram*, they had to notify the servants of the *haram* of their wish, and wait for a reply. From there the requests were sent to the officers of the palace, and "those who . . . [were] eligible" were given permission to enter the *haram*. Some women "of rank" could be given permission to remain in the *haram* for a whole month.[5]

Let us examine how the *haram* functioned to strengthen Akbar's claim to imperial status. In the thirty-ninth year of his reign, Akbar addressed a letter to the emperor of Persia.[6] He writes in one passage: "Let us proclaim in the pulpits of publicity; firstly, their glorious condition [of Divine humans, with the help of divine aid], and secondly . . . let us tell of the bounties and noble qualities of the 'members of the household' (*Ahl-i-bait*) who are confidants of the great secrets, and unveilers of the mysteries of the prophets, and let us, relying thereupon, implore new mercy!"[7] The citation evokes the sacredness of the Prophet's family and, by extension, of his earthly descendants—drawing a significant parallel to what is presented as the holy empire of Akbar. This ideal of the Prophet's household became key to Muslim monarchs who vied with each other to appropriate genealogical legitimacy by asserting they were descendants of the Prophet's family.[8] As Juan Campo points out, the "most important aspect of the 'people of the house' phrase is not its use in the Quran per se, . . . but what Muslims later made of it." After Muhammad's death, the term *ahl-i-bayt* came to designate the Prophet and his family, as well as his "noble" descendants.[9]

Abu-l Fazl too seems to be invoking for Akbar an association with the Prophet's family. He represents the emperor as making this connection alongside a community of divine monarchs, thereby enhancing what Abu-l Fazl refers to at one point as the "spiritual relationship" between Akbar and the Safavid king of Persia, both of whom are described as the members of the *ahl-i-bayt*.[10] The virtues of such a "divine household" (the members of which are "confidants of the great secrets"), highly praised by the monarch, would then become models for his own, earthly one—both in expectation and portrayal.

None of the terms discussed above is encountered as frequently as *haram*,

officially designated as the Shabistan-i Iqbal (literally, "the fortunate place of sleep or dreams") in the A'in-i Akbari.[11] Haram encompasses other meanings, including "those behind the curtain, not to be seen"; "that which is inside, internal, within, intrinsic"; "the house where the wives and the household live"; "a place of sleep"; and "Mecca," "Medina," "the area around the Ka'ba," and "the garden of the Prophet Muhammad."[12]

The fabric of invocations used of Akbar's dwellings and of their inhabitants is thus woven from matter close to the Prophet, including the holy sites associated with him: his garden, Mecca, Medina, and the Ka'ba. In this construction, the centrality of Akbar in the haram is absolute, like that of Muhammad in his haram. The parallel between Muhammad and Akbar is significant because it allows Akbar to claim to rule over a hallowed and "blessed" empire—here, premised upon domestic order.

One other thing must be said of this vocabulary: adjectives associated with the sacred that are used as prefixes or suffixes often appear to overshadow the substantive to which they are attached. Thus words translated as "holy," "sublime," or "illustrious" capture our attention first, rather than the noun for "family." What is most fascinating about this language is its advertisement of the purity and sanctity attached to the notion of the familial.

The pure and prophetic associations of the haram are deeply implicated in the happenings recounted in the chronicles of the time. Consider the following account from the Akbarnama. This description of the arrival of the "chaste" royal women from Kabul to Hindustan in 1557 refers to Akbar and the women in highly ornate and indirect language, only an echo of which can be captured in translation:

When the news of the chaste ladies reached the royal ears, [Akbar] was delighted. He sent that cupola of chastity, [the chief nurse] Maham Anaga, the mother of Adham Khan, who, on account of her abundant sense and loyalty, held a high place in his esteem, and who had been in his service from the time of the cradle till his adornment of the throne, and who trod the path of good service with the acme of affection, to welcome the cortege of [Akbar's mother, Hamideh Banu Begum] and other chaste ladies. That cupola of chastity entered the auspicious service of the ladies in Lahore, and after informing them of [Akbar's] eagerness to see them, proceeded with them towards the camp of fortune. . . . The auspicious conjunction took place at one stage from the fort (Mankot), and Hamideh Banu Begum's wishful eyes were gratified by his world-adorning beauty. There were mutual rejoicings, and the next morning Hamideh Banu Begum, Haji Begum, Gulbadan Begum, Gulchara Begum, Salima Sultan Begum and other relations and connections of the noble family and of the soldiery, arrived at the camp.[13]

Akbari chronicles commonly deployed reverential titles and honorifics for the women in Akbar's *haram*. The older the woman, the more she was revered. Hamideh Banu Begum was referred to as the veil of chastity and pillar of purity.[14] Maham Anageh, Akbar's foster mother; Haji Begum, his stepmother; Gulbadan Begum and Gulchihreh Begum, his aunts; and Salimeh Sultan Begum, his older (and therefore senior) wife, all received illustrious titles. But while they were revered and invoked as chaste and pure, they were at the same time explicitly referred to as the *pardeh-giyan*, "the veiled ones."

The veiled status of imperial women was now officially encoded in the imperial conventions.[15] This public declaration of their "required" veiling fits with their rendering more generally as perfect and hence secluded. They thus serve as icons of the sacred empire, and their veiling preserves the sanctity of the empire. The emperor too represents his empire, but as a visible emblem—the focus of all matters, spiritual and mundane, and of institutions, as well as of other peoples' lives. As if to balance this intensely visible, omnipresent hallmark of a new (sacred) power, the *haram* emerges as a particularly secluded sacred space.[16]

Births in the *Haram:* The Absent Mothers

To preserve the sacredness of the empire and its *haram*, women were honored and cloistered at the same time. As a consequence of this development, Mughal women—or at least most of them—became invisible in the public pronouncements and activities of the empire. This invisibility is especially striking in the case of Akbar's wives, including the mothers of his sons.

Consider Abu-l Fazl's account of the "auspicious birth" of Prince Sultan Selim, later known to the world as Jahangir.[17] He begins by writing about Akbar's keen desire for the "great boon" of a son and successor. Before Jahangir's birth, several children had been born, "but they had been taken away for thousands of wise designs, one of which might be to increase the joy in the acquisition of the priceless pearl." Jahangir was conceived with the blessings of the Sufi saint Shaikh Salim of the Chishti order, who lived near Fatehpur-Sikri. The pregnant wife was taken to repose in the shelter of the Shaikh's hospice, where she gave birth to Akbar's son, "the unique pearl of the Caliphate." Great joyousness and celebration followed.[18] The prisoners of the imperial domains were released, horoscopes were cast, and poets composed congratulatory odes.[19]

One of the most startling features of this description is that there is no mention of the name of Jahangir's mother. Nowhere in the official history is this

information provided. The reproductive power of a wife should surely be recognized as a major contribution, but here she appears only in metaphor: "shell of her womb," "the matrix of the son."[20] The only document that names the mother of Jahangir is a later edict issued by Maryam-uz-Zamani.[21] The seal on the edict reads "Vali Ni'mat Begum, valideh Nur al-Din Jahangir," thus clearly identifying Maryam-uz-Zamani with Vali Ni'mat Begum and unequivocally declaring her to be Jahangir's mother.[22]

In Abu-l Fazl's accounts of other births in the *Akbarnama*, noble wives remain the unnamed producers of noble children. Two and a half months after Jahangir's birth, in November 1569, a daughter was born in Akbar's *haram*. The girl was named Khanum, and Akbar "ordered rejoicings."[23] The name of the mother is not given. The mothers also remain unnamed in the cases of the births of other princes, Shah Murad and Prince Danyal.[24] In discussing Murad's birth, Abu-l Fazl emphasizes the union of "celestial fathers" and "the terrestrial mothers" that results "every spring [in] a fresh flower [that] blooms in the garden of fortune." Shah Murad was born in June 1570, a noble son on "whose forehead the lights of high fortune were visible, appeared in the fortunate quarters of Shaikh Selim in Fatehpur." Encomiasts composed verses and chronograms for this birth, and received rewards. Two horoscopes were cast: one according to Greek methods, the other according to Indian rules.[25] It must be acknowledged that the mother is referred to at least indirectly, included among the "terrestrial mothers" as the necessary instrument in this royal birth.

There is a difference between the narratives for the births of Jahangir and Murad, on the one hand, and that of Khanum, on the other. The birth of a daughter was not of the same order as that of a son. Missing from the description of Khanum's birth, despite the "rejoicings," are the casting of horoscopes, the celebratory odes, and the general environment of overflowing joyousness. The moment of birth is recorded, but not as an important event for the dynasty and its future. Similarly, the birth of Aram Banu Begum, in December 1584, is mentioned merely as "uneventful."[26]

Beginning with Akbar's reign, junior women, especially wives and birth mothers, disappeared from public dynastic records. As we will see in a later section, royal mothers—especially the emperor's mother—continued to play significant roles in public, political affairs, but only as elders. Although a wife's reproductive function was also vital to the empire's survival, the documentary record rendered the active participation of women, both senior and junior, as comparatively trivial. They were present but hidden, crucial to the maintenance of the empire but unnamed in its annals.

The Foster Community of Akbar's *Haram*

In Mughal domestic life under Akbar, the fostering and care of imperial children underlines the blessings that women were supposed to have obtained through any service or attachment to the emperor. Not least among these was the act of feeding and nursing the infant king. Like the rituals surrounding the birth of a son, descriptions of this act emphasized the centrality of the new axis of the empire—the great monarch himself.

A miniature from the British Library *Akbarnama*, "Akbar and Miryam Makani in Humayun's camp (1542)," portrays several nurses feeding the infant Akbar.[27] Its depiction of brisk movement, as well as caution and supervision, brings out the diverse meanings of feeding the newly born. The very capturing of the moment of feeding in this visual representation attests to its great symbolic importance: the presence of several nurses simultaneously, the flurry of activity that surrounds the feeding, and the centrality of the noble child each has significance.

Anthropologists emphasize that breast-feeding is far more than a merely biological act. It is an aspect of "mothering," the culturally constructed bonding between mother and child, and it is "grounded in specific historical and cultural practices."[28] Power relations within the family and extended kin relations determine the structure of breast-feeding. Thus, Vanessa Maher notes, "In many societies, it is men (fathers, wet nurses' husbands) rather than women (mothers, wet nurses) who determine which and how much food women and children may consume. . . . Men also decide whether the mother herself will breastfeed her baby or whether this will be done by another woman, a wet nurse. In the latter case, it is the father, not the mother, who is responsible for selecting the wet nurse."[29]

Although a premodern historian does not generally have access to the sorts of texts available to an anthropologist, the rules and practices specified in the Akbari literature can provide us with much information. Given the importance of feeding the divine emperor, the selection of nurses was undertaken with extreme care. Eleven are listed in the literature, among them the principal nurse, Jiji Anageh. Abu-l Fazl records that they had to be "even-tempered, spiritually-minded" women from whose breasts Akbar's "mouth was sweetened by the life-giving fluid."[30] Sufistic overtones interlace his description and establish the exceptional privileges enjoyed by the nurse. Abu-l Fazl writes of the various women feeding the young Akbar: "it was as if there were Divine wisdom in thus implanting varied temperaments [*masharib*] by this series of developments so that the pure entity advancing by gradations [*vujud*], might become familiar with the divers methods of Divine manifestation."[31]

The act of feeding was no small task. Two words here call for special attention: *masharib* and *vujud*. *Masharib* means "dispositions."[32] It is also used for beverages and for dishes or trays, as well as for stages or degrees; as the editor of the chronicle observes, "apparently one of the intended meanings is 'divers beverages in diverse vessels' signifying the varied nature [and qualities] of nurses' milk."[33] *Vujud* means "discovering," "procuring," "finding"; it also means "substance," "essence," "existing," and "beginning to exist."[34] The act of feeding an infant thus becomes more than providing nourishment; it has to do with fostering—and fostering in a manner appropriate to a noble child.[35]

Almost all of Akbar's nurses were closely tied to his father Humayun's court, either directly or through their relatives. Jiji Anageh was married to Shams al-Din of Ghazni, a "nobly born servant"; Daya Bhaval was a "special servant"; Fakhr-un-Nisa was Humayun's attendant from his childhood; Khvajeh Ghazi came to India with Humayun, and his wife also nursed Akbar; and Pija-jan was married to Khvajeh Maqsud of Herat, a man of "pure disposition and integrity."[36]

In Akbar's *haram* a new idea of consanguinity was built around practices such as wet-nursing and notions of fostering. Many of Akbar's nurses and their husbands became influential in his court. Their many-sided participation in the affairs of the monarchy shows how these new relationships and communities had shaped, and continued to shape, notions of family and kinship, as well as court politics itself. The head nurse, Maham Anageh, would soon be a major force in the politics of Akbar's court. Shams al-Din of Ghazni, husband of Jiji Anageh, and their son, 'Aziz Kukeh (foster brother of Akbar), both rose to be vice-regent under Akbar and received titles from Humayun and Akbar, respectively.[37] Both Prince Murad and Khusraw, sons of Akbar, married daughters of 'Aziz Kukeh.[38] Khvajeh Maqsud of Herat, "the tried servant of Akbar's mother Hamideh Banu Begum," and his wife Pija-jan, another of Akbar's nurses, had two sons. Of these two foster brothers of Akbar, Siyf Khan died during the conquest of Gujarat while Ziyn Khan Kukeh enjoyed high favor.[39]

The significance of Akbar's relationship with his foster community may best be judged from a comment attributed to the emperor himself: "Between me and 'Aziz [i.e., 'Aziz Kukeh] is a river of milk that I cannot cross."[40] The divine emperor was fed first, but the bounties that were to come to the feeders and their kin were endless.

Akbar's foster community pushed the boundaries of what would normally be recognized as blood relations and relationships of marriage and birth. What the words ascribed to Akbar by his chronicler point to is a relationship between two people that is based on milk but held to be on par with blood relationships. Akbar's statement seems to be invoking a saying attributed to

Prophet Muhammad—"What is forbidden as a result of blood relationships is forbidden as a result of milk relationships as well"—and another credited to ʿAyisheh, the Prophet's wife: "milk relationships prohibit precisely what blood relationships do."[41]

At crucial moments, negotiation and disquiet underlay the non-kin (or other than blood) relationships in Akbar's *haram*. I have already mentioned the high-ranking appointments of Shams al-Din Muhammad of Ghazni and his son ʿAziz Kukeh. The promotion of foster father and foster brothers produced uneasy moments. It might be worth reflecting therefore on incidents that enable us to think about the new expectations and the new rigors of behavior that circumscribed Akbar's most intimate relationships, and to consider how the theory of sacred incarceration in the *haram* was far from perfect when put into practice.

The Visible Matriarchs of the Empire

Among areas of tension and instability in the new dispensation, one revolved around the activities of older imperial women. Hamideh Banu, the emperor's revered mother, was not inappropriately christened "Empress Dowager" in W. H. Lowe's translation of ʿAbd al-Qadir Badauni's *Muntakhab-ut-Tavarikh*, a general history of the Mughal Empire. Every so often in the imperial chronicles, fragments related to Hamideh Banu Begum show that her opinion was sought on many matters and her intervention counted for a great deal. Taken individually, these might have remained of peripheral interest, but when put together, they make for an instructive statement.

Consider Shaikh Ilahdad Faizi Sirhindi's comment that Akbar's firstborn son Jahangir had committed great errors because of "loss of prudence" and "the intoxication of youth and of success."[42] He was in fact referring to a crime—Jahangir's plot, which he carried out, to put to death the distinguished courtier and chronicler Abu-l Fazl in 1602.[43] It was hard for anyone to speak in favor of Jahangir, but "the great lady of the age" Hamideh Banu and "the Khatun of the chamber of chastity," Gulbadan Begum (Akbar's aunt), pleaded with the emperor for his forgiveness. Akbar granted their wish and ordered the prince to court. He also ordered that "the cupola of chastity," Salimeh Sultan Begum (his senior wife), should give Jahangir the news of his pardon and bring him to court. "To soothe the prince's apprehensions," Salimeh took from Akbar an elephant named Fath Lashkar, a special horse, and a robe of honor and went to fetch the prince.[44]

The above description in the *Akbarnama* addresses the influence and authority of the most senior women. Other chroniclers and travelers of the time also mention Hamideh Banu Begum's high status and public role. On July 20, 1580, the Jesuit priest Father Rudolf Acquaviva wrote from Fatehpur-Sikri to Rui Vicente

Provincial regarding Akbar's "inadequate attention to the word of God."[45] In this context, he referred to the opposition of Akbar's own people—including the king's immediate family and other close associates—to Christian teachings: "On the one hand he has his mother, wives and friends to importune him, and on the other are those who wish him ill." Again, on July 30, 1581, he wrote to Father Everard Mercurian, informing him of the benefits they had received from the emperor and his mother: "To us the king grants many favours and so do the Queen Mother, and the princes."[46]

Even though the sources are fragmentary, they highlight the exalted status and frequent public appearances of Akbar's mother, Hamideh Banu Begum, and his aunt, Gulbadan Banu Begum. Note Akbar's responses to Hamideh Banu at several junctures in the records. In April 1578, when the emperor was hunting in the neighborhood of the town of Bhira, near Shahpur district of Punjab, he learned that Hamideh Banu had arrived at the camp and was eager to see him. Akbar was much delighted, says Abu-l Fazl, and "made arrangements for doing her honour." He also ordered that Jahangir, along with other officers, should go and meet her. After that Akbar went to receive the "visible God (his mother), an act of worship of the true Creator."[47]

The actions taken by the emperor to express his delight in honoring this "visible God" amplified his mother's status. Again, in September and October 1581, when Akbar visited the tomb of Humayun and went on to see his stepmother, Haji Begum, Hamideh Banu Begum followed him. This time Prince Danyal attended her. At the end of the day, Akbar was informed that his mother had arrived, and he treated her with great respect.[48]

Likewise, during Akbar's expedition to Afghanistan (1589), in her "desire to behold" him, Hamideh Banu Begum set off for Kashmir, along with Akbar's aunt Gulbadan Begum and several other ladies. When they heard that Akbar had gone to Kabul, they followed him there. On being given the news of their arrival, Akbar had them met first by Prince Danyal and some officers, and afterward by Prince Murad, and finally by Prince Jahangir. Then he himself went and received the Begums near Begram.[49]

Hamideh Banu Begum's persistent and unannounced journeys to see her son are not the only signs of her central presence in the imperial order. The English traveler Thomas Coryate also noted Akbar's devotion to his mother. According to him, Akbar never denied her anything *except once*. At some point she demanded of him that a Bible be hung around the neck of an ass to be paraded around Agra. This was in response to the treatment of a copy of the Qur'an that had been found on a Portuguese ship: it had been tied about the neck of a dog, which had then been beaten about the town of Ormuz. Akbar denied her request by saying "that if it were ill in the Portugals to doe so to the Alcoran, it

became not a king to requite ill with ill, for that the contempt of any Religion was the contempt of God, and he would not be revenged upon an innocent Booke."[50]

The striking visibility of the matriarchs in the records has a corollary in the declining public presence of younger and less centrally placed women—not altogether surprising, given that there were now hundreds of royal women in the *haram*, and that their activities were more regimented than before. These conditions are in marked contrast to the peripatetic Mughal domestic life of Akbar's predecessors Babur and Humayun. At that time the smaller groups of women in the emperor's camp—more widely dispersed and less permanently settled— probably had greater opportunities for initiative and intervention.[51]

It is notable that we find no trace of a loved one or a favorite wife associated with Akbar, whether in legend or in the contemporary literature. The presentation of the emperor on a sanctified pedestal meant that he was beyond the reach of any single, mortal woman—in the public narrative, at any rate.[52] Instead, the woman who emerges as an outstanding figure—an elder, a matriarch, and an authority in her own right—is the emperor's mother. Yet as we will see, mothers were not the only privileged seniors in the *haram*.

Intercession and Counseling by Senior Women

It is recorded in the *Akbarnama* that Khvajigi Fathullah "reposed for a while in the shelter" of the Mughal women who were returning from the Hijaz, the pilgrimage to Mecca undertaken by a number of royal women. "Now by their intercession he was pardoned, and laid hold of the skirt of daily-increasing fortune."[53] Khvajigi Fathullah's offense was that he had gone to Mecca without leave.[54] On one occasion, even the chief judge of the empire, Shaikh ʿAbd-un-Nabi, had sought "protection from the secluded ladies."[55] ʿAbd-un-Nabi was the grandson of ʿAbdul Qaddus Gangohi, a great saint of his day. After his appointment as chief judge, he was found by Akbar to have been involved in cases of bribery and murder. The emperor therefore gave the position to another man and banished ʿAbd-un-Nabi to Mecca.[56] It was after his return that he sought refuge with the women. In due time Akbar gave orders for his arrest "in such a manner that the ladies should not know of it." ʿAbd-un-Nabi was later put to death.[57] It is revealing that Akbar had to do this quietly, to avoid crossing swords with the senior women of his *haram*.

In detailing the intercession of senior women, chroniclers often emphasize the women's age and experience. In several instances, the focus is on the privileges conferred upon elder women by the monarch, the male head of the household and of the empire. These privileges are made manifest in several

ways: for example, in the honor and respect (and time) accorded to women (especially Hamideh Banu Begum), in seeking their advice, and in backing their unusual initiatives (such as the *hajj* to Mecca that Akbar's aunt Gulbadan Banu Begum performed along with several *haram* women).

Another senior woman in Akbar's *haram*, his stepsister Sakineh Banu Begum, also played an important role in political affairs. She was married to Naqib Khan Qazvini, "Akbar's personal friend."[58] Her brother (and Akbar's stepbrother) Mirza Hakim was the ruler of Kabul for most of his life. Akbar's cousin Mirza Kamran had operated in much the same area, which "remained poorly incorporated into Mughal territories."[59] On two occasions, Mirza Hakim had allied with rebels in Akbar's Hindustan, and once the *khutba* (pronouncement of sovereignty in accordance with Islamic law) was read in his name. In both instances, Akbar had marched against him.

Sakineh Banu Begum was sent to Kabul in 1578, before Akbar's second march on that city. Mirza Hakim had apparently conducted negotiations with the Abulkhairi Uzbek state of Mavra-un-nahr; with the Safavids of Persia, "who treated him as a sovereign ruler"; and with another Timurid potentate, Mirza Sulayman.[60] Akbar sent Sakineh Banu Begum to pacify the Mirza and was advised to offer a marriage between Prince Jahangir and his daughter as an incentive.[61]

The jostling for position between the stepbrothers Mirza Hakim and Akbar continued for a long time. Father Monserrate, the Jesuit priest at Akbar's court, describes the intervention of another woman later on in these proceedings. At the time of Mirza Hakim's defeat, Bakht-un-Nisa, another sister of the Mirza, went up to Akbar and "asked for pardon, and begged him [Akbar] to have mercy on his conquered brother and to give him back his kingdom, for he [Mirza Hakim] was sorry for what he had done. The result of her interceding was that the king, in reliance on her virtue, faithfulness and tact, handed over the kingdom to her charge."[62] Having thus successfully obtained the kingdom of Kabul, Bakht-un-Nisa quietly handed it back to her brother.

The handing over of Kabul to Bakht-un-Nisa is a fact of no little significance. It speaks to the extremely high profile of some senior Mughal women and to the authority they wielded. Another example of Mughal women's initiative and influence is Hamideh Banu Begum's being left in charge of Delhi when Akbar marched to Kabul in order to suppress a conspiracy, led by several rebels, to install Mirza Hakim as the ruler of Hindustan.

Monserrate comments on the arrangements made by Akbar before his departure. Hamideh Banu Begum remained at Fatehpur-Sikri with her youngest grandson, Danyal. Akbar's foster brother, ʿAziz Kukeh, was made the viceroy of Bengal, and Qutub al-Din Khan ruled Gujarat. "The king's mother was to be superior to both of these, and was to have charge of the province of Indicum or

Delinum [Delhi]." Ten thousand cavalry were left as a garrison in Gujarat and twelve thousand with the king's mother. Akbar also left his infant daughter with her grandmother at Fatehpur-Sikri. He took with him a few of his principal wives, and his older daughters. "On the day of his [Akbar's] departure his mother set out with him, and spent two days in camp with her son, in his immense white pavilion."[63]

Senior imperial women stand out time and again in the chronicles. They took over positions of public authority at several junctures. In addition, they counseled Akbar and mediated between dissenting kinsmen. Akbar and other royals sought their advice, and they frequently arbitrated and made suggestions on public matters. Although many senior women were privileged participants in the empire, the emperor's mother, the "Queen Empress," seems to have enjoyed an especially honored position during Akbar's reign. Her tenure as the governor of Delhi in 1581 is only its most striking illustration.

Senior Women's *Hajj* under the Leadership of Gulbadan Begum

There is a striking moment in the Akbari chronicles—perhaps the most arresting of all. It is hardly ever discussed, and the histories of the time allude to it only briefly. It concerns a pilgrimage to Mecca undertaken by the women of Akbar's *haram*, a journey that raises many questions about Akbar's newly emerging monarchy, the power of his new regime, the centrality of the emperor, the making of the *haram*, and, paradoxically in a confined *haram*, the unusual initiatives taken by women.

Abu-l Fazl describes the pilgrimage undertaken by Akbar's aunt Gulbadan Banu Begum in 1578 along with several other women of Akbar's *haram* as the "visit to the Hijaz [Mecca, Medina and the adjacent territory] of the veiled ladies of the Caliphate."[64] Gulbadan Banu had "long ago made a vow to visit the holy places." The *Akbarnama* records that she had not previously been able to fulfill this vow owing to the insecurity of the route to be traveled (particularly dangerous was Gujarat in western India). However, when there was relative calm in Gujarat, and after the "masters of the European islands who were a stumbling block in the way of the travelers to Hijaz" became submissive, Gulbadan Begum discussed her desire with Akbar for a pilgrimage. He sent her a large sum of money and goods, and gave her permission to proceed.[65] According to Abu-l Fazl, the caravan left on October 8 or 9, 1575, and stayed for three and a half years in Mecca.[66]

Prince Sultan Murad, age six, was directed to lead the pilgrims up to the shore of the southern ocean[67]—the clearest possible statement on appropriate hierar-

chies of age and gender! In a patriarchal world, a little boy was, by virtue of his gender alone, senior enough to escort the most senior women of the dynasty to lands across the seas. On hearing of this instruction, Gulbadan Begum requested that he might be kept back, precisely on account of his tender age. Akbar agreed. Three older men accompanied the convoy, along with some imperial servants.[68]

The composition of the pilgrim party is interesting. The voyage was led by one of the most senior and respectable women of the *haram*: Gulbadan Banu Begum, the emperor's aunt. Other members of the group were mainly elder members of the Mughal family, including close connections and relatives of Babur, Humayun, 'Askari (Akbar's uncle), and Akbar, as well as reliable servants. On such a special, and privileged, occasion—a pilgrimage to Mecca organized for, and by, the royal women—it is noteworthy that Hamideh Banu Begum and a longtime confidential servant, Bibi Fatimeh, did not take part.

The evidence of the intercessory activities of women in the records makes it possible for us to speculate about why Hamideh Banu Begum was absent from the *hajj*. Senior women of Akbar's *haram* were called upon to advise, to intervene, to conciliate, and to conduct the administration on certain occasions. The presence and support of senior women was clearly vital at critical moments; and since many senior *haram* women were going away on the pilgrimage, it may have been decided that one or two of the most important should stay behind to support Akbar if the need arose. Hamideh Banu Begum's taking charge of Delhi indicates that such possibilities always had to be kept in mind. Such considerations may have led her (and the trusted Bibi Fatimeh) to stay on in Fatehpur-Sikri, while the others performed the *hajj*.[69]

The composition of the pilgrim party once again points to the significance and privileges of senior women—of mothers, aunts, and other senior generations in the Mughal family. Those who joined Gulbadan Begum were mainly older women: Salimeh Sultan Begum, granddaughter of Babur, now married to Akbar; the daughters of his cousin Mirza Kamran; Akbar's stepsisters; an aunt by marriage; and old servants. Perhaps the only relatively young people in this gathering were Gulbadan's granddaughter and Salimeh Khanum. About the former we know practically nothing, and it is difficult to guess her age. Salimeh Khanum was the daughter of Gulbadan's husband, but as no other details are available (even about her maternal parentage), it is hard to make anything of her inclusion. Salimeh Sultan Begum was the only wife of Akbar who accompanied the pilgrims. She was a few years the emperor's senior.[70]

That none of Akbar's young wives accompanied the *hajj* pilgrims appears to be another illustration of the special status of senior women. But the elders may well have felt a more urgent need to go on the pilgrimage. The absence of

younger women might also reflect the view that they needed to be kept at home for their own protection.

The *hajj* by the senior women illustrates the multitude of concerns and interests that animated the activities and initiatives of *haram* women, yet historians who notice it tell us only that Akbar provided generous support to women for this journey.[71] The chronicles, in contrast, show that women themselves took a large part in planning the trip. While "preparing for a journey to Mecca," Gulbadan Begum was staying at Surat.[72] To ensure friendly treatment from the Portuguese, she went so far as to give them the town of Butsar (or Bulsar): Butzaris, as Father Monserrate calls it.[73] Her decision not to include Prince Murad as their escort, Hamideh Banu Begum's (and Bibi Fatimeh's) determination to stay back—a decision that may be read as having been taken by the *haram* women—and the shipwreck and the consequent stay of women in Aden for one year on their return journey (no details of which are found in the contemporary texts) are all signs of a most unusual enterprise.

Gulbadan had to choose between two possible routes, both of which posed difficulties.[74] One lay through Shi'a Iraq and the other through Gujarat, across the Arabian Sea. It required a pass, which "bore the idolatrous stamp of the heads of the Virgin Mary and of Jesus Christ ('on whom be peace')."[75] Abu-l Fazl notes that Akbar was familiar with these problems: he had, in fact, instructed "the great amirs, the officers of every territory, the guardians of the passes, the watchmen of the borders, the river-police, and the harbour-masters" to perform "good services" for the travelers.[76] In such circumstances, permission to perform the *hajj* was granted perhaps because it served a crucial political purpose but also, surely, because the elder women expressed their desire to go in no uncertain terms.

Gulbadan's *hajj* was organized as a spiritual journey for the participants, the records tell us: but it may have been more than that. It marks a moment of critical change in the structures of Mughal rulership: the shift from relatively fluid political structures to a more settled, consolidated government. It was one among the many pietistic activities supported by the emperor—part of a series of moves that he and others in his court may have found necessary for the consolidation of Muslim support in this uniquely polyglot empire. The undertaking (and the imperial sanction for it) may thus be seen as another sign of the ideological tension that marked this stage in the formation of the Mughal Empire. The empire was seeking different forms of legitimacy, and the *hajj* presumably helped to signal its "Muslim" character.

In addition, Gulbadan's *hajj* is a crucial indicator of women's agency. During the making of Akbar's empire, while its mechanisms and procedures were still being fashioned, a group of the most senior royal women was able to travel

across the seas as pilgrims. Although women continued, individually, to make trips to Mecca,[77] such a *hajj* by a large group of imperial women was never heard of again—not later in Akbar's reign or under any of his successors.

The women's initiative and decision making were displayed not only in how they brought forward to the emperor their wish to undertake the pilgrimage but also in how they organized it and faced the ensuing hazards. This episode is also a comment on an exceptional enterprise undertaken by royal women in restrictive circumstances. But crucially, and as a corollary to the first point, it dismantles the premises and understanding of historians writing on the Mughal *haram*.

There is yet another inference to be drawn from this evidence. The collective royal women's pilgrimage to Mecca, like the mediation by other women in male factional disputes, is an exceptional moment in the annals of the Mughals—a dream moment for a historian of gender relations in precolonial times. While Akbar and Abu-l Fazl were constructing a veiled *haram* world, the *haram* folk were responding to such prescriptions in unexpected ways. Gulbadan's *hajj*, and other undertakings by royal women, may be considered one of those unpredictable rejoinders. In the many messages conveyed by Gulbadan's journey, perhaps the one most pertinent is that the domestic world of the Mughals could not be so easily domesticated after all.

Notes

1. *A'in-i Akbari*, 1:45. I also use the Persian edition of the *A'in-i Akbari*, hereafter cited as *Persian A'in*. Throughout, I have used the modified version of IJMES (*International Journal of Middle East Studies*) for transliteration from Persian to English. This system was developed by Layla S. Diba and Maryam Ekhtiar for their edited volume, *Royal Persian Paintings: The Qajar Epoch, 1785–1925* (New York: I. B. Tauris in association with Brooklyn Museum of Art, 1998).

2. *A'in-i Akbari*, vol. 1, preface, p. 9.

3. *A'in-i Akbari*, 1:45–46.

4. *A'in-i Akbari*, 1:46–47

5. *A'in-i Akbari*, 1:47.

6. *Akbarnama*, 3:1008. The name of the "Shahinshah of Persia" is not clarified at the beginning of the letter. Judging by the time of the letter, the addressee should be Shah 'Abbas (1588–1629), Akbar's contemporary.

7. *Akbarnama*, 3:1008.

8. Campo 1991, p. 19; Peirce 1993, p. 162.

9. Campo 1991, p. 19.

10. *Akbarnama*, 3:1009.

11. *Persian A'in*, 1:39. See also *A'in-i Akbari*, 1:xxi. Henry Blochmann renders the title *Shabistan-i Iqbal* as "The Imperial Harem" (*A'in-i Akbari*, 1:15).

12. Dehkhoda 1993–93, 6:7786–89.

13. *Akbarnama*, 2:86; *Akbarnamah*, 2:54–57. Nizam al-Din Ahmad, another chronicler of Akbar's time, records the same event in his *Tabaqat*, and uses the expressions "Khalifa-i Ilahi" for Akbar, "pavilion of chastity" for women, and so on (see Nizam al-Din Ahmad [1929–39] 1992, 2:222).

14. *Akbarnama*, 2:85, 1:130.

15. *A'in-i Akbari*, vol. 1, *A'in* 15, p. 45; *Persian A'in*, 1:39.

16. On subsequent development of the notion of *purda* and the seclusion of women in the Islamic societies of the Indian subcontinent, see Papanek and Minault 1982.

17. *Akbarnama*, 2:502.

18. *Akbarnama*, 2:503.

19. *Akbarnama*, 2:507; *Akbarnamah*, 2:347. Beveridge's Persian rendition is *gohar-i-daraj-i Akbarshahi*.

20. *Akbarnama*, 2:503.

21. For detailed discussion of Maryam-uz-Zamani, see the introduction to Tirmizi 1979, esp. pp. xvii onward.

22. Tirmizi 1979, p. xxii; for the Persian text, see plate facing p. 10.

23. *Akbarnama*, 2:509. Jahangir refers to her as Shahzadeh Khanum in the *Jahangirnama* (p. 37).

24. *Akbarnama*, 2:542–43.

25. *Akbarnama*, 2:514–15.

26. *Akbarnama*, 3:661. Records for Jahangir also note the births of Shahzadeh Khanum, Murad, and Danyal, all three born of "serving girls." No names of or details about the mothers are given (*Jahangirnama*, p. 37).

27. *Akbarnama*, British Library, London, fol. 22a; Titley 1977, p. 4.

28. Parsons and Wheeler 1996, p. x, quoting Scheper-Hughes 1993; see also Maher 1992. For an excellent review of current anthropological and historical writings on breast-feeding, see Giladi 1999, especially the introduction.

29. Maher 1992, pp. 6, 8, 18, 23.

30. *Akbarnama*, 1:129.

31. *Akbarnama*, 1:131.

32. Steingass [1892] 1981, s.v. "Masharib"; *Akbarnama*, 1:131 n. 5.

33. *Akbarnama*, 1:131 n. 5.

34. Steingass [1892] 1981, s.v. "Vujud."

35. The idea that through milk the infant absorbs the physical as well as "spiritual" qualities of the nurse is widespread in the Qur'anic literature. For a discussion of Prophet

Muhammad and his relationship with his wet nurse Halimeh, see Giladi 1999, pp. 33–39, and also ch. 2, "Breastfeeding in Arabic-Islamic Medicine."

36. For details, see Lal 2005, pp. 196–202.

37. A'in-i Akbari, 1:337–38, 343–46.

38. A'in-i Akbari, 1:344–45.

39. A'in-i Akbari, 1:367–69.

40. A'in-i Akbari, 1:343.

41. Giladi 1999, pp. 21, 71. According to several Qur'anic traditions and in subsequent commentaries that discuss wet-nursing, milk and blood entail similar relationships, privileges, and restrictions. This issue of uncompromising identification between blood and milk is discussed in detail by Giladi (1999).

42. Akbarnama, 3:1217.

43. For details of Abu-l Fazl's murder, see Akbarnama, vol. 3, ch. 150.

44. Akbarnama, 3:1222–23.

45. Correia-Afonso 1980, p. 64. Rudolf Acquaviva wrote several letters to his mission headquarters, addressing Rui Vicente Provincial, among others; most of his letters relate to missionary activity at Akbar's court.

46. Correia-Afonso 1980, pp. 65, 96.

47. Correia-Afonso 1980, p. 348.

48. Akbarnama, 3:547.

49. Akbarnama, 3:859.

50. Thomas Coryate, quoted in Correia-Afonso 1980, p. 65 n. 5.

51. For an elaboration of this argument, see Lal 2005.

52. The Jahangirnama (p. 437) records Ruqayya-Sultan Begum as Akbar's "chief wife." No more details may be found in the text regarding the status ascribed to the Begum in reporting her death. The A'in-i Akbari calls her "Akbar's first wife" (zan-i kalan; A'in-i Akbari, 1:321), though not in the sense of the most important or favorite wife. See also Beveridge [1902] 1994, appendix A, p. 274, "Ruqaiya Begam Miran-shahi." Findly (1993, p. 32) also calls Ruqayya-Sultan Begum Akbar's "principal wife."

53. Akbarnama, 3:571.

54. Akbarnama, 3:571 n. 2; cf. Muntakhab, 2:323.

55. Akbarnama, 3:572.

56. A'in-i Akbari, 1:279–81, 282.

57. Akbarnama, 3:571–72 and n. 2.

58. Beveridge [1902] 1994, appendix A, p. 275, "Sakina-banu Begam Miran-shahi."

59. Subrahmanyam suggests that "Mirza Hakim represented an alternative power-centre, and an alternative focus of authority and patronage to Akbar; . . . even if the challenge from him did not wholly mature, we cannot dismiss it out of hand" (1992, p. 298).

60. Subrahmanyam 1992, p. 299.

61. *Akbarnama*, 3:353.

62. Father Monserrate, quoted in *Akbarnama*, 3:153 n. 231.

63. *Akbarnama*, 3:74–75.

64. *Akbarnama*, 3:205; see also *Muntakhab*, 2:216, 320.

65. *Akbarnama*, 3:205.

66. *Akbarnama*, 3:569. The date given in the *Akbarnama* (3:206 n. 3) for the return of Gul-badan Begum and her companions, April 13, 1582, is clearly not compatible with the suggestion that the pilgrimage lasted three and a half years. Henry Beveridge, the translator of the *Akbarnama*, resolves this discrepancy by pointing to the confusion over the dates of departure and return in the chronicles and concludes that her homeward journey must have begun in late 1580 or early 1581. The voyage to Surat, the detention in Gujarat, and the journey to Ajmer (where they performed a supplementary pilgrimage) and then on to Fatehpur-Sikri would have taken another year (*Akbarnama*, 3:570 n. 1).

67. *Akbarnama*, 3:71.

68. *Akbarnama*, 3:206 n. 3.

69. Old age might seem a likely reason that Hamideh Banu did not accompany the pilgrims. But at the time of the *hajj* in 1578 she was about fifty-one years old, (born in 1527), and she lived on for another thirty years or so (d. 1604). For a brief biographical sketch of Hamideh Banu, see Beveridge [1902] 1994, pp. 237–41.

70. Beveridge [1902] 1994, appendix A, pp. 276–79, "Salima-sultan Begam Chaqaniani."

71. Richards ([1993] 1998, pp. 30–31) observes that the *hajj* gave evidence of Akbar's "Islamic piety by actively organising and sponsoring an official pilgrimage to Mecca each year." The point about the emperor's sponsorship is emphasized in several contemporary chroniclers (Badauni and Nizam al-Din Ahmad, for example), as well as by recent scholars. But what emerges in the official chronicle is the exceptional enterprise of royal women, the complete omission of which, by Richards and others, is troubling.

72. Monserrate 1922, p. 167.

73. Monserrate 1922, p. 166 n. 255.

74. *Muntakhab*, 1:480.

75. Beveridge 1994, p. 72.

76. *Akbarnama*, 3:207.

77. In 1617, Jahangir sent a sister (probably Shahzadeh Khanum) to Mecca (*Embassy of Thomas Roe*, p. 418). The traveler Tavernier reports, sometime later in the century, that the Queen of Bijapur had visited Isfahan on her way back from Mecca (see Findly 1993, p. 121).

POLITICS IN AN AFRICAN ROYAL HAREM

6

Women and Seclusion at the Royal Court of Benin, Nigeria

Flora Edouwaye S. Kaplan

My study is the first to be based on direct observation and participation in the Oba's harem at the Benin royal court. What has previously been known is episodic, derived from oral tradition and information collected secondhand by colonial officials, historians, ethnographers, traders, and visitors who invariably were men—talking to other men about women, and then writing down what they assumed to be true. In this respect Benin resembles many early accounts of palace women in the Middle East, China, India, and elsewhere up to the twentieth century. On rare occasion, such as the letters of Lady Mary Wortley Montagu from Turkey (1763), and the famous book by Anna Leonowens, an English governess at the royal court of Bangkok in Siam (1870), Western women have written personal accounts of their glimpses of harems.[1]

The initial purpose of my research was to study the harem and the political roles played by royal wives. I also sought to identify sources of power and influence available to royal women, and then to assess what impact, if any, royal women had on the lives of ordinary women and men beyond the walls of the harem. *Politics* in this African harem is broadly defined to mean observable decision making and makers acting in public arenas to direct the control and distribution of resources perceived as scarce. It is not limited to offices held in a system of governance. *Resources* may be tangible in the form of lands, prestige and luxury goods, food staples, houses, people, and so on; and they may be intangible in the form of spiritual powers, knowledge, skills, and the like. *Power* is defined

here as the ability to implement and enforce decisions taken by royal wives; influence, as the ability through persuasion, personality, or by example to affect the decisions and actions of others. This study finds that the politics of decision making by royal women and their example reverberate throughout the larger society economically and socially.

Oral tradition suggests Benin royal women may have played a more overt political and public role during an earlier, less secluded and more egalitarian period, said to be ruled by Ogisos (literally, "sky kings"), in the tenth to twelfth centuries. Little is known of that period, since it is undocumented by archaeology. When Ogiso rule ended, the current dynasty of Obas began. What is known of their beginnings was collected as oral tradition in the 1920s from people who were adults in 1897, when a major British military assault on Benin City ended native rule.[2] We know the names of thirty-one Ogisos, including a few women (princes and princesses also are said to have ruled).[3]

With the coming of the Obas at the end of the twelfth century, a male ethos prevailed. Royal women no longer held high political office, but instead played subordinate sex roles as wives and mothers. A Benin oral tradition justifies women's exclusion: Princess Edelayo (a daughter of Oba Ewuare "The Great," who ruled ca. 1440–73) was almost as rich and powerful as the Oba. But "owing to a feminine indisposition," she was prohibited from becoming the Oba as she was about to be crowned. Thereafter, "it was enacted that women should not be allowed to reign in Benin any more."[4] No other women are mentioned in the succession of Obas, either before Princess Edelayo's missed opportunity or after her, up the end of the nineteenth century, when Oba Ovonramwen (r. 1888–1914), the last independent king to rule, came to the throne. In his classic text *A Short History of Benin*, Egharevba noted that some princesses or uvbi, royal daughters of Obas, were remembered for their beauty and wealth; others were remembered for the services they rendered to their fathers and brothers who ruled Benin. Among the royal wives, however, the only one who achieves lasting remembrance is the one who gives birth to the next Oba. She is shown in court art and memorialized in association with her son. The title of Iyoba, "Mother of the Oba," was created for Idia, the first queen mother of Benin, by her son, Oba Esigie (ca. 1504–50).

Indigenous royal harems in Nigeria are little known beyond those that are part of Muslim emirates established in the north. But the harem and the practice of secluding royal wives have been known at the court of Benin in southwest Nigeria since the late fifteenth century, following first European contacts by Portuguese explorers; and the practice is still being followed in the twenty-first century. This essay draws on the unique access to the harem and his wives

granted me by the thirty-eighth Oba of Benin, the indigenous ruler Oba Eredi-auwa (r. 1979–present). How royal women were and are recruited into a harem is relevant to the initial purpose of my study of royal women's political roles. The results of the study also shed light on the sources of power and influence available to them and why seclusion of the Oba's wives persists in association with polygamy and the harem as a social institution. It reveals as well how the Oba's wives, while rarely seen, contribute to the continuity of the court and its traditions in the contemporary Federal Republic of Nigeria.

Historical Background

From medieval times the Benin kingdom dominated much of southern Nigeria. The Obas who followed the Ogisos at the end of the twelfth century were warrior kings (see map 12.1, p. 233). They raided their neighbors to the west and east, and warred against their enemies to the north. Up to the end of the nineteenth century, they exacted tribute at different times from different ethnic groups in the dispersed villages or towns and city-states among the Yoruba, Igbo, Itsekiri, Urhobo, Nupe, Igala, and others. The Oba, who stood at the apex of a ranked and hierarchical state society, combined temporal and spiritual power in his person. He could raise and field armies of five thousand and even ten thousand men for conquest and defense as needed. He also extended, developed, and maintained Benin City, the urban heart of the kingdom, calling up large details of young adult males to work on major civic projects in the dense tropical rainforest, such as the more than 16 kilometers of Benin City's walls.

In 1897 the British, long engaged in colonial trade and expansion in Nigeria, and long frustrated by the Benin Oba's control of inland trade in the south, used the excuse of a "massacre" to mount a heavy military assault against Benin City. A few months earlier, an uninvited and decidedly undiplomatic party, led by Acting Consul Captain James R. Phillips, had attempted to visit Benin City against the express wishes of the Oba. Their ambush and deaths triggered the 1897 assault that the British titled a "punitive expedition." It ended in the executions of a number of important chiefs; the exile of the reigning Oba Ovonramwen to Old Calabar, in eastern Nigeria; and the destruction of his palace and that of his mother, Iyoba Iheya (or Iha II). The British expedition against Benin ended independent indigenous rule and ushered in an interregnum that lasted from 1897 to Oba Ovonramwen's death around the turn of the New Year in 1914. The British then found it expedient to officially restore the monarchy in Benin City. Oba Ovonramwen's first son and legitimate heir to the throne, Prince Aguobasimwin, took the title Oba Eweka II.[5]

The Oba's Palace

Oba Eweka II (r. 1914–33) found the palace severely damaged by fires and shelling by cannon after five days of fierce fighting in 1897. The British had also deliberately leveled many sections of the walls to prevent further resistance by Benin warriors. The harem at one end of the main building complex in the center of the compound was badly damaged, emptied of its shrines and contents, and the queens were sent away. With limited resources Oba Eweka II slowly started to restore the palace, replacing the burned thatched and shingled roofs with galvanized tin and iron sheeting, and walling in the compound (now less than half its previous size). The Oba soon filled his harem. He was widely reputed to have had a hundred wives, but no record of them remains. His many descendants acknowledge that most were "outside wives" who did not live in the harem at court. Oba Eweka II was not allowed by the British to name his mother Iyoba or to send her to Uselu, the traditional area for queen mothers outside the city. He kept her close in a palace that was nearby but, in keeping with tradition, apart from his own.[6]

Like his father before him, Oba Akenzua II (r. 1933–78) continued to restore the palace. He established a Benin museum on land belonging to the pre-1897 compound and slowly began to revive palace rituals. He had important events and visits photographed, and he allowed the public presence of his wives and children, and himself, to be recorded at Igue, an important annual palace festival. In actively making use of photography, Oba Akenzua II was extending the traditional practice of archiving Benin history in bronze and ivory. At the same time, he was innovating in permitting images of himself and his living wives and children to appear on film, for in the past they had never been recorded.

Today, the Oba's post-1897 compound covers more than 20 hectares in the center of Benin City. It includes dozens of buildings, interior courtyards, stables, garages, storage facilities, and offices. The size of his home sets it apart from the houses and compounds of other "big" men (and women) in the city. Up to the early decades of the twentieth century, the Oba's Palace had the highest walls and roofs and most elaborately decorated buildings in Benin. Some roofs had added turrets, decorated with monumental brass castings. Among them the most striking and ominous up to Oba Ovonramwen's time were the large articulated brass castings of sinuous snakes, whose heads with toothed jaws hung open above the entrances to main buildings. Other rare and costly palace building materials included wood shingles and repoussé brass sheathing over carved wood doors and lintels. Some buildings displayed polished clay decorative panels with large snakes and leopards carved in relief.

The palace houses hundreds of people and daily receives hundreds more who come to its societies and guilds as chiefs and priests, servants, attendants, and other classes of initiates. Each group has the exclusive use of its own section containing many rooms set around the courtyards of different buildings. The palace is said to have two hundred rooms, but "two hundred" in Benin is an expression meaning "infinite" or "without number." No one knows how many rooms there actually are. The present palace is and has been a work in progress since the thirteenth century, with some rooms, service areas, wells, and buildings abandoned from time to time and new rooms, courtyards, walls, offices, and spaces created and remodeled, redesigned, and reassigned. Like the houses of big men, as well as those of untitled men, the Oba's Palace is and was the center of an extended patrilineal (and polygamous) family, in this case royal. The continuity of the Oba's family ensures the continuity of the Benin people, as he and they are one and the same. His ancestors are the collective ancestors of the state, the (former) kingdom, and all the Benin. The royal palace is unique among the Edo-speaking peoples, however, in being the exclusive home of the sacred king, the Oba, who is at the center of the Benin spiritual and cultural as well as its political and temporal world. As such the Oba and the palace today serve to locate and constitute Benin identity as an ethnic group in the modern nation-state of Nigeria.

The Harem: Seclusion as Idea

Western notions of the harem are most often associated with seclusion in Islamic cultures. As a word and idea, harem is more widely defined and applied to the space of a house reserved for the women of a family, private and secure. It is not universally equated with seclusion. In Benin culture into the twentieth century, virtually all married women living in extended patrilineal families resided together in a harem, but neither were they forbidden to have necessary contact and transactions with men, nor were they secluded. Each woman in a harem had her own room or rooms for herself and her children, and she moved about outside the marital home to farm and trade locally. She could also visit her natal home and relations. Only the Oba's wives lived in the harem in strict seclusion.

Just when royal wives were first secluded in the Oba's Palace is unclear. But archaeology strongly suggests that royal women probably were living in seclusion at the palace by the early thirteenth century. Discoveries made in the early 1960s by Graham Connah, a South African archaeologist working in Benin City, revealed the bodies of some nineteen young women estimated to be between eighteen and twenty-five years of age. He found them at the bottom of a cistern

in an abandoned courtyard of the pre-1897 palace site. The richness of their dress was represented by a few surviving scraps of the embroidered and drawn cloth they had worn. They also wore many bronze ornaments and rings that support the interpretation that they were royal women, possibly young wives of the Oba, who was regarded as a god-king on earth. Ethnography has it that his favorite wives were buried with him when the Oba "went to meet his ancestors," a euphemism for his death. Fortunately, the rare and fragile materials associated with these young women and recovered by Connah yielded important and early radiocarbon dates.[7] Therefore, it is evident that human sacrifice and ritual burial associated with Benin culture were already being practiced by the thirteenth century, and seclusion was likely at the palace.

Seclusion of the Oba's wives was and is a function of the Oba's sacred nature and their bodily contact with him. Once married to the Oba his queens, the *iloi*, may not be touched even accidentally by any man, including their own fathers, brothers, or close relatives. His person is taboo, and the wives who partake of his body also are taboo. The word *taboo* (formed from *ta*, "marking off," and the intensifier *bu*) signifies something forbidden, something that would be polluting or bring about misfortune, illness, or death as a result of contact. The Oba's wives are secluded for their own safety and that of others. The profane world poses dangers of pollution to them through accidental or other types of contact, which threatens the lives of those who touch them. A queen who suffers the misfortune of being touched is expelled in disgrace from the palace.

A taboo is known to generate avoidance rules. It identifies a person or class of persons (such as a divine king, or mothers-in-law), or a thing in a culture (such as certain foods) or in nature (such as a totemic animal or class of animals), that must be avoided. The late Queen Mother Aghahouwa of Benin, for example, was forbidden to eat deer; another family's members are forbidden to eat python; and so on. Members of each group are forbidden something in nature according to their lineage and their shared "family morning greeting" in Benin.

European visitors to Benin City in the early nineteenth century reported the extraordinary way the Oba was regarded by his people and the danger implicit in the power that adhered to him (what anthropologists call *mana*). Both the French visitor Ambroise Palisot de Beauvois in 1801 and the Englishman John Adams in 1823 reported that "the King [of Benin] could live without food or drink, subject to death, but destined to reappear on earth at the time of a definite period."[8] It is still widely believed in Benin that the Oba does not sleep, eat, or drink as ordinary people do. He never dies, but is reborn anew. Reincarnation is a concept integral to indigenous Benin religion and clearly embodied in the person of the Oba. The Europeans described the Oba of Benin as a "fetish." (The

concepts of *taboo, mana,* and *animatism,* as they emerged in later nineteenth-century anthropology, were not then in wide circulation.) The word *fetish,* from the Portuguese *feitiço,* usually was applied to an object. In this case it described a person who was regarded with awe and worshipped as embodying a potent spirit or deity. In the words of Captain Adams, "The Oba is . . . fetiche, and the principal object of adoration in his dominions. He occupies a higher post here than the Pope does in Catholic Europe; for he is not only God's vice-regent upon earth, but a god himself, whose subjects both obey and adore him as such, although I believe their adoration to arise rather from fear than love; as cases of heresy, if proved, are followed by prompt decapitation."[9]

The Harem: As Place

The Oba's harem is a world within the world of the vast palace—very much part of it, and at the same time set apart. It is a sacred space only the Oba can enter and leave at will. As a place the harem is actually a series of interior buildings that, seen from the enclosed courtyard of its front entrance and massive wood door, appear to be separated from the main building of the palace that dominates the landscape. It is actually connected unseen at the rear through several secret doors. The large and spacious outer reception halls of the harem have high ceilings above coursed and smoothed whitewashed mud walls. On occasion the queens enter the halls to meet distinguished visitors and women's groups at the outer door.

Special groups, such as the market women and their leaders who were (and are now) critically important to the stability, prosperity, and peace of the state (and former kingdom), are welcomed. The wives and daughters of chiefs who serve the Oba are both formally constituted and named groups.[10] They come to the harem on a regular basis to sing and dance with the wives in the outermost reception hall. They also constitute the eyes and ears of the queens, whose links they are to a wide range of communities outside, because they have the access to pass and receive messages from the wives. These groups are an important presence at the palace, and they have public visibility in music and song with women's traditional instruments (netted calabashes, *ukuse*), complementing the male guilds that drum, sing, and dance when there is a festival, a celebration, or special event. The women's groups "keep the palace warm."[11] They keep the wives happy when the Oba travels, whether he goes to the national capital at Abuja to meet with the country's president and other high government officials or tours and gathers with other traditional rulers in Nigeria.

The harem is the place where women's groups and visitors, together with a relatively open petitioning process, provide the queens with informal occasions

to play political roles outside as well as inside the Oba's Palace. They hear and respond to petitions and requests confided to them by women and men from different parts of Benin City and the modern Edo state (formerly part of a more extensive Benin kingdom). A wife considered influential inside the palace has more opportunity to attract followers outside the palace. She can also become knowledgeable about grassroots sentiments and issues that may not yet have reached the Oba. Petitioners reward such a queen personally, thereby increasing her capital and the fund of intelligence available to her for further investment and material return. A queen can influence the outcome of disputes by choosing action or inaction on the basis of inside information she obtains from different sources and then weighs. Queens have direct power in making decisions about their own property and its management, but to carry out their orders they depend on their middlemen and -women, whom they must be astute in choosing and using. Even queens who are not favored by the Oba can implement their decisions concerning matters of importance to them, if they are judicious in what and when they choose to press a case. The Oba's favorites are generally considered to have even more influence with others at the palace. Given that Benin women and men frequently operate in quite different spheres of action, their knowledge seldom has the same origin. I suggest that these dual streams of information coming from different but complementary sources can have important and political effects on the Oba's decision making, and that of others outside the palace.

Close examination of wives' activities while they reside deep in the interior of the royal harem shows that they both are and are not out of touch with the outside world. They are tied through their husband and their extended families (whose contacts are constantly widened by marriages) to outside communities. A queen who is capable and has the needed skills can articulate a vital and valuable network of people. Her choices are made to enhance her position in the harem, please the Oba, and maximize her possibilities for individual success. The last is defined by values held and by material goods.

The Harem: People in Place

Iloi: The Oba's Wives

While rarely visible in public, the royal wives or queens—iloi, as they are known in Benin—have stood for traditional measures of success in marriage for women (and coincidentally for men). Success was and still is measured in number of children, followers, reputation, proper burial, and remembrance. Polygamy, the marriage of one man to two or more wives, increased a man's chances for success, especially in an agricultural society. Success for a woman

in a traditional home meant a child or children raised to maturity, thus ensuring comfort in her old age, a decent burial, and remembrance. Polygamy still flourishes not only at the royal court but in Nigeria generally, where today paradoxically it can be afforded by poor men as well as wealthy ones. The practice is usually masked by feigned ignorance, tolerated by the public, and often openly accepted. It is rarely challenged in the legal system, in which is inscribed de jure equality of the sexes and monogamy in marriage.

The queens in the royal harem follow a set of routines that structure their everyday activities. Each evening they retire to their separate quarters with their own children. Their servants (and, in the past, slaves) also return to the quarters they occupy adjacent to them. Queens move to special houses in the harem at the beginning of their menses and return to their own quarters when the cycle is completed. During that time they neither cook nor engage in any activities inside or outside the harem. They meet together under the aegis of the leader of the harem—the Eson, the Oba's senior wife—in her home or in an open courtyard. They discuss issues of importance to them, plan their role in festivals, watch young children play together, and meet with older ones coming from school or from abroad with news to tell. They and the children especially enjoy storytelling under the stars when the Oba joins them in the harem. Many princesses mentioned to me the happy times shared with their father, Oba Akenzua II, that they remembered from their childhood.

Queens otherwise conduct their affairs in private to the extent possible. Such affairs include managing their estates in other villages and towns, as well as businesses, houses, and other enterprises they either brought with them to or acquired in the harem. In the old days, their personal activities in the harem included trading (in cloth, beads, food stuffs, etc.) and creating domestic arts that generated income. In this regard they resemble most wives in harems across Benin, who are effectively but more modestly capitalized by their husbands with gifts or set-asides of land to be cultivated and animals to be raised. The proceeds wives receive from their enterprises are theirs to keep. In this way the Oba and other husbands make their wives partially or fully self-sustaining, with leeway to demonstrate and profit by their individual initiative and abilities.

Men are forbidden to enter the harem. Audiences with them are conducted at a distance, across the courtyard in front of the main harem entrance. Close female relatives of a queen or the wife of an important chief or civic leader may be admitted to one of the outer reception halls to greet the queens, to petition for someone else, to discuss a request, and to convey information. Today messages are usually brought in notes sent either through the palace pages— *emuada*, who are celibate young males—or through the female servants who attend the queens. No one else is allowed to enter the harem itself. Visits by the

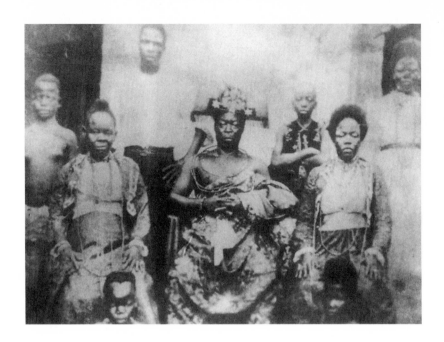

FIGURE 6.1.

Oba Ovonramwen in exile at Old Calabar, eastern Nigeria, ca. 1898–1900. In this colonial photograph the Oba is shown seated (center), wearing a traditional wrapper and a distinctive hat (notably *not* one of his coral bead crowns). His wives and some family members are with him. Queen Egbe (right) and Queen Aighobahi (left) wear Victorian attire and their hair resembles Western hairstyles. They are two of the wives he requested to be sent to him in exile. Two other wives are said to have joined him later. The young woman standing (right) is his daughter, Princess Orinmwiame; the tall young man standing behind the Oba is Prince Usuanlele, his son; the young boy next to the prince, arms folded, is another son, Prince Uyiekpen. The semi-nude young girl is an attendant to a queen. Those seated in front on the ground are royal children or grandchildren. Photographer unknown; photograph reproduced by S. O. Alonge, 1934. Property of the author.

queens outside the palace harem are still rare, and made only with the Oba's permission.

Unlike a reigning queen mother, the Oba's wives were and still are virtually invisible and largely unknown to the outside world. With few exceptions, even their palace names are not known to most people. A person wishing to refer to them often does so indirectly (as I witnessed a number of times at festivals and

on visits), citing some observable quality: "Ah, there is the *Yellow* Queen," or "See, there is the *Black* Queen," and so on. Even those who might have known of a woman or her family before she entered the palace do not use her original given name: it is forbidden. Once the Oba gives her a name, the old one is formally forgotten and never used again. At the palace and among those who either wish to or need to have contact with her, a queen will be known and called by the name or names of her children, such as Iye Ewere (Mother of Princess Ewere), or Iye Omoregbe (Mother of Prince Omoregbe).

Among the rare descriptions of the Oba's wives is an eyewitness account given by a British surgeon, Dr. Felix N. Roth, who accompanied the 1897 Benin Punitive Expedition. The occasion was the formal surrender of Oba Ovonramwen; the date, August 5, 1897. The Oba reentered the city on that day, after six months spent evading capture in the bush. He was richly dressed and heavily laden with coral beads. He processed to his captors with an entourage of seven hundred or eight hundred persons, including "[s]ome twenty of his wives, who accompanied him, [and] were of a very different class from those [women] seen previously. They had fine figures, with their hair worn in the European chignon style of some years ago, really wonderfully done in stuffed rows of hair, the head not being shaved on top like that of the lower classes, and they wore coral necklaces and ornaments and hairpins galore."[12]

When the Oba-in-exile reached Old Calabar, the British granted his request that some of his wives be sent to join and comfort him. Two wives were sent initially, and two others joined him a little while later. Their presence is made visible for the first time through photography (see figure 6.1).

Ibiwe

Of the Oba's three main palace societies, the male Ibiwe society has specific responsibility for the welfare of the Oba's wives and children. The head of Ibiwe, the Ine, is the leader and oversees the royal household in general. The Oshodin, his second, is charged with looking after the harem in particular. He settles quarrels among wives that cannot be worked out by the Eson, the Oba's senior wife. If there is too much conflict in the harem, the Eson calls on the Oshodin to intervene. He may enter the outer reception hall of the harem to conduct an inquiry among the parties involved. During such a query or on a visit, the Oshodin sits down on one of the polished red clay banquettes against the white wall of the large reception room, at a distance from the women he meets and questions. Theoretically, the Oshodin is empowered to settle any serious or unresolved problems—even those between the Oba and one or more of his wives. When asked how he would proceed, the Oshodin replied, "You must talk to each separately." Then with a smile he said, "Difficult to say . . . can you settle

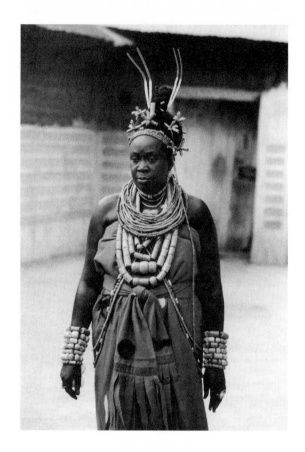

FIGURE 6.2.

Queen Eson N'Erie (r. 1979–present), the leader of the
royal harem and senior wife of the reigning Oba Eredi-
auwa. She is shown in a palace passageway in her full tradi-
tional regalia worn during the annual Igue cycle of festi-
vals. She wears a queen's ransom in coral beads around her
neck, wrists, and ankles. Her hair is elaborately dressed in
an exclusive style befitting her position, with numerous
coral bead rosettes, headbands, and graceful brass plumes.
Her wrapper is the traditional cloth of red flannel called
ododo, and it is appliquéd with black and yellow cloth
cutouts of swords, leopards, and other royal symbols.

a tiger and a goat? If you want to cross a river with a tiger, do not take a goat along."

The Eson, the Oba's senior wife, manages the harem's day-to-day affairs, along with its wives and children (see figure 6.2). She is called "the cock who crows the loudest," meaning she is to be heard and obeyed by all the other wives. The Eson is always the most senior wife in the harem, although she is not necessarily the Oba's first wife. Other Esons may have left the harem, passed away, or been banished for cause. Whoever is the Eson must see to it that order and harmony are preserved in the harem's domain if she is to retain the Oba's favor. She has the most power and influence over the wives and their children by virtue of her position as the senior wife and leader of the harem. Every harem and polygamous household in Benin had its "Eson," its leader and senior wife. But unbeknownst even known to her, younger wives who are favorites may use their influence in private, manipulating their husband's affections to benefit themselves.

Eunuchs

Into the early twentieth century, the royal harem's chief liaisons to the outside world were eunuchs. They constituted a separate group of persons who lived in the harem in their own quarters near the inner doors. It was the duty of eunuchs to guard the queens in the harem. They also performed daily supervisory and other duties. They could mingle with the women and even touch the queens. Eunuchs moved about freely within the harem itself and between the harem's sacred space and other parts of the palace compound. They also moved about in the profane world outside the palace.

Eunuchs were much sought after outside the harem by those seeking interviews with and favors from the queens. They carried messages and took action on behalf of the queens in other parts of the palace, in the city, and into the countryside and beyond. Eunuchs thereby greatly enriched themselves and enjoyed autonomy and considerable discretion in their dealings with others, both inside and outside the harem. They used their power and influence among the wives and those petitioners who sought them out. Various European traders and visitors noted the presence of eunuchs in Benin City, as well as in other large towns that had local rulers from the sixteenth century on. Their presence confirms the existence of royal harems in the contact period (and probably much earlier).

Sir Richard Burton, a peripatetic world traveler, provided an eyewitness description of a palace eunuch in the mid- to late nineteenth century: "He was a little beardless old man, clad in a tremendous *petticoat*" (emphasis mine).[13] What Burton calls a "petticoat" (a woman's nineteenth-century undergarment akin to today's women's slip) more closely resembled a crinoline that poufs out the

wide gathered skirt or dress worn over it. It was actually a standard garment for Benin men, called a "wrapper," and tied in several styles. The wrapper owed its puffed-out appearance to a stiff woven fiber underskirt worn on formal occasions or, ordinarily, to many layers of cloth on top, wrapped around a man's waist to achieve maximum width. The quality, quantity, and type of cloth as well as the overall bulk of a man's wrapper were key indicators of his wealth and status. Evidently, this eunuch was important and successful.

Burton had other things to say about the eunuch. He "assumed considerable dignity, speaking of the head Fiador [a major chief] as of a very common person." According to Burton, "The abominable institution is rare in Africa, and when found is borrowed from Asia. At Benin the habit of secluding the king's women has probably introduced their guardians of the harem."[14]

Palace Pages

There have been no eunuchs in the royal harem since the early 1940s and 1950s. Instead, the Oba's youthful and celibate pages, *emuada*, act as liaisons with the Oba and others by carrying messages to and from the queens. They also carry notes and provide information from outsiders to the queens. But they cannot touch them, nor do they live in the harem itself as the eunuchs once did. Their quarters are in another part of the Oba's Palace. It is said that there were once female pages who belonged to the same palace societies (Iweguae, Ibiwe) as the male pages. The difference between the two groups was that the girls left the palace once they reached puberty. Girls were chosen who looked very much alike, so no one could recognize them or tell them apart when they acted as go-betweens and performed services.

A Harem Apart: The Queen Mother

Historic sources and the literature on Benin contain few descriptions of the Oba's wives. The woman most often mentioned by Europeans is the queen mother, the queen who held the title of Iyoba, created by Oba Esigie (r. ca. 1504–50) for his birth mother. Idia was the first woman to become Iyoba and the queen mother of Benin. She and her successors figure in the reports and diaries of visitors, traders, and explorers after European contact. She is also the woman most often represented in art in bronze, brass, and ivory. Her title, Iyoba, is literally translated as "the (birth) mother of the Oba." Unlike queen mothers elsewhere, she has no role in running the Oba's harem, in choosing his wives, or in conferring with her son face-to-face. Her palace, built for her by her son, is separate and at a distance from his. She never again enters his harem or palace after being made Iyoba. Nevertheless, she continues to support him

and keeps him apprised of sentiments and actions in the larger outside community. As the Iyoba, she assumes a male gender role and functions as a senior male chief, hearing cases and settling disputes within her district and villages.[15]

Until the twentieth century, the Iyobas who came after Idia, the first Queen Mother, held court at their own palace at the village of Uselu, then on the outskirts of Benin City. The wealthiest and most powerful Iyobas appeared during periods of affluence in the mid-eighteenth to early nineteenth centuries, but one example of a queen mother taking independent action comes at the end of the seventeenth century. During a time of economic decline and internal political turbulence, some indigenous Catholic converts in Benin City exhibited serious lapses of faith. Their lapses undoubtedly included resumption of human sacrifice, as well as reported "idolatry" and "juju shrines."[16] The queen mother (possibly Iyoba Imarhiaede) famously assisted the Portuguese Catholic missionaries fleeing Benin City.

The recent Queen Mother Aghahouwa (1981–98) followed a traditional route into the palace. When she was a young girl, rumors of her beauty brought her to the palace. She was given to one of the trusted wives of Oba Eweka II (r. 1914–33) who raised her until she reached puberty. Then Oba Eweka II married her to his first son, who was later crowned and reigned as Oba Akenzua II (r. 1933–78). The Iyoba told me she remembered as a young bride wearing the flowing contemporary dress of the period, bubu, and a head-tying cloth. She attended church and afterward was much admired by her husband and his friends who visited their home, then outside the palace.

After Akenzua II came to the throne, they returned to the palace—she to the harem again, this time with the title of Eson, the senior wife and leader of the harem. Then, she said, she wore traditional dress: a wrapper, a long sarong-like cloth tucked in above the bosom and under the arms, and reaching to the ankles. The hairstyles she wore were those reserved for queens, iloi, modified as her status changed with the birth of the future Oba, other children, and award of a title. The number and quality of the coral beads worn in her hair, and on her neck, wrists, and ankles, reflected both her wealth and the favor she found in the Oba's eyes. The type and quality of cloth she wore were a statement of her importance and position. She wore imported brocades, handwoven Yoruba cloths known as Ashoke (woven on looms in narrow strips), lengths of Indian silk saris called "George," and later eyelet cotton lace as it became prestigious (see figure 6.3). So, too, the dress of other wives reflected their means and relative status, as well as the favor they found with the Oba.

Where Iyoba Aghahouwa's path to and in the palace diverted from tradition was in the decision of Oba Akenzua II, her husband, not to put her aside after she gave birth to the first son and future heir to the throne. Instead, she bore

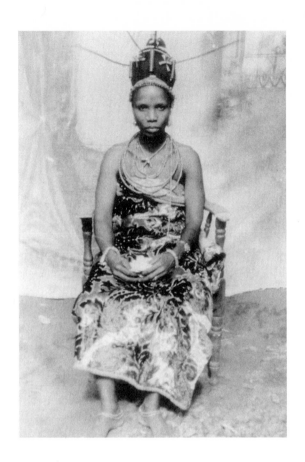

FIGURE 6.3.
The Iyoba Aghahouwa, Queen Mother of Benin, as the
Eson (ca. 1933). This early photograph shows the Iyoba
as a young queen and the Eson, the senior wife of Oba
Akenzua II. She wears the traditional wrapper of fine bro-
cade cloth, and a hairstyle permitted only to royal wives.
She wears many coral beads around her neck, wrists, and
ankles. She is seated as a sign of her high status, and is
barefoot. Photograph by S. O. Alonge, Ideal Photo Studio,
Benin City. Property of the author.

him other children. Later, she became the first queen mother to reign in nearly one hundred years (the last being Oba Ovonramwen's mother, Iheya or Iha II, ca. 1888). Oba Erediauwa bestowed the title of Iyoba on his mother on August 21, 1981. Thereafter, Iyoba Aghahouwa followed chiefly tradition by holding court at Uselu on specified days, hearing complaints, and receiving people from the community as well as other visitors. Some came to greet her, others to have disputes heard and decided, and still others to have requests granted. She reigned until 1998 when, at age ninety-five, she went to meet her ancestors.

Recruitment and Harem Politics

Young women viewed the Oba's harem with great fear and anxiety. Most of them were already well aware of the competition among wives in polygamous households. At the palace the stakes were higher to bear children, especially the first son and the first two daughters, and the consequences of inadvertently violating taboos, as well as the marriage oaths, were intimidating. All adultery was severely punished in Benin, but in the past adultery with an Oba's wife was worse and resulted in both parties being killed. There is a saying (and a warning) on this topic: "The tree the leopard mounts no other animals dare climb."[17] Heightening their fears was the isolation from supportive family members that young women knew awaited them. An Oba's wife might never see her mother or family again.

Traditionally, the Oba's wives were recruited into the palace harem in one of several ways: by a declaration, as a "gift," or by being "noticed." A young girl could be declared "an Oba's wife" by her father or a close male relative. She then had to be brought to the palace. In Benin, women viewed the declaration as something of a curse, because entry into the palace harem meant the girl was thereafter separated from her family. Mothers were particularly reluctant to let daughters go, since that girl might be a woman's only child (as was true of a favorite queen chosen by Oba Akenzua II). Fathers were less reluctant, especially chiefs, since they usually had many children—at least a dozen, and up to thirty and more. I know many chiefs and princes today who have children in comparable numbers. A child is the most precious gift a man could make to the Oba. Children were promised in fulfillment of a vow taken by a father (or at a mother's behest) for an illness cured, a misfortune avoided, good fortune realized, or the safe delivery of a baby after troubled pregnancies. A child could be given to curry favor with the palace, or to express gratitude for an honor or title received from the Oba. A budding young girl whose beauty was widely noted could be sent to the harem to be trained in palace etiquette as a future royal wife.

Such was the case of Queen Mother Aghahouwa, brought up in the harem by a trusted queen of Oba Eweka II.

Aside from gifts of young girls to the Oba, a young woman might catch the Oba's attention or be noticed at a festival, on his visit to a town or village, while he toured the kingdom, or when he heard a petition at the palace. This happened to one of the present Oba's favorite wives. An official was sent to ask for her, and she was brought to him willingly. In the past not all girls given to the Oba were married to him; some were subsequently given to chiefs and others the Oba wanted to reward for their service. Conversely, in the old days the Oba could, on occasion, take a married Benin woman into his harem with impunity. Oral traditions, like the story of how Queen Mother Idia's distinctive facial marks came to be made when she was "chosen" to marry Oba Ozolua (r. ca. 1481–1504), speak to the personal anxieties a royal marriage engenders.[18]

Many Obas had liaisons with women outside the palace, but there were no concubines in the royal harem. There were only wives and their children, wives-to-be, attendants, servants, and, up to the late nineteenth century, female slaves taken in raids and wars. Those who proved reliable and trustworthy were rewarded, but they remained slaves, becoming neither concubines nor wives of the Oba. Queens (see figure 6.4) were served only by women, with the exception of pages and, in the old days, eunuchs.

Occasionally, a father would send to the harem a young girl considered incorrigible. There the queens would discipline her. Isolation in the harem was itself a dreaded punishment; and when to it was added hard work, withdrawal of food if stubborn, and other measures, the queens usually produced the desired behavior change. The wives also taught by example, as their own behavior was held to a high standard. The unruly child was soon reformed and returned to her family outside the palace.

Though women were brought into the palace in myriad ways, those the Oba wished to marry were carefully investigated beforehand. The girl's family had to be without stain and its members of good character and repute; wealth was not a criterion. Great care was taken in investigating an intended wife's family for anomalies or histories of physical or mental illness. In Benin, in general, marriage is forbidden between members of the same lineage, even at a distant degree.

Potentially, the way to the palace was open to all women. There are no preferred lineages for marriage to the Oba, and no limit on the number of wives he could have. Wives who came from the families of powerful chiefs came with considerable entourages of servants, slaves, and resources at their disposal, but those advantages did not assure them status as a "favorite." They did, however, have the best chance of having sexual relations with the Oba and at least pro-

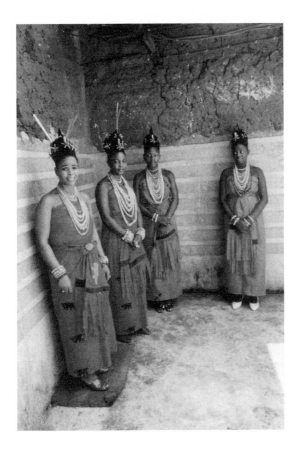

FIGURE 6.4.
Wives of Oba Erediauwa—the Oba's Palace, Benin City,
Nigeria (1989). In previous generations, each queen
dressed according to her individual taste and resources. In
the mid-twentieth to twenty-first century the queens are
seen in photographs wearing the same traditional regalia,
at Igue, the annual palace festival for the ancestors. On
this occasion they wear virtually identical wrappers of red
flannel cloth, with leopards, swords of office, and other
royal symbols in yellow and black appliqués, together
with many coral beads, rings, and ornaments, according
to their means. Photograph by author.

ducing a child or children. Some wives never had relations with the Oba; others did but never conceived. Wives who came from more humble families relied on their attractiveness and demeanor to win his attention. Taken together, wives provided links to families and communities throughout the Oba's domain.

From time to time, some wives and wives-to-be proved unable to adapt or were unsuited for life in the royal harem. These women were either sent away or looked for a chance to run away.[19] In those cases, they kept a low profile to avoid incurring the Oba's anger and bringing harm to their extended family. Wives who ran away tried to live quietly, as far from the palace as possible. In early colonial days, a runaway wife caused considerable problems for Oba Eweka II. He complained bitterly to a visiting British Resident of Ibadan about a policeman who had been sent to dig in the palace, looking for a missing "wife" rumored to have been sacrificed.[20] To dig in the ground at the palace, the abode of the ancestors in Benin, is an abomination. The missing woman (who may in fact have been a servant in the palace) was found in a distant community, alive and married.[21]

The Oba dispensed gifts among his wives and favorites and provided staples to virtually all. Those who were good managers in administering the land or lands and houses that they acquired from the Oba, or as gifts made to them by people seeking favors from the palace and the Oba, could grow rich and comfortable. Each wife made decisions for herself and her offspring that enhanced their life chances, the opportunities of her family, and her community of origin. Certainly, there was intense competition among the wives, and not merely to have the first son, other sons, and daughters. Wives also competed to attract followers and to acquire resources from petitioners.

Knowledge flowed to the queens from their families, communities, and constituencies outside the palace. This intelligence was valuable to them, to the Oba, and to others inside the palace. A wife's character and demeanor balanced her attractiveness to the Oba; the cleverness she showed in managing resources, including information, and in attracting followers enhanced all her positive features. For these reasons, wives necessarily had to make political choices.

Entry into the harem opens the way for queens to develop client patronage, to obtain services from others, and to be rewarded materially. They make decisions about the use and distribution of their resources in public arenas of action (e.g., in the harem, the palace, outside communities, villages, and the city). Visitors, petitioners, women's groups, chiefs, relations, and others also lay the groundwork for the development of personal networks. These sources of influence and power flow from and to the Oba's wives. Together, they offer the queens ongoing

opportunity and flexibility within the ranked and structured hierarchy of the harem. That hierarchy includes a limited set of offices as expressed in titles associated with the harem (Ine, Osodin, Eson, etc.) and in categories of positions of power. The Oba is the major source of power for the queens, because he alone has the ability to award the only chiefly titles traditionally available to the women who are his wives. Award of a title to a queen is celebrated and her status (and influence) affirmed publicly, thereby increasing her personal capital.

The opportunity for royal women to rise in status, to choose and dispose, and to garner and amass tangible as well as intangible resources in the harem ultimately functions to make the harem an essentially open institution despite the seclusion it enforces. Indeed, seclusion and taboo may actually enhance and cast a reflection of the Oba's power onto his wives. Further, the *mana* that adheres to him as a sacred being, by its very nature, limits the access of others to him and magnifies the roles of the queens. The joining of women from diverse levels of society in the royal harem ties the palace politically to the hinterland. It also moves to center stage the values and possibilities for women once pursued in all harems of the kingdom: a first son, children, a stable home, independent means, economic rewards, personal recognition, proper burial, and remembrance. Even now the restraints placed by the royal harem on personal mobility and visibility are offset by these pursuits, which are based on enduring Benin values: a good head, individual initiative, service, personality, and cleverness. For these reasons and more, the Oba's harem with women in seclusion survives along with its politics and polygamy into the twenty-first century.

Notes

1. There have been more studies of women by women (and some men) in the mid- to early twentieth century, e.g., Thoko Ginindza (1997), a Swazi woman, writing about an important queen mother in Swaziland, and Beverly Mack (1997) on women in the harem of the emir of Kano. These and others can be found in an important collection about women of power, Kaplan 1997b.

2. The interviews were initiated by Chief Jacob U. Egharevba, the first self-taught Benin historian, writing in English during British colonial rule (1897–1960). Most of his work was printed privately as pamphlets and booklets from the 1930s on.

3. Egharevba 1960, p. 76.

4. Egharevba 1968, p. 20.

5. Egharevba 1965, p. 28.

6. After Oba Akenzua II came to the throne in 1933, he gave his own deceased mother and his grandmother, who had not been allowed to reign as Iyoba, their titles.

7. Connah 1975, p. 268.

8. Palisot de Beauvois 1801.

9. J. Adams 1823, p. 62.

10. The present women's groups at the Oba's Palace consist of the Isikhuian, composed of the daughters and wives of chiefs, and a new one, Ugwuaguwaba, created for the mother of Oba Erediauwa—the first queen mother to reign since the nineteenth century, Iyoba Aghahouwa (r. 1981–98).

11. Queen Eson N'Erie, conversation with author, 1989.

12. Roth [1903] 1968, p. xiii.

13. Sir Richard Burton, quoted in Roth [1903] 1968, p. 40.

14. Burton, quoted in Roth [1903] 1968, p. 40.

15. Kaplan 1993, pp. 100–101.

16. Egharevba 1960, p. 37.

17. Enogie of Obazuwa-Iko, conversation with author, Benin City, August 10, 2001.

18. Kaplan 1997a, p. 91.

19. Kaplan 1997c, p. 259.

20. Ward Price 1939, p. 238.

21. Oba Erediauwa, conversation with author, Benin City, December 27, 2004.

Empresses, Concubines, and Aisin Gioro Daughters

Shuo Wang

When the Qianlong emperor took Xiang fei as his concubine in 1760, he made an exception by taking a non-Manchu woman into the inner palace. Xiang fei was Uyghur, considered a distinctly different ethnicity by the Qing court. Worse, she was Muslim in a court that used religious practices as one way to distinguish its ethnic identity from that of the surrounding Han Chinese population. Yet when the Qianlong emperor married his seventh daughter to a Mongol prince, no one thought anything of it. Although emperor and daughter belonged to the same social and ethnic group, they experienced status and ethnicity differently because of their gender.

During the Qing dynasty (1644–1911), when the Manchus ruled China, palace women played a significant role in maintaining Manchu ethnic identity and constructing a multiethnic empire. They can be divided into two categories: imperial consorts (empresses and concubines), who entered the palace through marriage, and Aisin Gioro daughters, who received imperial membership by birth. Starting in the eighteenth century, imperial consorts were selected exclusively from the hereditary military units known as banners.[1] They made the inner court a Manchu world for emperors and princes in distinction to the outer court, where men might easily be influenced by Chinese culture. As for

My thanks to Susan Mann, who helped me in shaping many ideas that appear in this chapter. My most sincere gratitude goes to Alan Sweeten, who generously read earlier drafts of this paper and provided valuable comments.

imperial daughters, the emperors usually married them to Manchu high officials or to the elite of other ethnic groups in order to buy support and cooperation. Imperial daughters thus played a significant role in shaping Qing territory and stabilizing Manchu rule.

Consorts and daughters served the Qing dynasty in different ways. Qing rulers chose marriage partners primarily from the banner population through triennial selections—a system that met Manchu imperial needs to maintain the ethnic purity of the ruling group. Whereas intermarriages between non-banner women and banner soldiers were tolerated (though not encouraged), Qing emperors and princes after the Kangxi period (1662–1722) were prohibited from marrying anyone not from the banners. Imperial daughters, in contrast, did not have to be married within the banners. Since they had high social status by birth, they became "gifts" to the Chinese high officials and Mongol princes to whom they were married in order to gain political or military support for the Qing in the dynasty's early years. As soon as the Qing stabilized their rule in China proper and on the frontier, more Aisin Gioro daughters married Manchu aristocrats. When examining imperial marriage from the perspective of the interaction of gender, ethnicity, and social status, one can see that in taking wives the Qing court was more concerned with ethnicity, while in giving wives social status became a more significant consideration.

Imperial Consorts

In early Chinese dynasties, emperors usually selected their marriage partners from the families of high-ranking officials. Establishing conjugal relations between the imperial family and the social elite was an effective way to consolidate the power of the ruling house. All too frequently, however, consorts' relatives tried to take advantage of their connections to develop their own power at court. Sometimes, when the emperor was young or weak, they might go so far as to override his authority. After the Song dynasty (960–1279), emperors generally selected imperial consorts from lower-ranking elites and even from commoners in order to reduce the potential power of consort families.[2]

The selection of imperial consorts marks an important difference between Chinese and conquest dynasties—those established by non-Han people.[3] Jennifer Holmgren lists three points to summarize common characteristics of marriage politics among non-Han rulers. First, nearly all non-Han states actively discouraged or severely circumscribed marriage ties between the imperial family and the Chinese. Second, the circle of imperial marriage partners tended to remain relatively stable. Consequently, the various sets of in-laws overlapped to a much greater extent than in native Chinese regimes: that is, the same groups

TABLE 7.1 The Reigns of Aisin Gioro Rulers

	Personal Name	Reign Name	Reign Dates
1	Nurhaci	Tianming	1616–1626
2	Hongtaiji	Tiancong; Chongde	1627–1643
3	Fulin	Shunzhi	1644–1661
4	Xuanye	Kangxi	1662–1722
5	Yinzhen	Yongzheng	1723–1735
6	Hongli	Qianlong	1736–1795
7	Yongyan	Jiaqing	1796–1820
8	Minning	Daoguang	1821–1850
9	Yizhu	Xianfeng	1851–1861
10	Zaichun	Tongzhi	1862–1874
11	Zaitian	Guangxu	1875–1908
12	Puyi	Xuantong	1909–1911

continued to supply both wives and husbands for imperial offspring almost in-definitely. Third, in non-Han states there was more careful regulation and thus a much higher correlation between political privilege and social status as seen through marriage relations with the royal house than in Chinese states.[4]

The Manchus did more than simply imitate previous non-Han dynasties. Like other non-Han rulers, they forbade intermarriage between the throne and the Chinese after they established the Qing dynasty. But the Qing imperial family did not have a stable and narrow circle of marriage partners comparable to the Xiao family, which in the Liao dynasty (907–1125) constantly provided wives and husbands to the imperial family. Instead, the Manchus generally chose imperial consorts from a broader social group, the banners. In the following pages, we will see how Manchu rulers adjusted the policies and practice of choosing imperial consorts according to the political and ethnic needs of the time. We will also see how women contributed to consolidating Qing political power and constructing Manchu ethnicity.

Since the names of Aisin Gioro rulers and their reigns appear frequently in this discussion of the policies and practice of imperial marriage, I have created a table to which readers can refer (see table 7.1).

Marriage Practices before the Eighteenth Century

Before the conquest of China, Jurchen/Manchu nobles often married women from different clans and ethnic groups. Nuptial bonds won Nurhaci and his son

Hongtaiji political and military allies during the unification of the Jurchen tribes in Liaodong (northeastern China) and the subsequent conquest of China. Nurhaci had fourteen consorts: two were daughters of the Khorchin Mongol elite and the rest were from the noble families of other Jurchen clans.[5] During Hongtaiji's reign, marriages between the Aisin Gioro family and the Mongols were most common. Among his nine high-ranking consorts, six were Mongol women.[6] In 1636, Hongtaiji changed the title of his regime from Jin to Qing. In the same year, to show his gratitude for Mongol support and further consolidate political relations, Hongtaiji granted official titles to his five consorts, all of whom were from distinguished Mongol families.[7]

After the Manchus entered Beijing in 1644, they adjusted their marriage policies to suit the new political and social environment. In 1648 the Shunzhi emperor issued a decree emphasizing harmony between Manchu and Chinese: "Our nation has brought order to the Central Plain and people under Heaven are one family. Manchu and Han officials and commoners are all my children. To promote a harmonious relation between these two peoples, there is no better way than encouraging them to marry each other. From now on, we will not stand in the way of Manchu and Han officials and commoners who want to join together in marriage."[8] Several days later, the emperor issued another decree on Manchu–Han intermarriage that focused on administrative formalities:

> I want to see harmonious cohabitation of Manchu and Han, so I issued a decree earlier to encourage intermarriage between these two peoples. Manchu officials' daughters who want to marry Han should inform the Board of Revenue. . . . If common bannermen's daughters who want to marry Han have registered with the Board of Revenue, they need approval from the Board. If they have not registered with the Board of Revenue, the captain of the banner company to which they belong has the right to marry them out. As for Han officials' daughters who want to marry Manchus, they should inform the Board of Revenue, too. This is unnecessary for commoners' daughters who want to marry Manchus. Manchu officials and common bannermen are allowed to marry Han women only when these women are taken as first wives [not as concubines].[9]

The Shunzhi emperor raised the issue of intermarriage because of tension between Manchus and Chinese in the wake of the conquest. He believed that the new intermarriage policies would help eliminate ethnic conflicts and bring peace.

The Shunzhi emperor tried to follow his own decrees. Intermarriage had occurred between the imperial family and the sons of the Ming defectors who

TABLE 7.2 Ranks of Qing Imperial Consorts

Title in Chinese	English Translation
Huanghou	Empress
Huang guifei	Imperial concubine, first rank
Guifei	Imperial concubine, second rank
Fei	Imperial concubine, third rank
Pin	Imperial concubine, fourth rank
Guiren	Imperial concubine, fifth rank
Changzai	Lower-level concubine
Daying	Lower-level concubine

NOTE: For a brief description and the ordering of ranks, see Brunnert and Hagelstrom [1912] 1963, pp. 2–3.

surrendered to the Manchus during the conquest and later became known as the Three Feudatories. In addition, some Han women entered the palace through marriage. Two of the Shunzhi emperor's consorts were Han Chinese.[10] The Kangxi emperor took the daughter of the Han official Wang Guozheng as his concubine.[11] Another source records that in the late years of the Kangxi emperor, six or seven Han women lived in the palace. Most of them were from Suzhou or Hangzhou. They had no titles until the last year of the Kangxi reign, when they were granted low-ranking titles (for titles, see table 7.2).[12] The Yongzheng emperor also had a Chinese concubine.[13]

During the first decades of the dynasty, Qing emperors did not perceive any danger of losing their ethnic identity and being sinicized. Instead, they saw the boundary of Manchu ethnicity as flexible and negotiable—a conception that sprang from the origins of the Manchus and their experiences in Liaodong, where many Han Chinese and other peoples were incorporated into Manchu banners. Rather than attempting to control marriages of Manchus with Chinese out of worry about sinicization, the Manchu rulers' priority was to incorporate social elites from other ethnic groups, especially the Chinese.

Choosing Imperial Consorts through the Draft

It is not known when the Manchu rulers established the system in which the young women in banners had to undergo a draft by the imperial house before their marriage could be arranged. I assume it began during the Yongzheng reign.[14] According to Qing statutes, all young women in banners, except those with certified physical disabilities or deformities, went through the process of

xiunu (elegant female) selection. If their parents or banner leaders married them out before they participated in the imperial inspection, all involved—including parents, clan leader, and local banner officials—would be punished.[15]

Under the draft system, every three years all banner women between thirteen and sixteen *sui* (age counted from the first new year after birth) were required to present themselves at the Forbidden City in Beijing. Before the selection, the Board of Revenue sent notices to banner officials in the capital and in provincial garrisons. With the help of clan heads, the banner officials submitted a list of all available women to the banner commanders' headquarters in Beijing and to the Board of Revenue. The Board of Revenue then set a date for the selection. On the appointed day, girls were brought by their parents or relatives, together with their clan heads and local banner officials, to the Shenwu (Martial Spirit) Gate of the Forbidden City to await inspection.[16]

Qing statutes did not state in detail how and by whom the girls would be inspected. Other sources indicate that court officials performed the first inspection by matching those present against the list previously submitted and choosing, on the basis of physical beauty, as many as were needed to serve in the palace.[17] Some were immediately rejected. They were free to marry other bannermen so long as they had the approval of their parents and banner leaders. Those who passed the initial inspection were called "registered" (*jiming*) or "documented" (*liupai*) and stayed in the palace.[18] During the next five years, they would go through a series of further investigations into their family background and birth dates to see if their astrological sign matched that of the person they were about to marry. Those who qualified remained in the palace as imperial consort candidates. They had no daily expenses and received one tael of silver per month as a stipend until they were either promoted into the consort ranks or released from the palace.[19]

Another source for imperial consorts was the imperial bondservant companies. The girls from these companies ages thirteen *sui* or older were required to go through the process of palace maid selection before they could get married. The Imperial Household Department supervised this annual draft, and the girls selected generally served the court as maids rather than as candidates for imperial consort. However, neither emperor nor princes were prohibited from finding mates among this group. Many imperial consorts, including empresses, were initially palace maids. For example, the birth mothers of the Yongzheng, Qianlong, and Jiaqing emperors all came from a bondservant background.[20] Four of the Kangxi emperor's consorts were palace maids before they were promoted. Two of the Qianlong emperor's consorts were also from bondservant families, and the Jiaqing emperor's first empress was the daughter of an Imperial Household Department manager.[21]

The drafts, which were intended to guarantee Qing emperors and princes the

best marriage partners, were significant in two ways. First, they broadened the scope of imperial consorts selected from Mongol and Chinese elites to the whole banner population, regardless of social rank. Second, the draft emphasized the ethnic identity of the candidates for imperial consorts. The girls who entered the palace had to come from banner families, either from the regular banners or from the bondservant banners. According to Evelyn Rawski's statistics, 76 percent of the imperial consorts entered through the xiunu draft and 16 percent were originally palace maids.[22] These figures suggest that banner affiliation, one of the trademarks of ethnic identity, became the Qing rulers' first consideration when selecting wives and concubines.

Problems with the Pursuit of Ethnic Purity

Manchu rulers had difficulty maintaining the ethnic purity of the imperial house and blocking Chinese cultural influence in the palace. After the Kangxi period, the Qing tolerated intermarriage between bannermen and women not in banners. In the eighteenth century and later, it was not uncommon for bannermen, especially hanjun, to marry Chinese women.[23] The emperors seemingly gave tacit consent to the status quo, admitting that "[m]arriage between Chinese bannermen and Han women has been going on for many years now. It is pointless to prohibit it."[24] Traditionally, the children of such unions were registered in banners. If the child was a girl, she would have to face the draft as soon as she came to age. Many girls who entered the palace as candidates for imperial consort actually had Chinese mothers and relatives and might have been raised in the Chinese way. According to So Changbo and Kim Kyongson, who traveled to China in the early nineteenth century as secretaries of the Solsticial Embassy from Korea, in cases of Chinese–Manchu intermarriage "sons followed the customs of their fathers, daughters those of their mothers. Thus the son of a Chinese mother and a Manchu father would contribute his military service under one of the Eight Banners, while the daughter would have her feet bound."[25] It is logical to think that these girls might have imitated their Chinese mother in other customs and practices as well.

Manchu emperors began to notice these problems as early as the mid-eighteenth century. When the Qianlong emperor inspected the candidates, he found some girls who emulated Han Chinese clothing and jewelry. In a decree issued in 1759 he declared: "This is truly not the Manchu custom. If they do this before me, what is willfully worn at home? . . . Although this is a small matter, if we do not speak to correct it, there must gradually be a change in our customs, which are greatly tied to our old Manchu ways. Take this and have the banner high officials proclaim it to the bannermen."[26] Later in 1804 the Jiaqing emperor found that some drafted girls even had bound feet, wore

only one earring (the Manchus customarily wore three earrings in each ear), and wore wide-sleeve robes like those of Chinese women.[27] In 1806, the emperor issued a decree emphasizing that "wearing wide sleeve robes and having bound feet are changing basic Manchu traditions. Nothing is more serious than this. I demand all the banners prohibit it."[28] As result, the Qing court narrowed the scope of the draft to exclude some daughters from hanjun households. While all the Mongol and Manchu soldiers were still required to send their daughters for the selection, the girls from common hanjun families were exempted from the inspection, unless their fathers were sixth-rank or higher banner officials. The court claimed that the new policy was "based on a consideration for financial problems and other difficulties experienced by the common Chinese bannermen. It showed that the emperor sympathized with their plight."[29] However, I see this change in the broader context of its ethnic and cultural implications for the imperial house, which the court doubtless considered.

Mark Elliott argues that whereas the court used the labels "civil" and "military" (wen and wu) to separate Han and Manchu men, it divided Han and Manchu women by the size of their feet, the number of their earrings, and the style of their clothing.[30] Reliance on this method explains why the Jiaqing emperor was so bothered by the problem when he learned about signs of sinicization among candidates for imperial consort. It is also logical to think that these Chinese-like outward appearances reflected only the surface of acculturation. Perhaps cultural erosion had occurred at a deeper level among banner women, particularly women from hanjun families. Therefore, after the mid-eighteenth century, the emperors became more and more sensitive to Chinese cultural influence in the inner court through marriage and tried to select as few imperial consorts as possible from Chinese banners.

Another means by which the ethnic purity of imperial consorts was contaminated was the practice of adopting children from civilian Chinese families. According to Manchu tradition, bannermen without legitimate heirs could adopt children from their own clans to maintain their family lines and inherit the family property. If there were no suitable children for adoption within the clan, they could adopt children from other clans, but the children had to be from banner families. The adoptive parents were to inform the head of their clan and the child's original clan, and then register the child in the banner as their own child.[31] However, after the Yongzheng period, many adopted children were taken illicitly from Chinese civilian families. As a result many "false Manchus" were registered in Manchu banners.[32] According to a census undertaken in 1821, there were about 2,400 Chinese registered in either the Manchu

banners or the Mongol banners in Beijing through adoption, and 1,795 in the garrisons at Jiangning and Jingkou.[33] Qing emperors thus made every effort to distinguish these people from the regular banner population.[34] But throughout the Qing dynasty, the ethnic boundary between true Manchus and "false Manchus" remained blurred.

That Aisin Gioro males chose wives and concubines from the entire banner population, using the banner registration system, heightened the problem for the Qing ruling house. In an effort to address this issue, the Qianlong emperor issued an edict in 1756, emphasizing that "by imperial favor, let all separate register, foster son, and entailed households in the capital Eight Banners and in the outer garrisons be made forthwith to leave the banner and become commoners."[35] An imperial edict of 1822 took a similar approach: "[L]et all adopted Chinese sons be registered in separate files. Their sons should be registered as civilians. Their daughters should be exempted from the election."[36] The court's effort to cleanse the false Manchus from the banners was important not only economically, as the court began having trouble feeding the increasing banner population after the Qianlong period, but also ethnically. If daughters of false Manchus entered the palace through the draft, it would bring Chinese cultural influence into the inner court and hurt the Qing national interest.

Women as Cultural Reservoirs

When examining the significance of ethnic boundaries for Manchu rule in China, Mark Elliott compares the Manchu situation with that of the European colonial regimes. He believes that "[f]or the sake of reproducing their power, both types of regimes required that the ethnic boundaries dividing them from the people they governed be very clearly drawn. This meant, in turn, that sexuality and nuptiality of the ruling ethnic elite had to be carefully monitored."[37] It is true that Manchu rule in China and European colonial regimes in Asia and Latin America shared common concerns over intermarriage or sexual relations between colonizer/ruler and colonized/ruled. One difference is that European colonial regimes never allowed their people to marry the local population (though concubinage was tolerated).[38] During the first years of the Qing dynasty, by contrast, Manchu rulers actively encouraged Manchu–Chinese intermarriage, as we have seen. Only after they saw the danger of becoming sinicized did they increase vigilance over ethnic boundaries by prohibiting intermarriage. Another difference is that Europeans made the prohibition universal: no Europeans, regardless of their gender and social status in the colonial regime, should marry indigenous people. But the prohibition against intermarriage during the Qing applied only to common banner women and Aisin Gioro males.[39] In other

words, intermarriage for the Manchus was more closely related to gender and social status than it was for Europeans.

Adjustments in intermarriage policies during the Qing dynasty always reflected the urgent need of rulers to further their political and ethnic interests. By the Qianlong reign, Qing priorities shifted from harmonizing Manchu–Han relations to preserving the Manchu ethnic identity. Women were given special attention. While the Qing court tolerated bannermen's taking Chinese wives, banner women were prohibited from marrying non-bannermen since female exogamy would threaten Manchu ethnicity by reducing the Manchu population.[40] Although common banner soldiers were allowed to marry Chinese women and make their families a site of acculturation, a marital tie with Chinese women was not an option for Aisin Gioro males. The drafts helped maintain the ethnic purity of the ruling house and minimize Chinese cultural influence in the inner court. It is clear that palace women had a role in the construction of ethnic identity that was not confined to childbearing— reproducing heirs for Aisin Gioro line; they also helped reproduce and maintain Manchu culture within the inner court.

Increased vigilance over acculturation in the inner court can be also seen in other regulations applied to palace women. In the late seventeenth and early eighteenth centuries, when Manchu rulers anxiously saw sinicization rising among the common banner population, they tried to build a closed Manchu world for emperors and princes, the core figures of the Manchu rule in China. Women were involved in this effort and played important roles as cultural reservoirs. For example, to emphasize the importance of the Manchu language, banner women who could speak it were hired as tutors to teach Aisin Gioro children in the Forbidden City.[41] At the shamanic shrines built inside the Inner City, rites performed after the 1660s were monopolized by shamans "selected from the wives of high officials belonging to Gioro households of the upper three banners."[42] These policies indicate that the Manchu rulers tried to reduce acculturation in the inner court to a minimum.

Discussions of significant roles for palace women in the Qing usually feature the empress Xiaozhuang (Hongtaiji's empress) and Empress Dowager Cixi, whose influence and power over court politics are emphasized. Such an approach implies that women were important only when they acted as men did, directly participating in policy making or other public affairs. That the Qing court strictly regulated the selection of imperial consorts indicates that women were a vital part of Qing political life. By playing women's roles—as wives, concubines, or mothers of the emperors or princes—palace women helped shape Manchu ethnic identity: they preserved an inner quarter in which the imperial elites could live their private lives in the Manchu way.

TABLE 7.3 Titles and Ranks of Imperial Daughters

Rank	Title	Rank	Relation to Emperor
1	Gurun gungju	Princess, first rank	Daughter of emperor and empress
2	Hosoi gungju	Princess, second rank	Daughter of emperor and consort
3	Junzhu	gege, first rank	Daughter of prince
4	Xianzhu	gege, second rank	Daughter of prince
5	Junjun	gege, third rank	Daughter of prince
6	Xianjun	gege, fourth rank	Daughter of prince
7	Xiangjun	gege, fifth rank	Daughter of prince

SOURCES: Brunnert and Hagelstrom [1912] 1963, p. 8; Wang Shuqing 1982, p. 31.

Imperial Daughters

Unlike consorts who married into the imperial family, Aisin Gioro daughters were born into it. Princesses include the emperor's daughters and sisters (the daughters of the late emperor), and daughters of princes fostered by the emperor or empress.[43] Some who were not related by blood to Aisin Gioro but received special favor from the emperor, empress, or empress dowager were also granted the title of princess.[44] Those without the title of princess were called *gege*, a Manchu term meaning "young lady."[45]

Imperial daughters were ranked according to their blood relationship to the emperor and the title of their mothers (see table 7.3). For example, the daughters of the empress had a title that gave them a rank equivalent to that of a first-degree prince; daughters of the emperor's concubines and those adopted by the empress were granted a rank equivalent to that of a second-degree prince. The daughters of princes were graded into five ranks determined by the blood relationship between their fathers and the emperor.[46]

Unlike low-ranking childless consorts, who might disappear from the Aisin Gioro genealogy, the names of imperial daughters were recorded even if they died in infancy. Imperial daughters "retained membership in their natal families throughout their lives."[47] They did not, as other wives usually did, become members of their husbands' families upon marriage. Instead, they brought their husbands into the imperial family and added their husband's name to the imperial genealogy.

The husbands of imperial daughters were called *efu*. Their status was determined by their wife's rank and was generally three grades lower than their wife's. For example, a first-rank princess's husband was given the title *gurun efu*,

with a rank equivalent to that of a fourth-ranking prince; a second-rank princess's husband became *hosoi efu*, a rank equivalent to that of a fifth-ranking prince. The men who married princes' daughters received various titles according to their wife's rank, and they thus were ranked lower than those who married princesses.[48]

Imperial daughter marriage is one of the keys to understanding Qing politics and relations with other ethnic groups. When discussing Qing policies of intermarriage, Rawski points out that "non-Han rulers tended to use marriage as a device to cement alliances within their own conquest circle or with foreign rulers."[49] This approach was embodied in the marriage of Aisin Gioro daughters. Whereas the emperor and princes chose wives or concubines from the banner population through the drafts, imperial daughters were married to Mongol princes, Manchu aristocrats, or, on some occasions, Chinese high officials. These marriages not only "reinforced and reaffirmed Qing bonds with particular noble houses in the banner elite"[50] but also cemented ties between the Manchu ruling house and its foreign allies.

Marital Ties with the Chinese

In the early seventeenth century, the rising power of Nurhaci and Hongtaiji threatened the declining Ming regime. Military conflicts erupted along the northeastern frontier. To win the support and cooperation of Ming generals in Liaodong, Nurhaci gave them Aisin Gioro women as wives. In 1618, before he attacked Fushun city, he promised the Ming general defending the city a woman from the Aisin Gioro clan in marriage if he surrendered. After the general surrendered, Nurhaci gave him one of his granddaughters.[51] Later the general joined the Chinese banner.[52]

In 1632, Hongtaiji accepted the suggestion of Prince Yoto, his nephew, and assigned one thousand Manchu women to surrendered Chinese officials and generals for them to marry. He also classified these Chinese into groups by rank and gave them wives accordingly. "First-rank officials were given Manchu princes' daughters as wives; second-rank officials were given Manchu ministers' daughters as wives."[53] Hongtaiji believed that only through intermarriage between Chinese and Manchus would he be able to eliminate ethnic conflicts in the areas he conquered; and "since the Chinese generals and Manchu women lived together and ate together, it would help these surrendered generals to forget their motherland."[54]

During their first years in China, the Manchu rulers continued to give imperial daughters to Chinese high officials. These included the sons of the Three Feudatories—the Ming defectors rewarded with large and almost autonomous fiefs in the south.[55] It is clear that when the Manchu rulers created their empire,

female exogamy with the Chinese "functioned as an important means of winning new allies and stabilizing military coalitions."[56] After Manchu rule was consolidated in China proper, marital ties between imperial daughters and Chinese officials or generals became less frequent. Whereas four Manchu princesses married Chinese during the first century of Manchu rule over China, none did so after 1750.[57]

Marital Ties with the Mongols

The preferred marriage partners for imperial daughters were not Chinese but Mongol princes. According to Rawski's statistics, more than 58 percent of imperial sons-in-law were Mongols.[58] The Manchus considered the Mongols to be their "brother state" because they shared common values. Nurhaci once said, "[T]he Manchus and Mongols have different speech but their clothing and customs are the same as one people."[59] More significant than this cultural familiarity was the Manchu rulers' need for Mongol military support during their conquest of China.

The Mongols shared geographical borders with the Ming in the south and the Jurchen/Manchus in the east. These three powers engaged in a tripartite confrontation in the early seventeenth century. Because the Jurchen/Manchus were not strong enough to attack the Ming with only their own troops, they needed to make the Mongols their military allies. Some tribes—for example, Khorchin Mongols and the five tribes of inner Khalkha Mongols—needed the Jurchen/Manchu forces to be their allies against other tribes as well, especially those in the north. Therefore women were exchanged as "gifts" to reinforce military alliances between the Manchus and Mongols. In 1617, Nurhaci married the daughter of his younger brother Surhaci to Enggeder, son of a Khalkha khan.[60] He also gave gifts and women to Mongols who surrendered and incorporated them into banners. For example, in 1621 two Khalkha princes led their tribes to the Manchus. In recognition of their support, Nurhaci married his daughter to one prince and his brother's daughter to the other.[61] In 1626, Nurhaci married one of his granddaughters to the Khorchin Mongol prince Aoba.[62] Nurhaci had nine daughters, and three were married to Mongol princes.[63]

After Hongtaiji took power in the late 1620s, he continued to marry Aisin Gioro daughters to Mongols, giving them in exchange for Mongol military support. The number of Manchu princesses married to Mongols reached its peak during his reign (1626–43). Of thirty-two princesses who married Mongol princes in the Qing dynasty, twelve were Hongtaiji's daughters.[64] During this time, the Manchus focused on developing and consolidating friendship with Khorchin Mongols, while simultaneously competing with Chahar Mongols over control of the Mongol tribes in southern Mongolia. In 1635, when the allied

forces of Khorchin and Manchus defeated the Chahar Mongol leader Ligdan Khan, Hongtaiji gave his second daughter to Erke Khongkhor Eje, son of Ligdan Khan, who would become the leader of the Chahar Mongols after his father died.[65] One change from previous custom was that Hongtaiji married his daughters not only to those who came over to the Qing and became banner members living in China proper, but also to Mongol princes who remained on the Outer Mongolia steppe. The frequency of marriage exchange with Mongol princes improved relations between Manchus and Mongols, as nineteen Mongol tribes came over to the Qing during the Hongtaiji period.[66] Incorporated into the banner system, they played a significant role in the Manchu conquest of Ming China.

Marital ties between the Manchu imperial house and Mongol elite also benefited Qing rulers when they expanded the empire to the west during the first decades of the dynasty. After the Manchus incorporated eastern Mongol tribes into the Qing system, the outer Khalkha tribes in the north and the Oirat (or Uriad) tribes in the west became targets—powerful Mongol tribes that, once controlled, could be used as a military buffer along the western and northern frontier of the Qing empire. In 1688, under the leadership of Galdan, the Zunghars from the Oirat tribes attacked the Khalkha and forced them to move south. The Qing seized this opportunity to create a feud between the two Mongol forces, supporting the Khalkha against the Zunghars. Within a decade, Khalkha tribes gradually submitted to the Qing, and by 1691, all the Khalkha Mongols were incorporated into the Mongol banners. Again, imperial daughters became a diplomatic weapon used in marriage exchange with the Khalkha to secure the alliance. In 1697, the Kangxi emperor married his sixth daughter to a grandson of Tushiyetu Khan.[67] In 1702, an alliance with the Jasaghtu Khan was cemented by his marriage to the daughter of a Manchu prince.[68] In 1706, Tsereng, a descendant of Sayin Noyan Khan, married Kangxi's tenth daughter.[69] These Mongol sons-in-law put their tribes under Qing rule.[70]

Marriage between imperial daughters and Mongol princes continued to the end of the Qing dynasty. However, it became less popular by the mid-eighteenth century, reflecting the declining political and military significance of the Mongols as the Qing western and northern frontier stabilized. The genealogy of the Aisin Gioro clan records thirty-one marriages between Manchu princesses and Mongol nobles from 1600 to 1750, while only four such marriages took place over the next one hundred years and no Manchu princess married a Mongol after 1850.[71] Moreover, no imperial daughters married western or northern Mongols after 1770, by which time the Zunghar and Muslim rebellions had been suppressed.[72] Instead, the Qing limited their selection of Mongol grooms to the seven tribes of southern Mongols who had submitted to the Manchus and

accepted incorporation into Mongol banners before the Qing dynasty was established.[73]

The new approach to selecting Mongol grooms can be understood as part of a Qing strategy for imperial security. On the one hand, after the western frontier was relatively secure, Manchu rulers no longer needed to ally with the Khalkha Mongols against the Zunghars and other rebellious forces. Therefore, sending imperial daughters to the remote Mongol steppe became meaningless. On the other hand, the Manchus still needed to maintain a harmonious relationship with Mongols, especially the thirteen banners of seven tribes in southern Mongolia and eastern Manchuria. In geopolitical terms, these tribes formed a crescent around Mukden and Beijing, cities that had political and military significance for Qing rulers.

Marriages of Imperial Daughters with the Manchu Elite

Marrying imperial daughters to Manchu aristocratic houses started before the Manchu conquest of China. Most common were marriages between the Aisin Gioro clan and the houses of Hohori and Eidu—both were the earliest supporters of Nurhaci when he unified the Jurchen tribes. Hohori had six sons: two of them married imperial daughters, and Hohori himself married Nurhaci's first daughter.[74] Marital ties between Hohori and Aisin Gioro lasted for generations.[75] Another prominent Manchu aristocrat was Eidu. Each generation of his family renewed marital ties with the Aisin Gioro during the first two centuries of Qing rule.[76] The Niohuru clan descended from Eidu's sons became a prominent marriage partner of the imperial house. From approximately 1600 to 1800, seventy-seven Niohuru males married Aisin Gioro daughters, while seventy-two Niohuru women entered the palace through marriage.[77]

Marriage exchange between the Aisin Gioro clan and Manchu noble families became more frequent after the Yongzheng reign, reaching its peak in the late Qianlong period.[78] The change began with the Qianlong emperor's decree in 1751. Under the existing system for choosing imperial grooms, as soon as a princess or a *gege* came of age to marry, a list of candidates would be submitted to the emperor for selection. In the 1751 decree, the emperor pointed out that the list contained nothing but the names of Mongol candidates. He emphasized that candidates from Manchu noble families should also be included on the list.[79] After the mid-eighteenth century, sons of Manchu nobles became the main source of imperial grooms. The Jiaqing emperor reinforced this requirement in 1801.[80]

If we view marrying across ethnic lines as a device to cement political alliances during the Qing dynasty, then the change brought about by the Qianlong

and Jiaqing emperors was clearly a sign that the significance of the Mongols in Qing rule had declined. In other words, Qing rulers no longer needed political and military support from the Mongols as much as they had during the conquest period and the dynasty's first decades. By the mid-eighteenth century, the main challenge was to preserve the Manchu ethnic identity. Therefore, the Manchu rulers became more sensitive to the original ethnic background of the imperial grooms and preferred to marry their daughters to nobles from Manchu banners rather than those from Mongol or Chinese banners, even though these bannermen were in theory part of the Manchu people and lived as the Manchu did.

The Political Implications of Marriage

Throughout the dynasty, Manchu emperors kept tight control over their daughters' marriages. Marriage policies changed over time as the needs of the Qing court varied, but some principles remained the same. Unlike imperial consorts, who might come from common banner families and might even be palace maids, imperial grooms had to be men of high social status. According to the regulations on imperial marriage, women of the Aisin Gioro clan were not allowed to marry bannermen registered as *linghu*.[81] No imperial daughter ever married a non-elite man. This pattern indicates that considerations of status and nobility played a crucial role when Manchu rulers chose their sons-in-law.

Since Aisin Gioro daughters had lifelong membership in the imperial family, they did not in fact marry out. Instead, they brought their husbands into the imperial family. Many Mongol grooms lived in Beijing after they married Aisin Gioro daughters; their children were reared in the capital and studied at the palace school.[82] During the early years of the Manchu conquest, some imperial daughters were married to Chinese generals or to the local elite. In such cases, their husbands were incorporated into the banner system and eventually became Manchu. In fact, as Evelyn Rawski notes, the Manchu emperor "did not 'give away' his daughters; he used them to obtain sons-in-law."[83] These men were either military leaders or the social elite in their own communities. Incorporating them into the Manchu ruling house helped the Qing establish and consolidate a multiethnic empire. In this way, imperial daughters played an important role in constructing the Qing empire.

Manchu rulers had two major concerns during their 267 years of rule in China. One was to maintain their ethnic identity in order to avoid sinicization; the other was to incorporate the elite of Mongol, Chinese, and other ethnic groups into the Qing ruling house and establish a multiethnic empire. As an important

part of the conquering ethnic group, Manchu women made a major contribution to Qing imperial interests.

In discussing women's roles in Chinese society, Rubie S. Watson raises a key question: if men could be fathers as well as officials, literati, landlords, woodcarvers, and so forth, were women in some sense "just women"?[84] By examining imperial women's lives, especially their marriage patterns, we see that women in the Qing were never just women. As imperial consorts, they constituted a reservoir of Manchu cultural identities, reproducing Manchu heirs for the empire and creating a closed Manchu world within the Forbidden City. As daughters of the Aisin Gioro clan, they helped consolidate a multiethnic empire by establishing marital ties between the Manchu ruling house and the elite of other ethnic groups.

A comparison of Qing policies regarding common banner people and those for Aisin Gioro members helps us understand how, in the Qing dynasty, gender was linked to ethnicity as well as social status. During most of the Qing dynasty, Manchu rulers implemented two sets of intermarriage policies. For the common banner people, the policy strictly forbade intermarriage between banner women and Chinese men. All banner women ages thirteen *sui* or older had to go through the triennial *xiunu* selection or annual palace maid selection. Only those who were not selected could marry, upon receiving permission from the banner authority. When they married, they were not allowed to marry Chinese commoners. If they did, they would be expelled from the banner and their parents (and sometimes the banner elders) would be punished. In contrast, bannermen were allowed, though not encouraged, to marry non-banner women.[85] This gendered duality reflected the main concerns of the Manchu rulers about their ethnic security. Since the children from marriages of banner women and Chinese men were considered to be Chinese while the children of bannermen and Chinese women were unquestionably Manchu, only female exogamy had the power to harm imperial interests by reducing the Manchu population. Therefore, as Mark Elliott argues, "controlling women's reproduction was indeed a way to secure ethnic boundaries and resolve a major 'tension of empire.' "[86]

The marriage policy applied to members of the imperial household looks very different from that for common banner people. A gendered duality still existed in the prohibition of exogamy, but it worked in the opposite way. Generally, Aisin Gioro males were not allowed to marry non-banner women, either as wives or as concubines. As a result, all imperial consorts were exclusively from one specific social and ethnic group—the banners. Whereas ethnic identity was a major concern when imperial wives were chosen, nobility became the primary criterion in the selection of grooms for imperial daughters.

Imperial daughters never married common bannermen. When a groom was selected, his family background—its status in society and its political or military importance to the Qing rule—took priority over his ethnic background. Although some princesses and *gege* married into Manchu aristocratic houses, the largest number married Mongol princes. A few even married the sons of high Chinese officials, especially before the Qianlong reign.

At first glance, it seems odd that Manchu rulers allowed common banner soldiers to take Chinese wives but forbade Aisin Gioro males to do the same. Whereas Manchu rulers prohibited female exogamy among common banner people, they married their own daughters and sisters to Mongol and Chinese nobles. However, if we look more closely at how Qing rulers used marriage to serve their political needs, the pattern becomes understandable. The Manchu court forbade imperial male exogamy for the purpose of keeping Chinese cultural influence away from the Forbidden City, a measure crucial to slow down the speed of acculturation of the emperors and princes. It used imperial female exogamy to reinforce and reaffirm Qing bonds with other ethnic groups, especially the Mongols, who played a significant role in helping the Manchus establish the Qing dynasty and expand the empire. Precisely because the Manchus ruled China as an ethnic minority, imperial women—empresses, concubines, and daughters—had to aid in meeting the state's special needs.

Notes

1. The banner system was a unique political, social, and military institution in Jurchen/Manchu society. It was created in 1601 with four banners, and expanded to eight in 1615. Another eight banners, called the Mongol Eight Banners, were added in 1635, when a great number of Mongols joined the system. In 1642, the Qing organized Chinese soldiers into the *hanjun* section (Chinese Eight Banners). For more information about the formation of the banner system, see Elliott 2001, pp. 56–63; Rawski 1998, pp. 61–63.

2. The above summarizes points made by Holmgren 1991, pp. 73–75.

3. After the tenth century, five conquest dynasties were established: Liao by Khitan (907–1125), Xi Xia by Tanguts (990–1227), Jin by Jurchen (1115–1234), Yuan by Mongols (1260–1368), and Qing by Manchus (1644–1911).

4. Holmgren 1991, p. 78.

5. Zhao Erxun 1976–77, pp. 8899–8901.

6. Hua 1983, p. 46.

7. Jiang 1987, pp. 67–71.

8. *Da Qing Shizu shilu* 1964, 40:11a.

9. *Da Qing Shizu shilu* 1964, 40:14 a-b.

10. One of them, Ke fei, was the daughter of the Han official Shi Shen, who served the Qing court as shilang (vice president) of the Board of Personnel (Zhao Erxun 1976–77, p. 8910). The other was Chen shi, whose father's name is unknown. She gave birth to the fifth prince Changying (see Wang Peihuan 1993, p. 335, table).

11. Wang Peihuan 1993, p. 337.

12. Zhang 1990, p. 668.

13. Wang Peihuan 1993, p. 341

14. Scholars generally hold that beginning with Shunzhi's second empress in 1653, the emperors and princes chose their consorts through the triennial xiunu selection (see Wei Qi 1984; Shan 1960, p. 98; Wang Shuqing 1980, p. 40; Rawski 1998, p. 131; Wang Daocheng 1985, 307). I believe, however, that the xiunu selection as a system was established much later (see Shuo Wang 2004, pp. 217–19).

15. Da Qing huidian shili 1899 (hereafter cited as Guangxu ed.), 1114:12.

16. Da Qing huidian shili 1764 (hereafter cited as Qianlong ed.), 154:13a-b.

17. Elliott 2001, p. 254.

18. According to Wu Zhenyu, each girl had an informational card with her when she was brought to the palace. The card listed her father's name, the banner she belonged to, and her age (Wu Zhenyu 1985, p. 274).

19. Da Qing huidian shili, Guangxu ed., 1114:12.

20. Rawski 1998, p. 134; Kahn 1971, p. 88.

21. Rawski 1991, p. 188, table 5.3; Zhao Erxun 1976–77, pp. 8917–8920; Wang Peihuan 1993, pp. 342–45; Wang Zhonghan 1993, p. 252.

22. Rawski 1991, p. 187; 1998, p. 131.

23. Ding 1999, pp. 335–36, table 13; pp. 337–40, table 14. Perhaps the best English-language translation for hanjun baqi is "Chinese martial" (see Crossley 1999, p. 97 n. 23).

24. Da Qing Gaozong shilu 1964, 748:30a.

25. This is Ledyard's translation of Yŏnhaengnok sŏnjip [1832] 1960–62, 1181ba; see Ledyard 1974, p. 14. I want to thank Susan Mann for directing me to this article and to the collection of diaries of Korean travelers.

26. Da Qing huidian shili, Guangxu ed., 1114:19. Here I use Rawski's translation (Rawski 1998, p. 40).

27. Zhang 1990, p. 951.

28. Zhang 1990, p. 39.

29. Da Qing huidian shili, Guangxu ed., 1114:19.

30. Elliott 1999, p. 65.

31. For more information on the fashion of adoption among the Manchus, see Elliott 2001, pp. 331–32. See also Lai 1997, pp. 37–52.

32. The term "false Manchu" is Elliott's (2001, p. 325).

33. Wang Zhonghan 1993, p. 59.

34. For details about adoption in the Eight Banners, see Wang Zhonghan 1993, pp. 56–59; Elliott 2001, pp. 322–42.

35. *Da Qing Gaozong shilu* 1964, 506:2b–6a.

36. *Da Qing huidian shili*, Guangxu ed., 1114: 19.

37. Elliott 1999, p. 69.

38. Stoler 1989, p. 637.

39. Imperial daughters married sons of the Manchu elite or the elite of other ethnic groups. See the second major section of this essay, "Imperial Daughters."

40. Female infanticide in Manchu society and the tradition that banner women married at a relatively late age or stayed unmarried in their natal families caused a shortage of available women in the marriage pool. If female exogamy were allowed, bannermen would find it difficult to marry within the banners. Moreover, if a banner woman married a Chinese, she would be expelled from the banner and her children were considered Chinese. Such customs would directly reduce the Manchu population.

41. Zhang 1990, p. 749.

42. Rawski 1998, p. 238. See also Jiang 1995, p. 63.

43. Wang Shuqing 1982, pp. 31–38.

44. Der Ling (1884–1944) was daughter of Lord Yu Keng, a high-ranking Manchu official. From 1903 to 1905 she held the position of first lady-in-waiting to Empress Dowager Cixi, and she was granted the title of princess as a special favor (see Der Ling 1929, p. 312). In some unusual cases, daughters of Chinese officials were also granted the title of princess. For example, the Ming general Kong Youde's daughter Kong Sizhen was granted the title of second-rank princess (see Liu 1987, pp. 109–11).

45. During Nurhaci's time, before the title of princess was adopted by Hongtaiji in 1636, all imperial daughters were called *gege* (see Wang Shuqing 1982, p. 31).

46. There were some exceptions regarding the titles granted to imperial daughters. The tenth and twelfth daughter of Hongtaiji bore only the title *xianjun* and *xiangjun*, respectively, four or five ranks lower than what they apparently were qualified to hold. In other cases, some princesses borne by imperial concubines were granted the title *gurun gongzhu* because either they or their mothers were favored by the emperor; still others were granted a higher title for political purposes when they married someone important to Qing rule. Here too we see a fondness for distinguishing people according to rank that goes far beyond what is common in other hierarchically structured societies. That even daughters and concubines had to be classified speaks to Confucian norms deemed necessary for regulating the household (Zhao Erxun 1976–77, pp. 5274–75).

47. Rawski 1998, p. 144.

48. Wang Shuqing 1982, p. 31.

49. Rawski 1998, p. 128.

50. Rawski 1998, p. 145.

51. *Manwen laodang* 1990, 1:57; Zhao Erxun 1976–77, p. 9327.

52. (Qinding) Baqi tongzhi [1739] 1986, 3:1590; (Qinding) Baqi tongzhi xubian [1799] 1986, 47:19403–4.

53. Da Qing Taizong shilu 1964, 11:5b–6a.

54. Sheng 1901, 25:3.

55. Da Qing Shizu shilu 1964, 77:15b, 92:3a, 136:22b. See also Zhao Erxun 1976–77, pp. 5276–80; Ding 1997, p. 326.

56. Rawski 1991, p. 175.

57. Zhao Erxun 1976–77, pp. 5276–85.

58. Rawski 1998, p. 147.

59. Manwen laodang 1990, 1:119.

60. Manzhou shilu 1986, 4:192.

61. Zhao Yuntian 1984, pp. 28–37.

62. Manwen laodang 1990, 65:632.

63. This figure includes one foster daughter (Zhao Erxun 1976–77, pp. 5266–69).

64. Hua 1983, p. 47. Hongtaiji had sixteen daughters (including two foster daughters), and twelve married Mongols. See also Zhao Erxun 1976–77, pp. 5267–77.

65. Hua 1983, pp. 47–48. See also Zhao Erxun 1976–77, p. 5270.

66. Zhao Yuntian 1984, p. 30.

67. Zhao Erxun 1976–77, p. 5282.

68. Rawski 1991, pp. 177–78.

69. Zhao Erxun 1976–77, pp. 5283–84. Tsereng's descendants were closely related to the imperial house through marriage: his grandson married the Qianlong emperor's seventh daughter.

70. For details, see Rawski 1998, pp. 70–71.

71. Rawski 1998, p. 148, table 10, based on the Tang Qing huangshi sipu.

72. Zhao Yuntian 1984, p. 36.

73. This tradition of selecting grooms was developed into the beizhi efu system in the early nineteenth century. The seven tribes—Khorchin, Tumet, Ongnirod, Aokhan, Naiman, Bairin, and Aro-Khorchin—were incorporated into the banner organization in 1636.

74. Ding 1999, p. 199.

75. Zhao Erxun 1976–77, pp. 9183–85.

76. Rawski 1998, p. 65.

77. Huang 1986, pp. 637–39.

78. Out of seventy-seven marriages between Aisin Gioro daughters and Niohuru males, sixty-three were in the Yongzheng and Qianlong reigns (Ding 1999, p. 198).

79. (Qinding) Zongrenfu zeli [1908] 2004, 2:6.

80. Da Qing Renzong shilu 1964, 8:9a

81. In their social status, *linghu* bannermen fell between the regular bannermen and servants ([Qinding] *Zongrenfu zeli* 1908, 31:19).

82. Rawski 1998, p. 150; Zhao Yuntian 1984, p. 34.

83. Rawski 1998, p. 159.

84. Watson 1991, p. 359.

85. Many cases of intermarriage between bannermen and non-banner women can be found in the Qing archives (see Ding 1999, pp. 337–40, table 14).

86. Elliott 1999, p. 70.

THE ROYAL WOMEN OF IVAN IV'S FAMILY AND THE MEANING OF FORCED TONSURE

Isolde Thyrêt

The turbulent private life of Tsar Ivan IV (1530–84) in the later part of his reign and the effects it had on his eldest son and heir, Ivan Ivanovich, decisively shaped the role of Russian royal wives (*tsaritsy*) during this period.[1] While Muscovite Russian society was based on the concept of one autocratic Orthodox ruler, the multiple marriages of Ivan IV and his son Ivan Ivanovich, which more often than not resulted in the forced tonsure of their wives, promoted the notion that during this period several royal wives rightfully coexisted in the realm. According to Antonio Possevino, a papal legate who visited Russia in 1581–82, Ivan Ivanovich had complained to his father about his use of forced tonsure to eliminate unwanted royal wives before receiving a mortal blow from Ivan IV's hands: "You thrust my first wife into a nunnery for no good reason; you did the same thing to my second, and now you strike my third, causing the son in her womb to perish!"[2]

Ivan IV, better known as Ivan the Terrible, was Russia's first official tsar, but his Rurikide dynasty was short-lived. The beginning of his reign was characterized by progressive administrative and legal reforms, territorial expansion, and a close cooperation between the tsar and the head of the Russian Orthodox Church. Ivan IV's later years, however, were marked by political, military, and economic crises. Ivan IV killed his own heir in a fit of rage, and his eventual successor, his younger son Fedor Ivanovich, died childless. This lack of an heir plunged Russia into a dynastic crisis and eventual civil war that threatened to undermine the social fabric and territorial integrity of Muscovite Russia. What is

noteworthy about Ivan IV's and Ivanovich's royal wives is that they managed to survive the so-called Time of Troubles that spanned the period from the end of the Rurikide dynasty to the establishment of the Romanov dynasty.

When Russian royal women were forced to take the veil, they continued to enjoy the title *tsaritsa* and the respect that went with it. Scholars, who generally regard them as losers in the larger struggle for dynastic survival, have so far overlooked the continued visibility of these women in spite of their monastic enclosure.[3] Moreover, scholars have disregarded their skillful attempts to manipulate this visibility in order to further their own private ends and to increase their influence at court. I argue that the role of the Muscovite ruler's wife was not affected by outward changes in her socioreligious status brought about by such phenomena as divorce and tonsure. Social isolation, whether associated with the dissolution of the marital bond or with the otherworldliness of monastic life, did not eliminate the responsibilities and privileges inherent in a tsaritsa's royal rank. Once she was married to a Muscovite ruler, she belonged to the spiritual family of pious royal men and women, to whom God had entrusted the government of and the care for the Orthodox Russian community.[4] As a member of this family, she was thus perpetually involved in issues concerning the continuity of the ruling dynasty and the prosperity of the realm.

Royal Women and the Tonsure

Ivan IV's and Ivan Ivanovich's wives followed the pattern set by Solomoniia Saburova, the first wife of Grand Prince Vasilii III, whose husband forced her to take the tonsure in 1525. Her reputation shows that Muscovite Russia continued to value her as helpmate to the ruler and intercessor for the realm although she failed to attain the status of royal mother. According to the *Tale of Solomoniia's Tonsure*, which appears in the *Pafnut'ev Borovsk Chronicle* and the Synodal copy of the *Tipografskaia Chronicle* (both composed in the 1540s), the Grand Princess voluntarily became a nun to devote her life to unceasing intercession with God for the well-being of the Russian ruler and his realm.[5] The tale sidesteps the issue of Solomoniia's inability to bear offspring (the justification for her husband's having forced tonsure on her) by introducing the claim that she had been destined by the divine spirit for spiritual, rather than physical, motherhood. With its assertion that "the Holy Spirit had sown a seed of wheat in her heart that the fruit of virtue might grow," the tale presented Solomoniia as still "fruitful," albeit in a spiritual sense.[6]

A similar fate allowed other royal women to survive and thrive despite being unable to produce an heir to the throne. The sister of Boris Godunov, Irina Godunova, continued to be respected as a pious tsaritsa who fasted and gave to the

poor after her retirement to the Novodevichii Convent following the death of her feeble-minded husband, Tsar Fedor Ivanovich (r. 1584–98), the last member of the Rurikide dynasty.[7]

The Wives of Ivan IV and Ivan Ivanovich

Ivan IV's first wife, Anastasiia Romanovna, died in 1560, but her reputation as a pious tsaritsa later helped her kinsmen claim the throne in 1613. After the death of his second wife, Maria Temriukovna, in 1569, Ivan IV entered into five more uncanonical marital unions. His third spouse, Marfa Vasil'evna Sobakina, for unknown reasons did not survive the wedding festivities in 1571.[8] The following two wives, Anna Koltovskaia (m. 1572, d. 1627) and Anna Vasil'chikova (m. 1574, d. 1576), incurred the tsar's displeasure, and he forced them to receive the monastic tonsure. Virtually nothing is known about Ivan IV's sixth wife, Vasilisa Melent'eva, who seems to have been of nonnoble origin. Maria Fedorovna Nagaia (m. 1580, d. 1606), who bore Ivan a male child, survived her husband, but was tonsured in 1591 by Boris Godunov.[9] Tsarevich Ivan Ivanovich's three wives all shared the fate of forced tonsure.

A closer look at the lives of several wives of Ivan IV and his son Ivan Ivanovich after their forced tonsure shows that these tsaritsa-nuns prized their continued relationship with the tsar's court and sought every opportunity to reap benefits from it. The maintenance of the royal nuns, which was considered the tsar's responsibility, presented these women with an opportunity to maintain regular contact with the ruler in Moscow. In a letter to the abbess of the Suzdal' Pokrov Monastery dated June 19, 1587, Ivan IV's successor, Fedor Ivanovich, allotted to Ivan Ivanovich's first wife—the "tsaritsa nun Aleksandra," previously known as Evdokiia Saburova—several thousand pounds of rye that had been left over from the supply stock of her fellow royal nun, Ivan Ivanovich's second wife and niece of Vasilii III's first wife.[10] Two months earlier the tsar had issued a donation charter to Aleksandra in which he willed to her the full possession of the crown village of Berezhok with other rural settlements. The document, which stipulates that she had the full right to will this property to any monastery of her choice for the commemoration of her soul, shows that the tsar felt responsible not only for her physical but also for her spiritual well-being.[11]

Even after the Rurikide dynasty became extinct with the death of Fedor Ivanovich in 1598, the future tsars tended to honor their obligations to the royal nuns. Possibly they were motivated by the wish to make a gesture of good will or the desire to maintain good relations with the close relatives of previous ruling families. In the case of Aleksandra, in 1599 Tsar Boris Godunov and his son Fedor accepted the same conditions stated by Fedor Ivanovich in his

charter, and Tsar Vasilii Ivanovich Shuiskii (r. 1606–10) confirmed the charter in 1606.[12]

Throughout the political and social turmoil of the Time of Troubles and thereafter, Aleksandra managed to protect the property willed to her by ingratiating herself with the Rurikides' successors. Invoking her privilege as "Lord Tsarevich Ivan Ivanovich's tsaritsa Aleksandra," she eventually bequeathed Tsar Fedor Ivanovich's donation to the Suzdal' Pokrov Monastery in 1613, without outside interference.[13] In her will, which she composed in 1613, she remunerated a close friend in the monastery and stipulated that two memorial services be sung for her every year. She also ordered that on both days the liturgy be performed for Saint Nicholas as well, but she insisted that no one else should institute the commemoration of this miracle worker on these days, probably so that the commemoration of the saint would not eclipse her own.[14] Aleksandra's devotion to Saint Nicholas was respected at the Muscovite court, as is evident in the treatment of an icon of Saint Nicholas that the tsaritsa had donated to the Suzdal' Pokrov Monastery together with a shroud for this image. The monastery's inventory of 1619 mentions that when the icon of Saint Nicholas was taken to Moscow after her death, Tsar Michael Fedorovich Romanov had it returned to its original location.[15]

The ability of royal nuns to maintain ties with the tsar's court is also displayed by Elena Ivanovna Sheremeteva, the third wife of Ivan Ivanovich. In 1581 Ivan IV forced her to take the veil in the Novodevichii Monastery, where she took the name Leonida.[16] Tsar Fedor Ivanovich donated a number of villages in Vereiskii district to the Novodevichii Monastery on her behalf, and Tsars Boris Godunov and Aleksei Mikhailovich Romanov confirmed and continued his donation.[17] As in the case of Ivan Ivanovich's first two wives, the Muscovite rulers pledged economic support to Leonida.

Her monastic confinement did not prevent Leonida from fostering ties with other women who had married into the Rurikide clan. As N. A. Maiasova has pointed out, Leonida was on good terms with Tsaritsa Irina Godunova, Boris Godunov's sister, who on April 21, 1586, donated a tablecloth and several towels to her.[18] During that year she also played a pivotal role in the baptism in the Novodevich'ii Monastery of Evdokiia, the daughter of Maria Vladimirovna Staritskaia and Maria's deceased husband, Prince Magnus, who was a younger brother of the king of Denmark and whom Ivan IV recognized as ruler of Livonia. Maria Vladimirovna was the daughter of Avdot'ia Aleksandrovna Nagaia and Prince Vladimir Andreevich Staritskii, a close member of the Muscovite royal family, whom Ivan IV had executed for alleged treason in 1569. In the aftermath of the bloodbath, Ivan had married the girl off to Prince Magnus, who took her with him to his "Latin" (i.e., Catholic) homeland, where she bore him

a daughter. Three years after Magnus's death in 1583, Evdokiia and Maria returned to Moscow.[19]

Leonida's role in the baptism of Maria's daughter was in keeping with the Muscovite notion of the tsaritsa as a defender of the Orthodox faith.[20] In addition, her association with the Staritskii women testifies to her being part of a network of women who at one time or another had suffered displacement from the royal court. Leonida's association with Maria Vladimirovna, who took monastic vows in the Monastery of the Virgin under the Pines near the distinguished Trinity-Sergius Monastery, seems to have continued even after the death of Maria's daughter in 1589. At some point Maria Vladimirovna returned to the Novodevich'ii Monastery, where her presence is attested during the Polish siege of 1611.[21] Any social isolation Leonida might have suffered as a result of her forced tonsure seems to have been mitigated by her contacts with other royal women who shared her fate.

Although the forced tonsure of royal wives was aimed at undercutting the influence of these *tsaritsy* and their kin at the Muscovite court, their retirement to a monastery did little to curtail their personal engagement in economic and administrative matters. Removed from the pressures of having to produce an heir and from the vicissitudes of political intrigue, the royal nuns could carve out their own space within the confines of their monastery. At the same time, their uncontested status as *tsaritsy* made it possible for these women to represent their own interests and those of their monastery at the Muscovite court.

One of the *tsaritsy* most successful in realizing the potential inherent in the role of the childless royal nun was Anna Alekseevna Koltovskaia, the fourth wife of Ivan IV. When in 1574, after a short period of marriage, her husband for no specific reason put her away in the Monastery of the Presentation of the Virgin in the Temple, located in the distant town of Tikhvin, Anna did not simply endure her disgraceful dismissal.[22] Instead, Anna—known henceforth as the nun Dar'ia—carefully manipulated her prestige as tsaritsa to further the fortunes of the Monastery of the Presentation of the Virgin in the Temple for which she became a patron. During the numerous dynastic changes that ensued after Fedor Ivanovich's death, Dar'ia fought for the recognition of the charter in which her ex-husband had willed to her property in Belozerskii district, which she in turn had given over to her own monastic institution. In 1587 she persuaded Tsar Fedor Ivanovich to confirm the charter. When he became tsar, Boris Godunov also approved Ivan IV's gift to her without changes, and on February 16, 1608, Tsar Vasilii Ivanovich Shuiskii endorsed the same charter.[23] After this property was taken from Dar'ia during the final stages of the Time of Troubles, she lost no time in approaching the new tsar, Michael Fedorovich, in 1614 with a petition to grant her compensation. Michael Fedorovich's donation charter from August 26, 1614, for the

village Nikiforskoe, to which a long list of hamlets was attached, was issued to the "nun Dar'ia, tsaritsa of the lord tsar and Grand Prince Ivan Vasil'evich of all Russia in blessed memory." The wording of the document indicates that the nun had invoked her kinship ties to the Romanov tsar's own royal relative, Ivan IV.[24] Dar'ia was to have full possession of the property, which was part of Michael Fedorovich's own crown villages, for life; but she was not allowed to bequeath it to her relatives or to a monastic institution for the commemoration of her soul.[25]

Encouraged by the success of her petition, Dar'ia apparently decided to exploit her favorable standing with the tsar still further. In another charter to her, which dates from March 28, 1616, Michael Fedorovich stated that she had again petitioned him, this time with regard to the village Nikol'skoe in the Belozerskii district that Ivan IV had given to her and that later had been taken from her. Dar'ia had presented Ivan's charter with Boris Godunov's and Vasilii Shuiskii's signatures and, along with it, Michael's present charter for the village Nikiforskoe. According to the charter, the royal nun had insisted that the same rights that had been applied to the previous property should also accompany the present deed.[26] Michael Fedorovich justified his eventual decision to comply with the nun's request and to grant her immunity from taxes and dues, along with extensive rights of justice, by pointing to his respect for the wishes of her late husband, Tsar Ivan.[27]

There may have been other reasons why Dar'ia gained so much from the succeeding dynasty. Although his two charters are silent on the matter, the tsar's generosity may have been influenced by his awareness of the experience of his mother, Marfa Ivanovna, who had shared Dar'ia's fate of forced tonsure. Marfa—who played an important role in the affairs of her son's government before June 14, 1619, when his father, Filaret, returned to Moscow from Polish captivity—may well have found it useful to strengthen her and her son's authority by maintaining ties with relatives of the previous dynasty who, themselves childless, could not represent a threat to the new royal line.[28] In the end Dar'ia clearly benefited from the early Romanov dynasty's need for legitimacy; after Filaret's return to Russia, the tsar and his father jointly confirmed Michael's previous charters to the nun of Tikhvin on July 4, 1621.[29]

If the new dynasty on the Russian throne appeared kindly disposed to the surviving Rurikide tsaritsy, the royal nun Dar'ia was quick to seize the opportunity to further her economic advantage. When the Swedes occupied Tikhvin and destroyed the Monastery of the Presentation of the Virgin in 1614, Dar'ia was forced to flee with her nuns to the town of Ustiug Zhelezopol'skii. A letter Dar'ia wrote to Boyar Boris Mikhailovich Saltykov in 1615 refers to a charter that Michael Fedorovich and his mother had sent on her behalf to the local authorities in Ustiug in the previous year. According to this charter, the royal nun and her companions

were to be given monastic cells and other buildings as needed. In 1615 the tsar and his mother reissued their charter to Dar'ia, noting that she was to receive the same amount of money and supplies as in the previous year. When Dar'ia met with resistance to her requests among the Ustiug authorities, she did not hesitate to call on Saltykov, a relative of Marfa Ivanovna's, to ask that he intercede with the tsar and his mother on her behalf. She informed Saltykov in detail about the absence of supplies and about her tight living quarters. She even expressed her wish that the royal authorities might force one of the inhabitants of Ustiug to sell her the houses in which her servants were staying so that she could tear them down and erect new, larger ones to serve her needs.[30]

Dar'ia seems to have used her connection to the Muscovite court in her dealings with local officials. Although the tsar's answer to her petition is not known, the royal nun apparently succeeded in her quest to buy land in Ustiug Zhelezopol'skii. In October 1616 she acquired from the monk Anton of the Ustiug Zhelezopol'skii Monastery of the Resurrection a garden plot that had lain adjacent to her own yard.[31] In 1617, when the town elder of Ustiug Zhelezopol'skii accused some of Dar'ia's peasants of several robberies involving livestock and horses, she petitioned to Moscow on behalf of her men.[32] Her letter implies that the official treated Dar'ia's servants poorly because she previously had lodged a complaint to the tsar against his brother concerning another case of property acquired illegally.[33]

Dar'ia's frequent correspondence with the tsar's court in Moscow served the purpose of impressing on the monarch the importance of maintaining kinship ties with members of the previous ruling family. The success of this strategy is evident in an order Michael Fedorovich issued on January 11, 1624, to a member of the upper service class, Prince Daniel Grigor'evich Gagarin, to go to Ustiug with a royal charter for Dar'ia and a gift of one thousand herring. Daniel Grigor'evich then was to accompany the royal nun and the remaining sisters back to Tikhvin and to make sure that the authorities in Ustiug provided the necessary means for the journey. Upon completion of his mission, he was to bring a written response by Dar'ia back to Moscow.[34]

After resettling in her monastery, Dar'ia anxiously upheld her kinship connection with the Romanov court. When Michael Fedorovich married Maria Vladimirovna Dolgorukaia in 1624, he dispatched to Tikhvin a member of the upper service class and a relative of hers, Dmitrii Koltovskii, who brought her a kerchief, a pall, and a share of the traditional foods served at the wedding banquet—the ritual wedding cake and cheese of which the newlywed couple partook. In his account of the conditions at the Muscovite court in the seventeenth century, Grigorii Kotoshikhin, a former clerk in the Russian Foreign Office, notes that it was customary for royal brides to hand out embroidered ritual towels as gifts during

the tsars' weddings.[35] The foods sent to Dar'ia symbolize the royal family's acknowledgment of Dar'ia as a valued relation of the royal family.[36] In a return letter to Michael Fedorovich, the nun expressed her gratitude to the tsar for the prestigious gifts and assured him that as the tsaritsa of Ivan IV, she would pray for his health and long life.[37]

Dar'ia's letter makes clear that the royal nun strove to be on good terms with the Muscovite court and manipulated this relationship to enhance her social status. At the same time, the correspondence between Tsaritsa Dar'ia and the Romanovs also testifies to the respect in which the Romanov dynasty held previous royal wives, no matter the circumstances under which they had lost their position at court. The reasons for this respect are not difficult to ascertain. The tsar's wedding not only presented the realm with a new royal couple that would take on the leadership of Russia but also represented a period of nervous transition when kinship groups realigned at the court.[38] Under the circumstances, the support offered to the tsar's family by the prestigious but politically harmless Rurikide tsaritsa-nuns must have been welcomed. In Dar'ia's case the Romanovs repeated their ritual gift-giving during Michael Fedorovich's second marriage to Evdokiia Luk'ianovna Streshneva. When, after the ritual combing of the couple, a kerchief, a pall, baked goods, and cheese were sent to the tsar's father and mother as wedding gifts, a package of similar presents was dispatched to Tsaritsa Dar'ia.[39] Within the context of this highly ritualized ceremony, the fact that the nun received nearly identical gifts as the royal parents suggests that she was considered part of the family.

The close relations that Dar'ia fostered with the Romanovs seem to have been carefully calculated on her part. After her arrival in Tikhvin, the royal nun immediately set about reestablishing control over her property. When in 1624 Stepan Bogdanov, son of Zabelin, was late paying dues for his service land in Petrovskii district, Dar'ia forced him to stop causing her tax collectors delays and to make up for any financial losses she had incurred in the matter.[40] Dar'ia then used her connection with the new royal dynasty to improve the infrastructure of her monastery, which had suffered damage during the incursion of the Swedes. In 1626 she petitioned the tsar for more land on which to maintain animals and from which to acquire firewood. Michael Fedorovich fulfilled her wish in honor of Tsar Ivan IV, whom he fondly referred to as his grandfather, granting Dar'ia and her monastery a charter for property to be held in permanent usage.[41] The nun lost no time in using her new income to rebuild the monastery; her will, which she had drawn up in March 1626, shortly before her death, mentions repairs on the cells and outbuildings.[42]

The content of Dar'ia's testament gives us further insight into the Rurikide nun's ability to exploit royal prestige for the benefit of her own kin and her

beloved fellow nuns. The will was composed in the name of the "Mistress Tsar-itsa, Tsaritsa of Grand Prince Ivan Vasil'evich of all Russia, and nun Dar'ia."[43] This styling implies that she was not interested solely in a disposition of a spiritual na-ture. She made elaborate arrangements for her burial and commemoration, which included the distribution of alms among the needy and the allotment of moneys to her own institution and numerous monasteries and churches in the areas of Tikhvin and Beloozero, the Solovetskii Monastery in the White Sea, and the Antoniev Monastery in Novgorod. In addition, she appointed the abbess of the Monastery of the Presentation of the Virgin in the Temple in Tikhvin and her own two nieces—Princesses Leonida and Aleksandra, daughters of Grigorii Gagarin and sisters of Daniel Gagarin, who had accompanied the nuns back to Tikhvin in 1624—to execute her property arrangements. She instructed these women, with whom she had shared her life behind monastic walls, to collect after her death the various sums of money that she had loaned to local peasants and an icon painter and to place them in the monastery's community treasury.[44]

The most important disposition of Dar'ia's will, however, concerned the vil-lage Nikiforskoe, with its numerous hamlets that Michael Fedorovich had granted her outright in 1614. Ignoring the tsar's stipulation that she was not to bequeath this property to any of her relatives or to a monastic institution for the com-memoration of her soul, Dar'ia ordered that it be handed over to the Monastery of the Presentation of the Virgin, to her two nieces, and to Abbess Agafiia.[45] The nun's blatant disregard for the restrictions on Michael Fedorovich's grant might at first glance be interpreted as an act of folly, but Dar'ia's warm relations with the tsar's family may have given her good reason to hope that the tsar would rescind his original stipulation. Counting on her ability as Ivan IV's tsaritsa to bolster the Romanov tsar's claim to dynastic legitimacy, the royal nun manipulated her eco-nomic arrangement with the Muscovite ruler to reward her own friends and fam-ily members in the cloister. If Michael Fedorovich valued her support, he would have been considered ungenerous if he had annulled the nun's will.

The tsar's reaction to Dar'ia's testament, which her two nieces and Agafiia presented to him a few months later, bore out the royal nun's expectations. In a charter dating from June 29, 1626, Michael Fedorovich approved Dar'ia's prop-erty transactions in her testament "for the sake of her soul" and willed the crown village Nikiforskoe with extensive rights of justice and exemptions from taxes and dues to the Monastery of the Presentation of the Virgin in the Temple in permanent possession.[46] The reason for the tsar's decision to countersign this will is easily surmised from his reference to her as "the nun Dar'ia, tsaritsa of our grandfather in blessed memory, the lord tsar and Grand Prince Ivan Vasil'evich of all Russia."[47] As in his charter from January 3, 1626, Michael Fe-dorovich's allusion to his great uncle Ivan IV as his grandfather clearly implies

that he sought to tighten his association with the illustrious first Russian tsar and was willing to accommodate the living and dead female relatives who supported his claim of dynastic continuity. For the same reason, the tsar also saw to it that Dar'ia's name would be entered into the memorial registers of her monastery in order that she be properly commemorated.[48]

A study of the wives of Ivan IV and Ivan Ivanovich who had been sent into monastic seclusion before giving birth to an heir to the throne shows that neither their monastic status nor their lack of royal offspring precluded them from enjoying the respect and prestige usually accorded the wives of Russian rulers. Further expression of the continued association of Ivan IV's and Ivan Ivanovich's royal wives with the Muscovite ruling dynasty can be discerned from their treatment after death: these women were usually buried in the royal women's monastery in the Kremlin, the Monastery of the Ascension, unless they had made other arrangements.[49] No longer directly involved in the politics of the court, they were offered the possibility to carve out a life of their own. Often they continued to maintain a network of relationships with female kin that included other Rurikide tsaritsy. Some of them—such as Evdokiia Saburova, the first wife of Ivan Ivanovich, and Anna Koltovskaia (Dar'ia)—directed their energy toward their new monastic home, which they sought to endow with property and legal rights. In their efforts to act as patrons of their monastic institutions, they frequently resorted to their old social ties with the Muscovite court. As a result, these monastic royal women continued to enjoy a certain degree of visibility and, along with it, social prestige.

Social prestige assumed a particular importance with the Muscovite rulers after the demise of the Rurikide line, when the royal nuns could convey a sense of dynastic continuity. The monastic royal wives began to turn the respect they enjoyed with the various ruling houses to their own advantage by urging the powerful men to honor the economic and legal privileges their predecessors had conveyed to them. In Dar'ia's case, this royal nun skillfully exploited the fledgling Romanov dynasty's need for legitimacy to recover her own property lost during the Time of Troubles, to bequeath it to the monastery of her choice, and to ensure the financial security of female relatives and friends.

Notes

1. Whenever possible, Russian first names are anglicized. In all other cases, names are transliterated according to the Library of Congress system.

2. Possevino 1977, p. 13. Ivan Ivanovich's first wife, Evdokiia Bogdanovna Saburova, already had been sent to the Suzdal Pokrov Monastery; his second one, Praskoviia

Mikhailovna Solovaia, had been banished to a monastery in Beloozero in the Russian north. Both women lived a long time and died in the same year, 1620. Ivan Ivanovich's third wife, Elena Sheremeteva, did not fare much better. One day, when Ivan IV entered the royal women's quarters, he found his pregnant daughter-in-law lightly dressed. To punish her moral laxity, the tsar struck her, which led to the quarrel between Ivan IV and his son that resulted in Ivan Ivanovich's death. The tsaritsa ultimately miscarried and was removed to the Novodevichii Convent outside Moscow (see Possevino 1977, pp. 48, 12–13).

3. For instance, McNally refers to the later wives of the first official Russian tsar as the "nameless pitiful wives of Ivan IV" (McNally 1976, p. 7).

4. On this point, see Thyrêt 2001, pp. 48–51.

5. Begunov 1970, p. 116.

6. PSRL, 24:222–23; Nasonov 1969, pp. 391–92. For a detailed discussion, see Thyrêt 2001, pp. 34–39.

7. PSRL, 34:204 (Piskarev Chronicle).

8. For the date of Ivan's third wedding, see Tikhomirov 1979, p. 259.

9. For Ivan IV's various wives, see D. Kaiser 1987, pp. 249–50; Skrynnikov 1975, pp. 208–13; PSRL, 34:194 (Piskarev Chronicle). For genealogical charts of the Muscovite rulers and their women, see Thyrêt 2001, pp. 181–83.

10. AAE, vol. 1, no. 333, p. 402; also see RIB, vol. 32, cols. 644–45. Several thousand pounds more were willed to the Pokrov Monastery. For a definition of the Russian weight measure chetvert' that is used in the source, see Hellie 1999, p. 646.

11. AI, vol. 1, no. 218, p. 414.

12. AI, vol. 1, no. 218, p. 415.

13. AI, vol. 1, no. 218, p. 415. On Muscovite nuns' ability to manage their own property, see McNally 1976, p. 124; Eck 1962, p. 413; Thomas 1980, pp. 92–112; Thomas 1983, pp. 235, 241.

14. AI, vol. 1, no. 218, p. 415.

15. Georgievskii 1910, pp. 7, 16. The tsaritsa also donated to her monastery icons of the Savior, the Virgin of the Sign, the Prophet Elijah, John the Theologian, and the Virgin of Georgia (Georgievskii 1910, pp. 7, 12, 13, 16). The icon of Saint Nicholas with its accompanying shroud and the image of the Savior are reproduced in Georgievskii 1927, plates XVIII, III.

16. According to the records of the Novodevichii Monastery, Elena Ivanovna Sheremeteva is commemorated on May 3, the feast day of Saints Timofei and Mavra (see Koretskii 1985, p. 195).

17. AI, vol. 4, no. 166, pp. 316–21.

18. Maiasova 1973, p. 141.

19. See Tikhomirov 1979, p. 238. According to the Englishman Sir Jerome Horsey, who spent large periods of time in Russia from 1573 to 1591 engaged in business and diplomatic activities, Maria had little inclination to return to Muscovy, since she feared that

upon her arrival she would be put away in a monastery (Berry and Crummey 1968, pp. 315–17).

20. On this point, see Thyrêt 2001, pp. 80–103.

21. For the mysterious circumstances of the death of Maria's daughter, see the remarks of Giles Fletcher, Queen Elizabeth's ambassador to Russia in 1588–89, and of Jerome Horsey in Berry and Crummey 1968, pp. 129, 317. On Maria Vladimirovna, see PSRL, 34:191 (*Piskarev Chronicle*); Tikhomirov 1979, p. 238; Tokmakov and Smirnov-Platonov 1885, p. 5.

22. *Pis'ma russkikh gosudarei*, vol. 1, no. 181, p. 315 n. 27.

23. *AI*, vol. 1, no. 217, pp. 413–14.

24. *AI*, vol. 3, no. 41, p. 37. Ivan IV's patronymic was Vasil'evich.

25. *AI*, vol. 3, no. 41, p. 38.

26. *AI*, vol. 3, no. 67, p. 61.

27. *AI*, vol. 3, no. 67, p. 62.

28. Vasenko 1912, p. 189. On Marfa Ivanovna, see Thyrêt 2001, pp. 116, 120–21.

29. *AI*, vol. 3, no. 67, p. 63.

30. Berednikov 1829, pp. 334–37, 341 n. 1.

31. *RIB*, vol. 35, col. 437.

32. Berednikov 1829, pp. 338–41.

33. Berednikov 1829, p. 340.

34. Berednikov 1829, pp. 341–42 n. 1.

35. Kotoshikhin 1988, p. 23. On Muscovite royal weddings, see D. Kaiser 1987, pp. 247–62.

36. On this point, see D. Kaiser 1987, p. 252.

37. *Pis'ma russkikh gosudarei*, vol. 1, no. 181, p. 140; SGGD, vol. 3, no. 69, p. 274. The letter dates from October 1624.

38. For the choreography of Muscovite royal weddings, see R. Martin 2004, pp. 794–817.

39. SGGD, vol. 3, no. 72, p. 283. The ritual combing occurred on the first day of a traditional Russian wedding. After the groom's arrival at the bride's home, the matchmaker combed the bride's hair and decorated the heads of her and the groom with sable pelts (see D. Kaiser 1987, p. 252).

40. *RIB*, vol. 35, col. 655.

41. *RIB*, vol. 35, cols. 671, 672.

42. Erdman 1851, p. 53. For Dar'ia's death date, see PSRL, vol. 14, pt. 1, p. 153 (*Novyi letopisets*).

43. Erdman 1851, p. 61.

44. Erdman 1851, pp. 62–63.

45. Erdman 1851, p. 62.

46. *AI*, vol. 3, no. 142, pp. 230–34. The charter was renewed by Tsar Aleksei Mikhailovich in 1646, Tsar Fedor Alekseevich in 1677, and Tsars Ivan and Peter Alekseevich in 1686 (*AI*, vol. 3, no. 142, pp. 233, 234).

47. *AI*, vol. 3, no. 142, p. 230.

48. *AI*, vol. 3, no. 142, p. 231.

49. The last wife of Ivan IV, Maria Fedorova Nagaia, and Ivan Ivanovich's first two wives were buried in the Monastery of the Ascension although their husbands had previously removed them from the Kremlin by forced tonsure (see *PSRL*, vol. 14, pt. 1, p. 150 [*Novyi letopisets*]; *DRV*, 11:238, 240).

9 | SERVANTS OF THE INNER QUARTERS

The Women of the Shogun's Great Interior

Hata Hisako

Sometime in the 1840s, a messenger in the shogun's service named Fujinami sent the following letter to her family: "As for having your acquaintance's fourteen-year-old daughter placed with me, it would be all right if it's only for one or two years because I have the leeway to cover the costs. Once you've brought her to Edo, you should first have her get used to the city at great-aunt Gyōzen's house. After that I'll take care of her here. Please have her bring her nightclothes with her."[1] Fujinami made a career of working for the shogun; bringing this young woman into the palace was one way of recruiting new staff. In the common parlance of the time, they were called servants of the inner quarters (*oku jochū*) or palace women (*goten jochū*).

Fujinami lived and worked in women's quarters for the Tokugawa shoguns called the "Great Interior" (*ōoku*). Although the term has often been employed as though it were singular, even in Edo Castle, where the shogun lived, there were three great interiors for the main enceinte, the west enceinte, and the second enceinte. Daimyo divided both their castles in the provinces and their residences in Edo into outer and inner quarters. Like the shoguns, some of them set up a middle interior for their own living space, and they too used the term *ōoku* to distinguish the women's quarters. Bevies of female servants and staff filled these women's quarters, the quarters set aside for women in the residences of the shogun's chief retainers, and the women's quarters in the mansions of the Kyoto aristocracy.

Translated by Anne Walthall.

When "servants in the inner quarters" are mentioned, the first people who come to mind are the concubines who gave birth to children in place of the shogun's wife.[2] In fact, concubines constituted a subset of the female servants who were attendants, performing services related to their master's physical well-being or partnering their master in scholarship and the arts. Those on the administrative track took care of office management and political negotiations just as male officials did. Every woman who worked in the inner quarters had to have a master in whose name she was employed. Because she filled an office attached to the shogun, Fujinami received an income from the Tokugawa shogunate, as did servants attached to members of the shogun's family who lived and worked outside the castle.

By the time Fujinami started working in Edo Castle around 1837, the Tokugawa shogunate had ruled Japan for more than two hundred years. Founded in 1603, it developed administrative structures, including those for the Great Interior, by the middle of the seventeenth century. The eighth shogun Yoshimune oversaw their reform in the 1720s. One result was a diminution in the power of concubines, to the advantage of wives and administrators. This essay focuses on the period after Yoshimune's reform, on the Great Interior of Edo Castle, and on the women who worked for the shogunate. Topics include the extent to which women remained secluded from men, the scope of the shogun's family and staff, the types of women who sought service, and the opportunities open to them. Using letters and other documents, I will trace the careers of Fujinami and some of her contemporaries for a close look at how women felt about living and working in the Great Interior.

How Secluded Was the Great Interior?

Located in the main enceinte of Edo Castle, the Great Interior shared space with the outer quarters and the middle interior.[3] The outer quarters included ceremonial halls and guard rooms for the daimyo; the shogun lived his daily life and handled important affairs of state in the middle interior. Between it and the Great Interior was a door called "the locked gate" (ojōguchi) that opened onto the bell corridor.[4]

The Great Interior can also be divided into three types of space. That called the *palace proper* contained living quarters for the shogun's wife and offices for the servants. Separate administrative offices provided space for male officials to do office work and guard the Great Interior. The apartments that housed the female staff were lined up two stories tall, with long corridors sandwiched between them and myriad rooms on either side. Women of high rank and status got their own rooms; all others had to share.

It is often said that the only adult male allowed to enter the Great Interior was the shogun, but this is not entirely accurate. Administrative offices inside the Great Interior provided space for men. Male doctors and painters attached to the inner quarters could enter the palace proper as the occasion required, and it also contained a boardroom where the senior councillors and senior women met for formal interviews.[5] When these officials wanted to speak to each other informally or exchange information, they might also meet at the locked door at the end of the bell corridor.

Male doctors spent considerable time in the Great Interior. They were kept especially busy during the reign of the eleventh shogun Ienari because the births of lots of daughters meant frequent sickness and deaths. No other shogun matched his prowess at propagation. The shogun's wife had to have a medical examination at regularly scheduled intervals regardless of whether she was sick. When the children too had their medical checkups, the doctors reported the results to the senior women attached to them. The doctors also had an audience with the shogun and his wife at the reception room in the palace proper on ceremonial days. On these occasions, as a matter of course they had to come face-to-face with female attendants, who sat in rows to either side.

Generally speaking, men did not enter the apartment zone. The only exceptions were workmen making repairs or doctors performing medical examinations on those who were severely ill. For the forerunner to the modern Dolls Festival held at the beginning of the third month on the first day of the serpent, servants of the inner quarters could invite their female relatives and friends into the Great Interior to see the display of dolls. The female staff employed male menials to take letters to their guarantor or parent and to buy goods. They interacted with these menials at the gate that closed at 4 P.M. Fujinami made use of such a domestic servant to carry letters to her brother and to arrange for the shipment of goods.

Despite these exceptions, access to the Great Interior in Edo Castle was more strictly regulated than to the daimyo's inner quarters. In addition, the shogunate placed restrictions on servants' excursions, limiting their opportunities to leave the castle. Unlike in previous dynasties, the outer male quarters and the inner female quarters kept separate the performances of the yearly round of ceremonial observances. All in all, the Great Interior maintained a high degree of seclusion, even in comparison with the women's quarters of other countries.

Who Lived in the Great Interior?

The shogun's family, his wife and children, lived in the palace proper. When the shogun's mother was alive, she too lived there. This definition is the starting point

for gaining a sense of the scope of the shogun's family. First, let us consider permutations in the positions of wives, concubines, and mothers. Beginning with the third shogun Iemitsu, it became the custom for the shogun's wife to come from the imperial family, a prince's family, or an aristocratic family in Kyoto. But with the exception of Iemitsu's mother, Eyo, the shoguns' mothers were concubines.[6] In the hierarchy of female staff, concubines ranked as attendants called chūrō. Even if they gave birth to children, they were never more than servants. A concubine might move from the position of being employed (the status of servant) to the position of being the employer (as a member of the shogun's family) only if the son she had borne became the shogun.

Even when the shogun was adopted from another branch of the Tokugawa family, his mother would be welcomed into Edo Castle. This happened with Jōen'in, mother of the eighth shogun Yoshimune, and Jitsujōin, mother of the fourteenth shogun Iemochi. But the eleventh shogun's mother, Otomi, was not allowed to live in Edo Castle following her son's adoption in 1787. Otomi was the concubine of Ienari's father, Hitotsubashi Harusada. She died in the fifth month of 1817 at the age of sixty-five, and Harusada died ten years later in the second month of 1827. In other words, she was prevented from entering the palace because Harusada lived longer than she did, and her first obligation was to him. Only after the father of a concubine's child had died would she receive a temple name (in) and be allowed to assume the position of employer.

Let us turn to the shogun's children. When the shogun's heir reached the right age, he moved to the western enceinte and took a wife called "the woman behind the screens." The few shoguns who lived long enough to retire then traded positions with their heirs and moved with their wives to the western enceinte. Male children who did not become the shogun's heir left Edo Castle to succeed to other houses. After that time, they were no longer considered to be part of the shogun's family.

In contrast, girls remained the shogun's daughters first and foremost. Even after marriage they were treated as members of the shogun's family and titled "princess." A princess always had more than fifty female staff attached to her; they accompanied her when she moved at marriage to her new home in a daimyo residence and remained employees of the shogunate. For this reason, it can be said that the shogunate's female staff could be found even outside Edo Castle.

Let us turn now to the servants who lived in the apartments and worked in the palace proper of the Great Interior. They might serve one of several masters, ranging from men such as the shogun or his heir to women such as the shogun's wife, the heir's wife, or a princess. In most positions, several women served at a time, and in addition each might have a chief, an assistant, and apprentices. Listed in table 9.1 are the approximately twenty staff positions from the senior

TABLE 9.1 Positions in the Great Interior

Title of Position	Japanese Term
Senior matron	Jōrō toshiyori
Elder	O-toshiyori
Chamberlain	O-kyakuashirai[1]
Wife's proxy	Chū-toshiyori[2]
Attendant	O-chūrō
Page	O-koshō[2]
Guardian at locked door	O-Jōguchi[1]
Transaction agent	Omote tsukai
Secretary	O-yūhitsu
Companion	O-tsugi
Inspector	O-kitte-gaki
Female monk	O-togi bōzu
Wardrobe	Gofuku no ma
Welcoming committee	O-hirozashiki
Maid-in-waiting	O-san no ma
Cook	O-Nakai
Fire Warden	Hinoban
Tea server	O-cha no ma[2]
Messenger	O-tsukaiban
Drudge	O-hanshita

[1]Position attached only to the shogun.
[2]Position attached only to the shogun's wife.

matron at the top to the drudges. Only women who served on the welcoming committee and above had the right of audience with the shogun's wife. Maids-in-waiting and below did not. Fujinami ranked near the bottom.

The elders ran the whole show. They made the final decision on all matters that pertained to the Great Interior and supplied instructions to everyone beneath them in rank. Transaction agents handled business affairs under the elders' direction, and since they were also in charge of managing outside relations for the Great Interior and of purchasing needed goods, theirs was a lucrative position. Drudges had to be strong, because in addition to cleaning and drawing water for the kitchen and baths, they had to carry—from the entrance of the male administrative offices into the interior—palanquins that bore the shogun's wife and also princesses and daimyo's wives whenever they visited Edo Castle.

The drudges constituted the lowest rank of servants in the inner quarters who received their salary directly from the shogunate. Women employed by female officials to take care of their needs also lived in the Great Interior.

It is not easy to estimate how many women the shogunate had to support. Generally speaking, the larger the shogun's family, the larger the number of women in the shogunate's employ. In addition to the women in the Great Interior at Edo Castle, we have to remember those attached to each princess who had married into a daimyo family, although documentation regarding their number is scarce. The staff swelled to its largest size during the retirement of the eleventh shogun Ienari, because there had to be separate female staffs attached to the retired shogun, Ienari; his wife, Tadako; the shogun, Ieyoshi; his wife, Sazamiya; the shogun's heir, Iesada; and Ienari and Ieyoshi's daughters.

Let us look at the numbers of palace women for just the Great Interior in the main enceinte. In 1778, 162 women were attached to the tenth shogun Ieharu. In 1797, Ienari employed 171 women; his wife Tadako employed 69; his daughter, Princess Hide, employed 32; and his son Atsushinosuke employed 19, for a total of 291. In 1854–58, the thirteenth shogun Iesada employed 185 women, his wife employed 60, and his mother, Honjūin, employed 41 for a total of 286.[7] In the case of Ieharu, his wife had already died, and Ienari, his heir, had moved to the western enceinte; thus the only women living in the Great Interior were those attached to the shogun. In Ienari's case, since his eldest daughter, Princess Hide, did not marry into the Owari daimyo family until 1799, she still had her own staff in the Great Interior. In Iesada's case, his mother Honjūin was still living, and so she too had her own staff in addition to the women serving Iesada and his wife.

In order to estimate the total number of women who lived in the apartments of the Great Interior for just the main enceinte, we need to add in the retinues for the female officials. Their salaries came out of the allotments for the women employed directly by the shogunate. We can assume that if there were 185 female officials serving in the inner quarters, then there must have been about 200 more women serving in their retinues. At times when only the shogun and his wife lived in the main enceinte, each would have had about 180 and 70 women, respectively, attached to them. If we then add in the number of women in the retinues of these attendants, we can adduce that the Great Interior must have contained more than 500 women.

How much space did these 500 women occupy? When the buildings in the Great Interior were rebuilt in 1845, the overall dimensions were 20,887 square meters. The apartments accounted for fully two-thirds of this area. In addition to what were deemed regular apartments, of which there were one hundred, there were five large dormitory-like rooms for the drudges. The apartments

varied greatly in size. The elders had apartments seventy tatami mats in area where they lived with the retinues that they themselves employed. Women at the rank of secretary and above had their own apartments; companions and below lived two to an apartment; the cooks, fire wardens, and lower guards were four to an apartment; and then there were the drudges, who really had to crowd in. As Fujinami noted in one of her letters, "I'm living in an apartment with as many as four other women."

Life cannot have been easy in such cramped quarters. We do not know exactly when it happened, but at one point Fujinami found herself caught up in a feud. As she explained in a letter to her younger brother Ikusaburō, she was on the second floor of her apartment when she was involved in a shouting match. This altercation made it impossible for her to continue living where she was. In the end the dispute ended without further incident when the transaction agent Murase stepped in to mediate. Fujinami was writing Ikusaburō to ask him to send a bag of white rice to Murase as a thank-you present.

Fujinami: A Case History

Born in 1811 in the farming village of Hirai (now Hinode township in western Tokyo), Fujinami, originally named Tora, was the daughter of Noguchi Kinbei, a trooper in the thousand-man guard headquartered at Hachōji. Largely made up of former retainers of the Takeda family from Kai province, the guard served as a peacekeeping force of rusticated samurai (gōshi) directly under the shogunate. Great-aunt Gyōzen (a retirement name), still working as a chief messenger attached to the retired Ienari when Fujinami entered service around 1837, provided Fujinami with the foot in the door she needed to work in the Great Interior. Fujinami too served as a messenger attached to Ienari. After his death, she managed to attach herself to the twelfth shogun Ieyoshi, and then to shoguns Iesada and Iemochi. The letters that Fujinami wrote from the Great Interior to the Noguchi family and to Gyōzen after she moved to Edo's Shitaya district have survived to this today. They offer an unparalleled look at the issues that concerned servants.

Although messengers ranked so low that they did not have the right of audience with the shogun's wife, they performed a variety of tasks, some of which could be quite lucrative. They accompanied the elders who acted as the wife's proxy in making pilgrimages within the city and performed low-level chores for the transaction agents. On an everyday level, they served in the guard office, took charge of opening and shutting the locked door between the women's quarters and the male administrative offices, negotiated with male officials, and guided visitors to various reception rooms. They also handed over passage permits to retinue staff and checked the papers of people going in and out the

4 o'clock gate between the male administrative offices and the apartments that opened around 8 A.M. and shut around 4 P.M. Since they were also involved in the issuance of licenses and name tags to male menials and official purveyors, they were said to get rich by accepting bribes from merchants.

In order to obtain even this lowly position, Fujinami apparently had to embellish her origins. On the "Register of Women Serving in the Great Interior" compiled in 1854, her name is listed fourth among the messengers attached to Iesada. Her guarantor is listed as her younger cousin Noguchi Ikusaburō in the division under the command of Kubota Kanesaburō of the Hachiōji thousand-man guard, and her place of residence is given as Hachiōji. Her brother has thus become her cousin, and Hirai village has become Hachiōji city. In letters to her brother she wrote, "It wouldn't do to tell other people that I am your elder sister. Since I have exaggerated a little on where I'm from, I want you to keep that in mind when you come to Edo."

Given these circumstances, it is not surprising that Fujinami wrote her mother in a panic when the fire warden Yasoji planned to visit Fujinami's house:

> I've never been honest in telling my colleagues where I'm from. For that reason, everyone thinks I'm not from Hirai village but from Sennin-chō in Hachiōji [where the head of the thousand-man guard and the division chiefs lived]. Since I've become friendly with Yasoji and she's done a lot for me, it would be bad for my reputation if what you say turns out to be different from what I've been saying all along. For the sake of consistency please say that as a child I was raised in Ryōgoku, and after that I entered Edo Castle. Only after my position changed did I end up using relatives in the Sennin-chō of Hachiōji as my guarantor.

In a postscript Fujinami also warned her mother against summoning the filthy brats in the neighborhood to meet Yasoji. Women often exaggerated their male guarantor's status when they went into service. A guarantor's rank tended to affect how women related to one another, and they had to spend much time together.

In 1858, Fujinami flew into another panic along with everyone else in the Great interior when the thirteenth shogun Iesada died unexpectedly. Almost at once a rumor spread that he had been poisoned. By this time Fujinami had been serving in the Great Interior for twenty-one years, and she was forty-eight *sui* (age counted from the first new year after birth). She immediately sent her brother Ikusaburō a letter showing just how keenly she had been affected:

> Iesada died at the age of thirty-five about 4 A.M. on the sixth day of the seventh month. This was such a sad event that I haven't been able to stop crying. All of

my friends and I are really worried about what will become of us. I don't know whether I can do it or not, but I really want to continue working as I've been doing up to now. At my age, there won't be any talk of marriage or any chance of finding another position. I don't think Iesada's death will be made public until the end of this month or possibly next month. This is something secret for your ears alone, but we are all guessing that members of the Hitotsubashi faction conspired together and got the doctor to prescribe him poison.

Similar rumors often circulated at such times. Its rapid sweep through the Great Interior shows that the servants did not think well of the faction pushing Hitotsubashi Yoshinobu, adopted from the Mito house, to be the next shogun.

Under ordinary circumstances, Fujinami should not have written such a letter to her brother at all. She wanted him to have the news as soon as possible, because the shogun's death might also have an impact on troopers in the Hachiōji guard; but regulations forbade her to record anything in a letter regarding work or political affairs. To make sure these regulations were obeyed, officials inspected the letters and packages sent out of the Great Interior by the servants. Despite these obstacles, Ikusaburō's receipt of Fujinami's letter reporting Iesada's death shows that the messengers developed good relations with male officials in the course of their official functions and that scrutiny had become lax in the shogunate's last decade.

Fujinami's final years were difficult. After Iesada's death, the servants attached to him faced the threat of dismissal. Fujinami asked her family to pray to the gods and buddhas that she be permitted to continue in her current position. Fortunately for her, permission was granted, but her health gradually deteriorated. When she had trouble with her personal relationships, she came to envy the casual life of her family in the country. In succeeding years she lost all of her belongings in the fires that swept repeatedly through Edo Castle, she was unable to save as much as she had expected, and thus, with one thing and another, she was never able to retire.

Recruiting Women to Work in the Great Interior

What kinds of women were allowed to work in the Great Interior, and why did they seek employment? As it turns out, regardless of the hereditary social status system designed to keep everyone firmly in place, Kyoto aristocrats, women from military families, townswomen, and even peasant women all found work in the palace. They entered it for different reasons and stayed for varying periods; but while they were there, they lived in close contact with women they would have otherwise never known.

Kyoto aristocrats accompanied the shogun's wife when she traveled from Kyoto to marry the shogun. They immediately took the highest positions as senior matron and apprentice matron. At the time of the Meiji Restoration, it was deemed outrageous for an aristocrat to serve a warrior, and the position of matron was therefore abolished.

Daughters of the samurai or shogunal retainers such as Fujinami had a different motivation. A book that appeared during the Edo period titled *A Hand Mirror for Servants of the Inner Quarters* provides several rationales for why women decided to seek service in the palace.[8] One reason was "My family is so poor that there is no money to bring me up. I had no choice but to seek work." This applied to many daughters from the families of shogunal retainers, particularly women who spent their entire lives working in the palace.

In contrast, women from merchant or peasant backgrounds were more likely to seek work in the palace if they came from wealthy families. For these women, work in a military household carried the connotation of high-class education. Board games popular during the Edo period provide pictorial evidence that happiness for women consisted of receiving such an education, which enabled them to make a good match and have children. Women of this sort did not plan to spend their entire lives working in the palace. Instead, the ideal pattern was for them to spend several years acquiring work experience before marriage; then, once the marriage arrangements reached a satisfactory conclusion, they would happily apply for dismissal. The term for dismissal literally meant "taking one's leave," and it could be used of a temporary leave of absence as well as permanent retirement.

There is a tendency to assume that no servant in the inner quarters had ever been married, but even wet nurses aside, such was not always the case. Consider the saying "Having learned a lesson from one husband, lifetime employment looks pretty good": clearly, another pattern for women was to work for a few years while young, take what they assumed to be a permanent retirement in order to get married, but then return to work when the marriage did not go well. In other words, they might use work in the inner quarters as a means of negotiating a divorce. For example, one of Fujinami's acquaintances named Kio worked in the inner quarters as a young woman before resigning in order to marry. She did not get along well with her husband's mother and younger sister, and so she left his house and found a new position in the inner quarters even before the divorce was finalized. It seems that working suited her personality, and she managed to rise to become a transaction agent for the Shimazu daimyo of Satsuma.

Most but not all of the women who experienced marriage before working in the Great Interior had once again become single through divorce or widowhood. The mother of Hisada Nobuyuki, male house elder for the Hitotsubashi

family, entered the Great Interior after her husband died. She became an elder and changed her name to Nakamura. While working there, she raised her son in her own apartment. Other women took positions in the Great Interior while still maintaining relations with a husband. In that case, they worked as servants because the husband did not make enough money to live on.

Before a woman could consider going into service, she had to acquire the basic skills of knowing not only how to read and write but also how to perform on an elementary level in dancing, singing, and music. The required attainments included mastery of the *samisen*, a popular three-stringed guitar; the *koto*, a type of zither; popular songs called *nagauta*; dance; and a type of chanting known as *joruri*. Undoubtedly this kind of training became popular after the middle of the eighteenth century because these performing arts had spread from the pleasure districts to military society. Especially for servants who served in close proximity to their master, they became indispensable accomplishments.

Since there were no examinations or formal credentialing process such as may be used by those seeking employment in a bureaucratic office today, women got positions in many cases through introduction by a woman, often a relative, who had previously been in service. It sometimes happened that a mother used her connections on behalf of her daughter, but since more than half of the women who worked in the inner quarters never married, the more common link was between an aunt and a niece. In farm villages intercessions might be made on behalf of not just a relative but also someone from the same neighborhood; Fujinami provided this kind of entrée for her parents' friend. Some people also make use of brokers, the equivalent of today's employment agencies. These brokers interceded with potential employers on behalf of people who flowed into the metropolis of Edo. Naturally they collected a fee for their services.

Another form of connection, besides that offered by women who had previously worked in the inner quarters and by brokers, was provided by businesses with ties both to the place of employment and to the family of the person seeking employment. In 1810, Tami, a daughter in the Yanagi house that dealt in striped fabric, rice, firewood, and charcoal produced in Ōme (now a western suburb of Tokyo), found a position in the Great Interior of Edo Castle through her uncle Yamada Sanae, who ran a home furnishings store in the Akasaka district of Edo and who served as the middleman and guarantor. Tami became a drudge attached to the eleventh shogun Ienari's son Naritaka. She resigned upon Naritaka's adoption into the Tayasu house and returned to Ōme, where she married. In 1812 the Yamada house received a license to serve as purveyor for the main enceinte in Edo Castle. This license gave Tami's uncle permission to go back and forth through the castle gates as needed for his enterprise. In other words, he got himself connected to the shogunate, with his niece's service in

the inner quarters and his purveyor's license functioning together in furthering his enterprises.

After using connections of various kinds to be considered for a position, candidates had to go through an official employment process as well. It consisted of an interview, followed by an inspection of the woman's residence, the presentation of family documentation, a move to the inner quarters, and the receipt of an appointment letter from the elder listing salary, name, and position. The interview was the equivalent of today's job interview, but in most cases it was just a formality because the unofficial decision already had been made. The guarantor, called a *yado* (a term that today conjures images of an inn or hotel but then also connoted the man owning such an establishment), indicated the person willing to take responsibility for the worker's good behavior. The family documentation is somewhat similar to today's résumé, except that it concerned itself not with the applicant but rather with her father or brother and his name and title. Sometimes the presentation of family documentation preceded the inspection of the future worker's residence.

Women who worked at the palace never used their original name. Instead, they received a name suitable for their position, and they sometimes took yet another name upon retirement. Attached to each position on the staff were a number of appropriate names. Women low in the pecking order who worked as drudges or messengers took their names from *The Tale of Genji*. The elders used names commonly written with two Chinese characters, such as Ōsaki, Takahashi, or Takiyama. Names were usually inherited along with the position; for example, the chief messenger attached to the shogun was always called Satsu. This practice makes it difficult to learn what a servant's true name was.

Opportunities for Promotion

Women had to take one of two routes if they wanted to rise in the Great Interior. One was to become a concubine and bear children; the other was to become an elder, the equivalent of a senior manager. The two ways to advance were thus entirely separate. In the board games called "Success in Serving in the Inner Quarters" published toward the end of the Tokugawa period, there are boxes for drudges, transaction agents, attendants, and other positions. Two boxes at the very top represent success. One of these boxes is labeled "concubine with a room of her own" (that is, a concubine who has had a child), and the other is labeled "elder" (see figure 9.1). The system of employment in the inner quarters made it impossible for one person to control both positions. This policy was designed to ensure that no one woman would be able to concentrate authority in her own hands.

FIGURE 9.1.
Board game: "Success in Serving in the Inner Quarters." Edo-Tokyo
Museum.

Let us examine specific cases of women who succeeded in the Great Interior. Not everyone started out in the lowest position of drudge, as one's first office was determined by one's status background. Fujinami began as a messenger, and for approximately thirty years she served in the same position without ever earning a single promotion. In contrast, Naniwae, a daughter of the Awazawa family whose head was a division chief in the Hachiōji guard, rose from being a drudge in the western enceinte to being a fire warden, and then transferred to the kitchen (the salary for the fire warden and the kitchen staff was the same). Gyōzen rose from drudge to messenger to chief of the messengers. The daughters of townspeople, peasants, and shogunal retainers who did not have the right of audience with the shogun might receive one or two promotions beyond the entry-level job of drudge or a similarly low post. It was unusual for them to become a chief. We can say that Gyōzen did quite well for herself.

Daughters of shogunal retainers who had the right of audience with the shogun entered at a position no lower than that of maid-in-waiting. Those whose families ranked just below the daimyo might even enter at the rank of companion or attendant. Tanino, from the Sone family, a middling ranked family of shogunal retainers, rose up the ranks from maid-in-waiting to wardrobe mistress, companion, secretary, transaction agent, and wife's proxy. She ended her ascent as elder attached to one of the princesses.[9] The salary for an elder attached to a princess was considerably lower than that for an elder attached to the shogun. Other women also went from being a transaction agent to being an elder attached to a princess. Their salary was about equal to that of a chamberlain. Despite the route to promotion depicted in board games, most women never advanced to the top square.

Vacations and Excursions

Since it was not easy for servants of the inner quarters to get out, they eagerly looked forward to vacations, when they were allowed to return to their parents or guarantors. According to oral testimony collected in the late nineteenth century, regulations specified that everyone at the rank of attendant and below was allowed to take such vacations: six days long in the third year of service, twelve days in the sixth year of service, and sixteen days in the ninth year of service. There is some doubt as to whether these guidelines were actually followed.

By drawing on evidence from Fujinami's letters, we can uncover the pattern of her visits to her parents. In a letter dated the fourth month of 1838, she reported: "I too will be coming home this spring. I am looking forward to seeing my parents and people in the neighborhood and going over all the stories I've saved up for you." She wrote this about a year after she had entered service,

probably in reference to her first visit home. As might be expected, she had become homesick for her parents and her village and appeared to be happy at the prospect of returning to the countryside. Any number of the extant letters show that Fujinami returned for vacations to her home village of Hirai.

What were the procedures for taking a leave to return home? First, Fujinami had to put in an application and get the elder's permission. The only entrance that servants of the inner quarters were allowed to use in going back and forth was the Hirakawa gate located on the north side of Edo Castle near the third enceinte. Fujinami arranged for a palanquin and bearers to carry her and porters to carry her trunk, and ordered Ikusaburō to come to meet her at this gate. Fortunately, Ikusaburō happened to be in Edo at the time. She was thus able to prepare for her return home riding in a palanquin, her brother at her side, and enjoy a leisurely triumphal stay in Hirai village. Being a servant in the inner quarters was a status symbol, and a family that could send a woman into service, especially at Edo Castle, could hold its head high in the neighborhood. The servant herself was addressed as "mistress" (*sama*) as a mark of respect.

Women such as Fujinami who came from far away also maintained temporary lodgings in Edo itself. For Fujinami those lodgings were her great-aunt Gyōzen's house in Shitaya. She characterized visits to Gyōzen not as a return home but simply as a leave. She visited Gyōzen fairly often, sometimes staying overnight, sometimes returning the same day.

Judging solely from the evidence in Fujinami's letters, we cannot determine the degree to which the length of time between returns home and leaves was regulated and how many days were permitted. We can assume that she traveled all the way to Hirai once every several years; leaves to go into the city of Edo occurred almost every year. The number of days taken for a leave ranged from less than one—an overnight absence, with an immediate return to the castle the following morning—to stays of two or three days. Since she wrote of her trips to Hirai village "we will have a leisurely visit," she must have been planning to stay there a little longer.

Servants also had opportunities to go on excursions. They might make pilgrimages as proxies for the shogun's wife, either to the Tokugawa family Buddhist mausoleums at Ueno's Kan'eiji and Shiba's Zōjōji, where the shoguns were buried, or to other shrines and temples to pray for the country's peace and security. When the shogun's wife went to Hama garden, the shogun's family retreat on Edo bay, the servants of inner quarters went along as her attendants. Umetani, the senior matron attached to the shogun's wife, wrote a short description of the visit paid there by Ienari's wife Tadako on the eighth day of the ninth month in 1826. From this account we know that since male officials accompanied the shogun and his heir, who were also part of the party, the women

attached to them accompanied the shogun's wife. Once they arrived at Hama garden, they rested in the eastern room. After enjoying a stroll and some fishing, they went out in the bay for a little boating.

Let's look a little more closely at Umetani. She started life with advantages unavailable to Fujinami, but she also was more deeply involved in factional disputes. Born the daughter of a Kyoto noble named Kushige Dainagon (Vice Minister) Takamochi, she became a senior matron attached to Tadako, wife of the eleventh shogun Ienari, in 1818. Following the deaths of the retired Ienari and the twelfth shogun Ieyoshi's wife in 1841, the main enceinte needed a mistress, and so Umetani followed Tadako back there. She probably retired when Tadako died in 1844.

Umetani was apparently thoroughly trained in poetry. When Tadako made the excursion to the shogun's retreat at Hama garden, Umetani wrote a number of poems to celebrate the occasion. Among the members of her retinue was Ikeda Kimi, the daughter of an oil seller in Ōme. As an adherent of her local Sumiyoshi shrine, Kimi entreated her mistress to write a poem praising this god's virtues. Since serving in the inner quarters of daimyo or shogun was a step in preparing for marriage, as far as the daughters of peasants and merchants were concerned, Kimi could be considered fortunate to be attached to such an erudite mistress. Even though Umetani had to deal with factional struggles between the women attached to the shogun's wife and the women attached to the shogun, her activities did not concern Kimi and the other women who served in her retinue for short periods of time.

The fire of 1844 came as a shock to Umetani. In the fifth month of that year, tragedy struck when the main enceinte of Edo Castle burned down and several people died. For Umetani, the problem was that the fire originated in the apartments of the Great Interior. She became embroiled in a dispute with Anenokōji, the senior matron attached to the shogun whose father was also a vice minister in Kyoto, over whether the fire came from her back room or from Anenokōji's bathroom. In the end, investigators concluded that the fire had come from Umetani's back room, and she was punished accordingly. In testimony taken in the late Meiji period, however, one woman claimed, "When I was still in service at the age of fifteen, the fire that burned down the main enceinte came from Anenokōji's bathroom."[10] It may well be that the judgment was in favor of Anenokōji because she, as the shogun's senior matron, had more influence.

Retirement

There was no mandatory age for retirement for the servants of the inner quarters. Many women died of old age or illness while still in service. When the

shogun died, women attached to the shogun had to decide what would become of them. Each had three choices—to remain in the palace, to take permanent leave, or to shave her head and become a nun. People who remained continued to serve the next shogun in the same position as before; in some cases they might be moved to a different section. Taking permanent leave was equivalent to what is meant by retirement today. The woman would receive a lump sum of money and return to her parents or guarantor. Depending on the woman, she might even get married. Shaving one's head was a step allowed only those women who had worked in the palace for more than thirty years. In that case in addition to the lump sum paid at retirement, the shogunate provided a yearly stipend (much like a pension today), and it was guaranteed for a lifetime.

Let's take a look at Fujinami's great-aunt Gyōzen in her old age. Since Gyōzen completed her long life in 1859 at the advanced age of ninety-one sui, we know that she must have been born in 1769. She was given the service name of Satsu and advanced to a position as chief of the messengers. When Ienari died in 1842, she was permitted to cut her hair as a reward for more than fifty years of service, and she retired to Shitaya. At that time, she received the Buddhist name Gyōzen. She enjoyed the company of her previous comrades and servants of the inner quarters who were still working. She also took pleasure in entertaining Fujinami and helping her out whenever she came to visit. Gyōzen had a leisured, comfortable retirement—but she did not get along with her adopted son Koshitaka Matashirō, about whom she constantly complained to Fujinami. She had adopted him while she was still working: servants of the inner quarters who made a career out of their work could adopt a son and have him found a house as a new shogunal retainer. The source of her anxiety was that Matashirō was apparently a stupid fellow. Gyōzen had a more than adequate pension, and her life was secure to her death. She apparently had plenty of savings, but as she aged she became senile, and other people were able to swindle her.

How much choice did a woman have about when she retired and under what conditions—whether to cut her hair or to accept permanent leave? In 1744 it was decided that women who had served for longer than thirty years would be allowed to cut their hair. For that reason, women who had served for shorter periods tried to remain in the palace. When a shogun died, the elders surveyed the servants to determine whether they hoped to retire or to stay, then sent the results to the men in the male administrative offices. Once the shogun had made up his mind, the senior councillors sent a document to the elders that listed the outcome for each servant. Women whose names were marked with a note explaining "This person asked to remain in service but she has been given leave" did not have their wish granted. When the tenth shogun Ieharu died in 1786,

out of the 164 women attached to him, 145 remained in service, 9 took permanent leave, and 23 cut their hair to become nuns. Since we can assume that most women preferred either to continue working or retire, it is remarkable that so many got what they wanted. As the shogunate's financial situation worsened, in 1841 it was decided that the years of service needed to qualify for becoming a nun would be increased to forty. Because cutting the hair was equivalent to today's national pension plan, its availability was affected by changes in the shogunate's fortunes.

Individual women had to decide for themselves whether to go into service in the inner quarters. Fujinami was about twenty-seven years old when she entered the Great Interior, an indication that she must have chosen work over marriage. But whether a woman would have the opportunity to learn and practice song, dance, and music from a young age and acquire sufficient skills to go into service depended on her parents' inclinations. With their backing she might glide right into a position. Other women stayed temporarily either in a senior person's quarters or with a guarantor in the city of Edo for a period of training. After it was over, a woman might decide that service was not for her or be so concerned about the state of her health that she would give it up. Women agonized over their life course and their future, whether they were choosing service, marriage, or divorce. Naturally enough, their decisions did not always lead to the anticipated results, but in those decisions we nevertheless can read their intentions.

The Great Interior and the servants who worked there helped support the shogun's authority within the framework of the overall political structure. When that political structure collapsed during the Meiji Restoration, a large number of servants found themselves without work. The Tokugawa family's main line and the daimyo became part of the new nobility, and they continued to employ maids to work inside their mansions as before. But these women simply performed personal services. In other words, the administrative track that encompassed political responsibilities disappeared; only the attendant track remained.

In the third month of 1866, Fujinami died in Edo Castle at the age of fifty-six while still in service. Many letters addressed to her, including those from Gyōzen, were bundled up and sent back to the Noguchi family, where they joined the collection of letters that she had written as memorials to her life. In a letter from 1865, she complained that she did not feel well, but nothing suggests that she knew she was suffering from a serious illness. We do not know the cause of her death, but perhaps it was fortunate for her that she did not live to see the collapse of the shogunate and the Tokugawa family's downfall.

Notes

1. Hata 2001, p. 48. Unless otherwise noted, the information in this essay comes from this book.

2. The rulers were permitted to keep concubines in addition to a wife for the sake of producing heirs; but this was not polygamous system, because there was always only one wife.

3. For a detailed examination of the spatial layout of Edo Castle, see Fukai 1997.

4. At first there was only one bell corridor, but about the time of the ninth shogun Ienari, a second was installed.

5. The senior councillors were in overall charge of affairs of state. The highest officials in the great interior, "senior women" (rōjo), held the three offices of jōrō toshiyori, kojōrō, and o-toshiyori. The first two were from aristocratic families in Kyoto; the third was of samurai stock.

6. The fifteenth shogun Yoshinobu's mother was his father's wife, not a concubine; but because Yoshinobu became shogun by being adopted, she was not the previous shogun's wife.

7. Matsuo 1997.

8. A copy of Oku jochū sode kagami, produced in 1858, is in the National Diet Library. It contains regulations regarding hairstyles, makeup, and clothing for servants of the inner quarters. In the section "Reasons for Entering Service," it lists five possible motives.

9. The Sone family of hatamoto (bannermen) enjoyed a hereditary stipend of 300 koku (one koku equals 5.1 bushels of rice, enough to feed one man for a year).

10. Kyūji shimonroku 1986, p. 162.

Kathryn Norberg

Versailles is one of the most written about palaces on earth, but we know more about the women of the palace at Edo or Aceh than we do about the ladies of Louis XIV's chateau.[1] To be sure, we know the French women's names: Madame de Maintenon, the marquise de Pompadour, and Marie-Antoinette. We even know a great deal about their lives: biographies of individual women, especially royal mistresses, fill the library shelves. Nor are primary sources wanting. Contemporary observers such as Saint-Simon and Primi Visconti filled their memoirs with portraits of duchesses, ladies-in-waiting, and (of course) royal mistresses.

Still, we cannot say (as we can for the Asian palaces) how many women lived or worked in Versailles, how they were recruited, why they came to the court, how their lives and their life chances differed from those of men—in short, how their sex determined their destiny. The place of gender in Bourbon strategies of domination has not been analyzed. Only one work approximates a serious study of the women of Versailles and it too espouses the biographical approach.[2] Open the index of books on Versailles and you will find no entries for "gender" or "masculinity." Even the rubric "women" is absent.

Bad faith has not produced this neglect. French historians tend to associate the history of palace women with the history of royal mistresses and with the anecdote and innuendo that prevail in that form. Also, the influence of Norbert Elias, dominant since at least 1970, has tended to lead historians in other directions.[3] Even more influential is the great French memoir writer Louis de Rouvroy, duc

de Saint-Simon (1675–1755). No figure has had a more profound impact on thinking about Versailles than the duke whose memoirs provide much of the primary source material upon which histories of Versailles draw. For Saint-Simon, Versailles was about nobility and the privileges and honors that came with it.

Historians have therefore considered status—particularly the hierarchy of rank within the nobility—to be the primary if not the sole distinguishing principle at Versailles. The king presided over a welter of rivalries pitting princes against dukes, duke/peers against other dukes, barons against counts, and so forth. Women were similarly divided into princesses, duchesses, countesses, simple nobles, and mere commoners. Add to that the differences between Parisian and provincial, rich and poor, and women do not seem to form a coherent group. They were the proverbial "potatoes in a sack," too diverse to have anything in common, too varied to constitute a category of analysis. In the Ottoman and Qing palaces, this was not the case. The women who inhabited the harem or inner court were a seemingly homogeneous group, easy to categorize and therefore easy to analyze. Consequently, we know more about the women of the Asian inner court—their numbers, status, background, daily life, and so on—than we do about the ladies at Versailles.

My assumption is that despite their differences, the Versailles palace women had commonalities that grew out of the practices and traditions of court life, commonalities that make it possible to study them as a group. This analysis locates some of these commonalities and points to gender patterns that characterized life at Versailles. My goal is to determine how a woman's sex dictated her life chances within the great palace and how sex was in turn used by the monarch to extend his dominion over the court. I focus on the years between 1682 (when the court moved into Versailles) and 1789 (when the court left the castle for Paris). Within this context, I have organized my essay around questions posed by the Asian specialists in this volume. How many women occupied the palace? How were they recruited? What work did they perform in the palace? What—if any—positions of authority did palace life provide? Were these positions equal or were they inferior to those offered to men? And finally, how did the gender arrangements in Versailles advance the monarch's rule?

How Many Women?

The number of women at Versailles is hard to compute because the female population of the palace was ill-defined and in constant flux. Unlike their Asian counterparts, the Bourbon monarchs did not have a closed and guarded quarter for women, nor did they impose strict segregation of the sexes. On the contrary, men and women mixed freely in the chateau and both entered and exited

it at will. Only a concierge stood guard at the gate and he admitted anyone, male or female, who was well-dressed. Every day, female petitioners came into the castle seeking a job for a male relative or a pension for an elderly parent. An example of such a visitor was Jeanne de La Motte, the impostor who launched the scandal known as the Affair of the Necklace. In 1783–84, La Motte haunted the halls and anterooms of Versailles hoping in vain for recognition and a fat pension.[4] At the time, she went unnoticed, for petitioners were a common sight and of no interest, just extras in the drama of court life.

More significant were the women who resided in the castle. These were first and foremost the king's relatives—his wife, daughters, daughters-in-law, aunts, nieces, and cousins. The Bourbon monarchy was a hereditary monarchy, so ties of blood were honored even if the king's relatives sometimes proved burdensome. Under pressure from his ministers to economize, Louis XV sent three of his seven daughters to a convent where they could be raised at virtually no expense. Once they were adults, however, he had to bring them back, even though the royal treasury was in worse shape than ever. Fiscal pressures and simple chance meant that the number of royal women at court varied considerably. In 1662, there were only three royal women: the king's mother, his wife, and his cousin, the duchesse de Montpensier (known as Grande Mademoiselle). In 1710, there were at least six; in 1780, nine.[5]

The number of royal women was important because it helped determine the number of female attendants lodged in the palace. These retainers included great aristocrats, the ladies-in-waiting who kept the royal women company, and lesser nobles, the women of the bedchamber, who performed many domestic chores. The ladies-in-waiting almost always supplemented their palace rooms with a town house where horses and carriages could be accommodated. Women of the chamber, on the other hand, lodged only in town and received a stipend to pay for their rented rooms.[6]

In 1721, Versailles contained 364 apartments exclusive of those used by the king's immediate family.[7] Most of these apartments were assigned to men, but women also inhabited them because they were courtiers' wives, distant relatives of the king, or members of one of the royal households—that is to say, retainers of a royal woman. Having a "function"—being a lady-in-waiting, for example—greatly increased the chances of receiving an apartment, because an attendant needed to be near her mistress. If we count the women in the royal women's households, we can arrive at a gross estimate of the number of women who resided or worked in the chateau.[8]

This number varied over time. The first female-headed household belonged to Queen Anne of Brittany (r. 1491–1514), who was also the first queen to reside permanently at the French court.[9] Anne brought sixteen married ladies and

eighteen "girls" with her when she married the French king Charles VIII.[10] Queen Catherine de' Medici (r. 1533–74) had the largest number of female attendants: 169 at the time of her regency. But most French queens had many fewer: the average from the time of Anne of Austria (r. 1615–61) to Marie-Antoinette (r. 1770–93) was approximately thirty.[11]

The houses of other royal women were much smaller than the queen's, but their retinues added up. In 1661, only two royal women—Queen Marie-Thérèse and her mother-in-law, Anne of Austria—were served by seventy female attendants. In 1699, three royal women—Madame, the duchesse de Bourgogne, and the duchesse de Chartres—were served by sixty-eight women. In 1736, Queen Maria Leszczyńska and the dowager duchesse of Orléans required the company of just forty-eight women. But in 1780, seven royal women, including Queen Marie-Antoinette, resided at Versailles and they required 131 female attendants.

Even at its peak, the number of female attendants—169—was extremely small. Almost certainly, there were more women in the palace, women not mentioned in the published lists or *Etats* of retainers. These might include wives of the great nobles, such as the duchesses who shared their husbands' apartments. Because there were no more than fifty duchesses in 1710, they could not tip the sex balance in favor of women.[12] Much more numerous were the wives of lower-level male retainers—the valets, cooks, scullery boys, and sweepers—who were part of the king's or the queen's household. Such men numbered in the thousands but they were rarely assigned choice rooms, much less apartments. One of the queen's wine stewards, for example, lived in a minuscule room without chimney or window. Wives were unlikely to have taken up residence in what was, basically, a service room.

Serving girls, on the other hand, might have swelled the number of women in the palace. The ladies who served in the queen's house employed servants to help them fulfill their duties. According to the *Etat* of 1699, the first woman of the bedchamber assigned to the duchesse de Chartres received 200 pounds to pay for "the maintenance of a serving woman to take care of the chamber pot and to clean the closet (in which it stands)."[13] Madame de Mailly, mistress of the wardrobe to Queen Maria Leszczyńska, employed a woman who in turn employed female menders and seamstresses to help care for the queen's clothing. These women did not reside in the palace but lived and worked at Mailly's city house on the rue St. Cloud.[14]

Moreover, the culture of Versailles and the French aristocracy made male servants preferable to female servants. Emblems of prestige were of great importance in the palace. Male servants—valets and footmen—were visible tokens of rank and wealth. They wore their master's livery and they followed their mistress on her

social rounds.[15] Madame de Mailly took advantage of one of the privileges of her office by having a Swiss guard accompany her every time she walked from the palace to her town house.[16]

French nobles tended to employ more male than female servants, and royalty was no exception. The queen maintained accountants, pages, equerries, valets, footmen, ushers, and priests—more than three hundred male retainers in all. These men took care of her property, argued her lawsuits, delivered her letters, cared for her horses, and ministered to her soul. Women were limited to the care of the queen's body and the bedchamber. Never did women constitute more than 10 percent of the queen's household and sometimes only 6 percent.[17] Still, women were relatively numerous in the household of the queen or dauphine (the wife to the heir apparent), especially by comparison to their representation in the biggest, the oldest, and most revered household in the palace: the king's. It included nine hundred "servants of the king's chambers," two thousand inhabitants of the Large and Small Royal Stables, and seventeen hundred guards of the palace. Of the 4,600 retainers in the king's household, usually only one—the linen mender—was female.[18]

Women appear to have been in the minority at Versailles. Even if we assume that every woman in every household employed a serving girl and every gentleman had a wife, women are still outnumbered. The business of the French crown was to make war, collect taxes, and defend the Catholic faith. Because of their sex, women could not become soldiers, priests, or ministers. High rank was of no avail: women played only a marginal role in the early modern European monarchy.

Responsibilities

The one official role that the Bourbon monarchy offered women was service in a royal woman's household. As noted above, a woman could be either an aristocratic lady of the palace (lady-in-waiting) or a woman of the bedchamber. Most of the activities of these two groups were highly ritualized. Every day, the ladies-in-waiting attended the queen's awakening, helped her dress, and served her dinner. The women of the bedchamber awakened the queen, pulled back the curtains of her bed, and handed her a shift. At this point, the lady of honor and the mistress of the wardrobe entered the royal bedchamber. As in the king's room, a strict ritual based upon rank dictated which lady handed the queen her gloves and which her jewels.[19] Should one of them be late, the queen would have to wait, because precedence and protocol could not be broken. Marie-Antoinette famously stood stark naked in the freezing cold one morning when her mistress

of the wardrobe could not be found.[20] The ladies-in-waiting also attended the queen's dinner and, when the king was present, served the royal couple.

Aside from these rituals, the ladies-in-waiting kept the royal women company. Here, a woman's household differed from the king's. The king's retainers were referred to as *commensaux,* or "those who ate with the king." The expression derived from medieval times, when the monarch led a band of armed men and offered them hospitality. The queen's household, on the other hand, took its shape much later, during the Renaissance, when European courts ceased to be barracks and became centers of courtesy. In the households of the royal women, the art of conversation was practiced and even came to be an institution of sorts, the "circle." Anne of Austria, for example, called her womenfolk together once a day and seated them in a circle around her to converse on a variety of subjects.[21]

Domestic chores on the queen's behalf—cleaning, making the royal bed, serving the queen when she dined alone, and so forth—were the purview of the women of the bedchamber. These women varied in number: Marie-Thérèse had five French and six Spanish women of the bedchamber, while her sister-in-law, Madame, had more than a dozen. Historians have assumed they were just domestic servants because many of the tasks they performed resembled housework. Madame de La Tour Du Pin, a lady-in-waiting to Marie-Antoinette, recounts seeing the chamber women change the queen's sheets and turn over her mattress in "less than five minutes."[22] While their tasks may sometimes have been menial, the women of the bedchamber were of the nobility (albeit the lower nobility). Some, like the memoir-writer Madame Campan, enjoyed extensive palace connections and performed tasks—running errands, dealing with palace tradesmen, and delivering the queen's correspondence—that went well beyond domestic chores.[23]

A different sort of establishment also provided women with opportunities to serve and distinguish themselves at court. The royal children, known as "the children of France," had their own household staffed almost entirely by women.[24] The head of this unit was the governess; she was assisted by an undergoverness, a dozen women of the bedchamber, two wet nurses, and the wet nurses' governess. A lady to rock the cradle and two to watch the sleeping heir completed the children's household.[25]

In this small world, the governess's responsibilities far outstripped those of just about every other female retainer, including those closest to the queen. The governess bore responsibility for the health and well-being of the royal children, including the heir who embodied the realm's future. In recognition of the importance of her charge, the king himself received the governess's oath of loyalty.

He heard her promise "to take care of the . . . earliest education" of the royal children and "inform the king of everything concerning the royal child." In all things, the governess was the king's representative in the nursery. Should she wish to absent herself, she had to receive permission from the king himself. Nor did she get a week off. Unlike the other members of the household, who served by the quarter, the governess was on duty every day.[26]

She did have help. The assistant or undergovernesses probably carried out many of her mundane duties. The rocker slept in the same room as the dauphin until he was three years old, dressed and undressed him, and monitored his health. She was seconded by the watchers who "watched" the dauphin in twelve-hour shifts. For the first three months of his life, the watchers did not sleep or recline. Thereafter they were allowed a mattress, but they continued to keep watch in shifts.

In his household, the heir to the throne was due the same respect as the king. That he was an infant made no difference. The women who cared for him were expected to wear full court attire, the famously uncomfortable *grand habit*, at all times. The dauphin always received his porridge from the noble hands of the governess and undergoverness. Only when these aristocrats were absent could the humble women of the bedchamber feed him. Swaddling the dauphin was regarded as a great privilege of which the rocker alone—a woman of higher nobility than the chamber women—was worthy. This protocol attached, it seems, only to the dauphin, the male heir to the throne. The daughters of France also lived in the household, but their care required fewer retainers and included no ritual. The princesses' second-class status was not lost on the most intelligent of Louis XV's daughters, Adelaide. As a child, Adelaide often asked why she could not inherit the throne, since she clearly possessed the courage and virtue required.[27]

Recruitment

How did a woman come to serve in the household of the children of France? How did she become a lady-in-waiting? The first step was to be "presented" at court. In the seventeenth century, the process appears to have been much more informal than it would become in the eighteenth century. One simply needed a sponsor. But in 1682 as in 1782, a strict division by sex obtained: men were introduced to the king, women to the queen. Men "met" the king at the hunt; women bowed before the queen in her apartments. Both men and women were supposed to be nobles with a pedigree verified by a court genealogist. Women needed female sponsors, and it was preferable that one be a relative. The Marquise de La Tour du Pin was presented to the queen by her aunt-in-law, Madame Hénin, herself a lady-in-waiting.[28] Madame de Pompadour, already the king's

lover, was presented to the queen by the Princess de Conti, who had to be bribed to perform this duty, which might offend the queen.[29]

As this example shows, women with money had little difficulty appearing before the queen. Louis XV's daughters, for example, had the right to grant "passes"—that is, entry to the court—without any proof of nobility but with payment of a fee. By the 1750s, court officers complained that it was easy—too easy—for women to be presented. The first gentleman of the king's chamber admitted to the genealogist Pierre de Clairambault that women were indulged "because their honors are hollow." Unlike their male counterparts, women did not get access to court offices or to the king, only to the queen. Their honors were therefore "inconsequential."[30]

The pinnacle of court life for a woman was appointment to one of the royal households. Be it lady-in-waiting or governess, these positions were ardently desired even by those already blessed with royal favor. At the height of her glory, with both king and court at her feet, Louis XIV's mistress Madame de Montespan requested that her position in the queen's household be elevated to that of intendant, or head of the queen's council and household.[31] When a new household was formed, as in 1696 at the arrival of the duchesse de Bourgogne (future wife of the heir apparent), the ladies of the court went into a frenzy, politicking, buying favors, and trying to influence the one person who would make the appointments, the king.[32] Sometimes, other court figures did influence him. Mazarin placed his nieces in Anne of Austria's household. Madame de Maintenon got her niece Madame de Mailly named mistress of the wardrobe to the dauphine.[33] The one person who had little say over who served the queen or future queen was the royal woman herself.[34] Marie Leszczyńska had to accept the duchesse de Luynes as her lady of honor when Louis XV (probably to vex her) passed over her own nominee, Madame de Mazarin.[35]

In principle, the king was free to pick whomever he wanted, but in fact he had to abide by an unwritten law of inheritance. The ladies-in-waiting expected to bequeath their positions to their daughters or daughters-in-law. They needed only to request this privilege of the queen to receive it. The French crown understood lineage; it was, after all, a hereditary monarchy. Sometimes a lady-in-waiting anticipated her daughter's succession and gave her on-the-job training. Madame de La Tour du Pin's aunt by marriage brought her to Versailles, where she waited upon Marie-Antoinette at her aunt's side.[36] Ladies-in-waiting often resigned their positions in favor of their daughters or granddaughters.[37] The inheriting of office eventually led to the creation of dynasties of ladies-in-waiting and royal governesses. The ladies of the house of Rohan, for example, monopolized the position of governess to the royal children from Louis XIV through the children of Louis XVI.[38]

These dynasties ensured that only women of the highest rank occupied the best positions in the royal households. The intendant, the lady of honor, and the mistress of the wardrobe were required to be duchesses and always were.[39] But the rest of the women could be nobles of any rank or sort, and the king tended to appoint the women of his most valued state servants to these posts. The wives and daughters of the highest-ranking army officers in the realm, the marshals of France, usually served as ladies-in-waiting to the queen. So too did the female relatives of ministers. Madame Colbert served as lady-in-waiting to Queen Marie-Thérèse, and her daughters and daughters-in-law "inherited" positions in the dauphine's and the duchesse de Bourgogne's households.

The chamber women were selected differently. The first woman of the bedchamber was always one of the king's former wet nurses.[40] In 1696, however, no former wet nurse was alive, so Louis XIV and Madame de Maintenon named Madame Quentin, wife of the king's *maître d'hôtel* and sister of the royal apothecary, to be first woman of the bedchamber.[41] Because Madame Quentin was a palace insider, her appointment came as no surprise. Several other women of the chamber also had husbands, sons, and fathers employed in the king's household. Service to the crown always paid off, but so too did close connections to the intendant or the lady of honor, both of whom had the right to nominate two of the women of the bedchamber themselves. The rest were chosen by the king or by his ministers.

Usually, the women of the bedchamber were palace insiders, like Madame Campan, Marie-Antoinette's trusted first woman of the bedchamber, married to the son of the queen's librarian. Sometimes the networks of a minister or a lady of honor reached down into the provinces and brought to the palace an obscure noblewoman. Such was the case of Marie-Madeleine de Mamiel, the daughter of an officer awarded the order of Saint Louis. Her father's distinguished service netted her a position as chamber woman to the comtesse d'Artois, wife of the king's youngest brother, in 1783.[42] For five years, Marie-Madeleine served in the palace, and during that time she was seduced by an officer of the king's guard. She married the guard and gave birth to two children, all the while serving her mistress. Only the Revolution separated her from the countess.

Benefits of Service

When women like Mamiel came to Versailles, they did so not only because the palace was "magical," to quote the marquise de La Tour du Pin,[43] but also because royal service brought important advantages. From the lowliest woman of the bedchamber to the grandest princess, being at court had tangible benefits

in money, in prestige, and in security. For chamber women such as Mamiel, there were financial advantages. Annual wages might not be much higher than those for a servant in a grand house: 300 pounds for a simple chamber woman and 500 in the last years of the seventeenth century for the first woman of the bedchamber.[44] But perquisites, privileges, and gifts supplemented wages. New Year's presents—several hundred pounds worth of silver coins—were distributed annually to all the house retainers. All living expenses were paid as well. A woman of the bedchamber took her meals at the queen's table and was given money to rent a room in town. Occasional gifts and grand gestures also added to a retainer's compensation. In 1758, Marie Leszczyńska awarded a gratification of 2,300 pounds to her chamber women because of their "low wages."[45] Every three years the royal woman's sheets were "renewed"—that is, divided between the chamber women and the lady of the wardrobe, a not inconsiderable gift when one remembers that the sheets had been purchased for upward of 40,000 pounds. Nor were those who had served royalty ever entirely abandoned. At a royal woman's death, linens and other goods were distributed to her retainers, and ladies-in-waiting and women of the bedchamber were shifted to other households. Should an individual decide to leave royal service, a small pension would be forthcoming. No other position in the Old Regime provided such retirement benefits, however small. The records of the royal women's households are filled with pensions requested and granted to former employees, their widows, and underage children.

The palace provided yet another benefit: a good marriage. A man who served in the chateau was a good catch (provided he was not a soldier), because he could usually bequeath his position to his son and receive a pension in old age. Moreover, the dowry was almost invariably provided by a girl's mistress. At the marriage of Marie Quentin, first woman of the bedchamber, the duchesse de Bourgogne gave her a dowry of 3,000 pounds.[46]

Another form of "capital" that an unmarried girl might bring to her marriage was a close relationship with a royal woman. An enormous difference of rank and culture separated a woman of the bedchamber from her royal mistress, but it did not preclude intimacy. A woman of the bedchamber was neither a rival nor a critic, unlike the haughty ladies-in-waiting. Intense relationships might develop between a royal woman and her women of the bedchamber, particularly if both were foreigners. The Dauphine Marie-Anne de Bavière, wife of Louis XIV's son, developed a morbid attachment to her chambermaid, a certain Bezzola, whom she had brought with her from Bavaria at the time of her marriage. For days, the melancholy dauphine would stay locked in her rooms with Bezzola, occasioning much comment at the court and finally the intervention of Louis XIV.[47]

Eventually Louis banned all foreign women of the bedchamber, but this action did not prevent strong relationships from developing between mistress and attendant, relationships that could profit the maid in question. Anne Balbien (called Nanon by her mistress) served Madame de Maintenon for more than forty years. Like her mistress she was quiet and devout. Despite her extremely humble background, Balbien commanded the respect of every courtier; and like the favorite's other servants, she became rich. In 1697, for example, Madame de Ludre gave Balbien more than 75,000 pounds to persuade Maintenon to appoint her as lady-in-waiting to the young duchesse de Bourgogne.[48]

Superior to a mere woman of the bedchamber, the mistress of the wardrobe held an unusually lucrative position. She was not responsible (as her title suggests) for the daily maintenance of the royal woman's wardrobe. Rather she functioned more like a contractor, selecting styles, employing artisans, and paying them for their work. She purchased all of the table and bed linens for the bedchamber and all the royal woman's clothes. For these expenses she received a substantial allocation taken directly from her mistress's civil list. Should this sum be insufficient, the mistress of the wardrobe was expected to advance the necessary funds. On the other hand, if there was a surplus she could pocket it. Under Marie Leszczyńska, Madame la duchesse de Villars made 50,000 pounds as the queen's mistress of the wardrobe.[49]

Ladies-in-waiting enjoyed certain perquisites and immunities. They were all exempt from the tenth tax (a benefit of some significance), and they had the right to have their disputes resolved in a special court. The intendant and governess had the additional privilege of selling to merchants and artisans the title of provisioner to the queen or dauphin.[50] Most ladies-in-waiting did not enjoy such perquisites, but they did have access to one ever-flowing source of wealth—the king. Louis XV sometimes asked the queen's ladies, a few of whom became his mistresses, to supper in his private apartments. The ladies-in-waiting also accompanied the queen to the royal hunting lodges at Madrid, La Muette, and Choisy. Louis XV usually invited the ladies to ride in his carriage—a great and coveted privilege—and to accompany him during the hunt. In fact, he probably saw the ladies-in-waiting more often than his neglected queen, Marie Leszczyńska.[51]

Because it entailed contact with the king, position in a royal household meant, among other things, money. Like male courtiers, ladies-in-waiting peddled their influence and functioned as brokers. Madame de la Motte, lady-in-waiting to Anne of Austria, observed that "the house of kings is like a large marketplace where it is necessary to trade in order to maintain life, advance one's own self-interest as well as that of those to whom we are bound by duty and friendship."[52]

Ladies-in-waiting could participate in this "market" by providing individuals, both in and outside the court, with preferment—that is, offices or positions granted by the king. The comtesse de Fiesque sold the rank of captain on a frigate for 2,000 pounds. The Princess d'Harcourt, lady-in-waiting to Queen Marie-Thérèse, charged only 1,500 pounds for much the same service.[53] Like male courtiers, ladies had the right to "recommend" or inform the crown of the "best" candidates for army contracts or new offices. When the king created the office of "receivers of the city refuse and lantern taxes," the duchesse de Guiche received 75,000 pounds from those whom she recommended for the post.[54]

Another lucrative activity was matchmaking. Versailles was, to a certain degree, a marriage market, and marriage was an extremely serious matter in the seventeenth and eighteenth centuries. The "girls" who served in the households of the royal women usually found husbands at court, and these unions provided the springboard for further offices and advantages in the palace. Men who sought a prestigious union often used a well-connected lady to facilitate the affair. In 1700, Monsieur de La Vrillière paid the Princess d'Harcourt a large sum of money to negotiate a marriage with one of the daughters of Madame de Mailly, mistress of the wardrobe. De La Vrillière also expected the princess to get him the rights to her father's office.[55] Princess d'Harcourt persuaded Madame de Maintenon to intervene on de La Vrillière's behalf. In less than twenty-four hours, the king had signed the appropriate papers and both bride and office were de La Vrillière's.[56]

Such machinations were far from unusual at Versailles, where just about anything could be sold. The Princess d'Harcourt peddled invitations to the king's weekend residence Marly for 6,000 pounds each.[57] Royal mistresses expected a gratuity for forwarding a petition to the king. Those in disgrace used those in favor to hasten their return to the palace. Ladies of the court worked hard because life at the castle was extremely expensive. The clothes, the carriages, the town house, and especially the gambling table made it difficult for nobles, male or female, to make ends meet.

Still, women are singled out in the memoirs of Primi Visconti and the duc de Saint-Simon for their greed and their "ambition." It is hard to prove or disprove such accusations, but women were likely to have been especially frantic in their search for money and honors. Few of the ladies-in-waiting were rich. Some, like Madame de Ventadour, were separated from a husband who had dissipated their wealth. Others, like Madame de Mailly, were widows burdened with a handful of children. Versailles provided these women with economic opportunities that a gentlewoman would otherwise not have had. Palace life even provided them with positions of authority.

Positions of Authority

Like many mostly female institutions, the queen's or dauphine's household included posts that allowed women to exercise some power over other women and also over some men. The most elevated of these was the intendant of the queen's household, a position invented by Mazarin for his niece in 1661.[58] According to a memo written in 1725, the intendant supervised all the men and women of the household and received their oaths of loyalty. She also had the right to nominate individuals to positions in the queen's household and to "confirm" or approve the appointment of the queen's valets and ushers.[59] She presided at the queen's council, which consisted of Her Majesty's barristers, accountants, and secretaries, and she oversaw the household's finances. She also resolved disputes between members of the household. In February 1676, Mancini signed a decree confirming that valets—not the guards—had the right to tips offered on ceremonial occasions.[60] Clearly, the queen's intendant wielded power over all the household's members—including men, albeit men of inferior social status.

In the hierarchy of the royal woman's bedchamber, the lady of honor came next. In fact, she took over the intendant's functions for most of Marie Leszczyńska's reign when the post was left vacant. When Leszczyńska was ill, Madame de Luynes, her lady of honor, reviewed the queen's guard and attended the funerals of members of the royal family. The lady of honor also enjoyed the much sought-after privilege of entering the king's most private chambers.[61]

Perhaps the most important position available to a woman in a royal household was that of governess to the dauphin and his siblings. It was not by chance that Marie-Antoinette had her closest friend, the duchesse de Polignac, appointed not to her own household but to that of her children. The main attraction of the position was that it allowed the governess to have contact with the king. Officially, the king appointed the governess, received her oath, and guaranteed her frequent audiences at which she would report on his children. There were other perquisites as well, as the governess had privileges to bestow and positions to fill. More valuable still was the relationship that the governess established with the dauphin. Though she cared for him for less than a decade, she was the most prominent mother figure in the future king's life. In the case of Louis XV, the bond forged with his governess, Madame de Ventadour, was still strong when he was a grown man. When she fell ill, Louis visited Ventadour repeatedly, forced his queen to do the same, and even ordered a *Te Deum* sung for her recovery.[62]

In the hierarchy of Versailles, the most coveted position for a woman was without doubt that of official royal mistress or favorite. "All the women," Primi Visconti claimed, "want to be the king's mistress,"[63] and no wonder. The advantages

were enormous: jewels, estates, chateaux, and coveted positions for relatives. These benefits accrued only if the union endured, however. In the fifty-five years of Louis XIV's personal reign, he had sexual relations with at least three dozen women of various ranks. Most were passing flirtations of which he tired within a few months or even weeks. The problem was not attracting the king's attention but keeping it.

His distractions were numerous. First there were mistresses from the past who suddenly reappeared, like Marie Mancini. Then there were the unmarried girls who attended the royal women. These maidens were not numerous: Anne of Austria kept only five in her household; Marie-Thérèse had but ten.[64] These girls came to the court to find a husband, but a few found a lover first in the king.[65]

Having unmarried women in such proximity to the king led to predictable consequences. In 1671, Louis XIV became infatuated with three young women: Mesdemoiselles Fontanges, Ludre, and Madame Soubise. At this time, Madame de Montespan was the king's official mistress, and she probably encouraged the king's infatuation with Fontanges to thwart a more serious rival, Madame de Maintenon. But while one flirtation was fine, Montespan would not tolerate three. Montespan persuaded the queen in 1673 to send away her "maidens" and abolish the institution forever.[66] The dauphine still maintained a dozen unmarried attendants, but in 1687 a licentious book found behind one of the girls' beds caused a scandal. The dauphine resolved to marry off the girls in her retinue and take in no more.[67]

The disappearance of unmarried girls tended to frustrate royal dalliances. So too did the court's pervasive Catholicism and its extreme distaste for scandal. Today the general public believes that Versailles was the scene of an ongoing orgy, a place where the courtiers, like their king, made love in every corner and stairway. In comparison to palaces outside Europe where women were secluded and monopolized by the ruler, the French court was a very free place. But the court (like the monarchy) was also deeply Catholic: clergymen constituted a significant portion of the courtiers, and mass was a daily occurrence. Louis himself was a devout Catholic despite his philandering, and he would not countenance open disrespect for the church. In the early decades of his reign, when Louis kept several mistresses, every Easter Thursday brought a crisis: would the king be allowed to make confession and to approach the sacraments or be barred for his adultery? Would he be publicly reprimanded in the Easter sermon?[68]

Scandal had to be avoided at all costs. Until 1674, the king's bastard children were raised in secrecy, first by Madame Colbert and then by Madame de Maintenon. To the extent that it was possible, Louis XIV tried to hide his unions with Soubise, Ludre, and Fontanges. His valets always acted as intermediaries, and communication between king and mistress was cloaked in deepest secrecy.

Madame Soubise wore emerald earrings on the days her husband left for Paris, a secret sign to the king that he could visit her that evening. The king's liaisons were inevitably revealed, but not for lack of trying to keep them secret.[69]

Louis did display his union with Madame de Montespan openly, but his "double adultery" (to quote the indignant Saint-Simon)[70] shocked and raised a dangerous question: was the king ruled by his mistress? In the eighteenth century, public opinion attributed unbounded influence to the king's mistress, Madame de Pompadour. But his great-grandfather, Louis XIV, took measures to prevent such suspicions from arising. Louis XIV remained in control of any relationship, and expected submission above all else. When the young Ludre publicized their liaison against his wishes, Louis dropped her immediately. When Fontanges demanded that her sister, like Montespan's, be named abbess of an important abbey, Louis complied but considered the demand premature and arrogant. The worst offense that a mistress could commit was to appear to govern the king. Montespan's involvement in the scandal known as the Affair of the Poisons forever poisoned the king against her: the rumor that she had bewitched the king accelerated her disgrace.[71]

If the king's mistresses had any influence on his conduct of public affairs, it is hard to measure. Louis XIV prized Montespan for her wit and her ability "to make all occasions agreeable," according to Saint-Simon.[72] As for Maintenon, courtiers attributed to her enormous influence just as they would fifty years later to Pompadour.[73] Recent work by Mark Bryant has confirmed Maintenon's power in the important area of the church, while research by Thomas Kaiser has underscored Pompadour's influence in creating the Franco-Austrian alliance of 1756.[74] The Bourbon monarchy contained few formal mechanisms for advising or influencing the king.[75] This informality enabled courtiers—including royal mistresses—to press the king to appoint their friends and relatives and to adopt policies that benefited their particular faction. In the highly personalized world of the court, nothing prevented a mistress from at least trying to influence the king.[76]

A mistress's success depended on her ambition, her political sense, and the king in question.[77] Nobody imagined that La Vallière, Montespan, or Dubarry wielded immense influence. Louis XIV in particular showed little tolerance for females who interfered in affairs of state. He frowned on women even discussing public matters: when the dauphine introduced more serious discussions into her household circle, the king let her know "that he was displeased and wanted her conversations to center on clothing in the future."[78] Nor would he have allowed a woman to appear to dominate him. In 1664, Louis remarked to his ministers: "I am young, and women usually have a lot of power over men of my age. I order you that should you ever suspect that a woman, no matter who she be, has power over me, tell me. I'll be rid of her in twenty-four hours."[79]

One woman whom Louis could not dismiss was his wife, the queen. For Catholics, marriage was a holy sacrament, meaning that the queen could not be divorced, repudiated, or sent away.[80] Her permanence gave her security but not necessarily power. Since the fourteenth century, the so-called Salic Law had banned women from the French throne. Although nothing but a fabrication, the "law" held sway throughout the Middle Ages and into the early modern period. Sixteenth-century jurists realized that the Salic Law was a sham, but they strengthened its effect nonetheless by arguing that natural law sufficed to exclude women from the French throne. Females, they argued, were constitutionally unfit to rule.[81] Paradoxically, this exclusion did not cover women serving as regents for their minor sons, a position that conferred on them sweeping powers (albeit briefly).[82] Yet from 1661 until 1791, when the Constituent Assembly barred women from the regency, no French queen acted as regent.[83]

The development of absolutism also undermined the queen. In the sixteenth and seventeenth centuries, jurists and political theorists concentrated all sovereignty in the king, depriving his relatives (male and female) of authority or power.[84] The queen's political authority dwindled and she could not, like the fifteenth-century Anne of Brittany, rely on her personal estates or clientele. From the mid-sixteenth century on, French queens were foreign women chosen to cement diplomatic ties. When the future queen crossed into France, she lost whatever wealth she had and was forced to abandon her retainers, personal servants, and even clothing. Still, the queen had power—certainly more than the average courtier—because she had access to the king. Thus cliques and cabals often formed around her. Both royal mistresses and ministers often opposed her, and the extent of her influence was always a function of her relationship to the king. If relations between the two spouses were cool, the queen was all but powerless. Louis XV neglected his queen, Maria Leszczyńska, and her credit suffered accordingly. When the abbess of the Frontrevault convent needed an important person to intercede in a lawsuit on her behalf, she thought of asking Queen Maria Leszczyńska but was told that the queen was of no use: "we have hundreds of examples of just how little the magistrates think of the queen."[85] Leszczyńska herself did not ask her husband for favors but rather solicited a minister, the duc d'Argenson, who was an old friend.[86]

Male and Female

Of course all Frenchmen and -women (including the queen) were inferior to the source of favors, sinecures, and sovereignty, the king. Superficially, everyone in the palace, male or female, was subordinate and therefore the same. But in fact, sexual difference divided the courtiers and assigned them different privileges and

honors. The tokens of status were not the same for men as for women. The length of a train or the use of a stool at the king's supper marked a woman's rank. The blue sash of the Order of the Holy Spirit or the colors of the king's hunt displayed a man's status.[87] Men and women also pursued different career paths at court. Men aspired to a marshal's baton, a minister's portfolio, or a cardinal's hat.[88] Women might struggle to acquire these for their male relatives, but they themselves could only hope at best to be named abbess of a prestigious convent or lady-in-waiting to the queen. Male courtiers could reach the highest echelons of the church and state; women had to settle for the relatively humble precincts of the queen's household.

The court of Versailles was a masculine place, dominated by men and focused on, above all else, military conquest. In this land of the Salic Law, masculinity was celebrated while femininity was quietly disparaged.[89] Court life was punctuated by rituals that underscored the king's virility, beginning with his birth. At the approach of each royal confinement, only one question mattered: will it be a boy? If the answer was in the affirmative, an outpouring of joy ensued. When Louis XIV's grandson was born, the court went wild and the king in his delight allowed courtiers to touch and embrace him in a way he would normally have discouraged. When a girl was born, as seven were to Louis XV, the scene was quite different. As soon as the royal physician announced the girl's sex, the courtiers dispersed, the king returned to his mistress, and the child was taken without ceremony to the royal nursery. Louis XV's daughters were so disappointing that courtiers called them not by their names but by number— Madame 1, 2, 3, and so forth.[90]

The king's coming of age was also marked by the affirmation of his masculinity. While an infant and child, the heir was raised by women, by his governess and her female assistants in the household of the children of France. Then, sometime between age nine and eleven, the king had his son "removed from women": that is, taken from his governess and spirited away to a (male) tutor and all-male household in another part of the castle.[91] The message was clear: femininity equaled childishness, while masculinity meant power and maturity—the attributes of a future king.

As a young man, the heir continued to project his virility by actively displaying his libido. The sovereign's fertility was connected in mysterious ways to the fertility of the country, and his ability to ensure the succession guaranteed peace in the kingdom. Louis XIV, for example, was famously sexual, allowing himself liberties that his courtiers could never have dared.[92] In this regard, he was not unlike the great Ottoman sultan.[93] He monopolized women and enjoyed an almost unfettered sexual freedom, both traits that symbolized his dominance.

But this strategy also presented dangers. Louis XIV could not afford to pose, like the sultan, as the only adult male in the palace.[94] He could dominate but not emasculate his courtiers; they might rebel. Consequently the king provided his dukes and counts with occasions upon which they too could display their virility. War was such an event, and because war was almost constant during Louis' reign the nobles had ample occasion to distinguish themselves in battle.

At court, the king organized various events that simulated war. In the 1660s, Louis XIV hosted *carrousels*. These spectacles featured teams of armed noblemen dressed in elaborate costumes who competed in military games and exercises. Like its ancestor the joust, the *carrousel* was an unusually decorative military maneuver that allowed for the display of virtuosity. In the 1670s, the hunt replaced the *carrousel* as the principal simulacrum of war. All the Bourbon kings loved to hunt, and they expended an inordinate amount of money and time on the activity.[95] Almost every day, a significant portion of the court's time was devoted to hunting. Usually, the court hunted stag—the most masculine of animals— and it was during the hunt that newcomers were introduced to the king. The neophyte was dressed in a special gray coat and was always assigned the wildest mount, so that the seasoned hunters could have a good laugh at his expense. Once the stag was down and its antlers removed, the king repaired to a hunting lodge or glade where a repast was laid out. At this point, the ceremony of "de-booting" took place. The new men were introduced to the king by their sponsors, and the newcomers chatted with the king as his boots were removed. A meal and wine followed, and as they ate at the same table the hunters felt they were the equals and companions of kings.[96] The hunt was a male ritual complete with hazing, commensality, and camaraderie. In the palace, the king ruled over men, but in the hunt he was their friend and companion.[97]

What role, one wonders, did women play in this celebration of masculinity? Stag hunting required no handling of weapons, so it was deemed appropriate for women. Portraits of the royal women sometimes showed them in hunt attire. But the role of women in the stag as in other hunts appears to have been largely passive. We know that the aging Louis XIV enjoyed having ladies watch him shoot birds. The Grand Dauphin, Louis XIV's son, would delay killing the wild boars he had trapped until after dinner, when his wife and her ladies-in-waiting could watch him ride among the nets trampling the beasts and stabbing them with his spear.[98] It would appear that the primary role of the women was to bear witness to male exploits.

One of the roles of women at Versailles was to act as a foil to the hypermasculinity projected by the king. But women also contributed to solidifying Bourbon

rule in material ways. Norbert Elias has characterized Versailles as a place where the courtiers were disciplined. Contemporaries tended to define it as a place where the courtesans were gratified. "Receiving, taking, asking"—that is how Figaro described the court, and observers remarked on how the courtiers badgered the king for favors. "The king never has enough grace to bestow," noted the duc de Saint-Simon,[99] but women helped him extend his store of favor. By establishing positions for women in the households of the royal women, the king created a whole new set of signs of distinction. These signs were all the more valuable in that they redounded to not one but two families. Women belonged both to their husbands' lineage and to that of their fathers, and thus benefits to them amplified the effects of the king's grace. The importance of the ladies-in-waiting and women of the bedchamber to Bourbon rule may be judged by the debate that ensued in 1725 when a household was established for the newly wed Queen Marie Leszczyńska. The royal officials had briefly contemplated making these offices venal as a means of recuperating the great expense incurred by the royal marriage. After some deliberation, the officials decided to keep the women's offices appointive: the king liked to give these positions to "the wives and daughters of individuals who become so to speak the king's creatures."[100]

Whether haughty ladies of honor or lowly women of the bedchamber, women helped multiply royal favor and diffuse it throughout the court and even the kingdom. Versailles women, like their Asian counterparts, served the dynasty. They contributed to the Bourbon rule, but only as wives and daughters. Women could make money at Versailles and occupy some positions of authority in the all-female precincts of the queen's or dauphin's household. But otherwise they were different from male courtiers. They could never hope to occupy the posts that conferred great distinction and honor: those of marshal, minister, cardinal, or for that matter king. Because of their sex, female courtiers experienced life in the great palace differently from male courtiers. The women of Versailles were not slaves, like some of their Asian counterparts, nor were they confined to an inner court or harem. Nevertheless, they lived in a male-dominated palace where their careers were circumscribed and their lives largely determined by their sex.

Notes

1. As Sharon Kettering has observed, "much less is known about the French royal court than other courts of Europe" (Kettering 2003). Recent studies by Da Vinha (2004) and Laverny (2002) have increased our knowledge of the Bourbon court. But its women remain less known than their Austrian sisters who are the subject of Keller's 2005 study.

2. Bertière 1998, 2000. More informative is Chaussinand-Nogaret 1990.

3. Elias's domination has not gone unchallenged. The most sustained criticism can be found in Duindam 1994, 2003.

4. Mossiker 1961, pp. 118–35. La Motte bilked thousands of pounds out of the king's almoner by claiming to advance his quest for a minister's portfolio. She maintained that she was an intimate of Queen Marie-Antoinette, who to her death maintained she had never even met La Motte.

5. In 1710, the royal women included four illegitimate daughters, the wives of two illegitimate sons, and the duchesse de Bourgogne, wife to the heir presumptive. The number would be seven if one counted Madame de Maintenon, the king's secret wife. In 1780, the royal women were composed of Louis XVI's four aunts, his queen (Marie-Antoinette), his sister (Madame Elisabeth), and a daughter (Madame Royale), as well as two-sisters-law, making a total of nine.

6. Levron 2003, pp. 218–19.

7. Newton 2000, p. 26.

8. Lists of the retainers in all the royal households, including the royal women's households, were compiled and published in books called the *Etats de France*. These *Etats* came out sporadically in the seventeenth and eighteenth centuries and they look much like almanacs or a guidebooks. In true seventeenth-century fashion, they are rarely accurate, but they provide a general picture of the number of women. Lists of household retainers can also be found in the manuscript collections of the French national archives, the Archives Nationales in Paris (cited hereafter as A.N.).

9. Medieval queens tended to reside most of the time in their own estates and only infrequently with their husband. This distance from the court neither prevented them from being powerful nor implied that their retinue was small. Most of these women appear to have been simple domestics rather than ladies-in-waiting, but the slippery nomenclature in the documents makes it hard to determine just what their function was (Munster 2000, p. 348).

10. This number eventually rose to fifty-nine ladies and forty-one girls.

11. A.N. KK 203; see also Kleinman 1990. Anne's daughter-in-law, Marie-Thérèse, had a household of 317 retainers exclusive of her stables. Of these thirty-seven were women, including nine Spanish chambermaids. After a long hiatus without a real "first lady" of the palace, Maria Leszczyńska formed her household, which contained twenty-nine women (Besongne 1736). Marie-Antoinette was notorious in her day for increasing the size—and expense—of her household. But her establishment was not much larger than that of her seventeenth-century predecessors. According to the *Almanach de Versailles* of 1780, the queen's household consisted of sixteen ladies-in-waiting and fourteen women of the bedchamber: a total of thirty-one, almost exactly the same number as her grandmother-in-law (see A.N. O1 3742).

12. On the number of duchesses, see Bluche 1990, s.v. "Ducs," pp. 502–3. Also, because many of these duchesses (again like the wives of Saint-Simon and Luynes) were attendants to the royal women, they are already contained in our initial count.

13. Besongne 1699, 2:174.

14. Archives départementales des Yvelines (hereafter cited as A.D. Yvelines), B. 3309. We know about Madame de Mailly's domestics because all testified in a law case involving a theft at the rue St. Cloud town house.

15. Valets could also serve in chambers; they cleaned Madame de Mailly's room and changed her bedding.

16. A.D. Yvelines, B. 3309.

17. Laverny 2002, pp. 148–58.

18. Primi Visconti 1908, p. 257; Boucher 1982; Griselle 1912, p. 153.

19. La Tour du Pin 1913, 1:112–14.

20. Campan 1895, 1:133.

21. The tradition of the "circle" was practiced by the duchesse de Bourgogne until her death in 1712. Whether it continued to be an important part of the life of a royal woman's household is hard to know. The Grande Dauphine, daughter-in-law of Louis XIV, spoke poor French and preferred to highlight music in her quarters (Bertière 1998, p. 353).

22. La Tour du Pin 1913, 1:148–49.

23. See Campan 1895, 1:5–25.

24. Two valets, two waiters, and a carrier (portefaix) were the men who worked in the household of the children of France (A.N. KK 1452).

25. On the household of the children of France, see Cortequisse 1990, pp. 39–60.

26. This description of the household of the children of France is derived from "Livre qui contient tout ce qui peut interessé Madame la Gouvernante des enfants de France sur l'intendance de leurs maisons" (A.N. KK 1452).

27. Cortequisse 1990, p. 46. Later in life, the sisters would fawn over their brother and defend him. Pious as an adult, he became part of the "devout party" that included his mother and sisters and shared their opposition to the royal mistresses.

28. La Tour du Pin 1913, 1:100–103.

29. Capon 1907, p. 96.

30. Clairambault, quoted in Bluche 1958, 1:13.

31. Petitfils 1989, p. 165.

32. Saint-Simon 1983, 1:310–21.

33. Saint-Simon 1983, 2:390.

34. The regent-queens—Catherine and Marie de' Medici and Anne of Austria—selected their own retainers and those of their daughters-in-law. Anne of Austria formed Marie-Thérèse's household long before the Spanish infanta set foot in France.

35. Luynes 1864, 1:127.

36. La Tour du Pin 1913, 1:112–13.

37. A.N. O1 3717.

38. See Poignant 1970, pp. 81–86; T. Kaiser 2006, pp. 403–20.

39. Saint-Simon 1983, 1:448.

40. Wet nurses—there were always at least two—were chosen solely on the basis of their health and good morals, both of which were carefully monitored by a special governess (herself a woman of the bedchamber).

41. Saint-Simon 1983, 1:307 n. 5.

42. Levron 2003, pp. 218–19.

43. La Tour du Pin 1913, 1:12.

44. A.N. O1 3716.

45. A.N. O1 3735.

46. A.N. O1 3735.

47. Houssonville 1899–1908, 1:290–93.

48. Saint-Simon 1983, 1:310, 5:573.

49. A.N. O1 3742.

50. A.N. KK 1452.

51. Bertière 2000, pp. 223–48.

52. De la Motte, quoted in Kettering 1993, p. 69.

53. Madame de la Motte, quoted in Kettering 1993, p. 76.

54. The right to recommend individuals for posts was virtually institutionalized at the court and constituted one of the favors that the king bestowed on worthy courtiers (Levron 1961, pp. 99–101).

55. Saint-Simon 1983, 1:724–725.

56. Saint-Simon 1983, 1:725.

57. Levron 1961, p. 105.

58. Saint-Simon 1983, 2:235. This new position, to be occupied by Mazarin's nieces, was added to the houses of both the new queen, Marie-Thérèse, and the queen mother, Anne of Austria.

59. A.N. O1 3742.

60. A.N. O1 3713. Where or even how often the queen's council met is not clear. Nor is its relationship to the queen or (more important) to the king and his ministers, who dealt with most important matters concerning the queen's affairs.

61. Luynes 1864, 1:161.

62. Luynes 1864, 1:124.

63. Primi Visconti 1908, p. 57.

64. Besongne 1672, p. 144; Marinière 1658, p. 20.

65. Anne of Austria usually supplemented the girls' dowries, generally by three thousand pounds (A.N. KK 201–4).

66. A.N. KK 139–40.

67. Newton 2000, p. 182.

68. Petitfils 1989, pp. 121–36.

69. See Petitfils 1989, pp. 140–42.

70. Saint-Simon 1983, 5:593.

71. In 1678, a Parisian murder touched off a wide-ranging judicial inquiry into the manufacture and use of poisons. The accused implicated a host of individuals, including women in the entourage of Madame de Maintenon. Whether Maintenon actually attempted to restore the king's affections by feeding him magical powders is unclear, but the rumor circulated nonetheless.

72. Saint-Simon 1983, 5:537.

73. In his *Mémoires* (1983, 5:560–70), Saint-Simon ascribes a great deal of influence to Maintenon (whom he loathed).

74. Bryant 2004, pp. 89–99; T. Kaiser 2005.

75. Hardman 2006, p. 65.

76. Peter Campbell, like John Hardman, emphasizes that in the courts of premodern Europe, politics tended to center on personalities more than policies and bore little relationship to our modern notions of state activity or public life (Campbell 1996, pp. 296–300).

77. Pompadour was particularly successful at maintaining a "faction" that included powerful ministers and court figures who sustained her influence and enabled her to fend off rivals and consolidate her credit with Louis XV.

78. Primi Visconti 1908, p. 171.

79. Louis XIV, quoted in Petitfils 1989, p. 157.

80. One French queen was exiled, Marie de' Medici—but by her son, Louis XIII. Anne of Austria also incurred his wrath, but as his wife he could not so easily pack her off, especially after she bore two sons.

81. On the Salic Law, see Hanley 2003.

82. Mothers made better regents than uncles because they could never sit on the throne. Therefore they, unlike uncles, posed no risk of permanent usurpation. At his legal majority—a mere thirteen—the young king would be crowned. Usually the queen regent stayed on as a part of the king's council and continued to administer the kingdom. But eventually her son would evict her from the site of power.

83. On the regency, see Crawford 2004.

84. On this issue, see Cosandey 2002.

85. Levron 1961, p. 122.

86. Rogister 2004, p. 207.

87. Labatut 1972, pp. 358–59.

88. Of course, women could and did seek these positions for their male relatives, but their role was always a supporting one, since they could never directly enjoy the favors they acquired for their male kin.

89. Few scholars have been interested in the gendered dimension of Bourbon rule. An important exception is Zanger 1997.

90. Cortequisse 1990, pp. 11–37.

91. This account is based upon the duc de Luynes's report of the "removal" of Louis XV's son in March 1736 (Luynes 1864, 1:63–70).

92. That Louis XIV's father had taken an inordinately long to father a child made a blatant display of libido all the more urgent.

93. On unflattering comparisons of Louis XIV to the Ottoman ruler, see Grosrichard 1998.

94. On the sexual politics of the Ottoman rulers, see Peirce 1993.

95. There were more horses and dogs connected to the palace than women, and they cost a great deal more to maintain. The king's elaborate system of stables and kennels has been the subject of a collection of essays edited by Daniel Roche (1998).

96. A particularly hilarious recounting of a hunt "presentation" appears in Chateaubriand 1947, 1:130–32.

97. The dauphin was initiated into stag hunting when he left the women, another sign that there was a connection between masculinity and the hunt (Salvadori 1996, p. 188).

98. Salvadori 1996, p. 200.

99. Saint-Simon, quoted in Solnon 1987, p. 365.

100. A.N. O1 3472.

CONCUBINES AND CLOTH

Women and Weaving in Aztec Palaces and Colonial Mexico

Susan Toby Evans

When Cortés arrived in the Aztec Empire of Mexico in 1519, he observed that rich men and noblemen had many wives. This marriage pattern, polygyny, contrasted to that of Cortés's native Spain and of the entire Christian world, in which only monogamous unions were legally recognized. The Spanish Conquest of the Aztec Empire changed much of Aztec culture: ancient Mexico's land and riches came under Spain's control, and its native people were converted to Christianity—and obliged to obey marriage laws that demanded monogamous unions. This change in marriage practices had severe economic consequences for the Aztec nobility, because Aztec women wove cloth, and cloth was so highly valued that it was a form of money. Therefore, a household with many wives produced much wealth, and one with only one wife was much poorer. The secondary wives, the "concubines," held a status of respect because of the prosperity they generated. Far from being denigrated as sexual service workers, as would have been the case in Europe at that time, they were a source of pride and wealth.

This essay traces the relationship between marriage patterns and wealth in textiles through three successive periods in Mexican history: the Late Postclassic period heyday of the Aztec Empire (ca. 1430–1521), the Early Colonial period (1521–1620), and the Middle Colonial period (1621–1720; see table 11.1). It was the value of cloth, not the desirability of maintaining a voluptuous harem, that led Aztec men to have many wives, and this practice became exaggerated in the social upheaval in the transitional Early Colonial period, beginning with the Spanish Conquest. By the early 1600s, Europeanized culture was firmly in place,

TABLE 11.1 Chronology and Culture of Mexico

	Late Postclassic Period (1430–1521)	Early Colonial Period (1521–1620)*	Middle Colonial Period (1621–1720)*
Political rulers	Aztec empire	Spanish king and viceroy of New Spain	Spanish king and viceroy of New Spain
Population size trend	Population increase	Severe population decline	Stabilization of surviving population
Religion	Veneration of native deities	Process of conversion to Christianity	Christianity
Marriage patterns	Rich men = polygynous; commoners = monogamous	Unconverted men practice polygyny; commoners and converted elites practice monogamy	Monogamy
Textile production	By women in household contexts, using traditional methods	By women in household contexts, using traditional methods; some use of European products and methods	By women in household contexts, using traditional methods; by men and some women using European products and methods

*Based on Charlton 1986.

and the surviving Aztec nobles had adopted Christianity and its monogamous marriage patterns. Patterns of textile production had also changed with the use of simple machines (treadle looms and spinning wheels) and factory methods introduced from Europe.

Chronology and Cultural Change

The land we now know as Mexico was named after the Mexica (pronounced maySHEEkah) Aztecs, an ethnic group who established their capital at Tenochtitlan (later Mexico City) in about 1325 C.E. A little over a century later, they had become so powerful that neighboring ethnic groups paid them taxes in goods and labor. By 1519, Aztec armies had subjugated a large part of the Middle

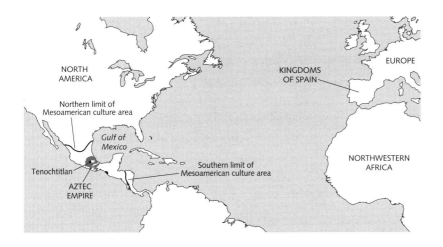

MAP 11.1.
The Atlantic world. In the early 1500s C.E., Europe and the
Americas were just beginning to become aware of each other.
This map shows the Middle American subcontinent and
(shaded) the territory controlled by the Aztec Empire.

American subcontinent (see map 11.1) and this territory's population of 5–6
million people was sending regular tribute payments to Tenochtitlan.

But other countries also had ambitions to expand their wealth by extending
their territories. Spain began sending explorers to the Americas in 1492; by
1521, the Aztec Empire was conquered, and the Spanish Empire straddled Eu-
rope and the Americas. The Spanish Conquest of the Aztec Empire ushered in the
Early Colonial period, a chaotic time of transition. Spaniards were eager to make
their fortunes and to convert the native peoples to Christianity. These aims were
complicated by the catastrophic death rate of the native population, as indige-
nous peoples succumbed to European diseases against which they had no im-
munity.[1] By the early decades of the seventeenth century, population levels had
stabilized and so had social patterns in New Spain, as Mexico was then called. The
Spaniards, of course, monopolized political power and access to key economic
assets, but they continued to permit native nobles to occupy administrative of-
fices at local levels and to retain such economic resources as they possessed in the
Early Colonial period. By this time, the indigenous nobles had fully adopted
Christianity and its attendant customs such as monogamous marriage. Many tex-
tiles for native markets were still produced by traditional techniques, but they no
longer served as a form of currency—nor were they valued by the new elites,
people of European descent who used cloth made by European methods. Thus
the old pattern of Aztec palace concubines producing woven wealth was entirely

superseded by monogamous marriage and textile fabrication in male-dominated factory settings. Let us look more closely at Aztec society and its patterns of marriage and textile production, and how these were transformed in the sixteenth and seventeenth centuries.

Aztec Society in the Late Postclassic Period (ca. 1430 to 1521)

The Aztecs were a set of ethnic groups in ancient Mexico who claimed to have descended from the inhabitants of a mythical homeland they called Aztlán.[2] As mentioned above, the Mexica Aztecs came to dominate related ethnic groups, and then came to control populations hundreds of miles from their main capital at Tenochtitlan. Like their European contemporaries, the Aztecs had distinct social strata: a small class of nobles, perhaps fewer than 10 percent of the total population, drew tribute in labor and goods from a huge mass of commoners who were farmer-artisans. There was no "slave class" as such; slavery could befall anyone who was brought low by extreme poverty or crime.

Family ties were the most important social relationships for nobles and for commoners, and every marriage created an alliance between two families. Here, as in many traditional agrarian societies, professional matchmakers brokered engagements for commoners. For Aztec nobles, important marriages were part of political alliances and were arranged through diplomatic channels.

Nobles and commoners tended to follow different marriage patterns. Most Aztec commoners were monogamous, married to one person at a time (divorce was legal, and both men and women had rights to their property and to custodianship of their children). However, there were no laws against polygyny, and any man could have as many wives as he could afford. Because wealth was necessary to set up a large household, the practice of polygyny was limited to affluent nobles and to a small number of wealthy commoners, such as long-distance merchants.

Different marriage practices resulted in considerable variation in household size. The size of the monogamous household was fairly small—perhaps five or six individuals living together. But polygynous households ranged in size from those that were only slightly larger than monogamous households to those containing hundreds of people—Motecuzoma, the Aztec emperor who was defeated by Cortés, is said to have had hundreds of wives, plus great numbers of children and servants. He had at least half a dozen palaces, so the members of his vast household no doubt occupied several different locations.[3]

Aztec Polygynous Family Households: First Wives, Secondary Wives, and Concubines

Motecuzoma's household, with its many houses and many family members, may have been the most complicated in the Aztec Empire. Each wife had a particular status, the most important being that of the "first" or "primary wife"—usually the man's initial legitimate spouse but always his most important one, and the mother of his fully legitimate children.[4] The Aztec nobleman's goal in this primary marriage was to marry up—to get a wife from a dynastic family that had more prestige than his own, so that his heirs would have powerful relatives who would help them advance.[5]

Secondary wives had a legitimate marital status, but it was one that assumed that they and their offspring would have a lesser position in the family. The choice of secondary wives, women whom Westerners might label "concubines," was less constrained by strategy and political considerations. Secondary wives could be selected—or accepted as gifts—in order to secure a stronger relationship with an ally or a client, or because the women themselves were desirable for such reasons as physical appearance or skill at necessary palace household work such as preparing special food and drink for feasts and producing fine-quality weaving and embroidery.

This system casts a different and non-Western light on the practice of concubinage. The term *concubine* in Western culture has a negative connotation of being servile—in particular, of having to perform sexual service. In societies like that of the Aztecs, women were given to a noble lord as a means of currying favor with him. However, the same considerations that made primary marriages the object of careful negotiation with matchmakers also encouraged men to protect the well-being and dignity of concubines. No sensible ruler carelessly antagonizes his clients by mistreating a member of their family. Nor was this arrangement unattractive from the viewpoint of the young women who became concubines in noble houses. The lives of the Aztec commoners were filled with hard work in a setting of simple living conditions, lacking many comforts. Marriage to another commoner would be inevitable if a young woman's exceptional good looks or household skills did not make possible life as a palace concubine, and even slaves could earn such a position.[6] Once a concubine was taken into the palace, her life largely revolved around these more specialized household duties, only in a much more luxurious setting, with basic drudge work taken care of by servants.

Whether the concubine found her sexual duties toward her lord to be onerous or highly pleasurable, they were unlikely to occupy a significant proportion of her time. Even if she were her husband's favorite partner, the inevitability of

pregnancy and customs of celibacy after childbirth would remove her from contact with him for years at a time. Furthermore, maternity could be translated into power, if a woman's child became an important member of the elite. A case in point is the great Aztec emperor Itzcóatl (r. ca. 1428–40). His father, Acamapichtli (r. ca. 1376–96), was the first Aztec ruler, but his mother was not a royal princess. She was described in various sources as a slave or as a seller of vegetables in the public market. Whatever her exact circumstances, she was low-born but highly appealing to Acamapichtli, and her son Itzcóatl was the Aztec ruler responsible for the establishment and early expansion of the empire. The mother of the emperor was usually also a high-ranking noble; but regardless of the social station into which she was born, the power of her son would elevate her to an exalted rank. The example of Itzcóatl's mother must have inspired many concubines to dream of upward mobility, fueled by a gifted and ambitious son.

Palaces

In contrast to the few imperial palaces with dozens of wives and concubines, most polygynous households in the Aztec period were probably much more modest. This assumption is based on the kinds and sizes of palaces dating from the Late Postclassic period and from our knowledge of how the Aztec Empire was administered. The archaeological evidence leads us to assume that in the Basin of Mexico (the region around Tenochtitlan) there were just two great imperial administrative palaces, in Tenochtitlan and in Texcoco, the other major Aztec capital. There were also about fifty much smaller administrative palaces in city-state capitals, and about three hundred local palaces, the residences of nobles who governed rural villages.[7]

What do we know about these different kinds of palaces? For the imperial palaces, there are accounts by eyewitnesses, both the Spaniards who lived in them in 1519 and 1520, or who saw the surviving palaces after the conquest, and native lords who described their family histories and residences during the Early Colonial period. However, we have little archaeological evidence, because later buildings were built over them. Motecuzoma's great palace, for example, was demolished during the siege of Tenochtitlan, and modern Mexico City's Palacio Nacional now occupies its site.

More is known of the smaller palaces, because often the communities in which they are located were not rebuilt after the sixteenth century. The only completely excavated palace in the Basin of Mexico, in fact, is located in the Aztec village of Cihuatecpan, which was abandoned in 1603. In 1519 it was a community of about one thousand people, most living in houses of three or four rooms that conformed to the needs of the commoner family.

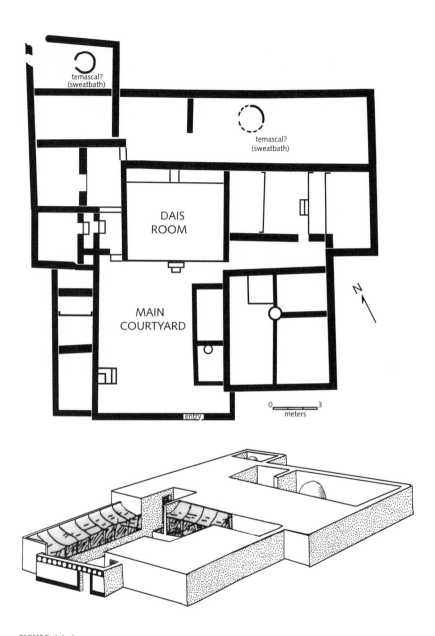

FIGURE 11.1.
Layout of the palace at Cihuatecpan, an Aztec village about 65 kilometers northeast of the capital city of Tenochtitlan (Mexico City). The local ruler would have lived in this palace, a smaller version of the great imperial palaces of the capitals.

The Cihuatecpan building that was probably an Aztec palace was three times the size of the average commoner house, and its construction was of much higher quality. As the building plan shows (see figure 11.1), suites of residential rooms surrounded a central courtyard spacious enough to hold meetings of all two hundred household heads in the village. The suites of residential rooms would have suited the needs of three or four wives and their children. The "dais room" is assumed to have been the ruler's own quarters, and also the stage from which he—or she—would address assemblies.

Service yards at the back of the palace contained sweat baths, which were important to Aztecs of both sexes but viewed as particularly essential for the health of pregnant women. Around the sweat baths were broken figurines of an Aztec fertility goddess (Xochiquetzal) who was also venerated by "embroiderers, and weavers."[8] "Xochiquetzal was the essential creative force, and those who participated in creative acts—transforming nature into art—paid homage to her."[9]

Cihuatecpan in the Aztec language means "woman palace" or "woman lord–place." Scholars do not agree about the meaning of this place-name, which is also used of several other communities. A palace where there are lots of women? a palace ruled by a woman? Such a name naturally makes one wonder whether women ruled Aztec palaces. The answer, as pertains to the city-state and village levels, is yes. Ethnohistorical documents record no women emperors, but a handful of women ruled city-states in the Basin of Mexico. Also, there were women heads of household, though the pattern was not common—2.2 percent in a traditional Aztec village in the Early Colonial period that supplies the best evidence on this question.[10] Extrapolating from these data and from our knowledge that Aztec women regularly occupied positions of administrative and financial responsibility, we can assume that occasionally, a woman governed at the village level.

Cloth Production and Palace Life

A few women may have ruled, but *all* women spun thread and wove cloth and embellished it with embroidery. Mastering needlework skills—spinning, weaving, and embroidery—was essential to their upbringing. This point is reiterated in such Early Colonial sources as the *Codex Mendoza* (see figure 11.2) and Fray Bernardino de Sahagún's *General History of the Things of New Spain*, also known as the *Florentine Codex* (see figure 11.3). Aztec kings admonished their daughters to master these important skills, because without them, they would not secure the dignity of a good marriage: "apply thyself well to the really womanly task, the spindle whorl, the weaving stick. Open thine eyes well as to how to be an artisan[;] . . . [selling] the herbs, the wood, the strands of chili . . . are not . . . thy gift, [nor] art thou to frequent another's entrance, because thou art a no-

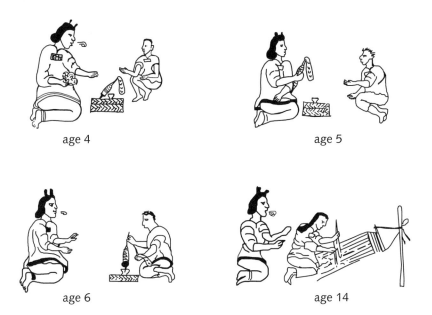

age 4

age 5

age 6

age 14

FIGURE 11.2.

Aztec mothers taught their daughters textile skills from an early age. The spindle, shown in the drawings for ages four, five, and six, has a hank of unspun cotton attached to the top; the bundle of spun thread forms an oval above the half-circle of the spindle whorl. The spindle rests in a ceramic spinning bowl, to keep it steady, and that bowl, in turn, rests on a mat. By age fourteen, this girl has mastered spinning and is also weaving, using a backstrap loom. The curved motifs emerging from the mother's mouth are speech scrolls, the Aztec glyph for speaking. Illustrations from the *Codex Mendoza*, fols. 58r, 60r, redrawn by author.

blewoman."[11] In other words, princesses do not make their living in door-to-door sales—unless they have utterly failed to achieve the necessary skills that will do credit to them as noblewomen. These values even extended to the afterlife. In the paradise of Tlalocan, "the women were great embroiderers, skilled in work with cotton thread."[12]

Archaeological evidence of these important skills is limited because wooden looms, and the textiles they produced, are biodegradable and have not survived from Aztec times. In fact, the only type of archaeological evidence for the entire Aztec textile industry is the spindle whorl: a baked clay solid hemisphere, pierced to be placed on a wooden rod (spindle) and serve as a weight to regulate the hand-spinning process (see figure 11.4). Spindle whorls are found in

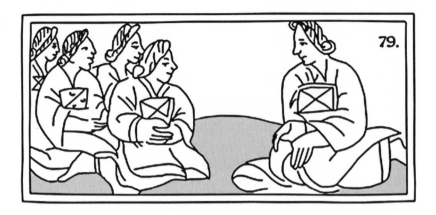

FIGURE 11.3.
Aztec noblewomen who were part of the same polygynous household looked to the principal or first wife for leadership and worked together on household tasks. "The Noblewoman," in Sahagún 1961, fig. 79, redrawn by author.

all Aztec sites; at Cihuatecpan they occurred in all houses, but at a slightly higher frequency in the presumed palace structure. There, 0.24 whorls were found per cubic meter of dirt excavated; at the other houses, the average was 0.17 whorls per cubic meter. These slight differences suggest not that each woman in the palace was spinning more thread than commoners outside it but that the practice of polygyny among nobles resulted in a disproportionately high number of adult women in the palace. More thread was spun there because there were more women committed to that task, and to weaving, and to embroidery.

Such a concentration of textile workers ensured that the palace was a moneymaking operation, because cloth was a standardized medium of exchange in Aztec society as well as a product valued for its many uses. Each woven cotton cloak (also known as the cape or mantle, *manta* in Spanish) took about one hundred person-days of labor to produce from raw, unspun cotton.[13] According to accounts preserved from the Aztec Empire, as many as 217,600 cotton garments were required in tribute, including 65,600 plain cloaks.[14] A string of jade beads cost 1,200 cloaks; a jaguar skin cost 40 cloaks.[15]

In addition to being demanded by the government in tribute, cloth was sold in Aztec marketplaces. Industrious women who were skilled spinners and weavers were thus empowered to maintain or advance their own social and economic status and that of their children. Not only could they sell what they pro-

FIGURE 11.4.
An Aztec woman's weaving tools were among her most impor-
tant possessions. Here, from left, the spindle, equipped with its
whorl near the bottom, then the parts to a loom neatly pack-
aged atop a basketry box. At upper right, a spinning bowl, and
below it, a decorated *huipil* (blouse), product of weeks of work.
Sahagún 1969, fig. 30, redrawn by author.

duced but, as mentioned above, they could use their textile skills to marry into
wealthy households.

Beyond their commercial exchange value, fine textiles had an important
prestige value in elite gift exchanges. Lords gave each other these goods as
high-level diplomatic gifts and in celebration of baptisms, betrothals, mar-
riages, and funerals.[16] The distinctive designs and valuable finishing materials
displayed in palace-produced textiles were subtle reminders of the many hours
spent by the high-status women of the royal household in making each of these
luxurious pieces. Thus, both economic and social forces encouraged nobles to
practice polygyny. As one Spaniard observed around 1540, "Aside from the
consideration of the wide distinction and relationship they established by hav-
ing the women, and also the great support they hereby obtained, it was
through the women they possessed a great advantage in having them weave
cloth, make clothes and render them many services, since the principal women
brought other serving women with them."[17]

New Spain in the Colonial Period

For the Aztecs, high-level diplomatic gifts included women. The Aztecs assumed
that women presented to other high-ranking men would be graciously received,

as would any diplomatic gift, and that the women themselves would cooperate with their new masters. As one Colonial period chronicler put it, the rulers of ancient Mexico had taken "absolutely whichever woman they wanted, and they were given to them as men of power. And, following this usage, many daughters of the rulers were given to the Spaniards, so that they would leave descendants there, in case they should go away from this land."[18] Thus, when Spaniards arrived on the Gulf Coast, native lords presented them with women. However, these women were moving from a culture in which polygyny was standard among the elites into one in which monogamy limited legitimate status to just one wife: all other women with whom a man had sexual contact were assigned one within a range of demeaning statuses (mistress, harlot, prostitute).

In 1519, in one of their first peaceful interactions with the native population, Spaniards under Cortés received twenty women, among them Malinalli (Malinche), whose facility with languages and shrewd ability to size up complicated political situations made her a pivotal character in the dramatic events of the Spanish Conquest.[19] Ironically, Malinalli was herself a noblewoman and in line to inherit not one but two rulerships. Her mother and stepfather had other plans for the disposition of these domains, however, and sold her into slavery instead. The fantastic intersection of her personal misfortune with the collision of two global empires made her life radically different from the Aztec noblewoman's routine of textile production and local political administration. Her story thus helps us understand the chaos of the Early Colonial period, when the ambitious and strong could advance themselves, regardless of the rules of the vanished Aztec Empire or the emergent Spanish colony

As the Spaniards moved toward the Aztec capital from the Gulf Coast, the rulers of other groups continued to present them with gifts, including women. "When the rulers of Tlaxcala presented noblewomen to the Spanish invaders, they were acting in accordance with the forms of donation of women and matrimonial alliances customary in the Nahua [Aztec] kingdoms."[20] According to a member of the Spanish expedition, Bernal Díaz del Castillo, the rulers also lavishly bestowed gold and textiles on the Spaniards.[21]

When Spanish intentions of conquest became clear, elite gift exchanges ceased and hostilities began. After Tenochtitlan was conquered in 1521, and neighboring groups were subdued and brought under Spanish control, a period began in which various strategies of adapting to old and new circumstances coexisted.

The Establishment of Colonial Period Patterns

Changes in marriage patterns included the imposition of monogamy as the only legal form of marriage. While a few Spaniards had Spanish wives, many

married native noblewomen, a practice that was encouraged in order to secure possession of the large estates held by native noble families.[22] The wealth that such wives brought to the marriage was in land, not textiles.

Native men thought of wealth in traditional terms, and their goal of maximizing their wealth through women and weaving was an obstacle to their conversion to Christianity. Native noblemen who refused to convert (or managed to avoid doing so) could amass huge households of women. As one eyewitness reported,

> Some [of these men] had two hundred women and others less, each one as many as suited him. Since the lords and chiefs stole all the women for themselves, an ordinary Indian could scarcely find a woman when he wished to marry. . . . The Indians would contend that the Spaniards, too, had many women and when we friars answered that the Spaniards had them in the capacity of servants, the Indians replied that they had them in the same capacity. It is true that, although the Indians had many women, to all of whom they were married according to their custom, they had them also as a means of profit, because they set all the women weaving cloth, making mantles.[23]

The Aztecs had good reason to see hypocrisy in the Spaniards, who insisted on monogamy yet practiced extramarital relations whenever they desired. However, the Spaniards were writing the social rules, and one of the most stringently enforced was the requirement that the natives be converted to Christianity. Resistance could result in death by torture, but most of the pressure to convert was more subtle. Catholic clergy traveling the countryside often stayed with nobles, and their mere presence encouraged the suppression of polygyny. The native chronicler Chimalpahin wrote that when a Franciscan friar came to stay in the palace of the ruler of Acxotlan, a city-state, the ruler "agreed to give up all but one" of his five wives.[24]

Another means by which the clergy pushed the natives toward accepting Christianity was to interject indigenous concepts and imagery into traditional Christian works. In 1583, Fray Bernardino de Sahagún produced *Psalmodia Christiana*, a hymnal in Nahuatl, and described Saint Anne in terms that would guarantee sympathy toward her: she was "a very strong woman. . . . She sought wool and cotton. Many were the capes she made, for well did she know her womanly tasks. . . . [She] took great pains with spinning [and] with weaving. At no time was she idle. She wasted neither day nor night." Saint Clare was similarly depicted.[25] At the same time, some aspects of native culture—such as the finely woven and expensively decorated clothing traditionally worn by perfectly respectable noblewoman—were, in the Early Colonial period, deliberately

associated by the Spanish authorities with harlots.[26] This association may have emerged from the Spanish assumption that Aztec concubinage was rooted in lust rather than in the value the Aztecs placed on the large polygynous household as prestigious and wealth producing.

In addition to insinuating the new religion into the traditional Aztec value system, the Spaniards imposed an entirely new pattern of gender relations. "Priests and Spanish officials alike extolled the patriarchal system as the divine design for humanity. . . . A husband had control over his wife, his children, and any others in the household. Women and children . . . owed him nearly total obedience. . . . His legitimacy rested upon his responsibility to support and look after the well-being of his family."[27] By contrast, the Aztec norms for commoner men and women were complementarity and equivalent legal rights, because in their culture "adult Mexica women were considered to be autonomous beings and not the dependents of men."[28]

Larger trends in the economy of Colonial New Spain undercut the economic strength of Aztec women and their ability to gain some degree of financial security through their skilled labor. Two related introductions—sheep and the treadle loom—transformed the textile industry. Sheep were among the herd animals (together with cattle, horses, and goats) that poured into the central highlands of Mexico, their numbers booming during the sixteenth century as the native human population underwent demographic collapse. In the Mezquital Valley north of Mexico City, the sixteenth-century conquest era saw the numbers of human inhabitants reduced by 90 percent; conversely, by 1565, three decades after their introduction, there were two million sheep.[29]

In the 1530s, small woolen mills (*obrajes*) were constructed in sheep-raising areas, each containing numerous "small European hand-and-foot looms" operated by commoner men.[30] Thus textile production was one of the first sectors in the Colonial Mexican economy in which European methods replaced the Aztec means of supplying an important resource. As part of that shift, Spanish standards of gender behavior were applied, isolating women in the home and increasing their dependence on their husbands as polygyny, which had played an important role in textile production, disappeared.

The changes that the Spanish Conquest wrought on women differed profoundly according to their status. By some measures, the quality of the lives of native women actually became worse. "By the seventeenth century . . . the legal status of Mexica women declined as new notions of separate but unequal spheres developed among the indigenous populations of the Valley of Mexico."[31] The complementarity that had characterized the relations between Aztec commoner

FIGURE 11.5.

Seventeenth-century Aztec noblemen and noblewomen: "The
men, bearded and clothed in Spanish style, have wide hats . . . and
carry rosary beads in their right hands. This could indicate reli-
gious piety or that they were members of a *cofradía* [brotherhood]
of the Rosary. . . . One of the men carries a sword, which was a
special privilege granted to certain individuals. The women are
garbed in pre-Hispanic styles, with *huipil* [blouse] and skirt deco-
rated in geometric designs. . . . Each woman carries a spindle
whorl, supporting cotton fibers, unspun over her left arm, carry-
ing the spindle in her right hand" (Horcasitas and Simons 1974,
p. 280). Horcasitas and Simons 1974, fig. 28, redrawn by author.

men and women was eroded as Spanish patterns such as male property inheritance replaced the Aztec custom of leaving an estate to all the offspring from a marriage. Unless they were widowed, married women had little say in the disposition of the family property; nor did they stand to inherit any significant assets from their fathers. These practices would have largely eliminated most women from access to family wealth after a few generations.

The changes forced on Aztec noblewomen depended on their marriages. Those who married Spaniards would find themselves absorbed into European-style life, while those who wed Aztec noblemen would have a lifestyle that merged native and European practices. Of course, no Aztec nobleman could have more than one wife, so each married noblewoman would have had an unchallenged position in her household. She would also have had much less help with household work, though native nobles still had servants. An illustration from a document related to Tepeaca, a town in the Mexican state of Puebla, shows native nobles adapted to two worlds in the first half of the seventeenth century (see figure 11.5). The couples are, of course, monogamous. Their piety and good citizenship are expressed through the conservatism of their clothes and the accoutrements they have chosen to carry. The men are depicted as more acculturated to Spanish ways than are the women, as is to be expected in a culture in which women were discouraged from participation in public life. The men's clothes are embellished with lace and they carry rosaries, which demonstrate their devotion to Catholicism. The women carry hand-spinning tools; the circular object dangling from each woman's right hand is the spindle whorl. In this simple drawing, the women's clothes convey the traditional native style of dress, but a closer look reveals that the artist has taken pains to show embroidered designs—these are not just any native garments but palace-quality clothes.

These couples illustrate the changes produced by more than a century of Spanish rule and by the imposition of Spanish customs. With the conquest, the Aztec noble class was demoted to a position little better than that of commoners. Some individuals took advantage of the upheavals of societal transformation to gain great wealth in the short term, but the overall trends, economic and demographic, crushed most native efforts to advantage themselves. Aztec royal concubines who had been exhorted to become master artisans in order to earn their place in a palace would have been heartbroken to see their granddaughters reduced to the extreme measure of selling vegetables door-to-door. And yet, as the drawing shows, a fortunate few families did survive, and with them the role of the woman of the palace, proving the worth of her womanhood with her spindle and loom.

Notes

1. Diamond 1997; Sanders 1992; T. Whitmore 1992.
2. For a general discussion, see Evans 2004a, pp. 437–540.
3. Evans 2004b.
4. Pomar [1582] 1941, p. 24.
5. Carrasco 1997.
6. Sahagún 1959, p. 46.
7. Evans 2004b.
8. Durán 1971, p. 244.
9. McCafferty and McCafferty 1999, p. 103.
10. Harvey 1986, pp. 287–88.
11. Sahagún 1969, p. 96.
12. Sahagún 1961, p. 188.
13. Hicks 1994, p. 92.
14. Berdan 2001, p. 184.
15. Gasco and Voorhies 1989, p. 77.
16. Sahagún 1969, pp. 129, 196.
17. Motolinía 1951, p. 246.
18. Muñoz Camargo [1584] 1984, p. 238.
19. Karttunen 1997.
20. Carrasco 1997, p. 103.
21. Díaz del Castillo 1956.
22. Carrasco 1997.
23. Motolinía 1951, p. 202.
24. Schroeder 1991, p. 77.
25. Sahagún 1993, pp. 207 (Saint Anne), 237–41 (Saint Clare).
26. Arvey 1988.
27. Carmack, Gasco, and Gossen 1996, p. 328.
28. Kellogg 1995, p. 95.
29. Melville 1994, pp. 40, 51.
30. West and Augelli 1989, p. 267; Melville 1994, p. 163.
31. Kellogg 1997, p. 124.

12 WOMEN, ROYALTY, AND INDIGO DYEING IN NORTHERN NIGERIA, CIRCA 1500–1807

Heidi J. Nast

This essay presents preliminary historical geographic evidence from three sites discovered in and near the ancient city-state of Kano, in northern Nigeria, that shows that as early as the 1500s, royal concubines in the Kano palace held exclusive rights over the production of indigo-dyed cloth; and that they did so because of indigo blue's association with human and earthly fertility over which royalty was understood to have control. The data suggest that over subsequent centuries, royal and nonroyal women across Hausaland (a linguistic region straddling Nigeria and Niger of which Kano was a leading economic and cultural part)[1] began producing indigo-dyed cloth for domestic and commercial purposes. It was only after a reformist jihad in the 1800s that men effectively wrested industry control away from royal and nonroyal women alike.

The findings offer an important historical and geographical corrective to earlier research showing that the celebrated city-state of Kano became renowned across West and North Africa as a center of high-quality indigo-dyed cloth, produced exclusively by men (see map 12.1).[2] Whereas men certainly controlled the industry for most of the nineteenth century, this work suggests that they built up the industry by drawing on women's heretofore-unacknowledged skills and technologies, developed over previous centuries. Thus, while the gendered makeup of Kano's nineteenth-century indigo dyeing industry was indeed anomalous in West Africa, it was so for only a relatively brief period of time.[3] The research findings require that indigo dyeing in the region be radically

MAP 12.1.

Principal long-distance trade routes in North and West Africa in
the sixteenth century. Kano city was located along the nexus of
many trans-Saharan trade routes and was, by the 1500s, a city
of great regional importance. Its importance continued after the
Fulani-led jihad of the early 1800s and the subsequent forma-
tion of the regional caliphate system.

rethought and that questions be addressed concerning how and why women
came to be displaced in Hausaland alone.

The three sites discussed here, all abandoned, are an extensive indigo-dyeing
yard inside the centuries-old Kano palace, historically administered by royal con-
cubines;[4] a sizable indigo-dyeing yard for women, behind the nearby village of
Limawa; and a large raised platform-like area close by, made up of a massive
amount of pottery shards, not far from the shores of the River Jambo. Because
no archaeological work has yet been done on any of the sites, my discussions of
the regional implications and meanings of royal and nonroyal women's indigo
dyeing are necessarily preliminary and partial. They depend, in part, on my pre-
vious study of royal women's history in the Kano palace;[5] on analysis of some of
the sites' attributes, gathered through ethnographic and field work; and on com-
parative examination of the findings in the North and West African cultural con-
text. The interpretations I offer here are therefore at times largely deductive and

even speculative, intended to generate rather than foreclose scholarly interest and discussion.

The collective significance of the sites and the apparent prevalence of women's indigo-dyeing practices prior to the nineteenth century make it clear that considerable resources will be needed to undertake a regionwide study of the phenomenon. None of the sites documented here, for instance, has been surveyed or archaeologically dated and analyzed. The difficulty of interpreting and assessing the significance of the sites is exacerbated by a dearth of scholarship on Hausa women's precolonial lives. Nonetheless, the relative ease with which the sites were found (using ethnographic methods), their geographical accessibility (near or on the surface), and indications that such sites are widespread suggest that many new historical and geographical grounds are waiting to be explored.

I begin this essay by presenting field evidence showing that palace concubines carried out indigo dyeing in an extensive dyeing yard inside the palace's female domain. Because I have studied the palace for more than fifteen years, it is the place with which I am most familiar. I preface my discussion of the yard by explaining briefly how the ways in which Islamic scholars and the king oriented and organized the palace effectively synthesized Islamic beliefs and non-Islamic, Sudanic kingship traditions. Placing the palace yard in cross-regional comparative context, I suggest that the royal household controlled the production and consumption of indigo-dyed cloth as early as the 1500s, in part because of indigo's pre-Islamic association with fertility and royalty's symbolic power over it; this control made concubines the first in the city-state to monopolize indigo-dyed cloth's production.

I then describe evidence from the two rural sites; taken together with the palace findings and data from secondary sources, it shows that indigo-dyeing yards for nonpalace women were created later in areas outside the palace. I propose scenarios for when and how production of indigo-dyed cloth diffused out of royal concubine domains and into nonroyal women's domestic and commercial spaces, detailing subsequently how and why men appropriated these spaces in the 1800s. I argue that the appropriation process was bolstered by Kano city's growing participation in, and importance to, trans-Saharan trade; the state's cultivation of local industry; and the gendered reforms enacted across Hausaland as a result of an Islamic jihad waged early in the 1800s by a group known as the Fulani. Finally, I discuss the larger implications of this research, both in local context and in terms of research in West and North Africa more broadly.

Royal Women and the Kano Palace Dyeing Yard

King Muhammadu Rumfa (1463–99) built the Kano palace around 1500 as a high-walled "compound" within which were located hundreds of individual buildings, a compound structure typical of vernacular households. For centuries, the palace accommodated up to two thousand persons, mostly slaves, many of whom held considerable state power. Today, fewer than 1,500 reside there, largely individuals descended from former slaves.[6]

Rumfa was the first king to accept Islam as the state religion, and he used the palace's monumental architecture to demonstrate his power and to structure important religiously inflected changes in state political culture.[7] The palace contained court chambers in part for a new all-male state council, typical of other extant Islamic sultanates. Most of the palace's terrain, moreover, was dedicated to the seclusion of the royal family, which included hundreds of concubines who worked either as the servants of royal wives or as key palace administrators (the latter, in some instances, carrying out important state functions), up to four wives (Islam's legal limit), all of the king's unmarried children (concubine children were royalty), and widowed royal women. While traditions of kingly seclusion expressing the divinity of the king existed throughout West Africa prior to Islamization, the particular ways that Rumfa chose to seclude himself and royal women indicate that he was following the instructions of Islamic scholars.[8] The royal family was served by hundreds of male and female slaves who lived within and outside the secluded domain.

The palace's high walls were rectilinear, an unusual shape in vernacular contexts. Also unusual was the placement of the palace inside a specially built, even more massively walled rectangular suburb, abutting the city to the southeast (see figure 12.1). The ex-urban placement signaled the state's decisive break with pre-Islamic "pagan" practices, centered in the circularly walled city. Moreover, the rectangularity of the suburb, reminiscent of the architecture of Tlemcen (Algeria), allowed clerics to align the linear, southernmost walls to point toward Mecca, another indication of royalty's commitment to Islam.

Between 1988 and 1990, I mapped in detail the sociospatial layout of the palace interior, a task that in part required inventorying its changing material content and architectural features, as well as discussing with many palace community members what slave titles and related hierarchies had existed in the past and where various categories of slaves and other persons had lived. In the process, the different names given to particular places through time and by different persons were documented and analyzed; I studied the strategic importance of each place in relation to other places today and in the past; and I gathered information about visible ruins and changes in slave locations, titles, and deployments.

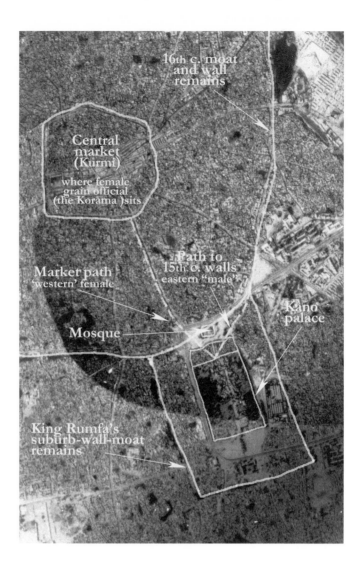

FIGURE 12.1.

Aerial view of the Kano palace, the length of which is approximately 540m. The palace was built as a rectangular suburb onto the main circular city walls circa 1500. The palace opened up onto the city through two northern entrance halls (to the right of the photograph). Like the city at large, the palace's landscape was made up of individual settlements organized into areas known as wards. Photograph from Kenting Air Services (Kano), 1984 composite of 1982 flight data.

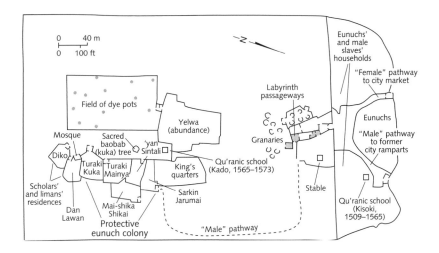

FIGURE 12.2.

A schematic reconstruction of the Kano palace in the 1500s. Note the presence of the large dyeing yard in the western "female" part of the palace. To the east was a large eunuch colony that was introduced into the interior in the late 1500s to guard the king, following a successful coup.

One of the most instructive places researched turned out to be the present-day palace cemetery, known by elders as *karofi*, which means "dye pits." To understand why it had this name, I spoke with the widowed daughter of a Fulani king (emir) who had died in 1919. She relayed that the cemetery had at one time been an extensive palace dyeing yard, and that as a small child she had played among the ruins of indigo-dyed cloth drying racks. I later learned from other informants that the dyeing yard was abandoned in 1807 and in 1846 converted into a dynastic burial ground for the ruling Fulani family (for its placement in the palace of the 1500s, see figure 12.2).

The yard's size and its location in what had, prior to the 1800s, been royal concubine territory proved that indigo dyeing not only had taken place inside the palace but had been an extensive endeavor and one controlled by palace concubines. I surmised at the time that production initially served domestic needs but eventually functioned as a kind of royal mint.

In 2000, I returned to the palace, in part to follow up on previous leads concerning women's indigo dyeing in and outside the palace. A conversation that proved especially useful was with an elderly male holding the slave title Maje Sirdi (Ibrahim), a title associated historically with one of the palace's three

most powerful state slave households. Malam Ibrahim spoke of how his mother had told him of a time before the Fulani (pre-1807), when palace women worked in the palace dyeing yard (the present-day cemetery), using large pots. The pots, he was told, were similar in size and geometry to those employed traditionally in birthing rituals and in the nearby massive central kitchen of Soron Tuwo (Hall of Porridge). Known as *kwatanniya* (or *kwatarniya*), the pots had mouths measuring roughly 3 meters in diameter and stood about half that high, the shape facilitating easy access to their contents. His recollections substantiated those of the elderly Fulani woman that I had recorded more than a decade earlier. This time, however, I was struck by how the dyeing yard's location at the very back of the palace compound corresponded exactly to that of women's indigo-dyeing yards in vernacular compounds in Yorubaland, to the southeast.[9]

I was now also struck by the fact that the palace's central kitchen (in 2005 converted into a women's mosque after having been abandoned for decades) abutted the dyeing yard, a location that would have given palace concubines easy access to the mordant or fixative required to prepare the dye bath: ash. A tremendous amount of ash was generated in the concubine-run kitchen, where food for at least two thousand persons was cooked daily over open fires in a large number of massive pots. I began to wonder if royal concubines' needs for so many large pots were unusual, providing the women with unique opportunities to experiment with, and even to innovate, larger pot types. If so, cooking-related innovations in pot technology might have influenced the size and shape of the pots used in the palace's dyeing yard.

The Color Blue and Fertility as Female and Divine

By 2000, it became clear to me that certain sociospatial and ecological relationships obtained among the concubine-managed places of birthing, cooking, and indigo dyeing and, therefore, that indigo blue was linked to places redolent of earthly and human fertility, a primary concern of the early state. Field and ethnographic data showed, for example, that royal children were born in the granary-shaped chambers of a special concubine known as Owner of the Granaries (Mai-Kudandan), who lived in community with the most powerful palace concubines inside the central concubine ward abutting the dyeing yard. Earlier research had shown that prior to the jihad, Mai-Kudandan had assisted in administering the grain-based forms of state taxation and had supervised the disbursement of palace grains from a large number of granaries located in the women's secluded domain.

Her grain- and birth-related tasks hinted at a pre-Islamic equation between children and grains, with fertility serving as the common denominator. Indeed, fertility was central to Kano's initial stability and growth in two ways: the economic growth of the city-state depended on the presence of an agricultural surplus, which effectively spoke of the fertility of the earth, something made manifest in the city-state's practical and ritual celebrations of royal grain, earthly farm fields, and times of harvest; its political growth, meanwhile, depended on territorial consolidations through marriage of important economic and political operatives to royal children, which called out to the fertility of humans—something made manifest in the city-state's practical and ritual celebrations of royal children, concubine pregnancies, and the times when the concubines gave birth. Thus, Mai-Kudandan's dual responsibilities, and the dual character of the birthing-granary hall, forged metonymic links between children and grain and, by extension, between fertility's holding places within the wombs of humans and earth. That indigo dyeing activities took place in an area immediately adjacent to the centrally located concubine ward, where Mai-Kudandan and other leading concubines lived, led me to conjecture that the color blue was perhaps linked to fertility by primarily metonymic relationships forged through women's practices: indigo dyeing was accomplished in cooking pots, with the help of ash produced from women's cooking fires.

Such speculation gained some empirical support when one of the emir's married daughters (Sadiya Bayero Sanusi, a longtime friend) remarked offhandedly that royal brides disliked always being forced by palace concubines (of which there are still ten) to wear blue on their wedding day (see figure 12.3). Over the next several years, Sadiya would lay out the details of a palace wedding ritual that not only helped explain the meaning of the ceremony that I had observed years earlier but also spoke clearly to indigo blue's identity with (female) fertility.

The ritual, she explained, begins on a Monday, with women of slave descent carrying a large number of implements used in grain preparation to a large open area in the center of the royal women's secluded domain. Attended to by many female supporters and onlookers, they compose themselves into three groups, arranged collectively in semicircular shape, around their implements, which include the traditionally large African mortar and pestles, massive flour sifters, and many large calabash bowls, some of which are inverted in larger bowls, filled partially with water. Standing or seated, they begin the different tasks required to grind and shift the large quantity of unprocessed millet grain into a fine flour to be used later in the day to make a special porridge (tukudi), eaten only by royal brides. In the process, the women playfully move their bodies and manipulate their instruments to create rhythmic accompaniments for both the milling

FIGURE 1 2.3.
A royal bride in the requisite blue wedding attire.
Photograph by author.

process and the praise and joking songs they sing. The mood is festive, enter-
taining, and fun.

Once the millet has been ground and sifted, it is brought to the palace's kitchen
in the central concubine ward (Abundance) that abuts the former dyeing yard.
Here, as the flour is cooked into the porridge, the most senior titled concubine,
Uwar Soro, adds in special herbs that she otherwise keeps locked inside what is
perhaps the oldest palace spirit house, adjacent to her chambers. The royal brides
are, meanwhile, sequestered in a special room nearby where they relax, tell sto-
ries, eat from a common bowl, listen to music, and generally commune with one
another.[10] Here, the concubines cajole them into eating all of the tukudi, which,
they are told, will prepare their bodies physically to receive their husbands'. The
same ceremonial preparation and eating of tukudi ensues on two subsequent days.
On Thursday, the concubines ritually bathe the brides, and the girls are clothed
in a special blue wrapper, which they are told they cannot remove until the fol-
lowing night when the marriage is consummated. At that time, they must lie on
their backs, on top of the cloth, and open it from the front.

The weeklong ceremony contains a number of ritual components that cause
grain to be linked metonymically and efficaciously to the color blue through the

body of the royal bride. The daily preparation and eating of the specially treated millet porridge, for example, is followed by the young girls' being dressed in the "royal" blue cloth: while the first ritual ensures that the bride can receive her husband, the second ensures that the act of coitus itself is engaged in in such a way that divine fertility is propitiated and allows life to take hold within her. Thus, the color blue's associations with female fertility are reflected and forged in two ritually linked consummative acts that, in turn, associate earth and woman through their products, grain and child. That the herbs are stored in a spirit house located close to the kitchen inside Abundance more closely links fertility's powers to the divine and underscores concubine supervision of the domains of fertility spirits.[11]

Indeed, divine fertility is similarly evident in the second of two concubine-controlled palace spirit houses that, like the first one, is granary-shaped. Inside, the room contains blue-colored furnishings, and has fine white sand mounded up in the middle of the floor. These elements, taken together, also speak to links created between grain (the granary) and indigo, albeit in conjunction with the color white (sand). If placed in comparative West African contexts, they evoke a river's white sands and (blue) waters, the latter essential to cultivating grain. The riverine Igbo of southeastern Nigeria, for example, regard blue and white as identical, associating both with coolness and femaleness and viewing both as divine. Here, women are likened to water insofar as they are fertile (the river floods its banks, fertilizing farmlands), vital to trade and communication, and fluid, liminal elements of the cosmos. Within this universe, women and water spirits are, according to Sabine Jell-Bahlsen, "at the crossroads between the ordinary and the extraordinary, between spirits and humans, life and death."[12] Similarly for the Bunu of northeastern Yorubaland, indigo blue is likened to black rain clouds, which, like pregnant women, portend and carry life.[13] Fertility's communion with blueness is also evident in the traditional requirement to use costly indigo-dyed "black" cloths for *all* Bunu marriage transactions, while only *married* women could wear indigo-dyed cloth.[14] Such stipulations show how marriage, adulthood, and pregnancy were coterminous with one another and how fertility was understood as a divine force "external" to humans. It was fertility itself that brought life into the womb of woman, just as it brought life into the womb of earth (plowed fields) or any of its other holding places. It visited and left as it wished, impotency being not a biological fact but a spiritual one. For fertility precipitated itself only after its divinity was recognized and respected. Female menses indicated only that a girl's body was strong enough to serve as a potentially viable site to receive fertility's force, but not that it was life's originary source. Marriage ritually sanctioned a girl's readiness, while coitus prayerfully reproduced the binary way in which fertility expressed

itself everywhere. The blue cloth beneath the bride conjured, appeased, and guided it to take hold within her body. Women's powers thus derived from their bodies' abilities to serve as *sites* where fertility's life force could be made manifest, and not from their own, innate fertility power.

Indigo itself was in fact felt by the Bunu to have such power over fertility that young women were not supposed to come near the dyeing pots. Perhaps similar beliefs obtained in royal and eventually vernacular contexts in Hausaland, explaining why palace, and later other, women dyed with indigo in open areas at some remove from men (see below).[15] Bunu women additionally ingested the dregs of indigo from dyeing pots as part of medicinal fertility rituals, rituals that may have had counterparts in the palace.

Indigo Blue and *Royal* Fertility

Placing the Kano dyeing yard in West African context suggests in addition that indigo-dyed cloth from the palace was initially produced for royal needs or circulated exclusively among royal court circles.[16] The Asante, for instance, historically associated the color blue not only with female tenderness but also often with the rule of a queen mother; and in Mali, only Bambara royalty could wear indigo-dyed cloth,[17] much as was the custom in the Jukun Court of northern Nigeria (see below). Philip Shea points out, moreover, that in sixteenth-century Kebbi (a kingdom west of Kano, along the Niger River) a royal wife is said to have owned a particularly prestigious indigo-dyed headdress, while in nineteenth-century Bamun (in present-day Cameroon), princesses were given indigo-dyed "Royal Cloth" to wear on their wedding day—a tradition strikingly similar to that described for the Kano palace, above.[18]

If indigo-dyed cloth was initially reserved for royalty, the persons most qualified to develop palace women's skills would have been Nupe women, the Nupe having migrated to Kano in large numbers during Muhammadu Rumfa's reign. If they were in fact involved, then perhaps nonslave labor was used to institute what ultimately became a slave-based palace practice (concubines were a kind of slave who, in the palace, depended on other forms of slave labor). Colleen Kriger's work shows, however, that female dyers in Nupeland were of Yoruba slave origin, suggesting that Nupe dyeing skills were themselves historically derivative. That is, captured Yoruba women in Nupeland were the ones who introduced the Nupe to indigo dyeing.[19] Enslaved Yoruba women might therefore have likewise introduced indigo-dyeing into the Kano palace while serving there as either female slaves or concubines. But if we consider that Kano was connected by trade to both Nupeland and Yorubaland as early as the 800s,[20] it becomes clear that palace concubines might have learned

dyeing skills from either freeborn or enslaved Yoruba or Nupe women.[21] Palace concubines were, after all, captured or purchased from areas across West and possibly North Africa, and it was not unusual for them to come from royal or otherwise important households, bearing diverse skills and geographical knowledge.

Moira Harris's work in Bamun suggests that by the 1700s, the Jukun Court had drawn upon the indigo-dyeing expertise of non-Muslim Hausa to make its Royal Cloth, considered the third of five of the most important textiles it produced. Though Harris does not specify which "non-Muslim Hausa" were involved in this knowledge transfer, it is not unreasonable to conjecture that Kano palace concubines participated directly or indirectly (through their persons or their slaves). Their participation would suggest that royal courts collaborated with one another in introducing the indigo-related processes and technologies involved in royal cloth production; such collaboration would enable the cloth's royal status and political value to be sustained and to assume larger geographical proportions.

The Jukun, for example, circulated indigo-dyed cloth exclusively among royalty.[22] Harris suggests that it was in fact through such royal exchange that the Jukun Court's Royal Cloth in particular dispersed swiftly to other palace households throughout the West African grass fields. By the 1800s, when indigo-dyed cloth from Kano was a commodity easily available for sale in markets throughout West Africa, indigo-dyed Royal Cloth was still being used in the Jukun Court for royal bride wealth, ransom, tribute, and gifts; as a marker of royal or court status; and in marriage and death rituals. Certain patterns of indigo-dyed cloth similarly held royal associations in nineteenth-century Bamun, providing a window onto indigo blue's intensely political "use value" in the past.

The Demise of Indigo Blue's Use Value and the Rise of Commerce

While Kano palace–based female artisans may have introduced indigo-dyeing skills and technologies to the Jukun Court by the 1700s, by the late nineteenth century royal and nonroyal women had clearly been expelled from indigo dyeing. Their loss of control is poignantly evident in King Njoya's late-nineteenth-century initiative that brought male Hausa artisans to his Bamun kingdom to establish commercial-scale indigo-dyeing works in front of his palace. Six pits were set up and worked exclusively by men, beginning an industry that, like Kano's, would grow and be taken up by nonpalace others. Even then, however, certain indigo-dyed cloth remained associated with femaleness, royalty, and the divine.[23]

Two indigo batik patterns in particular were reserved for royal matrilines: one, the *ntieya*, for the king and the queen mother; the other, *ntiesia* or *nti show*, for the king's maternal brother. Reserving certain patterns of indigo-dyed cloth for the two ruling matrilineal groups undoubtedly harks back to older associations of indigo-dyed cloth with royalty—its marking of matrilineality and hence (female "holding" of) fertility and children, more generally.

The Bamun case shows, on the one hand, how royalty might increase the exchange value of indigo-dyed cloth by encouraging the production of nonroyal patterns and the capitalization of an industry catering to markets beyond royal confines. And it at the same time demonstrates, on the other hand, how royalty might encourage the production of exclusively royal patterns of cloth that would allow indigo's older, political-spiritual values to persist. It was perhaps such a split that made possible the production and export of commercial quantities of solid blue or blue-and-white striped "Benin cloth" from Benin and Yorubaland in the 1600s and 1700s to the Dutch and the English; that is, the striped and solid patterns perhaps rendered the cloth profane and therefore of no sacred royal significance or use.[24] Colleen Kriger nonetheless mobilizes a great deal of primary and secondary data to show that the cloth was produced exclusively by women from the Benin and Ijebu areas, which implies that despite the profanity of certain patterns, indigo's ties to fertility still obtained.[25] Such a split might also explain the origins of "Kano cloth," used as a currency throughout West Africa before the nineteenth century, though its genesis and history remain largely unknown.

In any event, there is evidence to suggest that the dyeing skills and technologies evidenced within the Kano palace later diffused to other royal and nonroyal dyeing enterprises run by women: by the nineteenth century, women throughout rural Kano were dyeing for both domestic and commercial purposes (see below). Such commercialization, however managed, would have entailed an attenuation of indigo blue's historic significance as a marker of *royal* fertility. An analogous transition from royal use value to commercial exchange value is recorded in the context of textile production in precolonial Brazzaville. As Phyllis Martin explains, "In the pre-colonial era, the production and distribution of the most valued cloth had been in the hands of senior lineages and royal families who had seen this power diffused to a new entrepreneurial class with access to imported cloth."[26] In Kano, the transformation from use to exchange value would be greatly expanded upon by male entrepreneurs in the nineteenth century, a time when the economy was being thoroughly monetized with cowries—a change accompanied by a decline in the importance of fertility to the state. Such men would eventually wrest control over all commercial indigo-dyeing activities from women.

Commercialization of Palace Indigo Dyeing

As I have detailed elsewhere, the highest-ranking palace concubines commanded considerable political and even economic power.[27] Using eunuchs and slave women as intermediaries, their influence was felt far beyond the palace walls. For example, their secluded area was directly connected to the central city market and its highest-ranking official (a woman) by a special palace pathway, which allowed concubines regular contact with the market through their intermediaries. Moreover, Mai-Kudandan's grain-related duties required at least some concubines to be involved indirectly or directly in assessing and collecting grain taxes. Given their powers and public access, one would expect them to at least attempt to break into profitable trade networks. They might have accomplished this goal by developing nonroyal patterns for indigo-dyed cloth (as was done in Bamun), enlarging the size of the yard, experimenting with larger dyeing pot sizes and shapes, or enlarging the slave labor force. The latter would have consisted of women or eunuchs, the only adult males allowed in the palace interior. Eunuchs may have played a particularly large part, for pit-based dyeing was arduous work. If so, they were the first men in Kano to dye with indigo. Expansion of palace production may also explain why the palace yard eventually accommodated dyeing pots set in the ground (dye pits or *karofi*), akin to those at the Limawa site (discussed below) and to those that men later used to produce large batches of indigo-dyed material throughout Kano.[28]

By finding ways to increase production, Kano palace concubines could easily have participated in larger circuits of commercial exchange while still administering the production of royal, dyed cloth. Indeed, in the eighteenth- and nineteenth-century palaces of Dahomey, palace women founded, managed, and engaged in a number of for-profit trades and industries.[29] In light of the evidence, then, it is tempting to surmise that palace concubines were the first in the city-state to break into commercial forms of indigo-dyed cloth production. If so, they may have been the force behind the production of the celebrated "Kano cloth," used as a currency throughout West Africa perhaps as early as the sixteenth century.[30]

Beyond the Palace: The River Jambo and Limawa Village Indigo-Dyeing Sites

In 2003 I returned to Kano to continue my research on palace women's history and indigo dyeing, in part by comparing royal concubine spaces in the Kano palace with those in the palaces of nearby Daura and Dutse. I toured the old

FIGURE 12.4.
Babban Jakadiya Hadiza, the elderly guardswoman of slave de-
scent who told us where to find the two sites, along the River
Jambo and in the nearby village of Limawa, where women dyed
with indigo. Photograph by author.

nineteenth-century Dutse palace interior with three other Kano palace women,
including Sadiya Bayero Sanusi, and we spoke with several elderly palace women
who formed part of the remnants of a royal household belonging to the previ-
ous Dutse ruler. Among them was Hajiyya Hadiza, an elderly guardswoman of
slave descent (*jakadiya*), bearing the highest-ranking slave title awarded to a
palace guardswoman, Babban Jakadiya (Big Jakadiya; see figure 12.4).[31] When
asked whether women had dyed with indigo in the past, Hajiyya replied that
they had indeed done so, telling us of two places where we would find remains
of indigo dye pots: one along the shores of the River Jambo, and the other in
the nearby village of Limawa. That same day, the four of us set off to visit them,
guided by a leading Dutse palace "slave" official's son.

The River Jambo site was in some ways the more impressive of the two be-
cause of its topography (see figure 12.5). About 80 meters from the river's
edge, it consists of a hill-like mound composed mostly of potsherds. The sub-
stantial height and extent of the mound indicate that shards had probably ac-
cumulated there over a long period. Now abandoned, the flattened surface of
the mound is covered by the stubble of farm fields.

FIGURE 12.5.
The extensive potsherd mound near the River Jambo.
Photograph by author.

A great deal of archaeological work needs to be done to ascertain the nature of the site and learn how and why such a large amount of debris accrued in one place. Was it an ancient site where pottery was produced, some of which was used in women's indigo dyeing activities (see below)? Had the area served as a collection point for old pots? Did centuries of in situ, pot-based dyeing practices add to the mass of shards? An elderly woman who worked a nearby farm knew nothing about the area. Yet its size and proximity to the large Limawa dyeing yard, which we would shortly see, together with Hajiyya Hadiza's assertions that the place was associated with women's indigo dyeing, make it of potentially great significance to understanding the gendered dynamics that animated indigo dyeing's past.

After briefly surveying the area, we walked less than a kilometer to the second site, also abandoned: a wide expansive yard behind the village walls of Limawa. The yard contained deep, pottery-lined pits, presumably similar to the dye pits (*karofi*) that had at one time existed in the palace; they resembled the cement-lined pits associated with men's nineteenth-century dyeing practices in Kano. The

FIGURE 12.6.
Malam Nuhu Limawa standing in the abandoned indigo-dyeing
yard behind the village wall of Limawa. The yard contained very
deep clay pots set into the ground. The area is now used for
farming and, at the time of the photograph, was overgrown by
farm field stubble. Photograph by author.

yard, long ago converted into farmland, is so overgrown by field stubble that only
one of the clay pots was visible. According to Malam Nuhu Limawa (see figure
12.6), a religiously learned village elder who took us to the yard, the thin earthen
surface covering the pot had only recently collapsed under the weight of a child;
the child was trapped inside and the pot's upper contours were exposed (see fig-
ure 12.7). As he went on to explain, any woman could dye here, provided she
received permission from a woman who administered the area.

The large size and ground-level emplacement of the pots provide more evi-
dence that women's aboveground technologies evolved and advanced over the
years, in keeping with the cement-lined dye pit architecture purportedly devel-
oped by men in nineteenth-century Kano. About 1 meter in width, the pot-
lined pits are similar to the width of pots described by Maje Sirdi and narrower
than the cement-lined pits of men. Raising his arm over his head, Malam Li-
mawa indicated a pot depth of about 3 meters and explained that women used
the pits until the end of the 1800s, almost a century after the Kano palace dye-

FIGURE I 2.7.
The only dyeing pot currently exposed at the Limawa village site
(camera lens cap shown for scale). The pot has been largely silted
in, obscuring its considerable depth. Photograph by author.

ing yard was abandoned. Men took over the Limawa dyeing yard after the Kano
Civil War of 1893–94. When asked why, Malam Limawa shrugged and replied,
"Sabo da sun fi karfe" (Because they are stronger). His comments imply that for
women, the takeover was not welcomed and perhaps involved force.

The Limawa findings prove that eventually women beyond the palace were
involved in indigo dyeing and suggest, given the yard's size, that the work could
have been undertaken on a commercial scale. They also show that women's re-
moval from such activities was staggered: whereas the palace dyeing yard was
shut down in 1807, indigo dyeing continued in Limawa until the end of the
1800s. Moreover, the placement of the dyeing area at some remove from the vil-
lage suggests that by the end of the nineteenth century, at least in some rural
contexts, indigo was still linked to the powers of fertility and that married
women were still considered the only beings able to negotiate its force.

Other evidence that women continued, or may have been forced to shift to,
dyeing in small batches for domestic needs comes from a single line in *Hausa Cus-
toms*, a small pamphlet by Ibrahim Madauci, Yahaya Isa, and Bello Daura that was
first published in 1968: "Women in the villages still dye their clothes in

indigo."[32] While the authors provide no details, it can be assumed that because their work is written to address Hausaland as a whole, the dyeing activities to which they briefly refer obtained across the region.

Fulani Islamic Reforms, Men, and Indigo Dyeing

Following the religious jihad of 1807, the Fulani leadership restructured the city-state system that had for the most part characterized Hausaland's political organization; its replacement was a caliphate system divided into emirates, each one ruled by an emir. The caliph, in turn, loosely administered the emirate system. I have theorized elsewhere that it was the "ethnic" homogenization (all of the rulers were Fulani) and political centralization afforded by the caliphate structure that lessened the importance of royal marriages (and hence of concubines and their children) to territorial consolidation.[33]

It also appears that the leadership diminished the offices and titles of female officials across Hausaland, though the reason for doing so is unclear. Within the Kano palace, concubines' authority over grains was circumscribed, a loss in power accelerated by the shift in how state taxes were paid: now most were remitted in currency (cowries). And the first Fulani ruler of Kano emirate, Suleiman (r. 1806–19), abandoned the dyeing yard. Later, more than a third of the back end of the royal secluded domain, including the dyeing yard, would be walled off and converted into a male and largely administrative area. The area contained additional court chambers, a very large compound for eunuchs who attended to the emir, and residential quarters for male slaves, especially the emir's bodyguards and a new cadre of titled male slaves made responsible for storing grains from royal slave estates. The dyeing yard area itself would be made into a dynastic burial ground.[34]

Meanwhile, in Kano city proper, women's participation in the industry was outlawed with particular stringency. The Fulani leadership supported laws that banned women from the work of dyeing and forbade them from even owning dye pits. While women apparently continued to dye in some rural areas, their output would necessarily have become directed more to meeting domestic needs than to pursuing commercial markets. Nevertheless, the large size of the Limawa yard and of the pits it contains indicates that some women may have continued to dye at commercial scales, while Shea's research shows that a minority of women in other rural locales were permitted to retain ownership of commercial dye pits, but only if men (slave or free) provided the labor—a scenario ironically similar to the reliance on eunuchs I suggested for the pre-Fulani

palace context.[35] Shea notes, for example, that in the nineteenth century, a woman in the town of Dal, south of Kano, owned three dye pits worked by five slaves, while another Dal woman owned five dye pits. Similarly in Rano, near Dal, women could inherit dye pits but not work them; they were forced instead to lease the pits to men. An elderly informant from one of these places told Shea that although women did not presently own dye pits, they had done so in the past. And in a town outside the southern perimeter of Kano, a woman was found who owned five dye pits and rented more, her sons dyeing the cloth in the pits that she owned.[36]

After the Kano Civil War, however, even Limawa women were displaced from their commercial work. Unfortunately for Limawa, its leadership had sided with those who lost the war. The yard's subsequent takeover may therefore have been a retaliatory act by those in power who viewed the yard as part of the spoils of war.

Proscriptions against Kano city women and, eventually, rural women, along with the transfer of commercial dyeing operations to men and the state's support of male entrepreneurs, raise many questions; not the least of them is simply, Why? Perhaps it was thought that the concentration of this industry, of growing commercial importance, in women's hands would effect dramatic gendered asymmetries in wealth accumulation and spatial divisions of labor and social life, all untenable in the new political climate and economy of Islamic reformism. Some indication of reactionary sentiment is present in a complaint written by Usman dan Fodio, the regional leader of the Fulani jihad, and directed against women in Hausaland who worked in public venues without paternal constraints. According to him, "Among the innovations [of the Hausa] is the staying of men at home and the going out of women to market, competing with men; and it's a forbidden innovation and also an imitation of Christians. Their women sell and buy in the shops and the men (live) at (their) houses; and the law has prohibited imitating them."[37] Thereafter, the main activity in which women engaged was the spinning of cotton thread, reflecting not only substantial deskilling but also a significant loss of income that accrued from dyeing's valued-added labor. It is striking that despite the massiveness of this change and others, no scholarly research has been done on the jihad's regional negative impacts on the lives of women.

The paternalism and gendered nature of jihadist objections and their negative impact on royal and nonroyal women's economic powers strikingly parallel changes that occurred during the rule of an important late-fifteenth-century Benin *oba* or king, Oba Ohen. According to the oral history of a Benin palace guild of royal male weavers, Oba Ohen's guild was initially composed of seven palace women. It appears (though it is not explicitly stated) that these women

oversaw the weaving of royal cloth or did all of the weaving themselves, and that they were palace slaves rather than royal concubines or wives; palace men spun the thread. Oba Ohen, in anger, permanently shifted the responsibility of royal court cloth weaving to palace men after he discovered that the women had begun selling royal cloth in the public market. Thereafter, women were relegated to spinning the thread,[38] though they were apparently allowed to continue weaving in limited ways: they wove the waist pennants of the chiefs' and priests' ceremonial dress, for instance, along with the elaborate wigs worn by royal women on ceremonial occasions and the three-pronged elaborate hairstyle of the *oba* and cult priests. They likewise prepared the dyes, including indigo. All of these tasks are redolent of the greater textile-oriented powers they held in the past. As Paula Ben-Amos points out, if this history is taken seriously, it indicates that the production of royal cloth, like most cloth throughout the kingdom, was originally controlled by women,[39] which helps explain why it is solely guild men who today weave with a loom type ("vertical") that is otherwise used exclusively by women.

In Kano, the state actively cultivated men's dyeing activities, effectively transferring the industry to them. After the first Fulani leader, Suleiman, closed the palace dyeing yard, for example, he subsidized a male-run commercial dyeing yard in the city ward known as "Ward of the Nupe" (the Nupe are renowned for their weaving and dyeing skills). The dyeing yard was later relocated to the Ward of Takalmawa, near the central market and along the western women's pathway leading out of the palace. Shea's field interviews reveal that the first labor force for these male-run dye pits was made up of slaves,[40] again a labor scenario similar to that which I proposed in the case of the pre-Fulani palace yard run by concubines. Shea's informants noted close, joking relations between some dyers in the area and palace women, especially since the late 1800s, as a result of their special palace patronage, even though most of the dyers' business was geared toward export.[41] Similarly, Emir Bello (r. 1882–93) supported the dye pit business of an Islamic teacher in the ward of Sudawa. One of the sons of the entrepreneur cultivated his market niche by providing dyed cloth to palace women. The queen mother created and conferred upon him the honorary title King of the Dyeing Center. It appears, then, that palace inhabitants' continuing need for dyed cloth was met by local dyers, all men, and that new titles were invented to cement palace–dyer relations.

By favoring male commercial interests over those of palace concubines, the reformist leadership won out in a number of ways. It could now collect (nominal) taxes on city and rural dye pits;[42] it gained political capital by supporting a form of male-driven commoditization that encouraged the immigration of craftsmen skilled in weaving and dyeing; it secured the political support of Is-

lamic scholars and students, some of whom were set up in the dyeing business; and it secured the political-religious support of other reformist Fulani who objected to women operating in the marketplace. The benefits to be had by men, especially the reformist leadership throughout Hausaland, outweighed those to be had by women, especially palace concubines, whose value had once derived from fertility practices that—given the expansion of trade and industry, the monetization of the economy, and the consolidation of territory through the caliphate structure—were of declining importance to the state.

Jenny Balfour-Paul's observations about the gendered patterns of indigo dyeing in Islamicized North African contexts provide additional clues into how and why men progressively took over women's indigo-dyeing activities in nineteenth-century Hausaland. According to her survey, men historically controlled the most profitable commercial dyeing endeavors, many of these in cities; women, in contrast, carried out more restricted dyeing activities, catering to rural areas and often depending on wild indigo plants.[43] Balfour-Paul avers that this gendered asymmetry in location and surplus appropriation is found in indigo-dyeing endeavors worldwide, including in Southeast Asia.[44] Given Hausaland's, and especially Kano's, intimate economic and cultural connections to North Africa through Islamization and trans-Saharan trade, her work might be of particular relevance here. If so, it suggests that men began expropriating women's dyeing activities in Kano after it became clear that indigo-dyed cloth held substantial exchange value. They would have started in locations that generated the most profit, subsequently taking over those places where indigo dyeing was less lucrative.

If this scenario is correct, then the gendered patterns within the regions that Balfour-Paul explores might be understood as points along a trajectory of expropriation that traces growing male dominance. In other words, the degree to which female dyers in North Africa operated in less lucrative settings was inversely related to the degree to which men had displaced or excluded them from important markets. The economic reasons behind such a trajectory would explain, on the one hand, why Egyptian and Syrian men were anxious about women being anywhere near all-male dye houses and, on the other hand, why women's participation in nineteenth-century dyeing in Hausaland was severely restricted—or, as in Kano (the most lucrative center), outlawed. In the Kano case, the intensification and geographical diffusion of indigo-dyed cloth's commercialization, along with the emirate's decreased reliance on the traffic in grain and children (for revenue and territorial consolidation, respectively), would have hastened the emptying out of indigo's spiritual-political use value: a value derived historically from indigo's material-symbolic associations with the divine as expressed through the fertility of earth and human.

Women and Indigo Dyeing:
A Radical Reassessment

The findings presented here point to the need to radically and comparatively re-assess the significance and importance of fertility and gender in relation to indigo dyeing regionally, across West and North Africa, and even in Asia. Placed within its regional context, the material evidence found in the Kano palace intimates, for instance, that royal concubines initiated Kano city-state's indigo dyeing past, and that production skills were brought into the palace through free or enslaved Yoruba or Nupe women. Other data show that indigo-dyed cloth would have circulated as royal gifts, bride wealth, ransom, or other kinds of exchange involving persons of appropriately high status, and that concubines may have held special rights over the production and use of the cloth because of indigo blue's associations with fertility and because of the practical significance to the state of fertility's earthly (grain) and human (concubine children) form. Accordingly, royal cloth exchange involved a transfer of political-spiritual, and only secondarily (if at all) economic, value. The circulation of such a currency forged and reflected pre-Islamic associations between the divine and fertility; the cloth's blue color and symbolic content allowed for a productive and visible elision of the two and enabled royalty's control over the divinity-as-fertility equation. Kano palace concubines in this sense gained their symbolic and real powers from their bodies' ability to corral fertility's life force, "hold" or house its human precipitate, and, eventually, give it birth. It was the womb that made women divine—fertility's most valued subjects.

The evidence also indicates that indigo-dyed cloth production at some point—perhaps as early as the 1500s—broke out of its use value and palace confines, and women across Hausaland henceforth engaged in an activity that for centuries would be tied symbolically to fertility. After the Fulani-led reformist jihad, men were encouraged to develop indigo dyeing into a male-run industry, whereas women were enjoined to spin raw cotton yarn for male weaving and dyeing endeavors. Special laws were created in Kano forbidding women from engaging in indigo-dyed cloth's production. In this way, women were de-skilled and proscribed from participating in what would become one of the most lucrative commercial endeavors of the nineteenth century.

By historicizing indigo dyeing in gendered political economic terms, we can see not only that indigo blue was regionally so important because it symbolized the power and utility to the state of female fertility and royalty's control over it, but also the reasons why fertility's political-spiritual value waned in the 1800s. The reformist caliphate structure to some extent stabilized the position of individual emirates, making territorial alliances based on royal marriages (and,

hence, concubines and their children) less imperative. And monetization of the economy meant that grain (particularly as embodied in royal grain taxes) was much less important to the state than it had been in the past. As the primary significance of fertility declined, so did the value of signaling indigo's associations with it. The state instead saw benefit in supporting male-led industries geared toward long-distance trade. In his 1975 dissertation on indigo dyeing in Kano, Philip Shea suggests that the industry began and thrived in the 1800s because of regional demand structures, by this time tied firmly into trans-Saharan trade, and because indigo-dyed cloth was used as a regional currency. Still, it is important to amend Shea's analysis to show how the commercialization of the indigo-dyeing sector involved a profoundly gendered displacement of what had formerly been sacred and integral to an agrarian-based monarchical state: fertility.

At the same time, the research provides data with which to reassess indigo dyeing's importance in areas extending beyond Hausaland. For instance, my analysis of indigo dyeing in Kano offers a corrective to previous studies concerning the geography and use of indigo plant types within and beyond Hausaland, as summarized by Colleen Kriger. Drawing on previous scholarship, she theorizes that two distinct indigo-dyeing systems existed near the confluence of the Niger and Benue rivers from at least the 1300s until the 1800s. A "southern" system centered in Benin and Yoruba states was linked to European coastal trade. It involved mostly women who spun, wove, and dyed cloth in clay pots using the indigo variety *Lonchocarpus*. These women's participation in commercial textile-related activities was heightened in the 1600s and 1700s. Kriger posited a second, "northern" system, centered in Kanem, Borno, and Nupeland, of which Kano was part. It involved men who used large pits and the indigo plant variety *Indigofera*. End products were exported outside the region through Muslim trade networks.[45]

My work shows, however, that women in the Kano area dyed prior to the 1800s, well before men did, and that they used clay pots and, later, pot-lined pits. And the nineteenth-century Kano-born cleric Imam Imoru asserts that Kano dyers used both kinds of indigo: a wild variety (*talaki*, corresponding to Kriger's "southern" *Lonchocarpus*) and a more popular, domesticated variety (corresponding to her "northern" *Indigofera*).[46] The name of latter variety, *baban gida*, translates as "indigo of the household," suggesting that this type of indigo was historically used in household-based production, a location congruent with the palace findings. Imam Imoru's assertions and the evidence of women's dyeing presented here therefore establish that before the nineteenth century *no division existed between northern and southern systems*; that palace concubines in particular developed dyeing technologies early on, using clay pots and both indigo varieties; and that dyeing activities later extended to women outside the palace (although, as in the palace context, those activities were restricted to areas at some distance from male domains).

With the addition of comparative information from Niger, moreover, my findings allow me to formulate working hypotheses concerning the gendered use of indigo plants following the jihad. In particular, Barbara Cooper points out that in Maradi, Niger, men monopolized domesticated indigo production (*Indigofera*), which they grew on rich valley soils and to which they had exclusive access.[47] Men's monopoly over the Kano dyeing industry throughout the nineteenth century, Imoru's assertion that *Indigofera* was at this time much more popular, and Cooper's findings suggest that Kano women may have been increasingly forced to rely on the wild indigo variety (*talaki*), at least until the state banned them entirely from the industry.

My findings have the potential to complicate Balfour-Paul's gendered observations about indigo dyeing in North Africa and the Middle East. Specifically, she notes that men monopolized indigo dyeing in cities, whereas women controlled domestic production. My findings raise the question of who initially or historically initiated indigo dyeing in the male-dominated urban areas she describes. The Kano data suggest that research on earlier periods is warranted, for it appears possible that women originally controlled indigo dyeing in these areas and that as indigo-dyed cloth became an especially valued commodity, women were excluded or displaced from the industry and hence from large (typically, urban) markets.

No one has conducted work on women's indigo dyeing in the Hausaland region, or on the negative impacts of the jihad on women's lives. Nor has any systematic work been done to chart the central role of pre-jihadic female grain administrators within the state.[48] As a result, my analyses suffer from a lack of regional data with which to compare the Kano case, requiring that I work instead with mostly cross-regional information.

The preliminary findings presented here point to important new areas for research in a West African region where political economic analyses of gender or fertility have largely been ignored, particularly in the context of the pre-jihad period. Such research is especially important given Kano's significance: prior to the British conquest of 1903, Kano was the most lucrative and successful of Hausaland's city-states and, later, its emirates; and the post-jihad caliphate ranks as one of the most important historic entities of West Africa.

Notes

1. Hausaland is a linguistic region centered in northern Nigeria and southern Niger within which Hausa is the lingua franca. For centuries, the city-state (and, later, emirate) of Kano was its leading economic and cultural hub.

2. See Shea 1975, an unpublished Ph.D. dissertation that remains the most frequently cited text on indigo dyeing in the Kano and Hausaland region.

3. See, e.g., Plumer 1971, which documents women's control over pot-based indigo-dyeing activity across West Africa.

4. For the purposes of this essay, the terms *palace* and *royal* are used interchangeably with respect to concubines. Such concubines were extremely powerful, in part because Islamic laws defined their children as juridically equal in status to freeborn children; hence their children were royalty. For further details about palace concubinage, see Nast 2005.

5. Nast 2005.

6. Nast 2005.

7. Kano is unique in Africa in neither its monumental palaces nor its royal concubinage. European observers noted in the early 1700s, for example, that the largest palace of the Dahomey kingdom (in the capital city of Abomey) was "as big as a small town" and governed by the king's "wives," who numbered well over two thousand. Only a fraction of these women were conjugal with the king, many being either the king's servants or those of other important palace women. Nonetheless, the Abomey palace was not structured to impress or to express Islamic beliefs, and Islamic law did not define Abomey "wives'" status and activities, as was the case in Kano (Bay 1998, p. 67; see also Nast 2005).

8. Royal concubines and wives were secluded in the western palace interior. The king distanced himself for Islamic reasons, residing alongside important men and clerics in the eastern interior. The resultant landscape thus amalgamated pre-Islamic and Islamic tenets of seclusion, in that pre-Islamic patterns of kingly seclusion and gendered placement were still present, but in ways that proscribed women's mobility and contact with the king and that were sanctioned by Islamic scholars (see Gwarzo, Bedri, and Starratt 1974/77, pp. 15–28, for details about the counsel of perhaps the most influential of these scholars; Nast 2005).

9. See, for example, the excellent work and bibliography of Byfield 2002, and the archaeological findings of Folorunso 2002.

10. Princesses and princes that are to be married (for the first time) in any particular year do so collectively, on the same day. Their wedding preparations are thus streamlined but substantial.

11. A number of palace practices and traditions, including the institution of state concubinage itself, identified rulers as having special powers over fertility.

12. Jell-Bahlsen 1997, p. 12.

13. Renne 1995, p. 71.

14. Renne 1995, p. 65.

15. The palace dyeing yard lay adjacent to fields farmed by slave women and inhabited by pre-Islamic spirits associated with fertility. Indigo's associations with fertility may also be discerned in the comments of a nineteenth-century Kano-born cleric, Imam Imoru (b. 1858). He stated that after a wife weans her child, she "plaits her hair and rubs prepared indigo in it; covers her hands and feet with henna, *lalle*, puts on perfume, and goes to her husband who sleeps with her" (quoted in Ferguson 1973,

p. 254), though others might assert that this application is purely cosmetic (see Joseph 1978, p. 95 n. 7).

16. Nineteenth-century sources detail a number of alternative colors that would have been available to nonroyals—especially green, yellow, and red, options likewise recorded in the case of Senegambia (see Ferguson 1973, pp. 308–9).

17. Plumer 1971.

18. Shea 1975; Harris 1985, p. 259 (on Bamun). In Benin, only chiefs, priests, or priestesses could wear royal cloth, which had to be made by a special guild. As Ben-Amos explains (1978, p. 52), cloth was used to demarcate sacred space and for aesthetic purposes. Public palace rituals were of two sorts, each requiring a distinct genre of ceremonial dress. Unlike in Kano, the color reserved for royalty was red. Sumptuary privileges are almost universal and were historically common in Africa. Almost every culture has at one time or other permitted only select persons to wear certain clothing, clothing styles, or colors. For a recent survey of different global perspectives on clothing, see Hansen 2004.

19. Kriger 1993, p. 377.

20. Hiskett notes that in the case of Yorubaland and Nupeland, "a link of some dimension, however tenuous, did extend from Tripoli, through Hausaland and down to the Benue long before the 10[Islamic calendar]/16 century, although it is certainly not to be assumed . . . that there is now . . . an earlier date for the emergence of the major Hausa commercial centers [like Kano] than the 9/15 century" (1981, pp. 74, 78). Drawing on secondary material, he suggests that a precursor route from these southern areas to Kano existed as early as the 800s (p. 75).

21. Andrew Clark's work (1990, 1999) shows that slave women likewise prepared and dyed with indigo in Soninke villages of the Senegambia region, using wild and domesticated varieties of the indigo plant. The considerable value added through the dyeing process (Clark 1990, p. 73) would have been a boon to their owners, especially those with access to large markets. Jenny Balfour-Paul's survey (1997) of indigo dyeing in North Africa and the Middle East similarly shows that Soninke and Toucouleur women in the Senegal River region of southern Mauritania dominated indigo dyeing, using wild and cultivated indigo plant varieties, though she does not specify if the women were slaves.

22. Harris 1985, p. 155.

23. See Harris 1985, p. 165.

24. Ben-Amos (1978, pp. 50–51) notes that the first known historical records citing the existence of any kind of "royal cloth" in Benin date from the late 1700s and are sketchy. They indicate that a special kind of court cloth was woven and embroidered by "ladies of the palace" or "the king's boys"—presumably eunuchs, inside the palace. It is therefore not known if royal patterns of indigo-dyed cloth were produced at this time or earlier.

25. Kriger 1993, pp. 372–73.

26. P. Martin 1994, p. 406.

27. Nast 2005.

28. I deduce the replacement of dyeing pots by pits from the fact that the palace ceme-
tery area is referred to as *karofi*, a term that connotes dye *pits* rather than dye pots. The term
indicates that while some women may have continued to dye with dye pots, as described
by the Maje Sirdi in 2000, eventually the palace yard accommodated pits. Yet *karofi* is
made up of two etymological roots, one of which refers to pots, not pits. Shea surmised
that the two roots were the Mande words *kara* + *fye* (dye + place), which he interpreted to
mean dye pits (Shea 1975, p. 147). Neil Skinner's later comparative linguistic work
(1996) indicates, however, that the Mande term *fye* refers first to "a calabash utensil" and
only secondarily to an "open space," while *fi* means dark blue. If we then interpret *karofi*
to mean "dyeing + blue/calabash," we find in the word the material origins of cloth dye-
ing, namely the use of women's calabash-like containers or pots (including the shells of
tortoises or *kwarya*) for indigo dyeing. Over time, large pots modeled after those designed
to produce large quantities of food and to be used in birthing ceremonies presumably
replaced these containers; eventually, the pots were placed in the ground.

29. Among other unspecified activities, Dahomey palace women pursued smithing,
trading, and farming for profit (Bay 1998, pp. 147–48).

30. See Shea 1975. Women in Yorubaland had long been engaged in indigo dyeing for
commercial markets (see Renne 1995).

31. Dutse emirate was founded in the nineteenth century after the Fulani conquest of
Hausaland. As Dutse's palace was built three centuries after Kano's, well after the Kano
palace's dyeing yard had been abandoned, it is not surprising that none of the palace eld-
ers could recall a time when indigo dyeing was done on palace grounds. Today, the
nineteenth-century palace is inhabited by the remnants of the royal household of the
current emir's late father; the current emir lives with his family in an entirely modern
residence close by.

32. Madauci, Isa, and Daura [1968] 1985, p. 58.

33. Nast 2005.

34. See Nast 2005.

35. Shea 1975, p. 188. It seems that since at least the nineteenth century, cloth dyers
perceived the notion of slaves carrying out cloth dyeing as a threat. Shea writes, "There
was a slight prejudice shared by many against teaching slaves how to dye, or allowing
them to do so, but in some of the areas which experienced rapid growth . . . slaves did
do some of the dyeing" (p. 202). Slaves and sons, however, would have been the pri-
mary labor on which women business owners relied.

36. Shea 1975, pp. 161, 180–81. Unfortunately, he never follows up on any of these
gendered leads.

37. Usman dan Fodio, quoted in Kaura 1990, p. 88.

38. Ben-Amos 1978, p. 51; the same story is recounted in Kriger 1993, p. 73 n. 31.

39. Ben-Amos 1978, 51. Though the point is nowhere stated, we can assume that the
"female" powers associated with weaving would make it an inappropriate task for ordinary

men. It is therefore very possible that these men were eunuchs, a labor force I have elsewhere surmised was integral to Kano palace indigo dyeing.

40. Shea 1975, pp. 121–23.

41. After Emir Abdullahi (r. 1855–82) encouraged more Nupeland weavers to settle in the city, a dye pit area was established in a ward called Bakin Ruwa, west of the central market. This area was developed primarily for the dyeing of the blue thread used by the Nupe.

42. Shea 1975, p. 196.

43. Thus, though female Berber dyers of the Moroccan Atlas mountains might capitalize on their skills by traveling five days to reach a client's house, carrying their heavy iron dyeing pot and indigo on their backs, they were kept out of urban markets (Balfour-Paul 1997, p. 104). Likewise, women monopolized rural indigo dyeing in Tunisia, while men controlled the lucrative industry of towns (p. 110).

44. Balfour-Paul writes that in "many parts of South-East Asia . . . indigo dyeing is an exclusively female . . . job for those past the menopause[,] . . . above all due to their infertility, which will not jeopardize the fertile dye vat" (1997, p. 75).

45. Kriger 1993, pp. 366, 369. Shea notes that the two plant varieties used in Hausaland to dye cloth indigo were also used in Morocco and Thailand and that "the presumption is that the use of these plants began in the East Indies during ancient times and spread from there to much of the rest of the world. As early as 450 B.C. Herodotus described the use of indigo, and Marco Polo also reported about the use of indigo" (Shea 1975, p. 177).

46. Ferguson 1973, pp. 81, 113.

47. Cooper 1997, p. 50.

48. But see Nast 2005.

GENDER AND ENTERTAINMENT AT THE SONG COURT

13

Beverly Bossler

Some time during the twenty-fourth year of the Chinese dynasty known as the Song (960–1279)—the year we call 983—a young girl of fourteen was taken into the palace of a prince, the heir apparent to the Chinese throne. This young girl was an entertainer, known for her skill on the hand drum. The prince, only a year older than she, found her fascinating, and the love affair that ensued lasted until his death nearly forty years later. By that time the prince had himself occupied the dragon throne for twenty-five years; at his death, his lover took over the reins of power as regent for his young son. For the next decade, until her own death in 1033, the erstwhile hand drum player ruled as de facto head of the Chinese empire.

The extraordinary story of Emperor Zhenzong (968–1022; r. 997–1022)[1] and Empress Liu (969–1033; r. 1022–33)—for that is who the prince and the entertainer became—reveals much about the interaction of gender, pleasure, and power at the Chinese court. Although Empress Liu was unusually successful in parlaying her entertainment skills into political power, she was far from unique—indeed, she was not even the only Song empress who began her career as an entertainer. Yet we will see that, although court life would have been unimaginable without their presence, entertainers—especially female entertainers—were highly

I am grateful to Susan Mann, Mark Halperin, and the conference participants for their extremely helpful comments. Research on this essay was supported by a University of California President's Fellowship.

anomalous figures at the Song court: they fell outside (or in between) regular categories of court women; they moved freely between the court and the outside world; they were among the most despised of social groups, but they circulated among the highest reaches of Song society. They were deployed as symbols of power and prestige, and invoked as signs of decadence and decline.

This essay traces the anomalous status of court entertainers and examines the moralizing discourse that developed in response to their presence. I suggest that the liminal position of court entertainers was simultaneously an artifact of and a means of transcending the gender hierarchies of the Song court. The disparity between practice and discourse, both moralizing and legal, loomed especially large in the case of female entertainers. By functioning at the intersection of various desires, they exposed contradictions in the words and deeds that defined relations between men and women at court.

The Song Court

To understand why female entertainers were anomalous in the context of Song court life, let us survey how the court as a whole was structured. What we call the Chinese court was centered in the "Forbidden City," a collection of buildings and gates surrounded by a perimeter wall and theoretically off-limits to all but court officials and members of the imperial household.[2] Within the Forbidden City, the court was divided into "inner" and "outer" realms. The outer court consisted primarily of offices for the emperor's highest officials and their staffs. In theory, it was understood to be the purview of men who, from the emperor on down, concerned themselves with the administration of the realm. The inner court consisted of the various palaces in which members of the imperial family resided. In contrast to the male-dominated outer court, the inner court was a largely female domain. It was the realm of female palace servitors (often called *palace women* or *palace maids*), who, together with a small cadre of eunuchs, attended to the day-to-day needs of the imperial family.

The imperial family consisted of the emperor, his consorts, and their minor children. The consorts were women who had had a sexual relationship with the emperor, and whose relationship with him had been legitimated by the awarding of a consort title. Through most of the imperial period, Chinese emperors had only one main wife—the empress—at a time; but during the Song a total of twenty-three other titles, ranked by grade, could be awarded to lesser consorts.[3] A tiny percentage of consorts were wellborn women (usually descendants of high-ranking ministers), recruited into the palace as principal consorts or empresses. But by far the majority of imperial consorts (about 80 percent) were women who had been promoted from the ranks of the service organization that

ran the imperial household.[4] The processes by which women were recruited into the service organization in the first place remain almost completely obscure.[5]

In the Song as later, the female service organization constituted a huge bureaucracy, with six main divisions modeled on the six ministries of the outer court and overseen by a staff of more than 270 ranked and titled female officials.[6] Among other duties (and the following list is far from exhaustive), these female officials were in charge of palace seals, documents and mail, registers of female personnel, and traffic in and out of the inner palace; they handled the acquisition of texts and writing materials for the education of imperial women; they managed the preparation and distribution of clothing and jewelry, soap, towels, and combs for the denizens of the palace; and they oversaw the preparation of food. Female personnel also oversaw the cultivation of vegetables and flowers for use in the palace, took charge of the coal used for heating and the candles and lamps used for lighting, and managed the cleaning and interior decoration.[7] Precise records of the number of palace women involved in the service organization at any particular time do not exist, but references in official memorials (usually requesting that the emperor decrease the size of his household organization in order to reduce expenses) suggest that there were between two thousand and three thousand women during most reigns of the Song, and there may have sometimes been many more.[8]

In theory, the gendered division between the inner and outer courts was to be rigidly maintained, and only the emperor moved freely between the two realms. There were two important reasons for this separation. On the one hand, the Confucian officials who ran the outer court were particularly anxious that politics and policies remain the exclusive purview of the outer court, and not be influenced by denizens (eunuchs, palace women, or consorts) of the inner court. A long historical tradition warned of the dangers to the state when such "feminine" (yin) influence arose. On the other hand, the concern for legitimate succession meant that, ideally, adult males other than the emperor were not to have access to the inner court. According to our received image, all women in the palace were confined to the rear apartments, where they vied to attract the attention of the emperor. The hidden and cloistered inner court (like the harems discussed elsewhere in this volume) became the subject of rampant speculation and fantasy by those outside. The pathetic figure of the aging and neglected palace woman, bewailing her faded beauty and facing a lonely old age, was a favorite theme for sensitive Chinese poets. As we will see below, however, this image grossly overstates the degree to which the Song palace and its denizens were cloistered from the outside world. Court entertainments, in particular, were the site of constant slippage between the "inner" and "outer" realms, a slippage that reveals much about the actual (as opposed to the ideal) operations of the court.

Entertainers between Court and Society

Music and performance had always been important elements in demonstrations of political power and legitimacy in China. Ritual ceremonies punctuated with musical performance had been a central feature of most state activities for centuries. But it was the mid-Tang emperor Xuanzong (r. 712–755) who first made *popular* entertainments into a regular feature of court life. Early in his reign Xuanzong established the Court Entertainment Bureau, a training school-cum-theatrical institute designed to provide the court with entertainers skilled in the arts of popular songs, skits, and acrobatic displays.[9]

In the more than two centuries separating Xuanzong's era from the founding of the Song dynasty, popular entertainment became ubiquitous in Chinese society. Music and dance became standard features of the banquets that structured elite social life, both at government offices and in private homes. Entertainers plied their songs in the teahouses and marketplaces in the burgeoning Song cities. Like the geisha of Japan many centuries later, elite female entertainers in the Song were celebrated for their vocal, instrumental, or dancing skills; they were often literate and skilled in poetry composition, and they were expected to be masters of witty conversation.

At the same time, Song entertainers were not fully respectable; in fact, entertainers were generally regarded as debased persons. The category of "debased" had originally had legal implications, and Song law continued to stipulate that a debased person did not have the same legal rights as a respectable commoner: any crime she or he committed was punished more severely, and any crime against a debased person was punished more lightly. Traditionally, debased status had been hereditary, and marriage between entertainers and respectable members of society was (theoretically, at least) legally prohibited. Both the juridical category of debased and the assignment of entertainers to it were legacies of a time when musicians and other entertainers had largely belonged to hereditary groups with dependent, semi-slave status, attached to the houses of the wealthy and powerful. In the more fluid society of the late Tang and Song, such categories of hereditary dependency had largely broken down, and many who entered the entertainment profession in Song times came from ordinary commoner families. Still, social prejudice against entertainers continued. The assumption that female entertainers, in particular, were available for sexual as well as other forms of amusement rendered them socially and legally distinct from "respectable" commoner women.

In spite of the dubious reputation of musical performers, the early Song emperors deemed the presence of popular entertainers to be an essential element of an appropriately imposing court. Thus, when they established their capital at

Kaifeng, one of their first acts was to seek out the best musicians and entertainers from the various territories under their jurisdiction and gather them into their Court Entertainment Bureau, based on the Tang model. The Song Bureau troupe included male and female musicians skilled on (among others) the *pipa* (a pear-shaped lute), the five-stringed lute, the zither, the flute, the rhythm board, and a wide variety of drums.[10] It also included male and female dancers (both children and adults), as well as various types of acrobats and comedians, for a total of more than four hundred entertainers under the jurisdiction of a dozen or more officials.[11] Once again following the Tang model, the skilled musicians gathered into the Song Bureau were initially placed under the jurisdiction of the inner court, separate from the Court of Imperial Sacrifices that provided ritual music for outer court ceremonies. Yet, unlike other members of the inner court, the musicians and dancers of the Entertainment Bureau found that their duties frequently called for them to traverse the inner–outer court divide.

Although Bureau entertainers provided private amusements for imperial family members in the inner court, their role was not simply to amuse their royal masters. On the contrary, their performances were a significant element in the emperor's attempts to exhibit his power and prestige to the court and beyond. Outer court banquets featuring extravagant theatrical displays were held regularly to celebrate calendrical festivals and imperial birthdays and to honor newly successful examination candidates. These outer court banquets were elaborate and expensive affairs, involving as many as eighteen music and dance segments interspersed with the serving of food and wine, and even encompassing a change of the imperial raiment.[12] Such displays served to demonstrate the emperor's confidence and munificence, as expressed in this account of a celebration that took place in 1062:

As the wine went around, the emperor [Renzong] exhorted his officials:
"The world has long been at peace, and today we share our happiness with you. You must all get thoroughly drunk—no refusing!"
He then invited [the grand councillor] Han Qi to approach the throne and specially presented him with a large goblet of wine. Famous flowers and incense stored in golden vessels were brought out from the palace and given to each official to take home. They all got sopping drunk, and the banquet did not break up until dusk.[13]

As an essential element in banquet festivities, the female Court Entertainment Bureau entertainers, like their male counterparts (but unlike other women of the inner court), had an undeniably public presence. At banquets held in the outer court, they were in full view of the assembled officials. In the early twelfth century, the court official Wang Anzhong (1075–1133) recorded his impressions

of a banquet that lasted from early morning until midnight, after which the public thronged the streets to watch the drunken ministers return home.[14] As Wang tells it, "Several tens of female musicians were arrayed to the south of the palace court, exquisitely robed in lively colors, their ranks in perfect order. The wine went around and the singing began, the notes and rhythm clear and bright. While the music was playing the dancers entered, their voices and movements elegant and beautiful: all were drawn from the best of the forbidden [palace] training school. At the time the midwinter snows had just fallen, but the atmosphere was elegant and warm, already creating spring feelings."[15]

The public presence of the Entertainment Bureau women was not limited to the confines of the outer court. Although banquets were generally held at one or another of the court palaces, in some instances the emperor chose to display particular favor for a minister by having food, wine, and musicians dispatched from the palace so that the recipient could enjoy the emperor's largesse at his own home (and thus in the company of his friends and relatives, not all of whom would have been eligible to attend banquets at the palace). In 1087, for example, in addition to bestowing wine, incense, and fruit for a banquet held at the home of the favored minister Lü Gongzhu, the emperor also sent his own imperial drinking vessels and entertainers from the Bureau.[16] In fact, Bureau performers—female as well as male—left the palace precincts regularly: not only did they perform at private parties outside the palace, but their presence was also a crucial part of the grand spectacles that the court presented to the populace of the capital at regular intervals. To celebrate the lantern festival in the middle of the first lunar month, for example, the emperor made a ceremonial tour of the capital, and platforms were set up at the various city gates on which Bureau entertainers displayed their talents to people of the city.[17] Bureau entertainers also accompanied the emperor on all but the most solemn of his ritual processions,[18] and even joined processions that accompanied gifts given by devout emperors to Buddhist temples.[19]

Finally, and even more important, the public presence of the Bureau entertainers was not limited to performances. For when the court banquets were over, "All [members] of the Girls' Troupe exited through the Right Side Gate. Swashbuckling youths competed to present them with precious gifts and welcome them with food and wine. Each mounted an elegant steed and returned [home?], some in flowered caps, some dressed up like men. Along the Imperial Way they galloped, competing to show off their brilliant beauty. The onlookers [thronged] like a wall."[20]

The freedom of movement enjoyed by the female entertainers of the Court Entertainment Bureau shows us that, for at least some members of the court, the inner–outer court divide was no more than a polite fiction. Indeed, al-

though female Bureau musicians performed for the emperor and "belonged" to his court, their sexuality was clearly not guarded in the manner of other palace women[21]—on the contrary, young men who competed for their favors openly courted them. Evidently, then, the inner court included women whose sexuality was not reserved to the emperor's exclusive control. Presumably, performers of the Entertainment Bureau were considered to be beyond the pale as candidates for the emperor's bed. Their debased status rendered them unthinkable as potential imperial consorts, and thus there was no need to guard their sexuality.

The anomalous position of the Bureau entertainers—inner court women who nonetheless had a significant public presence—was tacitly acknowledged during a massive reorganization of the administrative structure of government in 1082. The reorganization removed the Bureau from the jurisdiction of the inner court and placed it under the direction of the Court of Imperial Sacrifices in the outer court.[22] This change, however, merely shifted rather than removed the anomaly. Though the specter of inner court women having a public presence no longer existed, now the outer court was asked to take responsibility for substantial numbers of female personnel. Still worse, the reorganization blurred the bureaucratic distinction between music for solemn state rituals and that for popular entertainments, much to the concern of moralist critics.[23] Yet in spite of the criticisms raised, the Court Entertainment Bureau continued to be administered by the outer court until in 1126 invaders from the north captured the Song capital.

The fall of the Northern Song[24] marked a significant turning point for the Entertainment Bureau as a court institution. In 1127 the newly declared emperor Gaozong, struggling to establish a successor regime in the South, initially abolished the Court Entertainment Bureau altogether.[25] This administrative act may simply have been an acknowledgment of reality, for there can have been few entertainers available in any case: most of the Court Entertainment Bureau personnel in Kaifeng had been taken prisoner by the invaders. That Gaozong's decision was motivated largely by practical considerations is further suggested by his reestablishment of the Bureau (still under the aegis of the outer court) in 1144, once peace had been established. But in 1160, toward the end of his long reign, Gaozong was persuaded to reduce the size of the Court Entertainment Bureau, and in 1164 his successor abolished it once more.[26] These measures did not mean that the court was prepared to do without entertainment altogether. Rather, the best of the Bureau entertainers were simply reassigned to other court organizations, where they continued to be on call for imperial entertainments.[27] On occasions when large numbers of performers were required—such as during the semiannual visits of ambassadors from the Jin regime in the north,

when national pride demanded a spectacular display of imperial hospitality—they were recruited from among the public entertainers of the capital (many of whom were themselves ex-Bureau performers).[28] The upshot of all these changes was to further elide the boundary between the court and the outside world. For most of the second half of the dynasty, not only could court performers be seen in public; public performers could be invited to perform at court.

Court Entertainment and Moral Discourse

The ease with which entertainers transgressed the boundaries between the inner and outer courts, and between the court and the larger society, was a source of constant concern to moralist Song officials. Ever mindful of their position as members of an official bureaucracy selected (at least in theory) on the basis of intellectual and moral attainment, outer court officials were deeply suspicious of others—eunuchs, palace women and their kin, and also entertainers—whose access to the imperial ear threatened their control of government policy.

Some officials couched their objections in the rhetoric of practicality, arguing that court entertainments were an unacceptable drain on the state fisc. Thus the 1160 reduction in Bureau personnel resulted from a memorial by the official Zhang Xi, who, in detailing various areas of wastefulness in the court, complained to Gaozong: "The number of musicians in the Court Entertainment Bureau increases daily; the extravagance and waste of their salaries and gifts are incalculable. They can all be dismissed." In response, the emperor reduced the number of musicians by "several hundred persons."[29] When, a few years later, Gaozong's successor abolished the Court Entertainment Bureau altogether, his decision was likewise presented as a practical one:

> The emperor said, "In the space of a year, other than the two imperial birthdays, there is no other use for [the musicians]. I don't know what their function is." The great ministers all said, "They could be temporarily gathered together; there is no need to maintain a Court Entertainment Bureau." The emperor responded, "Excellent." From [that time] on, when the Northern envoys came twice a year, they still used music, but they called in people from the city. They did not maintain a Court Entertainment Bureau, but simply ordered the Palace Maintenance office to direct their practice for the fortnight prior.[30]

Most commentators, however, saw the problems inherent in imperial entertainments as involving much more than mere expense. Sometimes officials expressed concern that overindulgence in the pleasures of entertainment would distract the emperor from his duties. Citing the example of the Tang

founder of the Court Entertainment Bureau, the moralist Fan Zuyu in 1090 warned the young emperor Zhezong (1076–1100; r. 1085–1100) that "When [Emperor] Xuanzong came to the throne, he paid attention to sounds and music, and as a result in his late years he indulged in pleasure and extravagance until the country was in chaos, and he nearly lost the empire. Alas, can a ruler afford not to be cautious about his pleasures?!"[31]

Still, for most critics the danger posed by entertainment was not so much that entertainments would cause the emperor to be negligent but that "debased" entertainers could interfere with outer court governance. Where male entertainers were concerned, one fear was that official positions in the music bureaucracy could be used as a stepping-stone to outer court offices. In the early years of the dynasty, the Song founder had gratified his bureaucrats by refusing to allow an aged Court Entertainment Bureau official to be given a regular outer court appointment; he noted, "That would bring chaos to the world. How could I make it a precedent? That sort of person can only be appointed within the Entertainment Bureau."[32] As far as can be determined now, later Song emperors seem to have taken the founder's example quite seriously: there is virtually no evidence of male music officials or their children entering the regular bureaucracy. Yet outer court officials continued to warn their rulers of the dangers of letting "that sort of person" insinuate themselves into the outer court. In the mid-eleventh century the famed poet and historian Ouyang Xiu devoted an entire chapter of his *New History of the Five Dynasties* to biographies of "Music Officials," with the explicitly stated intent of showing how earlier dynasties had been ruined by the involvement of such officials in politics. About the same time, the official Wang Gui urged that Court Entertainment Bureau officials not be permitted to obtain any office for their descendants except within the Bureau itself, again attempting to prevent entertainers from insinuating themselves into the outer court.[33]

Outer court officials were also aware that entertainers—female as well as male—could influence the outer court without being part of it, and they fretted that entertainers able to ingratiate themselves with the emperor could use his favor to enhance their power and position. A year before cautioning the emperor Zhezong about the dangers of popular music, in 1089 Fan Zuyu had responded vehemently to rumors that his young sovereign (then thirteen years old) had already impregnated a palace woman. Fan railed about the health risks of premature sex, but he also warned that "petty people" would seek to fulfill their own ambitions for office and nobility by taking advantage of the emperor's unregulated desires.[34] A century later, writing in response to the emperor Guangzong's call for advice after the appearance of an inauspicious omen, the official Wei Jing reiterated this latter concern in greater detail. In a memorial

outlining nine flaws in current governance, Wei's third complaint centered on the issue of court entertainments:

> I have heard that rulers take diligence and frugality as a virtue and must not regard their position as pleasurable. If they use music and beauty to delight their ears and eyes, making [the entertainments] constantly more novel and elaborate, there will be no leisure to devote to other affairs. This was the method the [Tang evil minister] Qiu Shiliang used to bewitch his lord. When I speak on this subject, it is nothing your majesty does not understand. I have personally heard that when you have leisure from the myriad duties of governance, the banquets and drinking parties in the palace are too frequent, and musicians compete to present themselves. The services of the six palaces cannot be called insufficient, yet pretty-faced performers and comical acts of the marketplace have been commanded to array themselves indiscriminately before you. The word on the street is not always worthy of belief, but when the criticism reaches this level there must be something to it. As for those with whom Your Majesty and the imperial ladies are close, these especially ought to present themselves at appropriate times and be received with proper ritual. Then grace and righteousness will both be completed, and names and positions will be pure and strict. If those who attend at banquets enter deep into the side palaces, I fear that with a surfeit of pleasure and intimacy, the waste will be great; with the proliferation of affection and favor, entreaties will be made. Can disaster then be avoided? That banquets and drinking parties are not regulated: this is the third flaw in governance.[35]

Wei finds the emperor's interest in entertainments troubling on several grounds. He revisits the argument that entertainments require time that an emperor, responsible for the running of the realm, can ill afford to take away from his duties. If the emperor is not attentive to governing, the power vacuum will be filled with men like Qui Shiliang, notorious for controlling the Tang court to his advantage while the ruler played. But Wei is even more disturbed that the emperor finds it necessary to supplement the diversions already available in the palace with popular entertainment from the city, and in a somewhat roundabout fashion he explains why. First he urges that interactions with imperial intimates be handled in a regularized, bureaucratic fashion, so that "names and positions" remain properly ordered. He warns that when banquet entertainers end up "deep in the side palaces"—that is, in the emperor's private apartments, if not his bed—they tend to ask for extravagant presents and unreasonable favors. In other words, Wei finds entertainments dangerous not only because they distract the emperor from ruling but especially because they encourage him to bestow excessive favor and influence on the wrong sorts of people. He reiterates this

point later in the same memorial, when, after pointing out that the treasure in the emperor's storehouses represents the blood and sweat of the people, he complains that golden waistbands (an honorary decoration usually reserved for high-ranking officials) have been "conferred on the hangers-on of debased and lowly entertainers."[36]

As Wei intimates, the real danger of court entertainments is that they arouse imperial desire. Like Fan Zuyu before him, he warns that the emperor's pursuit of desire leaves him open to the machinations of panderers, who enrich and ennoble themselves by seeing that the emperor gets what he wants. Haunting the moralizing rhetoric of both Fan and Wei is their awareness of how little power the outer court actually had in the face of imperial desire. And while entertainers were not the only women (and sometimes men) on whom imperial desire might settle, the fact that entertainers were trained to captivate rendered them particularly likely objects of that desire. The power of entertainers to attract imperial attention, together with the helplessness of the outer court in the face of such attraction, is nowhere more evident than in the biographies of two women who entered the court as entertainers and rose to become de facto rulers of the realm.

Entertainer Empresses

Who were these entertainer empresses, and how did they rise so high? The answer varies considerably depending on the sources consulted, for the historical presentation of those who ruled the realm had political ramifications of its own. Official historical sources, composed by Confucian officials of the outer court for the edification of later eras, constructed the empresses' biographies in accord with their own sense of what was proper. Not surprisingly, then, the formal biographies of the empresses Liu and Yang in the official *Song History* downplay their entertainer origins. Fortunately for us, Song literati were exceptionally fond of recording miscellaneous observations and gossipy anecdotes, and the rather sparse accounts preserved in the official histories can thus be supplemented with information preserved in anecdotal and other accounts (which, we might note, were composed much closer to the empresses' own eras than was the official history).[37] The differences between the two types of sources themselves reflect disjunctions between the court's idealized image and a much messier reality.

The *Song History* biography of Empress Liu provides her with a respectable family background. It claims that her grandfather had been a general during the Five Dynasties period that preceded the Song, and that her father had served as a regional official in Sichuan. It recounts the supernatural signs that attended the girl's birth (a standard feature in biographies of important people),

then relates that Liu was orphaned while still a babe in arms and was reared by her maternal relatives. After the terse comment "She was good at hand drums," the biography explains that one Gong Mei, a silversmith, first brought Liu to the capital. There, at age fourteen, she entered the palace of the heir apparent (the future emperor Zhenzong).[38]

Significantly, anecdotal sources say nothing about official positions for Liu's ancestors. One account simply notes she was from Sichuan and good at hand drums; another describes her explicitly as a courtesan-entertainer. All the sources agree that a silversmith named Gong Mei brought Liu to court; but here we learn also that Gong Mei's occupation as a silversmith gave him ready access to the household of the heir apparent, who had heard of the talents of Sichuan women and asked Gong Mei to acquire one for him. Other accounts claim that Gong had himself first taken Liu as a wife.[39]

The discrepancies between the official and anecdotal accounts are worth noting. It is not completely implausible that Liu was originally the daughter of an official: Song literature is full of stories about gently bred girls who, after a father's early death or other family crisis, ended up sold into concubinage or worse.[40] Still, the complete absence of mention of Liu's official background in contemporary sources suggests that such a background was a post facto construction, meant to provide a gloss of respectability for a woman who ultimately ended up ruling the realm quite competently for more than a decade. The provision of proper ancestors in the Song History account helped mask the fact that, whatever her origins, by the time Liu entered the heir apparent's palace she was an entertainer, chosen not for family background but for her aesthetic and erotic appeal.

Liu's erotic appeal soon proved problematic. The prince's infatuation with Liu was so intense that his wet nurse began to fear for his health (Chinese medical theory held that excessive indulgence in sex could undermine the male constitution). She complained to the emperor, who in turn ordered that Liu be expelled from the prince's palace. Unwilling to part with his new love, the prince ordered a retainer to house Liu in the latter's residence. Though reluctant, the retainer dared not refuse, and he was provided with five hundred taels of silver to build separate apartments for Liu. Eventually the wet nurse relented, and Liu was allowed to reenter the prince's household. When the prince ascended the throne in 998, she officially entered his palace. Six years later she was raised to a significant consort rank, and further promotions followed.[41] Ultimately, when the emperor's first empress (product of a marriage arranged by his father) passed away, he sought to raise Liu to her position. The outer court ministers objected strenuously, but the emperor got his way. In 1012 Liu, at age forty-three, became the "mother of all under heaven."[42] When late in life the emperor became too

ill to handle court affairs, she acted in his stead. After his death in 1022 she became regent for his young son (the child of another consort), whom she had reared as her own child. The official history dwells on her maternal devotion to the young emperor, and stresses the intelligence and diligence with which she aided her husband and his successor in governing. As others have pointed out, Liu ultimately earned the grudging respect of outer court ministers (not least because she was often willing to take their advice). She thereby helped make female regency an acceptable mode of government in the Song.[43]

The story of Empress Yang (1162–1232) two centuries later is similar in many respects to that of Empress Liu, though even the official biography of Empress Yang in the *Song History* is unable to provide her with a respectable background (or for that matter with any background whatsoever). Rather, it admits that she was chosen to enter the palace on the basis of her appearance. Although she was not sure of her own surname or origins, "it was said" she was from Guiji. Much later, after her rise to prominence, Yang claimed to be related to a man named Yang Cishan (1139–1219) who was also from Guiji, and only then did she become known by the surname Yang. Yang received a succession of consort titles in 1195 and 1197, and when the first empress (the descendant of a prominent Northern Song official) of the emperor Ningzong (1168–1224; r. 1194–1224) died in 1200, Yang was one of two favorites considered for promotion. The powerful court official Han Tuozhou, contrasting Yang's interest in power with her rival's tractable personality, urged the emperor to choose the rival. But, we are told, because Yang was somewhat literate, knew some history, and was quick-witted, in the end the emperor chose her.[44]

In Yang's case as in Liu's, anecdotal sources supply crucial information omitted from this official account. There we learn that Yang was the adopted daughter of a Madame Zhang, a woman known for talent as a singer.[45] Zhang had once held a position as a music official in the palace of the Grand Empress Dowager, but resigned owing to illness and married a man surnamed Li. Sometime thereafter, the Grand Empress Dowager, displeased with the quality of her musicians, wanted to call Zhang back into service, only to be told that she was already deceased. On learning that Zhang had an adopted daughter, the Grand Empress Dowager had the girl—then about ten or eleven—brought to her palace, where she joined the children's theater troupe. Growing up in the Grand Empress Dowager's establishment, Yang attracted the notice of the heir apparent (the future Ningzong) when he happened to visit his nominal great-grandmother. Taking note of the prince's interest (and perhaps seeing an opportunity to ingratiate herself with the future emperor), the Grand Empress Dowager bestowed the young woman on him, with strict instructions that he treat her well. At that point Yang officially became a palace woman.[46]

Once established as empress, Yang was known primarily for her participation in two highly controversial events. First, she is credited with (or blamed for) instigating the plot that led to the murder of Han Tuozhou, the court minister who had opposed her accession. She was also known for acquiescing, albeit reluctantly, in the machinations of the grand councillor Shi Miyuan to overturn her husband's choice of heir and establish another imperial son on the throne. When, with her compliance, the newly crowned nineteen-year-old emperor Lizong (1205–64) ascended the throne in 1225, she was invited to share the reins of power with him. Like Liu before her, she remained a major political force at court until her death in 1232.[47]

The biographies of Liu and Yang demonstrate the profound political ramifications of the ability of entertainers to move between society and the court. Though neither woman was, strictly speaking, a member of the Court Entertainment Bureau (which in any case had ceased to exist by Yang's day), as entertainers they shared the dubious social and moral status of the Bureau personnel—and yet this status does not seem to have been a bar to their selection as palace women. Indeed, we see here that, rather than being a bureaucratically managed selection of girls of good family, recruitment into the palace could take the form of pandering by men who had access to the imperial family as servants and tradesmen—just as the outer court officials feared. It may be significant in this regard that Liu and Yang began their careers as palace women in the households of imperial princes, rather than in the household of the emperor himself: perhaps the screening of palace women was more strict where reigning emperors were concerned. But even so, the lack of concern with background is striking. However respectable her early origins, by the time Liu entered the household of the prince she was an entertainer, and probably had already been married; Yang for her part had quite explicitly been reared as a "debased" entertainer.

The dubious backgrounds of these women in turn highlight the powerlessness of the outer court in the face of imperial desire. Although the official history tries to recuperate status for the two empresses (their entertainer origins are glossed over or ignored; Liu is given an official background; and both women are credited with intelligence, literacy, and a knowledge of history), the fact remains that Liu and Yang were performers who entered the palace through informal channels and managed to attract future emperors by dint of beauty and artistic talent. In theory, their status as entertainers rendered them legally ineligible for marriage even to an ordinary commoner, much less to an emperor. Still, neither Song law nor ministerial intervention could overcome the imperial will. In the Northern Song, ministers could and did inveigh against the inappropriateness of Liu's background (though, diplomatically, they characterized her as "humble" rather than "debased").[48] In the Southern

Song, Yang's interest in power also was deemed to render her unsuitable for elevation. Yet in both cases statute and ministerial opinion were ignored, and the entertainer became empress.

Although Liu and Yang are the only Song entertainers known to have risen to the exalted position of empress, it is likely that many others entered the ranks of palace women (and thus had at least the potential to influence imperial decisions). Consider just one example: the early-thirteenth-century official Shi Miyuan, knowing that the heir apparent was fond of lute playing, reportedly presented him with a lovely girl who was an accomplished lutist. In this case, Shi kept the girl's family on his own payroll, with the understanding that she would serve as his spy in the prince's household—evidently outer court officials were themselves not above pandering when political circumstances so dictated.[49]

We should also be aware that substantial lacunae in the biographies of Liu and Yang may make their rise to power seem more straightforward than was actually the case. In all of the extant sources, Liu's transition from clandestine paramour to palace denizen to ranked consort is presented as an uninterrupted sequence of events.[50] Only when the dates of these events are carefully compared do we realize that fully fifteen years separated Liu's introduction to the prince in 983 and her induction into the palace after his accession in 998 (when she was already twenty-nine). Similarly, we know next to nothing about Yang's life between the time she first attracted Ningzong's attention and her acquisition of a consort title about the time of his accession to the throne in 1195, when she would have been thirty-three. The ascent from entertainer to principal consort was a protracted process, and we can only guess at what sort of political machinations were involved.

It is notable that both would-be empresses early on established mutually beneficial connections with men who could presumably help guard their interests in the outer court. After becoming a consort, Liu claimed her erstwhile panderer/husband Gong Mei as her brother, and the latter wisely changed his surname to Liu.[51] In similar fashion, once identified as the favorite's brother (though he was twenty-three years older than she), Yang Cishan entered office and held a succession of respectable positions and high-ranking titles. Although Yang Cishan's official biography praises him for "not getting involved in national affairs," it was reportedly he who had informed his "sister" of Han Tuozhou's efforts to have her more tractable rival named empress in her place.[52]

If the protracted period over which Yang and Liu each became empress hints at ups and downs along the way, it also reminds us that more than just sexual desire was at issue. In the context of the Chinese court, where virtually all the emperor's female attendants were sexually available to him, neither Liu nor Yang could hope to claim exclusive rights to the emperor's libidinous interest.

Evidently, however, Zhenzong and Ningzong found a level of comfort or intimacy with these women that was sufficient to sustain their relationships over decades.

The Gendered Calculus of Pleasure and Power

Taken together, the stories of Liu and Yang not only reveal the ways in which the realities of court practice differed from the ideal image but also highlight a number of gendered contradictions at the heart of the Chinese court system. The first contradiction was between the court's need for entertainments as a sign of imperial prestige and munificence and its concerns that such entertainments would ultimately undermine both the economic and moral foundations of the empire. We have seen that the outer court's suspicion of entertainers was multifaceted and not entirely disinterested. First, the outer court wanted to ensure that the emperor remained focused on his duties and attentive to the opinions of his ministers. More importantly, ministers were anxious that their influence not be undercut by the plotting of inner court minions. By the same token, they preferred to see rewards and other material expressions of the emperor's esteem bestowed on outer court officials rather than on sycophantic favorites. Entertainments were a threat in all these respects: though outer court officials seem to have accepted that elaborate entertainments were necessary to the emperor's performance of power, they worried that the emperor was too easily distracted by the sensual pleasures his entertainers provided, and too easily swayed by those who pleased him. Their anxiety was exacerbated by the fact that entertainers as a group were both socially and morally suspect, and thus (in the outer court's view) likely to be a pernicious influence on the imperial person. Particularly when it came to choosing high-ranking consorts and empresses, outer court officials preferred to see the emperor select women of respectable family background, who were more likely to share their own values. Still, the ubiquity of court entertainments meant there was no way to keep entertainers from attracting the attention—and attentions—of the emperor. And in the face of imperial desire (whether for sex or for companionship), the outer court was powerless. When, as in the cases of Liu and Yang, a "debased entertainer" became a "mother of all under heaven," outer court officials could only stand by as the status categories by which they justified their own exclusive access to power were overturned.

A second contradiction, closely related to the first, was that between Confucian demands for production of progeny, on the one hand, and Confucian suspicion of pleasure, on the other. Because the production of an heir to the throne was critical to the perpetuation of the dynasty, it was desirable that the emperor

be sexually active and have exclusive access to a large group of women with which to mate. This was (at least in theory) the motivation for establishing an inner court in the first place. But while imperial fertility was to be encouraged, imperial pleasure was always suspect: in Wei Jing's words, rulers "must not regard their position as pleasurable." Pleasure threatened to undermine imperial diligence and frugality and to distract the emperor from his governmental responsibilities. As a result, the emperor was provided with an inner court of more than a thousand of the most beautiful women in the realm, and then subject to incessant ministerial warnings about the dire perils of enjoying them.

This second contradiction in turn gave rise to a third, for it helped ensure that the calculus of pleasure and power at the Chinese court differed profoundly for men and women. For the emperor, and to a lesser extent for his officials, pleasure was a prerogative and a legitimator of power (if also, in the eyes of moralists, a potential threat to it). Power both earned a man the right to pleasure and required that he display that prerogative publicly, especially through control of a large number of women. In this sense, court entertainers were critical to demonstrating, even legitimating, the monarch's power. Yet for court entertainers themselves, the calculus was precisely reversed. For these entertainers (and indeed for court women more generally), providing pleasure was one of the few available routes to power: by earning the attentions and affection of a powerful male, a woman could hope to improve her social position and even acquire political influence. Arguably, this general pattern held true in many societies, but the Confucian demand for heirs helped justify the introduction of any number of women into the households (and beds) of powerful men. To put it another way, Confucianism created more space for women to use the provision of pleasure as a means to power. At the same time, as the biographies of the empresses Liu and Yang suggest, the Confucian animus against pleasure ensured that power acquired in this manner could be legitimated only by erasing its origin. The historical standing of Liu and Yang as empresses could be justified primarily to the extent that the two women could be recast (whether through their own actions or through the rhetoric of biographers) as models of Confucian rectitude.

Notes

1. Here and throughout this essay, I follow Chinese convention and refer to Song emperors (anachronistically) by the "temple names" assigned to them after their deaths.

2. The term *Forbidden City* was in use at least by the time of the Southern Dynasties (420–589).

3. Conventional sources suggest that most emperors had no more than four or five consorts at any particular time, and Priscilla Ching Chung proposes that the largest number

of consorts recorded for any single emperor (the notoriously libidinous Huizong) is nineteen (Chung 1981, pp. 19–22). But a list of the personnel moved north after the fall of the Northern Song mentions 143 ranked consorts for Huizong (Ebrey 2003a, p. 57). This discrepancy suggests that the more conventional sources may grossly underrepresent the numbers of women who held consort titles. For a list of consort titles used in the Qing, see Shuo Wang, in this volume, table 7.2. The Song and Qing systems were similar, although there was variation in the precise titles used.

4. Chung 1981, pp. 24, 9.

5. See Shuo Wang, in this volume, for a description of palace recruitment practices in the Qing. Presumably some similar system was employed in the Song, but no concrete evidence of it survives.

6. This discussion of the institution of palace women is drawn primarily from Chung 1981.

7. Chung 1981, pp. 96–97.

8. Chung 1981, p. 9; Ebrey 2003a, esp. pp. 52–63.

9. Kishibe 1941.

10. SS 142.3349.

11. SS 142.3350–3351; Gong 1997, pp. 279–81.

12. SS 142.3348.

13. SS 113.2693.

14. Wang Anzhong 1983, 1.6–7b.

15. Wang Anzhong 1983, 1.6–6b. "Spring feelings" is a common euphemism for erotic sensations.

16. SS 119.2802.

17. SS 113.2697–98.

18. For example, see SS 111.2669.

19. Yu Jing 1983, 9.3a.

20. Meng 1962, 9.223; I have slightly emended the translation provided in Idema and West 1982, p. 55.

21. The term "returned" in the quoted description suggests that they did not even reside in the palace.

22. Gong 1997, p. 279.

23. See Fan 1983, 27.7b–8a.

24. The term "Northern Song" refers to the first part of the Song dynasty, when the capital was located in the northern city of Kaifeng. In 1126, Jurchen invaders from outside China's northern borders sacked the capital and transported both the reigning and retired emperors and most of the imperial household north to their own territory. A descendant of the Song imperial house who had evaded capture reestablished the "Southern Song" dynasty in the southern part of the country, with its capital at Hangzhou.

25. SHY, *zhi guan* 22.30, 2861/1; SS 142.3359.

26. SS 142.3359.

27. Idema and West 1982, pp. 102–3.

28. SS 142.3359; Gong 1997, p. 281.

29. Li Xinchuan 1983, 184.6b.

30. SS 142.3359.

31. Fan 1983, 27.7b–8a.

32. SHY, *zhi guan* 22.28 2860/2.

33. Ouyang 1974, 37.397; Wang Gui 1983, fu lu 1.11 (from Wang Gui's biography).

34. Fan 1983, 18.7.

35. Wei Jing 1983, 10.16b–17.

36. Wei Jing 1983, 10.17b.

37. The *Song History* was compiled under the auspices of the succeeding dynasty, the Yuan, in 1345.

38. SS 242.8612. See also Chaffee 2001, pp. 3–6.

39. Sima 1997, 5.100; 6.109; CB 56.1225–26; Chaffee 2001, pp. 4–5.

40. Bossler 2002, pp. 35–36.

41. SS 242.8612; Sima 1997, 5.100–101; CB 56.1225–26.

42. Chaffee 2001, p. 9; SS 242.8613.

43. SS 242.8613–14; Chaffee 2001, pp. 11–23.

44. SS 243.8656.

45. Note that it was common for courtesan-entertainers to adopt daughters to carry on their profession.

46. Ye 1997, 3.110–11; Zhou Mi 1997, 10.174–75.

47. SS 243.8657–58; R. Davis 1986, pp. 96–101.

48. SS 310.10173.

49. See Franke 1976, 2:1225. The girl reportedly alerted Shi to the heir apparent's intent to banish him, leading Shi to orchestrate the elevation of a different heir on the emperor's death.

50. For example, the *Song shi* says, "[The prince] set her up in the residence of his palace administrator Zhang Qi. When Taizong passed away and Zhenzong acceded to the throne, she entered the palace and became a [consort with the rank of] *mei ren*" (SS 242.8612).

51. Favored by Zhenzong as well as the empress, Liu Mei rose to lucrative positions, and his sons and grandsons enjoyed exceptional favor throughout their lives (SS 242.8612, 463.13548–52).

52. SS 465.13595–97, 243.8656.

14 THE VANISHED WOMEN OF KOREA

The Anonymity of Texts and the Historicity of Subjects

JaHyun Kim Haboush

About one-third of the way through *The Record of the Event of 1613*, the seven-year-old Prince Yŏngch'ang is taken from his mother, Queen Dowager Inmok, by order of King Kwanghae, his much older half brother. On that day, the royal messengers who had been ordered to take the prince engaged in a long struggle with Queen Inmok and her serving women, who pleaded and resisted his arrest. Later that day, it was obvious to all that the situation was hopeless and resistance vain.

> The women who were in service to the prince coaxed him, "Your Highness will have to be away only for several days. Please let's put on socks and a coat so that you can go outside with us."
>
> The prince replied, "I am treated as a criminal. They are asking me to go out through the gate meant for criminals' use. Of what use is it for a criminal to put on socks and a coat?"
>
> "Who told you that?"
>
> "No one told me, but I know. Sŏso Gate is the gate through which criminals are led. Now they are going to treat me as one and lock me up behind that gate somewhere." He then said, "If I were allowed to go out with my older sister, I would go. Otherwise, I will not go out, not by myself." At this, Her Highness the Queen Dowager grieved and cried even more. . . .
>
> His Highness the Prince then said, "Let Her Highness the Queen Dowager and my older sister go out ahead of me, and I will follow them."
>
> "Why do you say that?"

"It is because if I were to go first, then they will take only me and not them. So, let them stand in front of me so that I can see them." . . .

Yŏn'gap, the palace woman in service at the King's residence, held down the legs of the woman from our palace who was carrying the queen dowager on her back. Ŭndŏk blocked the woman who held the princess on her back from moving, while they forcefully took the woman who had the prince on her back, pulled her to the front, and pushed her out the gate. Then they pushed us back through the gate and shut it behind us. How unbearable this scene was. Taken by himself, His Highness wailed loudly, hitting his head on the back of the person carrying him: "Let me see my mother, let me see my mother." Then he said, "Let me see my sister." He cried so sadly and piercingly that his sobs echoed through Heaven and Earth, and his falling tears wet the ground. Everyone had tears in their eyes and blinded by tears, they could hardly find their way to the darkened path. Once outside, the prince was escorted by military men carrying swords and arrows. The prince stopped crying and became quiet as if asleep.[1]

The Record of the Event of 1613 is a fictionalized narrative of a famous struggle between the king and his stepmother. The narrative mode it adopts—intense emotion and a personal perspective, vividly rendered in the above scene—sets The Record apart from historical narratives, especially official histories written in an impersonal and objective mode. Judging by the narrative voice, The Record of the Event of 1613 is written by someone who was—or who imagined herself to have been—on the scene, and it expresses the pain of that experience. The author is unknown; the text was transmitted anonymously. The scholarly consensus is that it was probably written by a palace woman, or possibly a collaboration of a few women, in service of Queen Inmok,[2] but we have no information on any of them. The complete erasure of their individual existence is brought home more sharply when it is contrasted with the vividness of what they produced.

Who were these palace women? Although they remain faceless, there were, at any given moment until the nineteenth century, at least five hundred women in service at court during Chosŏn Korea (1392–1910). To borrow Roman Jakobson's well-known observation on the use of language, they are often seen in the dual perspectives of the metonymic and the metaphoric:[3] as representation and signifier of the monarchy. At the Chosŏn court, palace women not only actively participated in the daily and ritual life of the court; they also produced objects, some of which reflect the individual hand of their creator. Still, these women are conceived of and presented collectively and anonymously. Is there some way of seeing them beyond their collectivity,

some way of recovering and imagining at least some of them as historical, individuated subjects?

This essay is one contemplation on that question. I would like to attempt a strategy that would bring these women into focus and recover their identities as historical subjects. I will begin by focusing on the material objects that they produced, locating those objects in their cultural and historical context in order to decode their meanings through a system of signification. In this way, producers will acquire identities as historical subjects who were actively engaged in cultural production. This strategy may seem somewhat convoluted but what I am suggesting is simply the inverse of the usual approach: identifying subjects by contextualizing and historicizing their products.

The objects with which I would like to experiment in applying this strategy are two categories of writing: first, a memoir—*The Record of the Event of 1613*, an excerpt from which began this essay; and second, inner palace registries (*palgi*),[4] accounts of the objects produced that were consumed daily and on special occasions at court. The method I am proposing may be akin to that used by Judith Zeitlin in imagining identities of female poets through the poems they wrote on walls, although many of the poems she discusses disappeared from the walls on which they were written.[5] I will begin with the institution of palace women in Chosŏn Korea, and then discuss the two categories of texts, the politics of their production, and their cultural significations. These texts were produced by palace women in a specific structure of power, and both the products and producers should be placed within the context of this structure in order for them to acquire cultural meaning. Doing so requires an inquiry into the roles that these women played in the monarchy—their training, duties, and daily life— and the role of writing within the system. Lastly, I will contemplate the meaning of the anonymity of these objects and the historicity of subjects.

The Institutionalization of Palace Women in Chosŏn Korea

The institutionalization of palace women was first systemized in 1405, not long after the founding of the Chosŏn dynasty (1392). By the time the *Great Statutes for the Governance of the State* was published in 1469, the Bureau of the Inner Court Ladies, as the institution was referred to, was well integrated into the bureaucratic structure of the monarchy. The document regulated women who entered the palace to serve royal establishments, not female royal children or legal spouses of the king or princes. The Bureau paralleled, in its ranking system though not in its power or scale of remuneration, the state bureaucracy. Like the state bureaucracy, the Bureau of the Inner Court Ladies had eighteen ranks,[6] and

it oversaw palace women regardless of where they served. They served in several royal establishments, which had slightly different rankings for their palace women. The *Great Statutes* specifies the rank and duties of the women in the service of the king's and the crown prince's establishments. In the king's establishment, women who had been favored by the king and given birth to royal children were ranked from senior first rank to junior fourth rank. Ranks from the senior fifth to the junior ninth were given to women who performed specific duties in the day-to-day running of the establishment. These women constituted the bulk of the palace's female inhabitants, and they are the focus of this essay.

The crown prince's establishment was a replica of the king's establishment, on a smaller scale, and the ranks of its women were lower than those of women in corresponding categories serving in the king's establishment. For example, while the highest position for secondary royal consorts in the king's establishment was the senior first rank, the equivalent in the crown prince's was the junior second rank.[7]

In addition to the king's and crown prince's establishments, the palace contained the queen mother's and, sometimes, the queen grandmother's establishments, all of them with a certain number of palace women in service. The queen mother and the queen grandmother were not necessarily the king's biological parent or grandparent: they were the widowed queens of his predecessors. In these establishments of previous rulers, palace women in service had the same ranks as those in the king's establishment, and they were held in higher esteem by generation if only symbolically. However, with only a mistress in residence the scale of these establishments was somewhat reduced.

One should note that the palace precinct contained only one establishment per generation. Royal children other than the future heir to the throne could not stay in the palace when they reached adulthood; they were required to leave and set up their own residences. Deceased rulers' secondary consorts continued to live within the palace precinct. They were accorded due respect and financial support commensurate with their positions, but they did not constitute points of signification in the ritual order of the Confucian monarchy. These practices led to a clearly delineated vertical order in which younger generations owed filial devotion and deference to their elders. The coexistence of a vertical order that honored senior members of the royal family with a centripetal conception of power that centered on the throne produced an intricate web of symbolic and actual centers of authority and power. While the king was the present site of power, widowed queens could claim authority and senior status as guardians of the memories of past reigns.

The complicated positioning of these establishments, each occupying a separate physical and symbolic space, was reproduced in an elaborate system of

ritual and custom in which cultural and political significations were encoded. The most obvious signifier of the uncrossability of generational boundaries was the taboo against forming sexual liaisons with women from establishments across generations. All women who belonged to the Bureau of the Inner Court Ladies in the service of either the king's or the prince's establishments were available sexually to their respective masters. The same applied to women who belonged to the establishments of legal spouses of the king and the prince, which were organized somewhat separately but were viewed essentially as a part of their husbands' establishments. If a woman "received favor" from the king or the prince, she was accorded better treatment, but she gained higher rank only after she produced royal children. The taboo against forming liaisons with women in establishments across generations was sometimes breached, but such breaches were tolerated only in certain situations.[8]

Though these establishments were separate, they were bound together by their shared project of strengthening the Chosŏn monarchy and refining Confucian culture. Most of all, all inhabitants of the palace were bound by ritual, both daily and special. Ritual, by nature of its performativity and repetitiousness, was designed to foster interconnectedness and order among participants. Ritual was also a system of signification, and performers deployed it to negotiate their relationships to others and to calibrate their positions within the power structure. The inhabitants upheld order by confirming their membership in the monarchy by performing ritual, on the one hand, and by constantly negotiating their positions in relation to others through the manner of performance, on the other. In this way, a semblance of harmony could be maintained between the centers of symbolic and actual power. On a few occasions when one or another party no longer properly adhered to ritual, the system of signification was dismantled, order broke down, and drastic measures had to be taken to restore it.

I argue that palace women were active players in this ritual order. They made preparations for rituals of every category that their establishments were expected to perform and participated in them if required. This participation might be viewed as their duty, but through discharging their duty, and enacting their required roles, they also created a space for themselves as contributing members of the system, not passive observers. Moreover, they made a distinctive mark by producing new genres of writing that added to the scriptural and material culture of Chosŏn society. The Record of the Event of 1613 records a violation of the ritual order of the Chosŏn court, in contrast to the inner palace registries that confirm that order. Clearly, these works attest to the power of the court, by underscoring the importance of the breakdown or maintenance of order there. The politics of their production were inextricably intertwined with the identity and role of their producers as the guardians of the court.

The Record of the Event of 1613

In Korean literary history, *The Record of the Event of 1613* occupies a significant place. It spearheaded what is considered palace literature,[9] the genre that usually also includes *The True History of Queen Inhyŏn* and *The Memoirs of Lady Hyegyŏng.*[10] When these three representative works are examined closely, however, *The Memoirs of Lady Hyegyŏng* stands apart by virtue of being an autobiographical narrative by a known author. Nevertheless, the three works share a trope in that all are devoted to spectacular failures in the workings of the Chosŏn monarchy: a stepson's persecution of the queen mother, the dethronement and expulsion of the king's legal wife, and a royal filicide. All of them offer perspectives on these events distinct from the official historiography. While they seek to valorize their stories by claiming veracity, they ground that claim in different sources of authority. That *The Record of the Event of 1613* was written in the Korean script was in itself subversive, for previously all histories, both official and unofficial, had been written in literary Chinese. The other two works of palace literature similarly rejected literary Chinese. As a composition in the Korean script that challenges the official account, *The Record of the Event of 1613* created a new genre of historical narrative and constructed a new sociotextual community in which different modes of discourse on history were practiced.

As I mentioned earlier, *The Record of the Event of 1613* narrates the persecution that Queen Dowager Inmok (1584–1632) and her court endured at the hand of her stepson King Kwanghae (1575–1644) during his reign (1608–23). The rivalry between Queen Inmok and Kwanghae arose from their positions with respect to one another. Kwanghae was a second son of King Sŏnjo (r. 1567–1608), born of his secondary consort. When the Imjin War broke out in 1592 as Japan launched a massive invasion, there was a need for an heir apparent. Kwanghae was chosen, as he was regarded as the most capable of the princes. This was the first time that a nonlegitimate son (only the legal wife produced legitimate children) was made crown prince in the Chosŏn court, although it happened more frequently during the later part of the dynasty. The Imjin War inflicted incalculable damage upon Korea. During this difficult time, Kwanghae played a pivotal role in mobilizing the people's efforts and coordinating military counterattacks against the invaders. Despite generally favorable views of him and his gradual consolidation of power, Kwanghae felt threatened when Queen Inmok, whom Sŏnjo wed in 1602 after his first queen died, produced a son in 1606. Indeed, with the appearance of a legitimate son, the situation turned unfavorable for Kwanghae for a while. Nonetheless, he successfully ascended the throne upon his father's death in 1608.

Seeing his half-brother Yŏngch'ang as a potential threat, if not to him then to his own heir, Kwanghae initiated a campaign to eliminate him. In order to

accomplish this, two things were needed—the eradication of Queen Inmok's power base and the construction of a rationale to remove her from her position as the reigning queen dowager, an action that violated the ritual order of the Confucian monarchy. "The event of 1613" refers to King Kwanghae's killing of Queen Inmok's father, Kim Chenam (1562–1613), and his sons, on the grounds that they planned sedition against the throne in the hope of replacing him with Prince Yŏngch'ang, and the subsequent exile of the young prince to Kanghwa Island. Yŏngch'ang was put to death the following year. Kwanghae reduced the ranks of Queen Inmok and her daughter, Princess Chŏngmyŏng (1603–85), and placed both under house arrest.

Queen Inmok's establishment suffered increasing persecution and a gradual deterioration until 1623, when a palace coup dethroned Kwanghae and enthroned Injo, a prince of a collateral line in the Yi royal family. In accordance with Yi royal family custom, Queen Dowager Inmok, as the most senior member of the family, presided over the transition of power. She promulgated an edict in her name that charged Kwanghae with misrule and enthroned Injo.[11] Thus, the tale of the rivalry between stepmother and stepson ended with her triumph, although the tragedies she suffered—the deaths of her son, her father, and her brothers—could never be undone. Princess Chŏngmyŏng, her surviving child, became the most honored of royal princesses. Soon after Injo's enthronement, Princess Chŏngmyŏng wed Hong Chuwŏn (1606–72), an excellent poet and scholar, who on several occasions served as ambassador on missions to China. She was blessed with many children and a long and full life. Queen Inmok's triumph also led to The Record of the Event of 1613, the transmission of which would have been most unlikely had it ended with her defeat.

From a historical perspective, Kwanghae's rule was mired in a complex web of political, international, and familial contradictions.[12] That Kwanghae was the second and last monarch to be dethroned in the five hundred years of the Chosŏn monarchy testifies to the political tensions of the time. The complexities of Korean history need not be discussed here; suffice it to say that Kwanghae ruled over a country reeling from the devastating effects of the six-year war with Japan and facing the threat of another invasion, this time stemming from a reconfiguration of power in a different part of the region—the Manchu ascendancy and their ambitious project to replace China as the supreme power in the region. The entire political and intellectual community in Korea was passionately engaged with the question of how to deal with the Manchu, invaders regarded as "barbarian" culturally and ethnically in the mapping of the Confucian universe. Simply put, the community was deeply split between a camp that advocated ideological adherence to Ming China, the center of Confucian civilization and the benefactor of Korea during the Imjin War, and a camp that promoted "national" security and

negotiations with the Manchu. The pro-Ming camp denounced Kwanghae's policy, which is thought of as "even-handed" by modern historians for his attempts to accommodate Manchu demands while continuing relations with Ming China, as an affront to Korea's cultural identity. It appears that ideology won the day. Kwanghae was dethroned for having "betrayed" China and having reduced Korea, the country of civilization, to "barbarity."[13]

Kwanghae's blatant flouting of ritual order in persecuting his stepmother was also cited as unforgivable depravity. Not only did his violation of the vertical order alienate many politicians, who suffered grave consequences when they voiced objections to it, but his failure to stay within the limits of acceptable codes of behavior also created a general sense of unease. Exiled to Kanghwa Island, he died a natural death in 1641. The camp that supported his "nationalistic" policy was also expelled from power.

The Record of the Event of 1613 narrates the life of Queen Inmok and the palace women in her service from the perspective of the inner court. It makes little reference to outside events. For example, it does not report Prince Yŏngch'ang's death, the pivotal event in Inmok's life, until very late—and then by means of dreams by palace women. The narrative's chronology is thus faithful to the events as they unfolded, since Queen Inmok's establishment was not informed of Yŏngch'ang's death when it happened. This completely interior view of the event contrasts with the perspective from which the incident is portrayed in the official history.

Kwanghae's dethronement created problems for official histories as well. Because such works were always written after the completion of a reign, *The Veritable Records of Kwanghae's Reign*, the most authoritative of them, was compiled by an anti-Kwanghae group, and hence a certain amount of vilification was inevitable. Nevertheless, the historiographical method employed in official history allowed for the recognition of complexities. Each day, entries were made on all matters, small or large, considered relevant to the working of a Confucian monarchy. Thus the official history offers a multifaceted and at times even self-contradictory compilation of all strands related to events of significance. Moreover, the format of the *Veritable Records* does not permit a linear narration. The reporting of events is diffuse and fragmentary, much as in daily newspapers.

The Record of the Event of 1613 differs from official historiography not only in perspective and format but also in the narrative authority on which it is based. In the East Asian historiographical tradition, narratives were constructed along two axes—impartiality and emotion. In her discussion of the issue of authority in historical texts, Wai-yee Li points out that Xima Qian emphasized both empiricism and emotion in his *The Records of the Historian*.[14] Later official histories in Korea and China, compiled by a committee as it were, swung in the direction

of impartiality represented by third-person narrative. In fact, their authors sought to achieve historical veracity by presenting a completely impersonal view, and this effort led them to excise perspectives and ideas considered personal.[15]

The Record of the Event of 1613 does not completely eschew the appearance of objectivity: it adopts a third-person voice and narrates from the point of view of a nameless observer. But rather than being a jumble of all relevant events, it is constructed of a linear series of scenes of profound sadness and situations of dire difficulty. I should also note that nowhere in the narrative is King Kwanghae directly vilified. Instead, his violation of ritual order manifest by his neglect of filial duty to his stepmother is minutely recorded: the house arrest under which all residents of the queen dowager's establishment were placed; the planting of hedges of brambles around her walls, signifying her status as a serious criminal; the refusal to repair the palace or to take away garbage; and a reduction in provisions that left the women in service barefoot and in tatters. This dire situation was corrected by divine intervention—birds brought seeds that grew into the vegetables, fruits, and cotton that sustained the women through these dark years. The story of the birds becomes a metaphor for the degree of the women's deprivation and for their miraculous survival. By evoking divine protection, the narrative places Kwanghae's violation in the cosmic realm and thus casts his downfall as punishment for his immoral behavior.

It is by highlighting the intensity of emotion and the physicality of experience that The Record seeks to acquire narrative authority. The magnitude of Kwanghae's violation of order is displayed by means of the vivid depiction of the boy's being taken away from his mother in the scene quoted at the beginning of this essay and by the details of the physical deprivations to which the narrator and her fellow inhabitants were subjected. Physicality is also stressed in the process of transforming experience into text—the narrator's bodily suffering, her seeing and witnessing, and her actual writing by hand. Through the narrative strategy of empowering the immediacy of experience, The Record of the Event of 1613 opened a space for telling history by laying claim to an alternative source of authority.

Inner Palace Registries (palgi)

At first glance, inner palace registries written in beautiful calligraphy in palace style appear to be of a completely opposite nature from The Record of the Event of 1613. They contain concise and simple descriptions of things used for various occasions unaccompanied by interjections, interpretations, or personal views. The 721 extant inner palace registries, which date mostly from the nineteenth century, can be divided into two types. The first records things used in daily life, such as the

articles of clothing to be prepared for a new season for members of the royal family. The second was produced separately to record the categories of items required for specific occasions.[16] Weddings for members of the royal family, the princes' capping ceremonies, and the bestowal of honorary titles on queen dowagers produced the largest numbers of registries. Inner palace registries were also made for occasions when the royal house sent gifts to members of the royal family, officials, and other attendants, including palace women. In fact, all the items that were bought, received, and produced in the palace appear to have been recorded. The inner palace registries are thus unadorned windows through which the power of the court is displayed in its material splendor. They show how the court conducted its daily material life, how it celebrated special occasions, and how it displayed its magnanimity toward those who worked for it. Once housed in Changsŏgak, the Library of the Royal Family, they were later transferred to the library at the Academy of Korean Studies near Seoul.

The length of these registries ranges from about a dozen to hundreds of objects. The longest tend to be those cataloging the gifts bestowed upon the bride at the time of a crown prince's wedding. The inventory of jewelry given to the crown princess on the occasion of her marriage to Prince Hyomyŏng in 1819 is especially revealing. Thousands of items are listed, divided into such categories as pins, rings, hair decorations, blouse decorations, and type of jewel. There were 153 pairs of rings alone, in many shapes and with different gems (pp. 384–90). The inner palace registries produced for the occasion of the wedding of Crown Prince Sunjong (1874–1926; r. 1907–10) in 1882 seem to belie the declining fortunes of the Chosŏn dynasty, as many featuring different categories of items were made for the occasion. Among them are registries of quilts, with more than 500 items described by fabric, color, and manner of construction (p. 393); pillow cases embroidered with various kinds of auspicious animals and symbols (pp. 392–93); decorative objects made for the bride's quarters,[17] including screen paintings of orchids and bamboo (p. 132); the bride's spring clothes, with items numbering in the hundreds; her lingerie, totaling 133 items (pp. 397–98); and the gold jewelry that she was supposed to wear at the wedding ceremony, including such items as hair ornaments, rings, pins, and other decorative objects for her clothing (p. 390). There is also a registry of such imported goods as fabrics, fans, plates, and ornaments (pp. 412–13). Other registries enumerated utilitarian objects needed for the occasion, including several hundred wrap clothes in different fabrics, colors, and sizes (p. 392).

The distinction between inner palace registries made for special occasions and those made for daily life can be blurred, particularly when the "special" occasions are regular festivities such as the New Year and birthdays. In all cases, the registries are notable for their specificity. That of clothing prepared for the

occasion of Prince Yŏngch'in's capping ceremony records twenty-five items from coat to underwear and socks, detailing the fabric, color, woven pattern, and mode of construction for each (p. 381). The inventory of spring clothing for the new wife of one of the princes, on the other hand, falls into the category of registries that display the regular rhythm of court life. It contains a few dozen items, precisely categorized in the familiar manner described above (p. 399).

Undated registries are difficult to ascribe to a precise event. For example, some record only fabrics, presumably to be used for a specific occasion, but do not say for which.[18] Others describe particular items in exhaustive detail without specifying the occasions for which they are made. There is, for example, one registry of about 715 trousers, and another of 820 sashes and belts. These are believed to have been prescribed items to be prepared for a king or a prince in one year, but they do not name for whom (p. 397). In contrast to this ambiguity is a short registry of vests for King Kojong and Crown Prince Sunjong. Vests for father and son are made of the same material—patterned and imported silks—but those for the father are in dark blue and pale aqua, while those for the son are in green, pink, and dark blue (p. 396). The vest appeared as a part of male attire toward the end of nineteenth century, and this registry was probably made around the turn of the century.

Equally interesting are the menus for special occasions, and those for Crown Prince Sunjong's wedding in 1882 are particularly revealing. This was a celebratory meal eaten just before the prince went to the bride's pavilion to perform the first rite of the wedding.[19] It was attended by seven members of the royal family—the crown prince, his parents, his grandfather, two queen dowagers, and one of the secondary consorts of a previous king. According to custom each person received a separate table of food,[20] at appointed places, although they dined in the same room. The menus for the seven tables were similar, except that the crown prince received several extra dishes. What is curious is that next to the menus for this meal are those for the occasion of the first selection of the bride, the first part of a three-step process for choosing the spouses of royal children.[21] Sunjong's bride went through this process, and obviously she was included in this first group of potential brides. Two different menus are listed for this occasion, one for a snack and one for a meal. Each was prepared for twenty-six tables for girls who were selected and for fifty tables for the mayor and other officials of the capital city, who assisted at the event (pp. 405–6). Birthday celebrations seem to have produced the largest number of menus still extant. On most of these occasions, each member of the royal family received a table with the same menu, but the heights of the tables on which meals were served differed.

The menus of the ritual offerings for the dead were just as elaborate. The registry recorded for a birthday offering of 1891 for the deceased Queen Dowager

Cho contains eighty dishes. The items are not exactly the same as those provided for the living. Fresh fruits and cakes predominate, though all courses are covered, from soups to main dishes to desserts and, of course, drinks. The queen dowager had been dead for about a year and four months by this time, and presumably the offerings became simpler as time went on, but the elaborate and precise nature of the offerings is striking. Other registries specify the dishes offered at her gravesite during the month after her funeral in 1890. There were three offerings each day, and while each menu is far simpler than the one on her birthday, it still contains all courses—soups, broiled meat, steamed meat, raw fish, vegetables, pickles, noodles, and so forth—and apparently efforts were made not to repeat the same dishes (pp. 407–8).

It should be pointed out that these inner palace registries are not the only records of materials used for special occasions. The same information is also included in government-sponsored official records issued when such occasions involved members of the royal family. A temporary office was established to oversee each of these events, and one of its tasks was to produce a detailed record of the ceremony, including the protocol and the items used. The earliest complete record of a royal wedding is *The Illustrated Record by the Wedding Office for the Crown Prince*, a 125-page book detailing Crown Prince Hyŏnjong's wedding in 1651,[22] and many records of the king's and royal children's weddings from this period on have survived. For example, all the records of Sukchong's three weddings, in 1671, 1681, and 1702, and almost all the official records thereafter are preserved. The record for Crown Prince Sunjong's wedding in 1882, which contains many lists parallel to the registries discussed above, is also extant. Many other categories of rituals that the Chosŏn court deemed significant, such as funerals and offerings of titles to the senior members of the royal family, were treated in the same manner.[23] All these official records produced by the temporary office of the event are in literary Chinese, often with illustrations.

These inner palace registries raise two questions. One is whether there was a relationship between the registries produced by palace women and the formal official records compiled by the offices established for events. The other is why the surviving inner palace registries are all relatively recent, dating from the nineteenth century, while official records of special events from the seventeenth century on are preserved. I will hazard a guess. Although we have no evidence of registries predating the extant ones, it is likely that they were made and used as sources by the special offices compiling the records of events. During the Chosŏn dynasty, the creation of an official historical record was a multilayered process. Each unit in the bureaucracy kept meticulous records of what it considered relevant information, which were then submitted to the committee in charge of compiling the official record. Materials used in the compilation were often

destroyed afterward. *The Veritable Record (sillok)* of each reign, for example, was based on records kept at various government agencies, a substantial portion of which were destroyed after *The Veritable Record* was compiled.[24] The same fate probably befell the earlier inner palace registries.

In that case, why were inner palace registries from the nineteenth century preserved? I would like to propose as an explanation the aestheticization of palace-style calligraphy. Before the nineteenth century, the inner palace registries were discarded because they were considered purely as utilitarian documents used in accounting, serving no useful purpose once the information they contained was transferred into the official records. But later they were seen as items of beauty and value in their own right. It should be noted that calligraphy, viewed as a representation of one's aesthetic and moral self, was a genre regarded as sacred and pure;[25] moreover, it was identified as a male practice, as Chinese characters were used to treat subjects of a philosophical or poetic nature. Yet the inner palace registries were in woman's hand and in Korean script on such mundane subjects as material objects. It is a major step to claim for such an inner palace registry a place in the sanctified space of calligraphy.

The development of palace-style calligraphy—and the aestheticization of that calligraphy, which naturally followed—signified the opening of an independent space for women in the visual scriptural culture. In fact, palace-style calligraphy was widely practiced in the female community at court, including by members of the royal family. There is a Korean translation in beautiful palace style of a book titled *Record of Private and Public Anecdotes of the Court Seen and Heard*, originally written in Chinese.[26] It is believed that the Korean copy is by Princess Ch'ŏngyŏn (b. 1754), the daughter of Prince Sado and Lady Hyegyŏng and the sister of King Chŏngjo (r. 1776–1800), although it is not clear whether she also translated the work herself. By the late eighteenth century, if only within the confines of female community at court, palace-style calligraphy was being elevated into the aesthetic realm.

In contrast to *The Record of the Event of 1613*, written to protest the violation of the court's ritual order, the inner palace registries were compiled to confirm that order. But both categories of writing represented the creation of new genres in scriptural and visual culture: *The Record of the Event of 1613* opened an alternative mode of historical narration, whereas the inner palace registries pioneered an entirely new space in calligraphy. These are remarkable feats for women who remain nameless and faceless. What in the institutions and trainings of palace women made it possible for them to engage in such production? To be sure, these texts display the power of the court, to the extent that they embody a belief in the sanctity of the ritual order of the monarchy on the part of palace women, but at the same time their production was embedded in the day-to-day life of palace

women. What was the ethos of the court life in which they were placed that led to them to produce these objects?

Palace Women—Their Selection, Training, and Daily Life

At the beginning of their service, palace women joined a specific department in a specific establishment. Several royal establishments coexisted in the palace in a vertical hierarchy by generation: that of the past reign (represented by the queen dowager), that of the present king, and that of future king. Each establishment consisted of seven departments—a secretariat, a haberdashery, and divisions of embroidery and decoration, bath and toilet, snacks, food and meals, and laundry.

As a rule, palace women were selected as children. The age at which they entered the palace ranged from three or four for the secretariat and six or seven for the haberdashery and the division of embroidery to the early teens for the remaining departments. In principle, selections were made every ten years, but irregular selections could be arranged as needed. Upon entering the palace, each child apprentice was housed in the care of an older palace woman who looked after her as a surrogate mother.

Even those children who entered very young began their apprentice training at about age seven. They were all instructed in deportment, court language, and basic reading and writing of the Korean script, and they also received training in the specific skills required for their future positions. Preparation for children in the secretariat was exceptional in many respects. Unlike other apprentices, they studied an academic curriculum that consisted of basic Confucian morality texts, biographies of exceptional women, and history. They also received rigorous instruction in the palace-style calligraphy.

There is considerable uncertainty regarding the social status of families from which apprentices were drawn. Selecting child apprentices from families of *yangban* or commoner status was legally prohibited,[27] but according to Kim Yongsuk, this proscription was routinely broken. Most apprentices for the secretariat, the haberdashery, and the division of embroidery were selected from families of *chungin* (middling) professionals, while the rest were chosen from commoner families. She also mentions a tendency toward hereditary selection—palace women frequently recommended girls in the younger generation, often their nieces.[28]

The ambiguity surrounding the social background of palace women seems to be related to a certain ambivalence with which the position was viewed. While service in the palace was one of very few salaried professions open to

women, the ban against their marrying and having families plus the requirement to enter the palace at a young age led to a popular view of them as tragic figures suffering an undesirable lot. At the same time, they were also figures of fantasy and envy because of their nearness to power, their access to the court's pomp and luxury, and the possibility, however remote, that they might become mothers of royal children. They could thus achieve an exalted position with accompanying privileges that would extend to their natal families.

Fifteen years after their entrance, child apprentices were formally invested as woman of the inner court, a transition marked by a capping ceremony. This occasion was treated much like a wedding. A large feast was prepared, and the celebrant was permitted to wear costumes and decorative objects exclusively reserved for members of the royal family and the aristocracy. Afterward, she was given independent living quarters. As a rule, each shared an apartment with the roommate of her choice, and the two women also shared a maid. This cohabitation led to speculation concerning same-sex relations, which apparently did occur on occasion. As full-fledged women of the inner court, they were now responsible for carrying out duties specific to the department to which they belonged. Their working hours were long, but they were on duty only every other day. The exception was women in the secretariat, where two women served jointly for twenty-four hours, each on duty either during the day or at night, but still only every other day.[29]

After serving for fifteen years, women of the inner court were promoted to palace matron, a station that bore the rank of senior fifth grade. This was the highest rank that palace women could achieve without being favored by the king or the crown prince and bearing them children. Women so favored could become palace matrons without waiting for fifteen years.

Although all palace matrons held the same rank, their authority differed according to their posts and the tasks they were assigned. The most important posts belonged to the secretariat in the king's establishment. The highest was that of matron in chief. As head of staff, she supervised the management of all departments of all establishments within the palace. Her main duty was to carry out royal orders and to attend to births and other such important matters involving the queen. As a female equivalent of the head secretary in the Royal Secretariat, the matron in chief commanded considerable authority; even high ministers had to cultivate and consult her.

Below the matron in chief were other matrons. Immediately beneath her was the deputy matron in chief, who was responsible for managing the king's and queen's private properties. Matrons-in-waiting were always in royal attendance, ready to receive and execute royal orders. The duties for matrons in service seem to have most closely resembled those of male secretaries in the Royal Secretariat.

They were responsible for libraries, reading and writing speeches in the Korean vernacular, overseeing the proper performance of rituals, maintaining appropriate relationships with members of the royal family and the queen's family, sending suitable royal gifts and bestowing other royal graces, and functioning as the queen's or queen mother's messengers to their natal families.

There were other matrons as well, such as the matron-governesses responsible for educating royal children; the crown prince had two, and other children had one each. Other palace matrons managed the tasks of their respective departments and supervised women of the inner court. As a rule, matrons were provided with a maid, a seamstress, and a housekeeper whom they could choose from their natal family. The matron in chief was allotted two maids, plus a woman of the inner court assigned to her as an assistant.

What is striking about palace women of the Chosŏn court was the task-oriented character of their existence. While they were available sexually for their master, they were chosen and trained to carry out specific duties necessary to manage royal establishments. Except for those in the small minority who became the king's or the prince's secondary consorts, these women were evaluated and rewarded in accordance with their performance. In this sense, they occupied a space as professional women rather than as sexual objects. Not only did they play important roles in the day-to-day running of the royal residences, but their labor sustained the ritual order of the monarchy and contributed to material culture. The aesthetic sense of the women responsible for making clothes for everyday wear and costumes for special occasions, for example, even though they worked according to set specifications, must have contributed to the tastes and fashions of the time. Likewise, the women who embroidered screens and other decorative objects for ceremonial and daily use must have shaped the general aesthetics of court life. The extant examples of court costume hide individual aesthetics behind superb workmanship. Even though their subject matter and sometimes even their patterns were predetermined, embroidered screens in palace style more readily display personal taste.

Nowhere was the professional character of palace women more apparent than in tasks assigned to women in the secretariat. Their duties encompassed writing and other related work in scriptural space, which in most societies is traditionally viewed as being an exclusively male domain. Why did this violation of male space occur in Chosŏn Korea? The pervasiveness of writing in the enactment of ritual and in the daily life of the court was obviously a factor, but it cannot explain women's participation in scriptural culture, since this function can be assigned to others (such as eunuchs) if necessary. We must remember that the written culture of Chosŏn was diglossic. Writing in literary Chinese and writing in the Korean script were strictly distinguished and ranked, and palace women were officially sanctioned to remain

within the space defined by the Korean script. I have elsewhere argued that the configuration of the diglossic culture was far more complex than a hierarchy and division between the two spaces along the lines of gender and genre.[30] Nevertheless, this unusual phenomenon can be explained at least in part by the dominance of scriptural culture at court coupled with a diglossic culture that permitted women to enter into scriptural space without challenging the male hegemonic space of literary Chinese.

The professional ethos of palace women provided the backdrop for their extraordinary products. They were committed to the shared project of upholding and refining Confucian culture at court; they celebrated and defended this court community. In *The Record of the Event of 1613*, the community in question is Inmok's court, employed metaphorically, as it were, for the ritual order subjected to persecution. In the inner palace registries, the entire community—both those being served and those doing the serving—is on display. Each registry arises from the continuous rhythm of the daily and ritual life of the court. The registries were produced in a process involving all seven departments in which palace women worked. Women in different departments took part in each stage of planning, producing objects, putting them together, and registering them. The final stage also indicated a personal relationship between the objects and the registry maker, however brief this relationship may have been. Each object was gazed upon, examined, categorized, and recorded. It was through a particular woman's gaze, categorization, description, and calligraphy that these items were transformed into abstractions.

The Anonymity of Texts and the Historicity of Subjects

This essay began by contemplating the anonymity and collectivity of vanished palace women. Can we rescue them from anonymity by examining the objects that they left behind? Can we render them identifiable as historical subjects by placing these objects within their historical context? Can we recover the cultural meaning of their products by locating them in what we believe to be the system of signification at the time? If we define anonymity as namelessness, they remain anonymous. There is no way to meaningfully retrieve their names. Although some claim that the author of *The Record of the Event of 1613* may have been Pyŏn, a matron,[31] that name confers no meaning on an author who has remained anonymous for so long. By placing these objects within the system of cultural signification, however, I feel that we can imagine these women as engaged in activities with meaning, and see them as historical subjects who produced meaning.

Can we individuate them, perhaps as distinct subjects who produced individual objects? As each of these objects is different, can we perhaps attribute individuality to their producers? There is no question that individual talents and taste are displayed in these products. Perhaps we can render them an anonymous identity as we do for the painter the Master of the Sparrow, an identity defined by the traces they have left. Their identity, however, must rest on something fleeting and fragmentary—something in their hand and in their gaze.

Notes

1. Kang Hanyŏng's 1962 edition is regarded as the standard, and I cite it throughout by title (*Kyech'uk ilgi*, pp. 99–104).

2. *Kyech'uk ilgi*'s anonymous transmission has led to debates regarding its authorship. Hong Kiwŏn (1986, pp. 199–205), a direct descendant of Queen Inmok through her daughter Princess Chŏngmyŏng, for example, claims that the author was Queen Inmok. Min Yŏngdae (1990, pp. 12–48), however, disputes this claim and asserts authorship by Queen Inmok's palace women. Min's view seems to be dominant.

3. Jakobson 1956.

4. While the Chinese characters for this type of document would be usually read as *pan'gi*, in this case *palgi* is correct.

5. Zietlin 2003.

6. The hierarchy's eighteen ranks ran from the senior first rank and junior first rank down to the senior ninth rank and junior ninth rank.

7. *Kyŏngguk taejŏn* 1962, 1:17–18. For a description of a crown prince's establishment, see Haboush 1985.

8. While the taboo against women in the queen mother's or queen grandmother's establishment was violated occasionally, the one against those in service to one's son or one's father was viewed as inviolable.

9. Yi and Paek 1990, pp. 165–69.

10. For an English translation of *The True History of Queen Inhyŏn*, see Rutt and Kim 1974, pp. 179–233, and for a discussion of this text in comparison with other texts describing the same incident, see Haboush 2003; for an English translation of *The Memoirs of Lady Hyegyŏng*, see Haboush 1996.

11. *Injo sillok*, 1:5a–6a.

12. Haboush 2001, pp. 23–24.

13. *Injo sillok*, 1:5a–6a.

14. W. Li 1994, esp. pp. 377–405.

15. P. Wu 1990, pp. 3–14.

16. Kim Yongsuk 1987, pp. 376–77. Page numbers of this work are hereafter cited parenthetically in the text.

17. Consummation of the marriage did not take place until several years after the wedding, when the couple reached puberty.

18. *Kyŏrye ŏi Han'gŏl* 2000, p. 56.

19. For a description of the wedding ceremony of the crown prince in the later Chosŏn court, see Haboush 1996, pp. 57–69.

20. Koreans used a movable table, which was brought in to a person and then removed after the meal.

21. For a description of the selection process, see Haboush 1996, pp. 57–66.

22. *Changsŏgak tosŏ Han'gukp'an ch'ongmongnok* 1972, p. 344.

23. Nearly a hundred pages of the catalogue for the Changsŏgak Archive are devoted to books on special ritual events (*Changsŏgak tosŏ Han'gukp'an ch'ongmongnok* 1972, pp. 291–386).

24. See Haboush 2001, pp. 245–51.

25. Hay 1983.

26. Several copies of variant versions of this book, including one in pure Korean script, are at the Asami Library (see Fang 1969, pp. 91–92). Written by Chŏng Chaeryun (1648–1723), the son-in-law of King Hyojong (r. 1649–59), it contains private observations on court life.

27. *Hyojong sillok*, 11:43a.

28. Kim Yongsuk 1987, pp. 33–34.

29. Kim Yongsuk 1987, pp. 35–44.

30. Haboush 2002.

31. Min 1990, pp. 12–48.

THE PERILS OF THE SENTIMENTAL FAMILY FOR ROYALTY IN POSTREVOLUTIONARY FRANCE

The Case of Queen Marie-Amélie

Jo Burr Margadant

Modernizing the domestic face of monarchy constitutes a major challenge for royal families even today in Europe, to judge only by the spectacular example of the House of Windsor. At the least opportunity, the popular media turn royal domesticity into soap opera or worse to feed a public hungry for glimpses of royals' intimate lives. That interest and the political problems it creates for monarchies are not new to European royalty. As any number of historians of France and England have shown, politically potent revelations of imagined or actual royal family secrets developed over the course of the eighteenth and early nineteenth centuries into a major form of popular political protest, as rising literacy permitted a long-standing taste for shocking tales about authorities a new outlet through the press.[1] What linked that scandal-mongering press to the sorts of storytelling that still surrounds and occasionally imperils royal persons was its connection at the time with a newly sentimental conception of the family. This essay explores the uniquely problematic position into which that version

For a shorter version of this article, see Margadant 2006. Fellowships from the American Council of Learned Societies and the National Humanities Center together with the generosity of Santa Clara University made the research for this article possible. I would like to thank the recently deceased comte de Paris and the current comte de Paris for their kind permission to consult the Orléans family papers in the Archives de France of the National Archives. The Photographic Service of the Bibliothèque Nationale de France kindly provided several of the illustrations that appear in this article. I am grateful to Santa Clara University for a grant to defray the cost of copyright fees.

of a royal household placed a queen in nineteenth-century France. However widespread elsewhere in Europe, in France mixing royalty and a sentimental style of family life turned out to be not merely hazardous but also, I will argue, potentially fatal to the throne.[2]

Historians of the Old Regime and Revolution have often pointed out the dangers under absolutism of mixing monarchy and conjugal devotion—something all French kings managed to avoid except Louis XVI, whose fidelity to Marie-Antoinette accounts in part for the immense popular hatred of the queen. The evidence presented here pursues the conundrum of mixing royal authority and marital bliss in the decidedly different setting of postrevolutionary France during the reign of Louis-Philippe (1830–48), when his wife, Queen Marie-Amélie, became a universally recognized paragon of domestic love and duty in a royal couple known to be uncommonly devoted to each other.[3] Paradoxically, by exhibiting those very virtues most admired in a wife and mother by a Europe-wide elite, Queen Marie-Amélie only helped undermine the dynasty that she tried so hard to save.

Kings and Queens in French History

To explain this paradox requires some historical understanding of how queens figured in the constellation of monarchy as it had developed over time in France, which accounts for certain peculiarities in the royal position assigned to Marie-Amélie.[4] In the first place, the position of queens in relation to the French throne and public authority had been whittled down progressively from the fifteenth century onward. By the beginning of the July Monarchy under Louis-Philippe, by law and in the symbolic representations of her royal nature, a queen had become no more than the wife of the king and the mother of his children. The origins of this diminished version of a queen's significance can be traced to the fourteenth century, when jurists invented the legal fiction of an ancient Salic Law that barred women from the Capetian throne.[5] An important change in royal ceremonials in the seventeenth century, when coronations of the queen ended altogether, further underscored the exclusively male right to mount the throne.

All the same, up until the Revolution, French queens had retained the possibility, in the absence of the king, to serve as regent for an underage son in line for the throne. The widely understood political advantage of turning to a mother in such cases depended on the very limits placed upon her by her gender. She could not usurp her offspring's right to the throne, and her presumed maternal interest made unlikely any connivance with another contender. Although a regency had not been exercised by a French queen since the minority

of Louis XIV (1643–60), the presence of Marie-Antoinette in the Council of Ministers beginning with the birth of her first son reminded the nation of the option of a female regent on the eve of the Revolution. Even before the monarchy fell in 1792, however, the Constitution of 1791 had foreclosed that possibility with a provision that barred women from any future regency.

Of the five men who would occupy the throne of postrevolutionary France from 1804 to 1870, Louis-Philippe alone opposed restoring the legal possibility of female regencies, partly on political principle and partly for reasons directly related to the argument presented in this essay. Louis-Philippe's political outlook worked in lockstep with a sentimental version of the family and a reconfigured understanding of the nation that dated to the Revolution and made such expediencies seem to him unnecessary for a royal family and historically outdated for the nation. Only sixteen years old when the Revolution broke out, Louis-Philippe had embraced its radical reordering of familial relations with the gusto of youth.[6] However disillusioned he later became by the violence of republican politics, throughout his life he kept faith with its familial ethos and made it integral to his own understanding of a constitutional monarchy. In that respect Louis-Philippe reflected, as he persistently maintained, the future of French political culture and not its past. But his claim needs deeper probing than it has heretofore received.

In a host of recent studies of the political culture through which contemporaries imagined their changing circumstances just before and during the Revolution, scholars have discovered links between a newly sentimental literary version of the family and some equally freshly minted metaphors for king and nation.[7] In the seventeenth century, the king's symbolic relation to his realm had been that of husband to France and of patriarch to his people. In both capacities the king had exercised authority in the same absolute way that individual French husbands and fathers ruled their own families. But by the time Louis XVI came to the throne, the popular image of kingship, like that of fatherhood for many in the reading public, had mutated from an authoritarian patriarch into the nation's beneficent father. That image of his authority would carry Louis XVI over the threshold created by the Revolution into his brief experiment with constitutional monarchy. It could not survive the discovery of Louis XVI's treason after he first tried to flee France in June 1791 and later conspired with foreign heads of state at war with France. The overthrow of the monarchy in August 1792, followed by Louis XVI's execution in January 1793, opened the way for a different familial metaphor for the nation, under a republic based on fraternal rather than fatherly symbols. Already at war with much of Europe, the First Republic would quickly transform France symbolically into a nation of brothers armed in defense of liberty. Significantly for the political imaginary bequeathed

to postrevolutionary France, the Napoleonic state remained a fraternity of men in arms engaged in world conquest without turning Frenchmen symbolically into sons of their warrior emperor.

But what happened to the "queen" through all of these adjustments to the familial metaphor for king and nation? The fate of Marie-Antoinette illuminates the process clearly enough. Without a coronation, her title of queen rested on whether she could produce a male heir for the throne; otherwise she risked repudiation. Once she did achieve that goal, she became the royal mother of the heir to the throne; but she was never "mother" to the nation. Nonetheless, under the rituals of the Old Regime, in addition to attending the King's Council Marie-Antoinette could legitimately stand beside the king in May of 1789 to receive the delegates to the newly elected Estates General who had come to consult with the king. That was no longer possible once the Revolution had reinvented the nation. Marie-Antoinette became, like all French women, a "passive" citizen with a duty to raise her son for patriotic service, a task that republican political culture would later relegate also to republican mothers. The provision in the Constitution of 1791 barring a royal mother from any future regency followed necessarily from this exclusively maternal role. Marie-Antoinette's trial and execution ten months after Louis XVI's death pursued a perversely similar logic. The Revolutionary Court accused her of sexually molesting her eight-year-old son in addition to plotting with foreign governments. The presumption behind the charge of sexual perversity could not be more apparent. Rather than teaching him to revere the principles underlying the virtuous new political order, the deposed queen had taught her son the corrupted mores of the old one.

A New Royal Family for a Meritocratic Monarchy

By the time he learned the fate of Marie-Antoinette, Louis-Philippe had been hiding in Switzerland for several months following a narrow escape from arrest for treason while a lieutenant general in the republican army.[8] For him the queen's demise, however shocking, had nothing like the personal impact of king's execution, an event that set in motion his own gradual disillusionment with republican democracy. He would eventually decide, after several years in exile (two of them in the United States), to reclaim his heritage as the duc d'Or-léans and head of the junior branch of the Bourbon royal line, though he would not return to France until the victorious coalition against Napoleon's army decided in 1814 to restore the Bourbon throne under Louis XVIII. By then, Louis-Philippe had already found, with an Italian Bourbon princess, the affectionate union to which he had aspired since his own youthful infatuation with

Rousseau.[9] Together, Louis-Philippe and Marie-Amélie produced ten children within fourteen years of marriage, eight of whom survived a particularly joyful childhood supervised with great attention and affection by both parents.

Unquestionably, the conjugal harmony and style of parenting that the duc and duchesse d'Orléans put on public view during the reigns of his Bourbon cousins, Louis XVIII (1814–24) and Charles X (1824–30), contributed to the duke's popularity in liberal circles. Leading spokesmen for a constitutionally limited monarchy assumed a connection between companionate marriage, affectionate parenting, and liberal politics, as did Louis-Philippe himself.[10] But this cultural nexus held a hidden political danger for the Orléans that would become apparent only after Louis-Philippe ascended the throne in 1830 as "King of the French," a title chosen to emphasize a new relationship between French citizens and their king that eschewed familial or absolutist references. While Louis XVIII always referred to the French as "my children" in his annual address from the throne, and Charles X called them his "subjects," all such terminology from the Old Regime lost whatever aura of legitimacy it might have had once the Revolution of 1830 overthrew the Bourbons, and the Chamber of Deputies made Louis-Philippe "king" by an act of law. Louis-Philippe had come to the throne neither by divine right nor through foreign intervention; the king-makers, however restrained in number, had made their choice in the name of the French citizenry. This was the meaning of his title "King of the French." The duc d'Orléans would assume power as the citizens' king under a slightly revised version of the constitution that Louis XVIII had given the French in 1814 and that Charles X had violated in 1830, to his everlasting regret.

From the beginning, the pact between the new king and the citizenry was filled with ambiguities. Its promoters on the liberal left imagined that the new monarchy would resemble a republican form of government once a revised constitution had democratized its institutions. Its defenders on the liberal right imagined that a liberal monarchy would differ from the previous regime only in its fidelity to the existing constitution and in the political class on whose support it rested. As for the duc d'Orléans, he accepted the throne as a personal sacrifice, or so he told himself, in order to prevent the revolution from sliding into anarchy or toward a republican form of government that would surely prompt Austria, Russia, and Prussia to invade. But another equally powerful motive inspired the duc d'Orléans' decision. He was personally ambitious, not in the self-interested way that his enemies imagined, but in keeping with his own idea of service to the nation. Having meditated deeply ever since the Revolution on the reasons for its disastrous outcome, he had concluded that a king attuned as he was to the culture of his time and committed to the liberal principles protected by the constitution could bring political stability and prosperity to France and

peace to Europe. In his view, this possibility, though admittedly uncertain, justified accepting the throne of his ousted cousin, Charles X, instead of simply serving as regent for the ten-year-old heir to the throne, the duc de Bordeaux, then on his way into political exile with his grandfather and his mother. Unfortunately, Louis-Philippe's own monarchical solution to the political divisions left over from the Revolution and the Empire and exacerbated under the Bourbon Restoration brought together two incompatible principles of social organization and political right that would undermine support for the regime, even among its original supporters. The king's character and motives would be so completely vilified, as a result, that historians have only just begun to reexamine the likely origins of the moral stigma attached to his regime.[11] The difficulties facing Marie-Amélie in her own efforts to represent a "Queen of the French" are inseparable from Louis-Philippe's dilemma.

The cultural logic behind the political acts that installed the duc d'Orléans on the throne rested on the fraternal and egalitarian model of French society as a brotherhood first introduced into the French political imaginary by the Republic of 1792. According to that logic, Louis-Philippe acquired the throne in 1830 not by right of blood—which he did not really possess, having leapfrogged over the next Bourbon in line for the throne—but by personal merit. This was no minor feature of the monarchy he now headed. The principle of promotion by merit bequeathed to the French by the Revolution, and famously retained for officers in the *Grande armée* by Napoleon, had lost ground under the Restoration when membership in the appointed upper chamber of the legislature, the Chamber of Peers, was made hereditary. Under the July Monarchy, however, the meritocratic principle would regain its earlier ascendancy after the revised constitution eliminated hereditary peerships in 1831.[12] Once again, as during the republican phase of the Revolution, civic life in France replicated in all its institutions (with the telling exception of the succession to the throne) a meritocratic and egalitarian ethos, which had also been forced on all French families with regard to property. Ever since the Revolution, French parents had been required by law to divide most of their property equally among their children.[13] The restrictions imposed on married women by the Napoleonic Civil Code, which gave husbands control over their wives' property, guaranteed that this equality of opportunity remained a male prerogative. Thus, French society at large, whether engaged in civic or private affairs, preserved the cultural logic behind the fraternal metaphors of republican political culture. A republican logic presumed that individual merit would regulate competition for wealth and power among men who shared a civic concern for the common good. Louis-Philippe was himself a product of that social outlook and, at least in the first few years of the July Monarchy, its beneficiary.

Of course, once opposition to the policies of the new regime gave rise to an organized republican movement, whose leaders made common cause with legitimist supporters of the exiled Bourbons in attacking the new king and royal family, the cultural contradiction underlying a popularly chosen monarch came quickly to the fore.[14] In the first place, if personal merit had brought Louis-Philippe to the throne, the same merit was presumably required to preserve it; second, and more serious over the long run, a "meritocratic kingship" and the dynastic principle necessary to monarchy were logically inconsistent. All the same, for these contradictions to acquire the powerfully corrosive force that they developed over the course of Louis-Philippe's reign, another feature of French political discourse had to reshape public perceptions of the royal family. The solvent in this case involved the historically protean term *bourgeois*.

The Perils of a "Bourgeois" Royal Image

Almost immediately after the duc d'Orléans came to the throne, the sobriquet "bourgeois king" was launched. There exists no evidence that Louis-Philippe ever referred to himself that way, but at the outset of his reign, he would not have considered it offensive since *bourgeois* had two meanings at the time with which he could identify. As Sarah Maza has recently argued, leading liberal historians set the stage for the "bourgeoisie" to become a historical actor. François Guizot and Augustin Thierry each wrote histories during the Restoration that traced the distant origins of the Revolution to the town charters elicited from feudal overlords by bourgeois elites in the thirteenth century.[15] Five centuries later, according to these historians, their social heirs had overthrown absolutism and a privileged nobility in the Revolution to establish a liberal constitutional monarchy. The same social forces were now fighting off an aristocratic and clerical rearguard action. The duc d'Orléans identified himself with that liberal cause.

But the adjective *bourgeois* had another, domestic register for him and his contemporaries. Applied to this arena, it conjured up the image of a tightly knit family, bound by affection, reciprocal duties, and the attractions of home, whereas *aristocratic* presumed a familial style based on obedience and respect with spouses leading separate social lives.[16] The bourgeois version of marriage and the family had always been the centerpiece of Louis-Philippe's conception of a modern prince. One clue to understanding how the term *bourgeois* became a lightning rod for marshalling contempt for the July Monarchy in general, and for its monarch in particular, lies in its perceived connection with this particular style of family life, or so I am going to argue.

In making this argument, I intend to build upon Sarah Maza's provocative study, *The Myth of the Bourgeoisie*. Maza contends that once liberal historians had

fabricated a historical narrative that would give their purported bourgeoisie the starring role in the July Monarchy, opponents of the regime and its disillusioned supporters concocted a different version of this bourgeoisie as self-serving and morally corrupted philistines. I agree with her assessment. Furthermore, as imagined by the enemies of the regime, Louis-Philippe headed the list of worst offenders. However, my own account differs from Maza's in the way it locates the origins of this vicious so-called bourgeoisie in the political fantasies that imperiled the July Monarchy. Still locked in a struggle with Marx's version of events, Maza dismisses the existence of an actual bourgeoisie by repeating the now standard economists' argument about French economic retardation and the absence of a major sector of investment capital in the first half of the nineteenth century (hence no "bourgeoisie"). But the variety of occupations that caricaturists, novelists, and playwrights conjured up for public scorn in the July Monarchy ranged so widely across social and economic sectors, as so few professional or business types escaped their ridicule or bile, that historians may need to reconsider what contemporaries understood to be the source of egotism in the despised bourgeois whom satirists at the time so thoroughly mocked.[17]

My reading of the evidence lies closer to William Reddy's interpretation of the peculiarly conflicted position of journalists and government bureaucrats under the Restoration and July Monarchy, whose career ambitions placed them at odds with the ideal of public service in their own professions.[18] To earn a living for their families and public honors for themselves, journalists wrote for whichever of the several politically embattled newspapers would employ them; government bureaucrats relied on influence to secure appointments or suspected others of the same recourse. The moral ambiguities of their situation made men in both professions hypersensitive about their honor and suspicious of the motives of everybody else. In the political press, personal slander became the order of the day, while social satirists depicted the world of the propertied as saturated with egoism and ambition. What Reddy fails to mention, though it relates directly to the fate of Louis-Philippe's throne, was how this disenchantment repositioned families in relation to the public sphere.

By the 1830s, the sentimental family as imagined by Rousseau and promoted in the Revolution as the bedrock for the nation and a patriotic war had lost its raison d'être in public discourse. In the process, the sentimental family had slipped imaginatively from a school of patriotism into a realm suspected of promoting private interests and hiding secrets. As long as elite families managed to remain discreetly out of the public eye, individuals and not their families remained the object of slanderous attack and satire. But for a royal family, such invisibility was not an option. Therein lies the key, I think, to the curious fate

awaiting the duchesse d'Orléans as queen. Her much-admired domestic virtues helped place her husband on the throne, since Restoration liberals assumed a connection between affectionate parenting, a companionate marriage, and their own political views.[19] And yet those very virtues, once associated with a royal dynasty and the wife of an unpopular king, could only further undermine the monarchy.

The Sentimental Family of the Liberal Duc d'Orléans (1817–1830)

Marie-Amélie was not a queen like any other who had previously held that title in France.[20] She had lived in the country for a total of fourteen years before her husband's reign began, a length of time that made her seem less foreign than her predecessors. Nor had she and the duc d'Orléans ever resided in the royal palace. They had led their lives in ways that set them visibly apart from both the court and royal family throughout the Restoration Monarchy. As a result, the duchesse d'Orléans was only marginally distinguishable from other fashionable hostesses of Paris. Her and her husband's regular appearances as a couple strolling arm in arm under the arcades of the Palais Royal or through the Tuileries gardens advertised their companionate marriage. In a remarkable departure from French aristocratic practice, they had common sleeping quarters from the outset of their marriage; it held an unwieldy piece of furniture, designed for this shared pleasure, of which the couple was extremely proud and which many visitors saw. A broader spectrum of the Parisian populace would have noted in the style of education that they gave their children the other salient feature of their domesticity that advertised their liberal views.[21]

Both Marie-Amélie and Louis-Philippe placed the highest value on an excellent education, even for their daughters. All the children received a governor or governess to oversee their studies and moral development; and as the Restoration advanced, the Orléans' choice of tutors reflected ever more clearly the progressive views of this princely household. Frequently, Marie-Amélie led the children on educational excursions in the city. But of all the public displays of the education offered to their children, the most spectacularly novel came with the Orléans' joint decision to send their sons to the lycée, a step of which Louis XVIII strongly disapproved when the duc d'Orléans first announced his intention in 1819 but which the old king had to accept once the duchess indicated her support. This decision exposed the entire family to the consequences for their own reputation of the success or failure of their offspring. Each summer, at the end-of-year ceremonies, the Orléans sat with other anxious parents to watch their young accept some coveted award or endure the humiliation of receiving nothing. Marie-Amélie hung all the crowns that her sons received before and after

their father came to the throne on her dressing-table mirror in a classic gesture of maternal pride that also advertised the family's commitment to the principle of merit.

Representing the Family of the "Bourgeois King" in 1830

The efforts of printmakers to introduce the new royal family to the nation in 1830 captures something of the confusion over what a liberal monarchy born of revolution portended for the French. I have discovered eighteen different versions of such family portraits, a collection that, though representative, surely does not exhaust the extant record. For my purposes, the curiosity of these prints lies, above all, in the placement of the busts of individual family members in relation to each other. Popular prints depicting the restored Bourbon princely family circa 1814 had invariably positioned the men to reflect their proximity to the throne. When the Bourbons again reclaimed the throne after Napoleon's second overthrow in 1815, they insisted on a providential explanation for their return captured in this illustration of the royal family beneath a protective god and the souls of their own illustrious forebearers (see figure 15.1). Only the position of the duchesse d'Angoûlème, married to the nephew of Louis XVIII, varied from one print to another. By contrast, artists depicting the Orléans family circa 1830 placed their members in whatever order seemed appropriate to them.

One issue involved the placement of the king in relation to the queen, his sister, and his principal heir. Another was how to position the heir to the throne in relation to his siblings. In all of the clearly popular prints, Marie-Amélie and Adélaïde appeared on either side of Louis-Philippe, usually positioned beside and slightly below him but occasionally underneath. The only print in which the heir to the throne replaced his mother on the right side of the king was also artistically far superior to all the rest, suggesting both a higher purchase price and a well-off audience (see figure 15.2). This version of the royal family also placed Marie-Amélie, Adélaïde, and the king's second son, the duc de Nemours, who at sixteen already had a military command, on the same horizontal plane with the king and heir. In all respects except the position beside his father of the new duc d'Orléans (formerly the duc de Chartres), this portrait could pass for a republican-style family. All three unmarried daughters appear with their underage brothers on a different horizontal line above the five principals. The two oldest daughters—Louise and Marie, ages eighteen and seventeen, respectively, in 1830—figure in the center. The next oldest siblings—Clementine, age thirteen, and the duc de Joinville, age twelve—frame this line of busts on the far right and left, respectively. The two youngest brothers—Aumale and the duc de

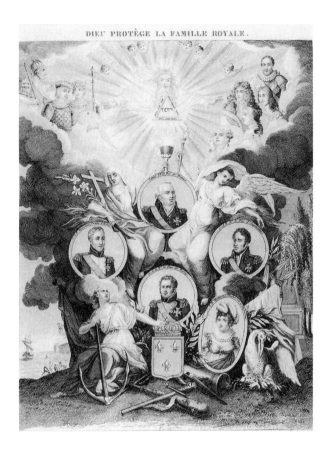

FIGURE 15.1.

"God Protects the Royal Family" (caption above image). "Let us
call all the people together and show them their King: Let them
come to his hands to renew their faith. Providentially recalled
from our erring ways, we renew our vows to him" (caption
below image). The kings represented in heaven are Charle-
magne, St. Louis, Louis XII, Henri IV, Louis XIII, Louis XIV, Louis
XV, Louis XVI, and the child Louis XVII. The members of the
royal family pictured in the medallions are Louis XVIII; his
brother, the comte d'Artois known as Monsieur; his two
nephews, the duc d'Angoûlème and the duc de Berry; and the
duchesse d'Angoûlème. D 197642, N 2 - fol. Portraits, Louis
XVIII (Roi de France) 2, Estampes, BNF.

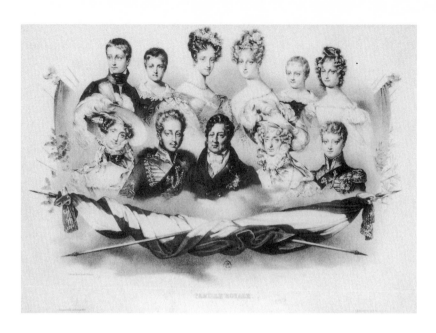

FIGURE 15.2.
The royal family of Louis-Philippe. D 198750, N 2 - fol. Portraits, Louis-Philippe I,
Roi de France (1), Estampes, BNF.

Montpensier, ages eight and six—appear protectively positioned between their
elder siblings. One might read this upper line of portraits as representing that
part of the family unrelated yet to public life, where age trumps sex in sorting
out the children's precedence in the family at the same time that everyone looks
out for its youngest members. Liberals and republicans alike would have recog-
nized and approved such a configuration.

Illustrations of the royal family aimed at a popular audience followed no con-
sistent pattern in positioning the Orléans children with regard to their relative
importance to the nation. Most but not all recognized the dynastic principle by
giving the new duc d'Orléans, whom the family always called Chartres, a clearly
central position in relation to his siblings, with Nemours also situated in a cen-
tral position. Some divided the children by a combination of age and sex, po-
sitioning the three eldest brothers on one horizontal plane, the three daughters
on another, and the two youngest boys either at the bottom of the image or at
the center of a family circle (see figure 15.3). Two of these images placed all
five brothers above the girls.[22] However, many of these versions of the royal
family did not separate the visual field allotted to the daughters and younger

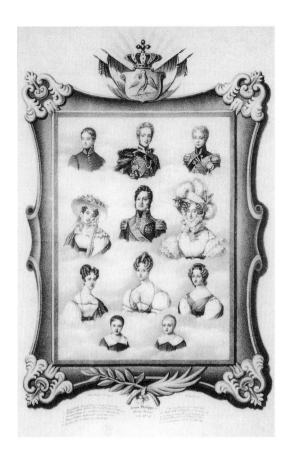

FIGURE 15.3.
Another vision of the royal family of Louis-Philippe. D
198711, N 2 - fol. Portraits, Louis-Philippe I, Roi de
France (1), Estampes, BNF.

children from where their uniformed brothers appeared.[23] Most intriguing of
all are the family portraits that gave Louise the central position beneath her par-
ents and her aunt. In one case an aesthetic choice may have determined this
placement, since the collage of medallions in this family portrait alternated male
and female busts in a balanced and attractive pattern.[24] The position of Louise
beside all five of her brothers in another print may have gestured toward a pos-
sible marriage for her with a foreign sovereign that would raise her potential
importance for the nation.[25] One curious image offers a sequence based on age
that managed all the same in its visual arrangement to sideline the heir to the
throne (see figure 15.4). The variety of family types captured in these family

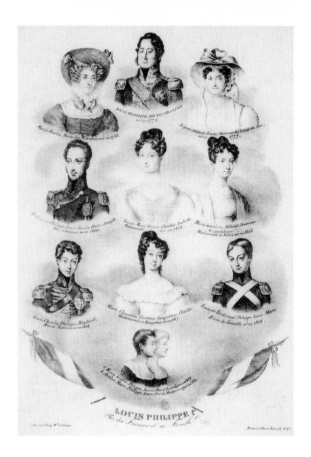

FIGURE 15.4.
Louis-Philippe I: The King of the French and his family. D
198678, N 2 - fol., Portraits, Louis-Philippe I, Roi de
France (1), Estampes, BNF.

portraits and the confusion they reflect about how various members might re-
late to public life visually record the uncertainty surrounding a liberal royal fam-
ily's position in postrevolutionary France.

The first popular prints presenting the "bourgeois" domesticity of the new
royal family gave special prominence to Marie-Amélie as mother. The best
known, because widely circulated and of superior quality, also contains a num-
ber of signals about how the new royal family would relate to public life (see fig-
ure 15.5). Although the scene is set outdoors to suggest the family's public func-
tion, the queen, wearing a hat, is nevertheless sitting in a chair beside a round
table that clearly gestures to her functions in the home. Little Montpensier, seated

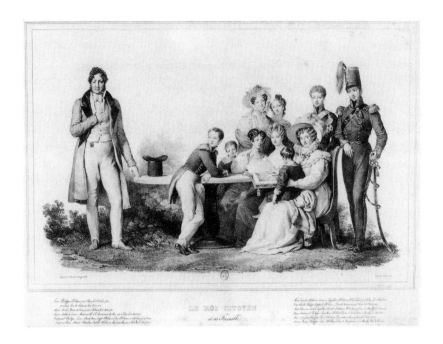

FIGURE I5.5.
"The Citizen King and His Family." Lithograph by Alexandre
Fragonard. Fol., Portraits, Louis Philippe I, Roi de France, Es-
tampes, BNF.

on her lap, is looking at an album that his mother has opened for her children's
and Adélaïde's entertainment and instruction. The round table and the album, to-
gether with the clustering of everyone around Marie-Amélie, reproduce the
imagined intimacy of the classic sentimental family. It also accurately depicted
the centrality of this particular mother in the royal household. Moreover, by po-
sitioning all five females inside a circle created by the placement of the sons, the
image subtly imitated the gendered social order of the July Monarchy while si-
multaneously indicating the present and future responsibilities of the princes, all
of whom would go into military service. The heir to the throne with his hand
on his sword is the only figure not looking directly at the viewer or at anyone else,
as if to signify his exalted future role. Placed in the center and dressed meaning-
fully here in the uniform of the citizens' national guard, Joinville directs atten-
tion by his gaze toward his father. Posed in street clothes as the citizen-king, with
his right hand on his heart as if vowing service to the nation, Louis-Philippe sets
his left hand lightly on the table that connects him and the hat he has removed
to the interior familial space of the nation presided over by its mothers. No

wonder some contemporaries looking at this engraving might have thought, at least initially, that this version of royalty could somehow magically transmogrify into "the best of republics," as Lafayette epigrammatically put it.[26]

Family Matters or National Concerns?

Of course, that this royal family might become indistinguishable over time from any other and, therefore, dispensable for the nation was an equally strong potentiality present in this image. But for that possibility to be realized, the regime's political enemies had to take advantage of the cultural contradictions in which the king and queen were trapped. The problem before them was how to forge a national identity in which their own family could stand for all French families, while at the same time meeting specific parental obligations within their household. Four principal tasks constituted their duties toward their own offspring that differed not at all from the concerns of other elite parents: to provide for the safety and comfort of the home, to launch their sons' careers, to ensure the future material welfare of each child, and to find appropriate spouses for them all. In pursuing each of these objectives, the king and queen strove as a matter of personal and family honor to make all familial decisions conform to the nation's interests, whatever personal sacrifice doing so might entail for them. The task set by their political opponents, not surprisingly, was to stop the public from perceiving any national interest in the royal family's personal and, therefore, selfish interest. Their stated objective was to expose hypocrisy, and their favorite weapon was satirical exaggeration.

From the very beginning of the monarchy, the funding of the royal family brought the contradictions between monarchy and the familial culture inherited from the Revolution into sharp relief in a way that opened the new king to the charge of greed. Over the course of the Restoration Monarchy, Louis-Philippe had gradually paid off the family's enormous debts and amassed a private fortune, by 1830 reputedly the largest in France. Having suffered from penury himself during his long political exile, he was extremely leery of preparing a similar fate for his own children. Should the new monarchy meet the fate of the Restoration Monarchy, they would most surely lose any legal claim on the property of the state, as the Bourbons had discovered. Therefore, the day before accepting the throne, Louis-Philippe put all his private property into a trust to be divided equally at his death among his seven youngest children while reserving the revenues from the trust for himself. He intended to spend this income on projects in the national interest—an honorable plan, if one accepted his own definition of what served the nation's interest, which his political enemies certainly did not.

The opportunity to smear Louis-Philippe's reputation with the charge of greed came early in the regime with his demand for a civil list of eighteen million francs, which was six million less than what Charles X had received but six million more than what the legislature eventually agreed to give him. A second test of wills occurred over which properties within the former Orléans *apanage* would be included in the new king's royal patrimony.[27] But the most serious disagreements involved providing for the new king and queen's numerous children. Louis-Philippe had deliberately excluded his dynastic heir from the family trust since, like the king, the young duc d'Orléans had an official position in the nation that required compensation, an argument that the Chamber of Deputies accepted. The difficulty arose over dowers and dowries for his younger brothers and sisters when they married into foreign ruling families. Should their father provide these payments, or should the state? The answer depended on answers to two other questions. Would these dynastic marriages promote the nation's interests, as the king and queen believed? Or were they private contracts between two families that had no bearing on national concerns? Satirists leapt gleefully into the fray. In caricatures and polemical pamphlets, the "King of the French" would step out from behind his glorious title to become just another *père de famille*, out to enrich himself and his family—in this case, at the expense of the nation (see figure 15.6).

The Queen's Vulnerable Position

Initially, the queen escaped the poisoning effects of this satire. Her reluctance in July 1830 to forsake domestic tranquillity and supplant the Bourbons on the throne was well known in high political circles. The legitimist paper *La Mode* even sharpened its attacks on the king and his sister by using the queen as a convenient foil. Her own guarded manner helped temporarily to preserve her from attack, since she conscientiously avoided commenting on nearly all political matters. Behind closed doors she served as political confidant to her older children and sometimes for her husband as well, but her official image touted a certain humane political neutrality and her charity. To that end, a famous painting by Nicolas Gosse, reproduced as a print and placed eventually in the museum at Versailles, recorded her visit to a makeshift hospital after the July Revolution to comfort victims from both sides of the bloody battles.[28] Moreover, her initial popularity made her presence as spectator for the king's review of the National Guard and Army on the anniversary of the July Revolution not only necessary to that event but even prominent in visual recordings of it.[29]

With the arrest of the duchesse de Berry in November 1832, following her failed legitimist insurrection the preceding spring, satirists finally turned their

FIGURE 15.6.
"An impoverished father of a family who has only several millions
in revenues." Lithograph, artist unknown. *Le Charivari*, série poli-
tique, no. 129 (November 10, 1833). A 19513, Estampes, BNF.

mockery on the queen, but then it was no wonder. The family rivalries went deep.
Not only were the two women rival royal mothers for their respective dynastic
parties, but Marie-Amélie was Marie-Caroline's aunt. She had even helped raise
her headstrong niece in Sicily after Marie-Caroline's mother died. Temperamen-
tally poles apart, the two women had never been close. Now Louis-Philippe's gov-

ernment had turned the intrepid and still young Bourbon mother into a perfect martyr for the legitimist cause—until, of course, her rumored pregnancy turned out to be true. Still, the dishonor splashed against all parties to the scandal. An editorial in the republican *Le Charivari* calmly pointed out that the simplest grocer would not expose a woman in his family to such public ignominy. Under these particular circumstances, the queen could hardly avoid the line of fire, no matter how profound her own chagrin.

The initial volley appeared in *La Caricature* on November 15, 1832, with a lithograph mocking a reception at court by representing everyone in the shape of a pear (see figure 15.7).[30] The commentary accompanying the lithograph identified the pear on "the left of the principal fruit" as "the pear from Naples." Even without that comment, the pear's skinny stem and feathered hat signaled Marie-Amélie, who was uncommonly thin and often appeared in popular prints in a feathered bonnet. On December 20, *La Caricature* offered its readers the more ominous spectacle of eleven tombs in front of an altar, unmistakably sized and positioned to hold the royal family.[31] Avarice, once imputed only to the king, now also found its targets in the entire royal family. One particularly successful caricature published in July 1833 pictured a giant rotting pear sliced open to reveal the royal family huddled around a treasure where the pear's seeds should have been, offering a perfect allegory for the familial culture that the Pear King's own avarice had wrought.[32] The same week, *Le Charivari* reversed the violence directed at the royals by turning them into a many-headed monster with their tongues outstretched, railing at the public with their lies. Although Marie-Amélie's face appeared on the underbelly of the beast in a nightcap with her eyes and mouth closed, her presence at the center of this ferocious creature with its five other Orléans heads made her a party to their collective crimes (see figure 15.8).

By the end of 1833, this onslaught against the entire family had subsided. The last caricature to include the queen appeared in November 1833.[33] It mocked the royal family's supposed efforts to place their younger sons on foreign thrones, either directly or through an advantageous marriage, a policy that the king actually eschewed in the 1830s to avoid antagonizing other great powers. A decade later, however, such suspicions would revive to deadly political effect when Montpensier's marriage in 1844 to the younger sister of the heiress to the Spanish throne, at the same time as her older sister married a Spanish Bourbon likely to prove impotent, touched off a major diplomatic crisis with the English. Once again Marie-Amélie's blood relations complicated the issue, since the mother of the Spanish princesses was another of her Sicilian nieces (in this instance, one who had remained close to the Orléans family). All Louis-Philippe's efforts to disentangle family interest from national interest in the ensuing debates

FIGURE 15.7.
"Reception." Lithograph by Jean Ignace Grandville and Eugène
Hippolyte Forest. *La Caricature*, no. 106 (November 15, 1832):
pl. 219. A 14344, Estampes, BNF.

over the diplomatic damage of the Spanish marriages proved unavailing. Given
rampant Anglophobia in France, he had expected public approval for blocking
the British government's candidate, a Coburg relative of Queen Victoria, from
marrying into a Bourbon royal stronghold. His political opponents easily turned
the whole affair into another tale of familial ambition in disguise.

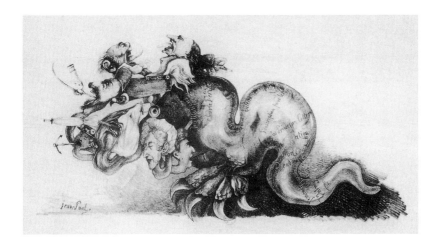

FIGURE 15.8.
" 'The Hydra of Anarchy.' There is no serpent, no odious mon-
ster, who cannot please the eye through the art of imitation."
Accompanying commentary: "The heads of this monster are,
for the most part, identifiable by their symbolic tongues: the
duc d'Orléans with his large saber and his cannon, the prince de
Joinville, by his marine anchor, Louis-Philippe by his umbrella
and the duc de Nemours by his lance. One recognizes other
heads as well, that of Marie-Amélie beside her husband and the
princesse Adélaïde above the duc d'Orléans" (column 4). Litho-
graph by Jean-Paul. *Le Charivari*, série politique (July 3, 1833):
pl. 55. A 14357, Estampes, BNF.

Public skepticism ought not to have surprised the king, considering how royal
domesticity had fared in the satirical press in the 1830s. Even after caricaturists
had stopped attacking the queen directly, allusions to the king's familial inter-
ests remained a mainstay of political satire. In signature caricatures of the king
from 1833 to 1835, Daumier invariably placed a nightcap on the royal head and
an accountant's visor on his brow to mock royal domesticity and the king's pre-
sumed attention to his own account books (see figure 15.9). One such litho-
graph produced in the summer of 1835 would turn the king into a barbarian
tyrant grasping the constitution in one hand and a club in the other as the
always-present nightcap slipped down over his eyes (see figure 15.10). This car-
icature, which attacked pending laws imposing censorship, explicitly linked the
abuse of public power with the king's domestic life and hence to family inter-
ests. It was the last of Daumier's satirical images to target the king directly until
the monarchy's overthrow in 1848.

FIGURE 15.9.
"Where are we headed, where are we headed? We're walking on the top of a volcano, the abyss of revolution opens under our feet . . . the ship of state has been halted by the torrent of malicious passions." Lithograph by Daumier. *La Caricature*, no. 203 (September 25, 1834): 425. Property of the author.

Republican Satire of Bourgeois Domesticity

Despite censorship, the visual keys and satirical themes that Daumier and his fellow artists had developed in their political satire continued to challenge the regime. Now, however, they targeted self-important, self-serving, hypocritical, or simply ludicrous men and women of property in varied occupations and domestic settings. A few examples of the genre will suffice to make the point. One of them, titled "Shared Honors," by the forgotten artist Jacot, carried as its caption "A *parvenu* decorated with the Legion of Honor strolls in the Tuileries gardens with his stupidly proud wife on his arm and salutes a soldier who, from his

FIGURE 15.10.
"France represented constitutionally" (caption at the bottom).
The caption printed upside down at the top of the image reads
"BALANCE OF POWERS." Lithograph by Daumier. QB1 1835
(January–December) M112566, Estampes, BNF.

FIGURE 15.11.
"Shared Honors." Lithograph by Jacot. *Galerie Pittoresque*, produced
between 1839 and 1840, plate 102. A 19575, Estampes, BNF.

sentry box, presents arms to him" (see figure 15.11). The family resemblance
with earlier satirical images of the king and queen requires little comment. The
sharp-nosed, skinny wife and the large umbrella, robust body, and sideburns of
the besotted parvenu fairly jump from the page in a blatant commentary, how-
ever implicitly projected, on Louis-Philippe's regime. Meanwhile, Daumier's fer-
tile satirical pen found numerous venues for ridiculing the besotted "bourgeois
couple," including the double bed. Illustrations in his series of caricatures titled
"Conjugal Mores" included several bedroom scenes. In one, a husband berates
his wife, who has uttered her lover's name while dreaming. Another depicts a
sleeping couple, cat, and infant at midnight enjoying "a momentary peace, bet-
ter late than never." A third depicts the saccharine birthday of "papa," crowned
with a ring of flowers over his nightcap as his son recites a poem clearly not of
his own making.[34] Given such relentless laughter around the sentimental family,
it became more difficult than ever to make royal domesticity visible with any
hope of dignity and emotional resonance with the public.

RÉPUBLIQUE FRANÇAISE

PARIS LE 24 FÉVRIER A 2 HEURES.

Vaincu: Le Peuple eût été sacrifié!!
Vainqueur: LE PEUPLE A PARDONNÉ!!

PARIS EL 24 DE FEBRERO A LAS 2 DE LA TARDE.

Vencido:...El Pueblo se hubiera visto sacrificado!!
Vencedor: EL PUEBLO HA PERDONADO!!

FIGURE 15.12.
" 'French Republic.' Paris, February 24 at two o'clock. The van-
quished: The people would have been sacrificed!! Victorious:
THE PEOPLE HAVE PARDONED!!" Lithograph, artist unknown.
Property of the author.

The satirical culture that pervaded public life during the July Monarchy cre-
ated a dialectic of opposing social images still more fatal for the regime. With
its production of a "mythic bourgeoisie" engrossed in its own selfish interests
that stretched vertically from the king and queen down to the lowly grocer and
his wife, social satire in all its forms—whether in caricatures, in the theater, or
in novels—set the stage for the development of a countering mythic figure of
the "virtuous people" in the political imaginary of republicans. Whereas the
term bourgeois presupposed individual families like the Orléans with interests sep-
arate from the nation, le peuple, imagined as one virtuous collective, could mir-
ror the country's interests.

For the final act of this political melodrama, the roles assigned to the queen
in caricatures was entirely predictable, if instructive nonetheless. Most satirists
simply ignored her in recounting the February Revolution of 1848. However, in
satirical images of the king's departure from the Tuileries palace, she generally

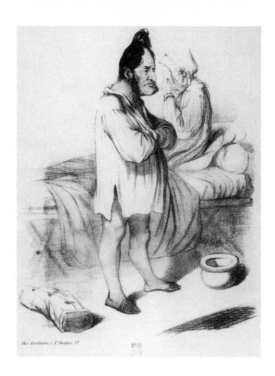

FIGURE 15.13.
" 'The Morning after February 25.' They say that if I
had wanted the reform! . . . I would not have been
reformed! . . . You can weep, Madame. The Republic
has been proclaimed, but the people will not weep."
Lithograph, artist unknown, no. 12. P 315.27, Es-
tampes, BNF.

appeared behind a hanky sobbing over the calamity.[35] In one caricature, this iconic
image of wifely despair made her a perfect foil for a dishonorable ex-king who
climbed ungraciously into a carriage ahead of her while victorious and decidedly
virtuous men of the people ignored them both (see figure 15.12). Another and
particularly pointed satirical record of the royal family on the run placed the
weeping Marie-Amélie in a miserable, fold-up double bed as Louis-Philippe paced
beside her in his nightshirt, rehashing their personal debacle (see figure 15.13).

While building on Sarah Maza's suggestive insights into the selfish image of the
bourgeoisie under the July Monarchy, the argument presented here locates its
origins not in capitalism, where Marx would place it, but in the imagined rela-

tion of the family to the nation in postrevolutionary France. Beginning in 1792, republican festivals, rhetoric, and symbolic imagery had created a powerful imagined version of the French nation in which the sentimental, patriotic family was to be the moral bedrock for a public-spirited outlook in its citizenry. The Orléans shared that vision of the nation. They also believed that if their sons demonstrated by their accolades in school and their daring as military officers that they merited the honors they received, they could overcome the contradictions between a monarchy and this fundamentally republican version of the nation. Queen Marie-Amélie held a particularly delicate position in this dubious project, since there existed no place for women in the cité outside their familial roles as wives and mothers. So how could she represent anything more to the French than her own family's place in public life? Once republican polemicists created a mirror image of the royal family, headed by the philistine, self-serving "bourgeois" who looked out for himself and kin alone, her own loving and attentive version of a royal wife and mother could only achieve the opposite of its intended political effect.

Notes

1. Lacqueur 1982; Hunt 1992; Goodman 2003; T. Kaiser 2006.

2. For examples of politically successful sentimentalized royal women in the eighteenth and nineteenth centuries, see Margadant 2000; Colley 1992, pp. 273–281; Homans 1998.

3. Lozachmeur 1995; comtesse de Paris 1998.

4. For an overview of French queens from the fifteenth century to the Revolution, see Norberg 2004.

5. Hanley 1997; Taylor 2006.

6. Louis-Philippe 1977; Castillon du Perron 1963.

7. Hunt 1992; Maza 1993; Darnton 1984.

8. Louis-Philippe's unpublished memoirs, 1793–94, AN, 300 AP III 11, 300 AP III 12.

9. Louis-Philippe's personal papers, AN, 300 AP 13, 300 AP 14.

10. Perrot 1990; Mainardi 2003.

11. Margadant 1999.

12. Napoleon's Senate and the Chamber of Peers under the Restoration Monarchy were both hereditary, though if an heir's personal wealth fell below a stipulated amount, he became ineligible.

13. Desan 2004.

14. Collingham 1988; Furet 1988, pp. 326–84.

15. Maza 2003, pp. 131–60.

16. Adams 2000; Perrot 1990, pp. 131–35.

17. Cuno 1992; Kenney and Merriman 1991; Petrey 2005; Chu and Weisberg 1994; Margadant 1999.

18. Reddy 1997, pp. 114–227.

19. Perrot 1990, pp. 134–35.

20. Marie-Amélie 1981; Imbert de Saint-Amand 1891–94. I have relied for my interpretation of Marie-Amélie and Louis-Philippe on their vast personal correspondence (AN, 300 AP III, 300 AP IV).

21. Martin-Fugier 1992.

22. See D 198713, N 2 - fol. Portraits, Louis Philippe I, Roi de France (1); D 198710, Estampes, BNF.

23. D 198827, N 2 - fol., Portraits Louis Philippe I, Roi de France (1), vol. 1119, Estampes, BNF.

24. D198779, N 2 - fol., Portraits, Louis Philippe I, Roi de France (1), Estampes, BNF.

25. D 198701, N 2 - fol., Portraits, Louis Philippe I, Roi de France (1), Estampes, BNF.

26. The *Moniteur Universel* (August 8, 1830) attributed this remark to General Lafayette during his interview with the duc d'Orléans on August 1, 1830. However, Louis Blanc attributed the remark to Odilon Barrot in response to republicans at the Hôtel de Ville on July 30, 1830 (Blanc 1841–44, 1:347).

27. An *apanage* consisted of the royal estates and manors assigned to princes for their personal use and livelihood. The July Monarchy eliminated *apanages*.

28. "Her Majesty the Queen of the French visiting the wounded men of July at the Field Hospital of the Stock Exchange (25 August 1830)." Painting by Nicolas Gosse; engraving by Nargeot (Diagraphe et Pantographe Gavard). Property of author.

29. E.g., see QB1 M111211, Estampes, BNF.

30. For the history of the "pear" caricature, see Petrey 2005, pp. 1–36.

31. "Requiescant in pace amen!!" Lithograph, artist unknown, *La Caricature*, no. 124 (December 20, 1832). A 14368, Estampes, BNF.

32. "The Pear and Its Seeds." Design by Auguste Bouquet, lithograph by Becquet, *La Caricature*, no. 139 (July 4, 1833): pl. 289.

33. "A Little Throne If You Please." Lithograph, Benjamin Roubaud, *La Caricature*, série politique 156 (November 1833). QB1 1833 M112409, Estampes, BNF.

34. "Conjugal Mores," in Daumier 1968, nos. 44, 29, 4.

35. E.g., see "February 24," engraving by Cabasson and Lechard, P 31512, Estampes, BNF; "Fuite de Louis Philippe le 24 Février 1848" (Paris: Imprimerie de Mangeon), property of the author.

BIBLIOGRAPHY

A.N. See Archives Nationales.

AAE. See Arkheograficheskaia kommissiia 1836.

Adams, Christine. 2000. *A Taste for Comfort and Status: A Bourgeois Family in Eighteenth-Century France*. University Park: Pennsylvania State University Press.

Adams, John. 1823.*Remarks on the Country Extending from Cape Palmas to the River Congo*. London: G. and W. B. Whittaker.

Adams, Richard Edward Wood. 1974. "Trial Estimation of Classic Maya Palace Populations at Uaxactun." In *Mesoamerican Archaeology: New Approaches*, ed. Norman Hammond, pp. 285–96. London: Duckworth.

Adat Raja-Raja Melayu. 1983. Ed. Panuti H. M. Sudjiman. Jakarta: University of Indonesia Press.

AI. See Arkheograficheskaia kommissiia 1841–42.

Aʿin-i Akbari. [1927–49] 1993. Ed. Henry Blochmann. Trans. H. S. Jarrett, further corrected by Sir Jadu-Nath Sarkar. 3 vols. New Delhi: Low Price Publications.

Aʿin-i Akbari by Abul Fazl-I-ʿAllami. 1872–77 Persian text, ed. Henry Blochmann. 3 vols. Calcutta: Printed by C. B. Lewis at the Baptist Mission Press. Cited as *Persian Aʿin*.

Akbarnama of Abu-l-Fazl. [1902–39] 1993. Trans. H. Beveridge. 3 vols. New Delhi: Low Price Publications.

Akbarnamah by Abul-Fazl I Mubarak I ʿAllami. 1873–86. Persian text, ed. Maulawi ʿAbdur-Rahim. 3 vols. Calcutta: Asiatic Society.

Alberi, Eugenio. 1840–55. *Relazioni degli Ambasciatori veneti al Senato.* Series 3, 3 vols. Florence: Società editrice fiorentina [etc.].

Andaya, Barbara Watson. 1979. *Perak, the Abode of Grace: A Study of an Eighteenth-Century Malay State.* Kuala Lumpur: Oxford University Press.

————. 1993. *To Live as Brothers: Southeast Sumatra in the Seventeenth and Eighteenth Centuries.* University of Hawai'i Press.

————.2000. "Delineating Female Space." In *Other Pasts: Women, Gender and History in Early Modern Southeast Asia,* ed. Barbara Watson Andaya, pp. 231–53. Honolulu: Center for Southeast Asia Studies.

————.2002. "Localising the Universal: Women, Motherhood and the Appeal of Early Theravada Buddhism." *Journal of Southeast Asian Studies* 33.1 (February): 1–30.

————.2006. *The Flaming Womb: Repositioning Women in Early Modern Southeast Asia.* Honolulu: University of Hawai'i Press.

Andaya, Leonard Y. 1975. *The Kingdom of Johor, 1641–1728: Economic and Political Developments.* Kuala Lumpur: Oxford University Press.

————.2004. " 'A Very Good-Natured yet Awe-Inspiring Government': The Reign of Sultana Taj al-Alam of Aceh (1641–75)." In *Hof en Handel: Aziatische Vorsten en de VOC 1620–1720,* ed. Pieter Rietbergen and Elsbeth Locher-Scholten, pp. 59–84. Leiden: KITLV Press.

Antonetti, Guy. 1994. *Louis-Philippe.* Paris: Fayard.

Aram, Bethany. 2005. *Juana the Mad: Sovereignty and Dynasty in Renaissance Europe.* Baltimore: Johns Hopkins University Press.

Archives Nationales, Archives de France. Paris.

Arkheograficheskaia kommissiia, ed. 1836.*Akty sobrannye v bibliotekakh i arkhivakh Rossiiskoi Imperii Arkheograficheskoiu ekspeditsieiu.* 4 vols. St. Petersburg: Tipografiia II otdeleniia sobstvennoi e. i. v. kantseliarii. Cited as *AAE.*

————, ed. 1841–42. *Akty istoricheskie sobrannye i izdannye Arkheograficheskoiu kommissieiu.* 5 vols. St. Petersburg. Cited as *AI.*

————, ed. 1848.*Pis'ma russkikh gosudarei i drugikh osob tsarskago semeistva.* Vol. 1. Moscow: Universitetskaia tipografiia. Cited as *Pis'ma russkikh gosudarei.*

————, ed. 1872–1927. *Russkaia istoricheskaia biblioteka.* 39 vols. St. Petersburg-Leningrad. Cited as *RIB.*

Arvey, Margaret. 1988. "Women of Ill-repute in the Florentine Codex." In *The Role of Gender in Precolumbian Art and Architecture,* ed. Virginia E. Miller, 179–97. Lanham, Md.: University Press of America.

Babad Tanah Djawi in proza, Javaansche geschiedenis loopende tot het jaar 1647 der Javaansche jaartelling. 1941. Trans. W. L. Olthof. The Hague: Koninklijk Instituut voor de Taal, Land en Volkenkunde van Ned.-Indië/J. J. Meinsma.

Baecque, Antoine de. 1997. *The Body Politic, Corporeal Metaphors in Revolutionary France, 1779–1800*. Trans. Charlotte Mandell. Stanford: Stanford University Press.

Balfour-Paul, Jenny. 1997. *Indigo in the Arab World*. Richmond, Surrey: Curzon.

Barkan, Ö. L. 1966. "Edirne Askeri Kassamï_na Ait Tereke Defterleri (1545–1659)." *Belgeler* III: 1–479.

Barozzi, Nicoló, and Giglielmo Berchet, eds. 1871–72. *Le relazioni degli stati Europei*. Series 5, *Turchia*. 2 vols. Venice: Società editrice.

Barrow, John. [1806] 1975. *A Voyage to Cochinchina*. Kuala Lumpur: Oxford University Press.

Baudier, Michel. 1631. *Histoire généralle de Serail, et de la cour de Grand Seigneur, empereur des Turcs*. Paris.

Bay, Edna. 1998. *Wives of the Leopard: Gender, Politics, and Culture in the Kingdom of Dahomey*. Charlottesville: University of Virginia Press.

Beeckman, Daniel. [1718] 1973. *A Voyage to and from the Isle of Borneo*. London: Dawsons.

Begunov, Iu. K. 1970. "Povest' o vtorom brake Vasiliia III." *Trudy otdela drevnerusskoi literatury (TODRL)* 25: 105–18.

Bekker, I., ed. 1838. *Theophanes Continuatus; Ioannes Cameniata; Symeon Magister; Georgius Monachus*. Bonn: E. Weber.

Bell, Ellen E. 2002. "Engendering a Dynasty: A Royal Woman in the Margarita Tomb, Copan." In *Ancient Maya Women*, ed. Traci Ardren, pp. 89–104. Walnut Creek, Calif.: AltaMira Press.

Ben-Amos, Paula. 1978. "Owina N'Ido: Royal Weavers of Benin." *African Arts* 11: 48–53, 95–96.

Berdan, Frances F. "Cotton." 2001.In *Archaeology of Ancient Mexico and Central America: An Encyclopedia*, ed. Susan Toby Evans and David L. Webster, pp. 184–85. New York: Garland.

Berednikov, Iakov, ed. 1829. "Pis'ma chetvertoi suprugi Tsaria Ioanna Vasil'evicha Groznago k Boiarinu Saltykovu." *Syn otechestva i severnyi arkhiv* 5, no. 27, sec. 2: 333–46.

Berry, Lloyd E., and Robert O. Crummey, eds. 1968. *Rude and Barbarous Kingdom: Russia in the Accounts of Sixteenth-Century English Voyagers*. Madison: University of Wisconsin Press.

Bertière, Simone. 1998. *Les femmes du roi soleil*. Vol. 3 of *Les reines de France au temps des Bourbons*. Paris: Editions de Fallois.

———. 2000. *La reine et la favorite*. Vol. 2 of *Les reines de France au temps des Bourbons*. Paris: Editions de Fallois.

Besongne, Nicolas. 1672. *L'Etat de la France*. Paris.

―――. 1699. *L'Etat de la France*. Paris.

―――. 1736. *L'Etat de la France*. Paris.

Beveridge, Annette S., trans. [1902] 1994. *The History of Humayun: Humayun-Nama by Gul-Badan Begam*. Delhi: Low Price Publications.

Bibliotèque Nationale de France, Paris.

Blanc, Louis. 1841–44. *Révolution française: Histoire de dix ans, 1830–1840*. 5 vols. Paris: Pagnerre.

Bluche, François. 1958. *Les honneurs de la cour*. 2 vols. Paris: Les Cahiers nobles (Imprimerie du Chateau d'Eau).

―――. 1990. *Dictionaire du grand siècle*. Paris: Fayard.

BNF. See Bibliotèque Nationale de France.

Bossler, Beverly. 2002. "Shifting Identities: Courtesans and Literati in Song China." *Harvard Journal of Asiatic Studies* 62.1 (June): 5–37.

Boucher, Jacqueline. 1982. "Evolution de la maison du roi des derniers Valois au premiers Bourbons." *XVIIe siècle* 34: 359–80.

Bouhdiba, Abdul Wahab. 1985. *Sexuality in Islam*. Trans. Alan Sheridan. London: Routledge and Kegan Paul.

Bowrey, Thomas. 1905. *A Geographical Account of Countries Round the Bay of Bengal, 1669 to 1679*. Ed. Richard Carnac Temple. Cambridge: Hakluyt Society.

Bradbury, R. E. 1973. *Benin Studies*. Ed. Peter Morton-Williams. London: Oxford University Press.

Bristowe, William S. 1976. *Louis and the King of Siam*. London: Chatto and Windus.

Brunnert, H. S., and V. V. Hagelstrom. [1912] 1963. *Present Day Political Organization of China*. Trans. A. Beltchenko and E. E. Moran. Taipei: World Book.

Brunschvig, R. "ʿAbd." 1960. In *Encyclopedia of Islam*, 1:24–40. 2nd ed. Leiden: E. J. Brill; London: Luzac. Available at www.brillonline.nl/public.

Bryant, Mark. 2004. "Partner, Matriarch and Minister: Mme de Maintenon of France, Clandestine Consort, 1680–1715." In *Queenship in Europe, 1660–1815: The Role of the Consort*, ed. Clarissa Campbell Orr, pp. 77–107. Cambridge: Cambridge University Press.

Byfield, Judith. 2002. *The Bluest Hands: A Social and Economic History of Women Dyers in Abeokuta (Nigeria), 1890–1940*. Oxford: James Curry.

Cadière, L. 1916. "Les Funérailles de Thieu-Tri d'Après Mgr. Pellerin." *Bulletin des Amis du Vieux Hué* 3.1 (January–March): 91–103.

Campan, Madame (Jeanne-Louise-Henriette). 1895. *Memoirs of the Court of Marie Antoinette*. Ed. Alfred Rayney Waller. 2 vols. London: H. S. Nichols.

Campbell, Peter Robert. 1996. *Power and Politics in Old Regime France*. London: Routledge.

Campo, Juan Eduardo. 1991. *The Other Sides of Paradise: Explorations into the Religious Meanings of Domestic Space in Islam*. Columbia: University of South Carolina Press.

Cannadine, David. 1985. "Splendor out of Court: Royal Spectacle and Pageantry in Modern Britain, c. 1820–1977." In *Rites of Power: Symbolism, Ritual, and Politics Since the Middle Ages*, ed. Sean Wilentz, pp. 206–33. Philadelphia: University of Pennsylvania Press.

Capon, Gaston. 1907.*La vie privée du Prince de Conty*. Paris: J. Schemit.

Carey, Peter, ed. 1980. *The Archives of Yogyakarta*. Vol. 1, *Documents Relating to Political and Internal Court Affairs, 1792–1819*. London: Oxford University Press for the British Academy.

———, ed. 1992. *The British in Java, 1811–1816: A Javanese Account*. London: Oxford University Press for the British Academy.

Carey, Peter, and Vincent Houben. 1992. "Spirited Srikandis and Sly Sumbadras: The Social Political and Economic Role of Women at the Central Javanese Courts in the 18th and Early 19th Centuries." In *Indonesian Women in Focus: Past and Present Notions*, ed. Elsbeth Locher-Scholten and Anke Niehof, pp. 12–42. Leiden: KITLV Press.

Carmack, Robert M., Janine Gasco, and Gary Gossen, [eds.]. 1996. *The Legacy of Mesoamerica: History and Culture of a Native American Civilization*. Upper Saddle River, N.J.: Prentice Hall.

Carrasco, Pedro. 1997. "Indian-Spanish Marriages in the First Century of the Colony." In *Indian Women of Early Mexico*, ed. Susan Schroeder, Stephanie Wood, and Robert Haskett, pp. 87–103. Norman: University of Oklahoma Press.

Castillon du Perron, Marguerite. 1963. *Louis-Philippe et la Revolution française: Le Prince*. Paris: Perrin.

CB. See Li Tao 1979–90.

Chaffee, John. 2001. "The Rise and Regency of Empress Liu (969–1033)." *Journal of Song-Yuan Studies* 31: 1–25.

Chakrabongse, Prince Chula. 1960. *Lords of Life: The Paternal Monarchy of Bangkok, 1782–1932*. New York: Taplinger.

Changsŏgak tosŏ Han'gukp'an ch'ongmongnok. 1972. Seoul: Changsŏgak.

Charlton, Thomas H. 1986. "Socioeconomic Dimensions of Urban-Rural Relations in the Colonial Period Basin of Mexico." In *Ethnohistory*, ed. Ronald Spores, pp. 122–33. Vol. 4 of *Supplement to the Handbook of Middle American Indians*, ed. V. R. Bricker. Austin: University of Texas Press.

Chateaubriand, François René, vicomte de. [1848–50] 1946. *Mémoires d'outre-tombe*. 2 vols. Paris: Gallimard.

Chaussinand-Nogaret, Guy. 1990. *La vie quotidienne des femmes du roi d'Agnès Sorel à Marie-Antoinette*. Paris: Hachette.

Choisy, Abbé de. 1963. *Journal of a Voyage to Siam, 1685–1686*. Ed. and trans. Michael Smithies. Kuala Lumpur: Oxford University Press.

Chŏng Chaeryun. N.d. "Kongsa kyŏnmunnok." MS, Asami Library of Korean Literature, University of California, Berkeley.

Chosŏn wangjo sillok. 1955–63. 49 vols. Seoul: Kuksa p'yŏnch'an wiwŏnhoe.

Chou Ta-kuan. 1967. *Notes on the Customs of Cambodia*. Translated from the French version of Paul Pelliot by J. Gilman D'Arcy Paul. Bangkok: Social Science Association Press.

Chu, Petra ten-Doesschate, and Gabriel P. Weisberg, eds. 1994. *The Popularization of Images: Visual Culture under the July Monarchy*. Princeton: Princeton University Press.

Chung, Priscilla Ching. 1981. *Palace Women in the Northern Sung*. Leiden: E. J. Brill.

Clark, Andrew F. 1990. " 'The ties that bind': Servility and Dependency among the Fulbe of Bundu (Senegambia) circa 1930s to 1980s." Draft paper, Department of History, University of North Carolina, Wilmington.

———. 1999. *Economy and Society in the Upper Senegal Valley, West Africa, 1850–1920*. Lanham, Md.: University Press of America.

Codex Mendoza. [ca. 1541–42] 1992. Volume 3, *A Facsimile Reproduction of "Codex Mendoza."* Ed. Frances F. Berdan and Patricia Rieff Anawalt. Berkeley: University of California Press.

Colley, Linda. 1992. *Britons: Forging the Nation, 1707–1837*. New Haven: Yale University Press.

Collingham, H. A. C. 1988. *The July Monarchy: A Political History of France, 1830–1848*. London: Longman.

Connah, Graham. 1972. "Archaeology in Benin." *Journal of African History* 13.1: 25–38.

———. 1975. *The Archaeology of Benin*. Oxford: Clarendon Press.

Constantine VII Porphyrogenitus. 1829–30. *Constantini Porphyrogeniti Imperatoris De Ceremoniis Aulae Byzantinae libri duo*. Ed. J. J. Reiske. 2 vols. Bonn: Weber. Cited as *De Cer.*

Cooke, Nola. 2004. "Expectations and Transactions: Local Responses to Catholicism in Seventeenth-Century Nguyen Cochinchina (Đàng Trong)." Paper presented at 18th Conference of the International Association of Historians of Asia, Taipei, December 6–10.

Cooper, Barbara. 1997. *Marriage in Maradi: Gender and Culture in a Hausa Society in Niger, 1900–1989*. Portsmouth, N.H.: Heinemann.

Corfield, Justin, and Ian Morson, eds. 2001. *British Sea-Captain Alexander Hamilton's "A New Account of the East Indies" (17th–18th Century)*. Lewiston, N.Y.: Edwin Mellen Press.

Correia-Afonso, John, ed. 1980. *Letters from the Mughal Court: The First Jesuit Mission to Akbar, 1580–1583*. Bombay: Heras Institute of Indian History and Culture.

Cortequisse, Bruno. 1990. *Mesdames de France: Les filles de Louis XV*. Paris: Perrin.

Cosandey, Fanny. 2000. *La reine de France: Symbole et pouvoir, XVe–XVIIIe siècle*. Paris: Gallimard.

Crawford, Katherine. 2004. *Perilous Performances: Gender and Regency in Early Modern France*. Cambridge, Mass.: Harvard University Press.

Creese, Helen. 2004. *Women of the Kakawin World: Marriage and Sexuality in the Indic Courts of Java and Bali*. Armonk, N.Y.: M. E. Sharpe.

Crossley, Pamela K. 1987. "Manzhou yuanliu kao and the Formalization of the Manchu Heritage." *Journal of Asian Studies* 46.4 (November): 761–90.

———. 1999. *A Translucent Mirror: History and Identity in Qing Imperial Ideology*. Berkeley: University of California Press.

Cruysse, Dirk van der. 1991. *Louis XIV et le Siam*. Paris: Fayard.

Cummings, William. 2002. *Making Blood White: Historical Transformations in Early Modern Makassar*. University of Hawai'i Press.

Cuno, James Bash. [1985] 1992. "Charles Philipon and La Maison Aubert: The Business, Politics and Public of Caricature in Paris, 1820–1840." 2 vols. Ph.D. diss., Harvard University. Ann Arbor, Mich.: University Microfilms International.

Da Qing Gaozong shilu (Qing veritable records of Gaozong reign). 1964. Taipei: Huawen shuju.

Da Qing huidian shili (The collected institutes and precedents of the Qing dynasty). 1899. Guangxu edition. 1963. Taipei: Zhongwen shuju.

Da Qing huidian zeli (The collected institutes and precedents of the Qing dynasty). 1764. Qianlong edition. 1986. Taipei: Shangwu yinshuguan.

Da Qing Renzong shilu (Qing veritable records of Renzong reign). 1964. Taipei: Huawen shuju.

Da Qing Shengzu shilu (Qing veritable records of Shengzu reign). 1964. Taipei: Huawen shuju.

Da Qing Shizu shilu (Qing veritable records of Shizu reign). 1964. Taipei: Huawen shuju.

Da Qing Taizong shilu (Qing veritable records of Taizong reign). 1964. Taipei: Huawen shuju.

Da Vinha, Mathieu. 2004. *Les valets de chambre de Louis XIV*. Paris: Editions Perrin.

Dampier, William. [1697] 1968. *A New Voyage around the World*. Ed. Albert Gray. New York: Dover.

Darling, P. J. 1984a. *Archaeology and History in Southern Nigeria: The Ancient Linear Earthworks of Benin and Ishan. Part 1, Fieldwork and Background Information.* Cambridge Monographs in African Archaeology 11, BAR International Series 215(i). Oxford: B.A.R.

⸻. 1984b. *Archaeology and History in Southern Nigeria: The Ancient Linear Earthworks of Benin and Ishan. Part 2, Ceramic and Other Specialist Studies.* Cambridge Monographs in African Archaeology 11, BAR International Series 215(ii). Oxford: B.A.R.

Darnton, Robert. 1984. *The Great Cat Massacre and Other Episodes in French Cultural History.* New York: Random House.

Daumier, Honoré. 1968. *Humours of Married Life.* Ed. Philippe Roberts-Jones. Trans. Angus Malcolm. Boston: Boston Book and Art Shop.

Davis, Fanny. *The Ottoman Lady: A Social History from 1718–1918.* Westport, Conn.: Greenwood, 1986.

Davis, Richard L. 1986. *Court and Family in Sung China, 960–1279.* Durham, N.C.: Duke University Press.

De Cer. See Constantine VII Porphyrogenitus 1829–30.

Dehkhoda, Aliakbar. 1993–94. *Loghatname, 1879–1955.* Vols. 1–14 of Encyclopedic Dictionary, ed. Mohammad Moʾin and Jaʿfar Shahidi. Tehran: Chapkhanah-i Muʿssasah-i Intisharat va Chap-i Danishga.

Der Ling. 1929. *Kowtow.* New York: Dodd, Mead.

Desan, Suzanne. 2004. *The Family on Trial in Revolutionary France.* Studies on the History of Society and Culture 51. Berkeley: University of California Press.

Diamond, Jared M. 1997. *Guns, Germs, and Steel: The Fates of Human Societies.* New York: Norton.

Díaz del Castillo, Bernal. 1956. *The Discovery and Conquest of Mexico, 1517–1521.* Ed. Genaro García. Trans. A. P. Maudslay. New York: Farrar, Straus, and Cudahy. (Written in Spanish in 1568.)

Ding Yizhuang. 1999. *Manzu de funu shenghuo yu hunyin zhidu yanjiu.* Beijing: Beijing daxue chu ban she.

DRV. See Novikov [1788–91] 1970.

du Loir, Sieur. 1654. *Les Voyage du Sieur du Loir.* Paris.

Duben, Alan. 1985 "Turkish Families and Households in Historical Perspective." *Journal of Family History* 10 (Spring): 75–97.

Duindam, Jeroen. 1994. *Myths of Power: Norbert Elias and the Early Modern European Court.* [Trans. Lorri S. Granger and Gerard T. Moran.] Amsterdam: Amsterdam University Press.

⸻. 2003. *Vienna and Versailles: The Courts of Europe's Dynastic Rivals, 1550–1780.* Cambridge: Cambridge University Press.

Durán, Diego. 1971. *Book of the Gods and Rites and The Ancient Calendar.* Ed. and trans. Fernando Horcasitas and Doris Heyden. Norman: University of Oklahoma Press. (Written in Spanish in 1574–79.)

Düzdağ, M. Ertugrul. 1976. *Şehyülislâm Ebussuûd Efendi Fetvalari.* Istanbul: Enderun Kitabevi.

The Dynastic Chronicles, Bangkok Era: The First Reign. 1978. Trans. and ed. Thadeus and Chadin Flood. 2 vols. Tokyo: Centre for East Asian Cultural Studies.

Ebrey, Patricia. 2003a. "Record, Rumor, and Imagination: Sources for the Women of Huizong's Court Before and After the Fall of Kaifeng." In *Tang Song Nüxing yu shehui* (Tang-Song Women and Society), ed. Deng Xiaonan et al., pp. 46–96. Shanghai: Shanghai ci shu chu ban she.

———. 2003b. *Women and the Family in Chinese History.* London: Routledge.

Eck, Alexandre. 1962. "La situation juridique de la femme russe au moyen âge." *Recueils de la Société Jean Bodin, pour l' histoire comparative des institutions* 12: 405–20.

Egharevba, Jacob U. 1956. *Bini Titles.* Benin: Privately printed.

———. 1960. *A Short History of Benin.* 3rd ed. Ibadan: Ibadan University Press. (First edition published in 1934.)

———. 1961. *Marriage of the Princesses of Benin.* Benin: Kopin-Dogba Press.

———. 1965. *Chronicle of Events in Benin.* Benin: Privately printed.

———. 1968. *A Short History of Benin.* 4th ed. Ibadan: Ibadan University Press.

Elias, Norbert. 1983. *The Court Society.* Trans. Edmund Jephcott. New York: Pantheon.

———. 2000. *The Civilizing Process: Sociogenetic and Psychogenetic Investigations.* Trans. Edmund Jephcott. Rev. ed. Oxford: Blackwell.

Elliott, Mark C. 1999. "Manchu Widows and Ethnicity in Qing China." *Comparative Studies in Society and History* 14.1 (January): 33–71.

———. 2001. *The Manchu Way: The Eight Banners and Ethnic Identity in Late Imperial China.* Stanford: Stanford University Press.

The Embassy of Sir Thomas Roe to the Court of the Great Mogul, 1615–1619, as Narrated in His Journal and Correspondence. 1899. Edited by William Foster. 2 vols. London: Hakluyt Society.

Erdman, D. Ch., ed. 1851. "Kopiia s dukhovnoi skhimonakhini tsaritsy Darii." *Vremennik obshchestva istorii i drevnostei rossiiskikh* 9: section III, 61–63.

Esposito, John. 1982. *Women in Muslim Family Law.* Syracuse, N.Y.: Syracuse University Press.

Evans, Susan Toby. 2004a. *Ancient Mexico and Central America: Archaeology and Culture History.* New York: Thames and Hudson.

————. 2004b. "Aztec Palaces." In *Palaces of the Ancient New World*, ed. Susan Toby Evans and Joanne Pillsbury, pp. 7–58. Washington, D.C.: Dumbarton Oaks.

La exposición de la civilización maya. 1990. Tokyo: Mainichi Newspaper.

Fan Zuyu (1041–98). 1983. *Fan Tai shi ji*. In Wen yuan ge, Si ku quan shu, vol. 1100. Taipei: Commercial Press.

Fang, Chaoying. 1969. *The Asami Library: A Descriptive Catalogue*. Ed. Elizabeth Huff. Berkeley: University of California Press.

Ferguson, Douglas Edwin, [trans.]. 1973. "Nineteenth Century Hausaland: Being a Description by Imam Imoru of the Land, Economy, and Society of His People." Ph.D. diss., University of California, Los Angeles.

Findly, Ellison Banks. 1993. *Nur Jahan: Empress of Mughal India*. New York: Oxford University Press.

Folorunso, C. A. 2003. "The Archaeology and Ethnoarchaeology of Soap and Dye Making at Ijaye, Yorubaland." *African Archaeological Review* 19: 127–45.

Forbes, Amy Wiese. 1999. "The Satiric Decade: Satire and the Development of Republicanism in France, 1830–1849." Ph.D. diss., Rutgers University.

Franke, Herbert. 1976. *Sung Biographies*. 2 vols. Wiesbaden: Franz Steiner.

Fukai Masaumi. 1997. *Zukai: Edojō wo yomu*. Tokyo: Hara Shobō.

Furet, François. 1988. *Revolutionary France, 1770–1880*. Trans. Antonia Nivelle. Oxford: Blackwell.

Gasco, Janine, and Barbara Voorhies. 1989. "The Ultimate Tribute: The Role of the Soconusco as an Aztec Tributary." In *Ancient Trade and Tribute: Economies of the Soconusco Region of Mesoamerica*, ed. Barbara Voorhies, pp. 48–94. Salt Lake City: University of Utah Press.

Geertz, Clifford. 1975. "Centers, Kings, and Charisma: Reflections on the Symbolics of Power." In *Culture and Its Creators: Essays in Honor of Edward Shils*, ed. Joseph Ben-David and Terry Nichols Clark, pp. 150–71. Chicago: University of Chicago Press.

————. 1980. *Negara: The Theatre State in Nineteenth-Century Bali*. Princeton: Princeton University Press.

————. 1985. "Centers, Kings, and Charisma: Reflections on the Symbolics of Power." In *Rites of Power: Symbolism, Ritual, and Politics Since the Middle Ages*, ed. Sean Wilentz, pp. 10–33. Philadelphia: University of Pennsylvania Press.

Georgievskii, V. 1910. "Ikony Ioanna Groznago i ego sem'i v Suzdale." *Starye gody* (November): 3–21.

————. 1927. *Pamiatniki starinnogo russkogo iskusstva Suzdal'skogo muzeia*. Moscow: Glavnauka.

Gerber, Haim. 1980. "Social and Economic Position of Women in an Ottoman City, Bursa, 1600–1700." *International Journal of Middle East Studies* 12.3 (November): 231–44.

Gervaise, Nicolas. 1989. *The Natural and Political History of the Kingdom of Siam*. Trans. and ed. John Villers. Bangkok: White Lotus.

Giladi, Avner. 1999. *Infants, Parents and Wet Nurses: Medieval Islamic Views on Breastfeeding and Their Social Implications*. Boston: Brill.

Ginindza, Thoko. 1997. "Labotsibeni/Gwamile Mduli: The Power behind the Swazi Throne 1875–1925." In Kaplan 1997b, pp. 135–58.

The Glass Palace Chronicle of the Kings of Burma. [1923] 1960. Trans. Pe Maung Tin and G. H. Luce. Rangoon: Rangoon University Press.

Goens, Rijklof van. [1666] 1995. *Javaense Reyse: De Bezoeken van een VOC Gezant aan het Hof van Mataram 1648–1654*. Ed. Darja van Wever. Amsterdam: Terra Incognita.

Goldstein, Robert Justin. 1989. *Censorship of Political Caricature in Nineteenth-Century France*. Kent, Ohio: Kent State University Press.

Gomes, Rita Costa. 2003. *The Making of a Court Society: Kings and Nobles in Late Medieval Portugal*. Trans. Alison Aiken. Cambridge: Cambridge University Press.

Gong Yanming. 1997. *Song dai guan zhi ci dian*. Peking: Zhonghua shu ju.

Goodman, Dena, ed. 2003. *Marie-Antoinette: Writings on the Body of a Queen*. New York: Routledge.

Graham, Ian, and Eric Von Euw. 1977. *Yaxchilan*. Vol. 3 of *Corpus of Maya Hieroglyphic Inscriptions*. Cambridge, Mass.: Peabody Museum of Archaeology and Ethnology, Harvard University.

Griselle, Eugène. 1912. *État de la maison du roi Louis XIII, de celles de sa mère, Marie de Médicis, de ses soeurs, Chrestienne, Élisabeth et Henriette de France*. Paris: Catin.

Grosrichard, Alain. 1998. *The Sultan's Court: European Fantasies of the East*. Trans. Liz Heron. London: Verso.

Guilland, Rodolphe. 1967. *Recherches sur les institutions Byzantines*. 2 vols. Amsterdam: Hakkert.

Gwarzo, Hassan I., Kamal I. Bedri, and Priscilla E. Starratt. 1974/77. "Taj addin fima yahib ʿala al-muluk, or The crown of religion concerning the obligations of princes." *Kano Studies* 1: 15–28.

Haboush, JaHyun Kim. 1985. "The Education of the Yi Crown Prince: A Study in Confucian Pedagogy." In *The Rise of Neo-Confucianism in Korea*, ed. Wm. Theodore de Bary and JaHyun Kim Haboush, pp. 161–222. New York: Columbia University Press.

———. 1988. *A Heritage of Kings: One Man's Monarchy in the Confucian World*. New York: Columbia University Press.

————, ed. and trans. 1996. *The Memoirs of Lady Hyegyŏng: The Autobiographical Writings of a Crown Princess of Eighteenth-Century Korea*. Berkeley: University of California Press.

————. 2001. *The Confucian Kingship in Korea*. New York: Columbia University Press.

————. 2002. "Gender and the Politics of Language in Korea." In *Rethinking Confucianism: Past & Present in China, Japan, Korea, and Vietnam*, ed. John Duncan, Benjamin Elman, and Herman Ooms, pp. 220–57. Los Angeles: UCLA Asian Pacific Monograph Series.

————. 2003. "Versions and Subversions: Patriarchy and Polygamy in the Vernacular Narratives of Chosŏn Korea." In *Women and Confucian Cultures in Premodern China, Korea, and Japan*, ed. Dorothy Ko, JaHyun Kim Haboush, and Joan R. Piggott, pp. 279–303. Berkeley: University of California Press.

Hall, Edward. 1966. *The Hidden Dimension*. Garden City, N.J.: Doubleday Anchor.

Hanley, Sarah. 1997. "Identity Politics and Rulership in France: Female Political Place and the Fraudulent Salic Law in Christine de Pisan and Jean de Montreuil." In *Changing Identities in Early Modern France*, ed. Michael Wolfe, pp. 78–94. Durham, N.C.: Duke University Press.

————. 2003. "The Salic Law." In *Political and Historical Encyclopedia of Women*, ed. Christine Fauré, pp. 3–13. London: Routledge.

Hansen, Karen. 2004. "The World in Dress: Anthropological Perspectives on Clothing, Fashion, and Culture." *Annual Review of Anthropology* 33: 369–92.

Hardman, John. 2006. "Decision-making." In *The Origins of the French Revolution*, ed. Peter R. Campell, pp. 63–87. Basingstoke, Hampshire: Palgrave Macmillan.

Harris, Moira Flanagan. 1985. "The Royal Cloth of Cameroon." Ph.D. diss., University of Minnesota.

Harvey, Herbert R. 1986. "Household and Family Structure in Early Colonial Tepetlaoztoc." *Estudios de Cultura Nahuatl* 18: 275–94.

Hata Hisako. 2001. *Edo oku jochū monogatari*. Tokyo: Kōdansha.

Haviland, William A. 1997. "The Rise and Fall of Sexual Inequality: Death and Gender at Tikal, Guatemala." *Ancient Mesoamerica* 8.1: 1–12.

Hay, John. 1983. "The Human Body as a Microcosmic Source of Macrocosmic Values in Calligraphy." In *Theories of the Arts in China*, ed. Susan Bush and Christian Murck, pp. 74–102. Princeton: Princeton University Press.

Hellie, Richard. 1999. *The Economy and Material Culture of Russia, 1600–1725*. Chicago: University of Chicago Press.

Hendon, Julia A. 1997. "Women's Work, Women's Space, and Women's Status among the Classic-Period Maya Elite of the Copan Valley, Honduras." In *Women in Prehistory: North America and Mesoamerica*, ed. Cheryl Claassen and Rosemary A. Joyce, pp. 33–46. Philadelphia: University of Pennsylvania Press.

Herrin, Judith. 2001. *Women in Purple: Rulers of Medieval Byzantium*. London: Weidenfield and Nicolson.

Hicks, Frederic. 1994. "Cloth in the Political Economy of the Aztec State." In *Economies and Polities in the Aztec Realm*, ed. M. G. Hodge and M. E. Smith, pp. 89–111. Studies in Culture and Society 6. Albany: Institute for Mesoamerican Studies, University at Albany, State University of New York; distributed by University of Texas Press.

Hiskett, Mervyn. 1981. "Reflections on the Location of Place Names and on the 10/16th Century Map of Hausaland and Their Relation to *fatauci* Routes." *Kano Studies*, n.s. 2: 69–98.

Holmgren, Jennifer. 1991. "Imperial Marriage in the Native Chinese and Non-Han State: Han to Ming." In *Marriage and Inequality in Chinese Society*, ed. Rubie S. Watson and Patricia Buckley Ebrey, pp. 58–96. Berkeley: University of California Press.

Holum, Kenneth. 1982 *Theodosian Empresses: Women and Imperial Dominion in Late Antiquity*. Berkeley: University of California Press.

Homans, Margaret. 1998 *Royal Representations: Queen Victoria and British Culture, 1837–1876*. Chicago: University of Chicago Press.

Hong Kiwŏn, ed. 1986. *Sŏgung ilgi*. Seoul: Minsokwŏn.

Hong, Lysa. 1999. "Palace Women at the Margins of Social Change: An Aspect of the Politics of Social History in the Reign of King Chulalongkorn." *Journal of Southeast Asian Studies* 30.2 (September): 310–25.

Horcasitas, Fernando, and Bente Bittmann Simons. 1974. "Anales jeroglíficos e históricos de Tepeaca." *Anales de Antropología* 11: 225–93.

Houssonville, Le comte de. 1899–1908. *La duchesse de Bourgogne et l'alliance Savoyarde sous Louis XIV*. 4 vols. Paris: Calmann-Lévy.

Houston, Stephen D. 1993. *Hieroglyphs and History at Dos Pilas: Dynastic Politics of the Classic Maya*. Austin: University of Texas Press.

Houston, Stephen D., and David Stuart. 1996. "Of Gods, Glyphs and Kings: Divinity and Rulership among the Classic Maya." *Antiquity* 70: 289–312.

———. 2001. "Peopling the Classic Maya Court." In Inomata and Houston 2001b, pp. 54–83.

Hua Li. 1983. "Qingdai de Man Meng lianyin" (Marriage alliances of Manchus and Mongols in the Qing). *Minzu yanjiu* 2: 45–54.

Huang Pei. 1986. "Qingchu de Manzhou guizu (1583–1795)—Niugulu zu." In *Lao Zhenyi xiansheng bazhi rong Qing lunwen ji*, pp. 637–39. Taipei: Shangwu yinshuguan.

Hunt, Lynn. 1992. *The Family Romance of the French Revolution*. Berkeley: University of California Press.

Hyjong sillok. In Chosŏn wangjo sillok 1955–63, vols. 35–36.

Idema, Wilt, and Stephen H. West. 1982. *Chinese Theater, 1100–1450: A Source Book.* Wiesbaden: Franz Steiner.

İnalçïk, Halil. 1973. *The Ottoman Empire: The Classical Age, 1300–1600.* Trans. Norman Itzkowitz and Colin Imber. New York: Praeger.

———. 1980. "Military and Fiscal Transformation in the Ottoman Empire, 1600–1700." *Archivum Ottomanicum* 6: 283–337.

Injo sillok. In *Chosŏn wangjo sillok* 1955–63, vols. 33–35.

Inomata, Takeshi. 2001a. "The Classic Maya Royal Palace as a Political Theater." In *Reconstruyendo la ciudad maya: El urbanismo en las sociedades antiguas,* ed. Andrés Ciudad Ruiz, María Josefa Iglesias Ponce de León, and María del Carmen Martínez Martínez, pp. 341–62. Madrid: Sociedad Española de Estudios Mayas.

———. 2001b. "King's People: Classic Maya Royal Courtiers in a Comparative Perspective." In Inomata and Houston 2001b, pp. 27–53.

———. 2001c. "The Power and Ideology of Artistic Creation: Elite Craft Specialists in Classic Maya Society." *Current Anthropology* 42.3: 321–33.

———. 2006a. "Plazas, Performers, and Spectators: Political Theaters of the Classic Maya." *Current Anthropology* 47.5: 805–42.

———. 2006b. "Politics and Theatricality in Maya Society." In *The Archaeology of Performance: Theaters of Power, Community, and Politics,* ed. Takeshi Inomata and Lawrence Coben, pp. 187–222. Lanham, Md.: Altamira Press.

Inomata, Takeshi, and Stephen D. Houston. 2001a. "Opening the Royal Maya Court." In Inomata and Houston 2001b, pp. 3–23.

———, eds. 2001b. *Royal Courts of the Ancient Maya.* Vol. 1, *Theory, Comparison, and Synthesis.* Boulder, Colo.: Westview Press.

Inomata, Takeshi, and Laura R. Stiver. 1998. "Floor Assemblages from Burned Structures at Aguateca, Guatemala: A Study of Classic Maya Households." *Journal of Field Archaeology* 25.4: 431–52.

Inomata, Takeshi, Daniela Triadan, Erick Ponciano, Estela Pinto, Richard E. Terry, and Markus Eberl. 2002. "Domestic and Political Lives of Classic Maya Elites: The Excavation of Rapidly Abandoned Structures at Aguateca, Guatemala." *Latin American Antiquity* 13.3: 305–30.

Inomata, Takeshi, Daniela Triadan, Erick Ponciano, Richard Terry, and Harriet F. Beaubien. 2001. "In the Palace of the Fallen King: The Royal Residential Complex at Aguateca, Guatemala." *Journal of Field Archaeology* 28: 287–306.

Ito Takeshi. 1984. "The World of the *Adat Aceh.*" Ph.D. diss., Australian National University.

Jackson, Sarah, and David Stuart. 2001. "The *Aj K'uhun* Title: Deciphering a Classic Maya Term of Rank." *Ancient Mesoamerica* 12.2: 217–28.

Jacobs, Hubert, ed. 1971. *A Treatise on the Moluccas (c. 1544) . . . of Antonio Galvão.* Rome: Jesuit Historical Institute.

Jahangirnama: Memoirs of Jahangir, Emperor of India. 1999. Trans. and ed. W. M. Thackston. Washington, D.C.: Freer Gallery of Art, Arthur M. Sackler Gallery; New York: Oxford University Press.

Jakobson, Roman. 1956. "The Metaphoric and Metonymic Roles." In *Fundamentals of Language*, ed. Roman Jakobson and Morris Hale, pp. 76–82. The Hague: Mouton.

Jell-Bahlsen, Sabine. 1997. "*Eze Mmiri di Egwu* the Water Monarch Is Awesome." In Kaplan 1997b, pp. 67–96.

Jennings, Ronald C. 1975. "Women in Early 17th Century Ottoman Judicial Records—the Sharia Court of Anatolian Kayseri." *Journal of Economic and Social History of the Orient* 18: 53–114.

Jiang Xiangshun. 1987. "Qing Taizong de Chongde wu gong houfei ji qita" (The five consorts of Qing Taizong and other issues). *Gugong bowuyuan yuankan* 4: 67–71.

———. 1995. "Lun Qinggong saman" (Shamanism in the Qing palace). *Shenyang gugong bowuyuan yuankan* 1: 62–66.

Jin Qicong. 1989. *Beijing jiaoqu de Manzu.* Huhhot: Neimenggu daxue chu ban she.

Joseph, Marietta. 1978. "West African indigo cloth." *African Arts* 11: 34–37, 95.

Josserand, J. Kathryn. 2002. "Women in Classic Maya Hieroglyphic Texts." In *Ancient Maya Women*, ed. Traci Ardren, pp. 114–51. Walnut Creek, Calif.: AltaMira Press.

"Journal of a Mission to Aceh." 1636. Algemeen Rijksarchief, The Hague. VOC 1199.

Joyce, Rosemary A. 1992. "Images of Gender and Labor Organization in Classic Maya Society." In *Exploring Gender through Archaeology: Selected Papers from the 1991 Boone Conference*, ed. Cheryl Claassen, pp. 63–70. Madison, Wis.: Prehistoric Press.

———. 1993. "Women's Work: Images of Production and Reproduction in Pre-Hispanic Southern Central America." *Current Anthropology* 34: 255–74.

———. 2000. *Gender and Power in Prehispanic Mesoamerica.* Austin: University of Texas Press.

Kahn, Harold L. 1967. "The Politics of Filiality: Justification for Imperial Action in Eighteenth Century China." *Journal of Asian Studies* 26.2 (February): 197–203.

———. 1971. *Monarchy in the Emperor's Eyes: Image and Reality in the Qianlong Reign.* Cambridge, Mass.: Harvard University Press.

Kaiser, Daniel. 1987. "Symbol and Ritual in the Marriages of Ivan IV." *Russian History* 14.1–4: 247–62.

Kaiser, Thomas E. 2005. "Royal Mistress as Diplomat: Madame de Pompadour and the Reversal of the Alliance of 1756." Paper presented at the Annual Meeting of the Society for French Historical Studies, Palo Alto, Calif., March.

———. 2006. "Scandal in the Royal Nursery: Marie-Antoinette and the *Gouvernantes des Enfants de France*." In *Historical Reflections/Reflexions* 32.2: 403–20.

Kang Hanyŏng, ed. 1962. *Kyech'uk ilgi*. Seoul: Minhyŏp ch'ulp'ansa.

Kaplan, Flora E. S. 1993. " 'Iyoba,' the Queen Mother of Benin: Images and Ambiguity in Gender and Sex Roles in Court Art." In *Representation and the Politics of Difference*, pp. 386–407. Special issue of *Art History* (16.3).

———. 1997a. " 'Íyóbá,' The Queen Mother of Benin." In Kaplan 1997b, pp. 73–102.

———, ed. 1997b. *Queens, Queen Mothers, Priestesses, and Power: Case Studies in African Gender*. Annals of the New York Academy of Sciences 810. New York: New York Academy of Sciences.

———. 1997c. "Runaway Wives, Native Law and Custom in Benin, and Early Colonial Courts, Nigeria." In Kaplan 1997b, pp. 245–313.

———. 2004. "Understanding Sacrifice and Sanctity in Benin Indigenous Religion, Nigeria: A Case Study." In *Beyond Primitivism: Indigenous Religions, Traditions and Modernity*, ed. Jacob K. Olupona, pp. 181–99. New York: Routledge.

Karttunen, Frances. 1997. "Rethinking Malinche." In *Indian Women of Early Mexico*, ed. Susan Schroeder, Stephanie Wood, and Robert Haskett, pp. 290–312. Norman: University of Oklahoma Press.

Kaura, J. M. 1990. "Emancipation of Women in the Sokoto Caliphate." In *State and Society in the Sokoto Caliphate*, ed. Ahmad Mohammad Kani and Kabir Ahmed Gandi, pp. 75–103. Zaria, Nigeria: Gaskiya Corporation.

Kazhdan, Alexander, and Michael McCormick. 1997. "The Social World of the Byzantine Court." In *Byzantine Court Culture from 829 to 1204*, ed. Henry McGuire, pp. 167–97. Washington, D.C.: Dumbarton Oaks.

Keller, Katrin. 2005. *Hofdamen: Amtsträgerinnen im Wiener Hofstaat des 17. Jahrhunderts*. Vienna: Böhlau.

Kellogg, Susan M. 1984. "Aztec Women in Early Colonial Courts: Structure and Strategy in a Legal Context." In *Five Centuries of Law and Politics in Central Mexico*, ed. Ronald Spores and Ross Hassig, pp. 25–38. Vanderbilt University Publications in Anthropology No. 30. Nashville, Tenn.: Vanderbilt University.

———. 1995. *Law and the Transformation of Aztec Culture, 1500–1700*. Norman: University of Oklahoma Press.

———. 1997. "From Parallel and Equivalent to Separate but Unequal: Tenochca Mexica Women, 1500–1700." In *Indian Women of Early Mexico*, ed.

Susan Schroeder, Stephanie Wood, and Robert Haskett, pp. 123–43. Norman: University of Oklahoma Press.

Kenney, Elise K., and John M. Merriman. 1991. *The Pear: French Graphic Arts in the Golden Age of Caricature*. South Hadley, Mass.: Mount Holyoke College Art Museum.

Kettering, Sharon. 1993. "Brokerage at the Court of Louis XIV." *Historical Journal* 36: 69–131.

———. 2003. Review of Sophie de Laverny, *Les Domestiques commensaux du roi de France au XVIIie siècle*. *H-France Reviews* 3 (August): no. 82, at www.h-france.net/vol3reviews/kettering.html (accessed July 8, 2007).

Khan, Shaharyar M. 2001. *The Begums of Bhopal: A Dynasty of Women Rulers in Raj India*. New York: Palgrave for I. B. Tauris.

Kim, Hongnam, ed. 1993. *Korean Arts of the Eighteenth Century: Splendor and Simplicity*. New York: Asia Society Galleries.

Kim Yongsuk. 1987. *Chosŏnjo kungjung p'ungsok yŏn'gu*. Seoul: Ilchisa.

"The Kingdom of Laos: An Edited Reprint of the 1759 Universal History." 2002. In *Breaking New Ground in Lao History: Essays on the Seventh to Twentieth Centuries*, ed. Mayoury Ngaosrivathana and Kennon Breazeale, pp. 169–238. Chiang Mai: Silkworm Books.

Kishibe Shigeo. 1941–42. "Tōdai kyōbō no sōsetsu oyobi hensen" (The establishment and evolution of the Tang dynasty Court Entertainment Bureau). *Tōyō gakuohō* 28: 280–308.

Kleinman, Ruth. 1990. "Social Dynamics and the French Court: The Household of Anne of Austria." *French Historical Studies* 16: 517–35.

Koçu Bey. *Risale*. 1939. Ed. Ali Kemali Aksüt. Istanbul: Vakit Kütüphane[si].

Koenig, William J. *The Burmese Polity, 1752–1819: Polities, Administration and Social Organization in the Early Kon-baung Period*. [Ann Arbor]: Center for South and Southeast Asian Studies, University of Michigan, 1990.

Koretskii, V. I., ed. 1985. *Istochniki po sotsial'no-ekonomicheskoi istorii Rossii XVI–XVII vv.: Iz arkhiva Moskovskogo Novodevich'ego monastyria*. Moscow: AN SSSR.

Kotoshikhin, Grigorii. 1988. *O Rossii v carstvovanie Alekseja Mixailoviča*. Ed. A. E. Pennington. Oxford: Clarendon Press.

Kowalski, Jeff Karl. 1987. *The House of the Governor: A Maya Palace at Uxmal, Yucatan, Mexico*. Norman: University of Oklahoma Press.

Krejci, Estela, and T. Patrick Culbert. 1995. "Preclassic and Classic Burials and Caches in the Maya Lowlands." In *The Emergence of Lowland Maya Civilization: The Transition from the Preclassic to the Early Classic*, ed. Nikolai Grube, pp. 103–16. Möckmühl: Anton Saurwein.

Kriger, Colleen. 1993. "Textile Production and Gender in the Sokoto Caliphate." *Journal of African History* 34: 361–401.

Kumar, Ann. 1997. *Java and Modern Europe: Ambiguous Encounters*. Richmond, Surrey: Curzon Press.

Kunt, İ. Metin. 1983. *The Sultan's Servants: The Transformation of Ottoman Provincial Government, 1550–1650*. New York: Columbia University Press.

Kyech'uk ilgi. See Kang 1962.

Kyŏngguk taejŏn. 1962. Seoul: Pŏpchech'ŏ.

Kyŏrye ŭi Han'gŭl. 2000. Seoul: National Museum of Korea.

Kyūji shimonroku. 1986. Vol. 1. Tokyo: Iwanami Shoten.

La Loubère, Simon de. [1693] 1969. *A New Historical Relation of the Kingdom of Siam*. Ed. David K. Wyatt. Kuala Lumpur: Oxford University Press.

La Tour du Pin, marquise de. 1913. *Journal d'une femme de cinquante ans, 1778–1815*. 2 vols. Paris: M. Imhaus and R. Chapelot.

Labatut, Jean-Pierre. 1972. *Les ducs et pairs de France aux XVIIe siècle*. Paris: Presses Universitaires de France.

Lacqueur, Thomas. 1982. "The Queen Caroline Affair: Politics as Art in the Reign of George IV." *Journal of Modern History* 54: 162–87.

Laffin, John. 1967. *Women in Battle*. London: Abelard-Schuman.

Lai Hui-min. 1997. *Tianhuang guizhou: Qing huangzu de jieceng jiegou yu jingji shenghuo* (The Qing imperial lineage: its hierarchical structure and economic life). Taipei: Institution of Modern History, Academia Sinica.

Lal, Ruby. 2005. *Domesticity and Power in the Early Mughal World*. Cambridge: Cambridge University Press.

Laverny, Sophie de. 2002. *Les domestiques commensaux du roi de France au XVIIe siècle*. Paris: Presses de l'Université de Paris-Sorbonne.

Ledré, Charles. 1960. *La presse à l'assaut de la monarchie 1815–1848*. Paris: A. Colin.

Ledyard, Gari. 1974. "Korean Travelers in China over Four Hundred Years, 1488–1887." *Occasional Papers on Korea* 2 (March): 1–42.

Lello, Henry. 1952. *The Report of Lello, Third English Ambassador to the Sublime Porte*. Ed. O. Burian. Ankara: Türk Tarih Kurumu Basïmevi.

Leonowens, Anna. 1870. *The English Governess at the Siamese Court: Being Recollections of Six Years in the Royal Palace at Bangkok*. Boston: Fields, Osgood.

———. [1873] 1991. *The Romance of the Harem*. Ed. with introduction by Susan Morgan. Charlottesville: University Press of Virginia.

Lerner, Gerda. 1986. *The Creation of Patriarchy*. New York: Oxford University Press.

Leupe, P. A., ed. 1856. "Bali in 1597." *Bijdragen tot de Taal-, Land en Volkenkunde van Nederlandsch-Indië* 5: 203–34.

Levron, Jacques. 1961. *Les courtisans*. Paris: Editions du Seuil.

————. 2003. *Les inconnus de Versailles: les coulisse de la Cour*. Paris: Editions Perrin.

Lewis, Bernard. 1988. *The Political Language of Islam*. Chicago: University of Chicago Press.

Li Tana. 1998. *Nguyen Cochinchina: Southern Vietnam in the Seventeenth and Eighteenth Centuries*. Ithaca, N.Y.: Cornell University, Southeast Asia Program Publications.

Li Tana and Anthony Reid. 1993. *Southern Vietnam under the Nguyen: Documents on the Economic History of Cochinchina (Dang Trong, 1602–1777)*. Singapore: Institute of Southeast Asian Studies/Economic History of Southeast Asia Project.

Li Tao. 1979–90. *Xu zi zhi tong jian chang bian*. Peking: Zhong hua shu ju. Cited as CB.

Li, Wai-yee. 1994. "The Idea of Authority in the Shih Chi." *Harvard Journal of Asiatic Studies* 54.2 (December): 345–405.

Li Xinchuan (1166–1243). 1983. In *Wen yuan ge, Si ku quan shu*, vols. 325–37. Taipei: Commercial Press.

Liu Lu. 1987. "Qingchao Hanzu gongzhu Kong Sizhen." In *Qinggong jiemi*, ed. Zheng Yimei, pp. 109–11. Hong Kong: Nanyue chu ban she.

Looper, Matthew G. 2002. "Women-Men (and Men-Women): Classic Maya Rulers and the Third Gender." In *Ancient Maya Women*, ed. Traci Ardren, pp. 171–202. Walnut Creek, Calif.: AltaMira Press.

Loos, Tamara. 2005. "Sex in the Inner City: The Fidelity between Sex and Politics in Siam." *Journal of Asian Studies* 64.4 (November): 881–909.

Louis-Philippe, King of the French. 1977. *Louis-Philippe's Memoirs, 1773–1794*. Trans. John Hardman. New York: Harcourt Brace Jovanovich.

Love, Robert S. 1996. "Rituals of Majesty: France, Siam and Court Spectacle in Royal Image-Building at Versailles in 1685 and 1686." *Canadian Journal of History* 31 (August): 171–98.

Lozachmeur, Estelle. 1995. "Du visage au masque: les représentations de Marie-Amélie, Reine des français (1830–1848)." 2 vols. Mémoire de maîtrise, University of Paris I.

Lustig, Friedrich V., ed and trans. 1966. *Burmese Classical Poems*. Rangoon: U Khin Pe Gyi.

Luynes, duc de. 1864. *Mémoires du duc de Luynes sur la cour de Louis XV*. 18 vols. Paris: Firmin Didot et fils.

Mack, Beverly B. "Authority and Influence in the Kano Harem." In Kaplan 1997b, pp. 245–313.

Madariaga, Isabel de. 2005. *Ivan the Terrible: First Tsar of Russia*. New Haven: Yale University Press.

Madauci, Ibrahim, Yahaya Isa, and Bello Daura, comps. [1968] 1985. *Hausa Customs*. Zaria: Northern Nigeria Publishing Company.

Maher, Vanessa. 1992. "Breast-Feeding in Cross-cultural Perspective: Paradoxes and Proposals." In *The Anthropology of Breast-feeding: Natural Law or Social Construct*, ed. Vanessa Maher, pp. 1–36. Oxford: Berg; New York: distributed by St. Martin's Press.

Maiasova, N. A. 1973. "Tri shitykh pokrova XVI veka v sobranii muzeev Kremlia." In *Materialy i issledovaniia*, ed. Gosudarstvennye muzei Moskovskogo Kremlia, 1:133–47. Moscow: Iskusstvo.

Mainardi, Patricia. 2003. *Husbands, Wives, and Lovers: Marriage and Its Discontents in Nineteenth-Century France*. New Haven: Yale University Press.

Malinovskii, A., ed. 1813–94. *Sobranie gosudarstvennykh gramot i dogovorov khraniashchikhsia v Gosudarstvennoi Kollegii Inostrannykh del.* 5 vols. Moscow: Tip. N. S. Vsevolozhskago. Cited as SGGD.

Manwen laodang (Manchu old archives). 1990. 2 vols. Beijing: Zhounghua shuju.

Manzhou shilu (Manchu veritable records). 1986. 8 vols. Beijing: Zhonghua shuju.

Margadant, Jo Burr. 1999. "Gender, Vice, and the Political Imaginary in Postrevolutionary France: Reinterpreting the Failure of the July Monarchy, 1830–1848." *American Historical Review* 104.5: 1461–96.

———. 2000. "The Duchesse de Berry and Royalist Political Culture in Postrevolutionary France." In *The New Biography: Performing Femininity in Nineteenth-Century France*, ed. Jo Burr Margadant, pp. 33–71. Berkeley: University of California Press.

———. 2006. "Representing Queen Marie-Amélie in a 'Bourgeois' Monarchy." *Historical Reflections/Réflexions Historiques* 32.2: 421–2.

Marie-Amélie. 1981. *Journal de Marie-Amélie, reine des Français, 1800–1866.* Ed. Suzanne d'Huart. Paris: Perrin.

Marini, G. F. de. 1998. *A New and Interesting Description of the Lao Kingdom (1642–1648).* Trans. Walter E. J. Tips and Claudio Bertuccio. Intro. Luigi Bressan. Bangkok: White Lotus Press. (Originally published in Italian in 1663.)

Marinière, Pierre de la. 1658. *La vrai estat de la France.* Paris.

Marmon, Shaun. 1982–89. "Concubinage, Islamic." In *Dictionary of the Middle Ages*, ed. J. Strayer et al., 3:527–29. 13 vols. New York: Scribner.

———. 1995. *Eunuchs and Sacred Boundaries in Islamic Society.* New York: Oxford University Press.

Martin, Phyllis M. 1994. "Contesting Clothes in Colonial Brazzaville." *Journal of African History* 35: 401–26.

Martin, Russell. 2004. "Choreographing the Tsar's Happy Occasion: Tradition, Change, and Dynastic Legitimacy in the Weddings of Mikhail Romanov." *Slavic Review* 63.4: 794–817.

Martin, Simon, and Nikolai Grube. 2000. *Chronicle of the Maya Kings and Queens: Deciphering the Dynasties of the Ancient Maya.* London: Thames and Hudson.

Martin-Fugier, Anne. 1990. *La vie élégante ou la formation du Tout-Paris 1815–1848.* Paris: Fayard.

———. 1992. *La vie quotidienne de Louis-Philippe et de sa famille 1830–1848.* Paris: Hachette.

Martindale, John, ed. 2001. *Prosopography of the Byzantine Empire, I (641–867).* CD-ROM. Aldershot, Hampshire: Ashgate.

Mathews, Peter. 1980. "Notes on the Dynastic Sequence of Bonampak, Chiapas, Mexico, Part 1." In *Third Palenque Round Table, 1978—Part 2,* ed. Merle Greene Robertson, pp. 60–73. Austin: University of Texas Press.

———. 1997. *La escultura de Yaxchilán.* Trans. Antonio Saborit. Coleción Científica 368. Mexico City: Instituto Nacional de Antropología e Historia.

Matsuo Mieko. 1997. "Edo bakufu jochū bunkenchō ni tsuite." In *Nihon joseishi ronshū,* vol. 2, *Seiji to josei,* ed. Sōgō Joseishi Kenkyūkai, pp. 60–97. Tokyo: Yoshikawa Kōbunkan.

Maza, Sarah. 1993. *Private Lives and Public Affairs: The Causes Célèbres of Prerevolutionary France.* Berkeley: University of California Press.

———. 2003. *The Myth of the French Bourgeoisie: An Essay on the Social Imaginary, 1750–1850.* Cambridge, Mass.: Harvard University Press.

McAnany, Patricia A., and Shannon Plank. 2001. "Perspectives on Actors, Gender Roles, and Architecture at Classic Maya Courts and Households." In Inomata and Houston 2001b, pp. 84–129.

McCafferty, Geoffrey G., and Sharisse D. McCafferty. 1999. "The Metamorphosis of Xochiquetzal: A Window on Womanhood in Pre- and Post-conquest Mexico." In *Manifesting Power: Gender and the Interpretation of Power in Archaeology,* ed. Tracy L. Sweely, pp. 103–25. London: Routledge.

McCormick, Michael. 1985. "Analyzing Imperial Ceremonies." *Jahrbuch der Osterreichischen Byzantinistik* 35: 1–20.

McNally, Susanne. 1976. "From Public Person to Private Prisoner: The Changing Place of Women in Medieval Russia." Ph.D. diss., State University of New York at Binghamton.

Melville, Elinor G. K. 1994. *A Plague of Sheep: Environmental Consequences of the Conquest of Mexico.* Cambridge: Cambridge University Press.

Meng Yuanlao (fl. 1147). 1982. *Dong jing meng hua lu.* In *Dong jing meng hua lu zhu,* ed. Deng Zhicheng. Beijing: Zhongguo shang ye chu ban she.

Miller, Mary Ellen. 1986. *The Murals of Bonampak.* Princeton: Princeton University Press

————. 2001. "Life at Court: The View from Bonampak." In *Royal Courts of the Classic Maya*, vol. 2, *Data and Case Studies*, ed. Takeshi Inomata and Stephen D. Houston, pp. 201–22. Boulder, Colo.: Westview Press.

Min Yŏngdae, ed. 1990. *Kyech'uk ilgi yŏn'gu*. Taejŏn: Hannam Taehakkyo ch'ulp'anbu.

Moffat, Abbot Low. 1961. *Mongkut, the King of Siam*. Ithaca, N.Y.: Cornell University Press.

Molloy, John P., and William L. Rathje. 1974. "Sexploitation among the Late Classic Maya." In *Mesoamerican Archaeology: New Approaches*, ed. Norman Hammond, pp. 431–44. London: Duckworth.

Monserrate, S. J. 1922. *The Commentary of Father Monserrate: On His Journey to the Court of Akbar*. Trans. J. S. Hoyland. Ed. S. N. Banerjee. London: Oxford University Press.

Montagu, Lady Mary Wortley. 1965. *The Complete Letters of Lady Mary Wortley Montagu*. Ed. Robert Halsband. Vol. 1. Oxford: Clarendon Press.

Moore, Jerry D. 1996. *Architecture and Power in the Ancient Andes: The Archaeology of Public Buildings*. Cambridge: Cambridge University Press.

Mossiker, Frances. 1961. *The Queen's Necklace*. New York: Simon and Schuster.

Motolinía, Toribio. 1951. *History of the Indians of New Spain*. Trans. and ed. Francis Borgia Steck. Publications of the Academy of American Franciscan History: Documentary Series 1. Washington, D.C.: Academy of American Franciscan History. (Originally written in Spanish in 1541.)

Mottahadeh, Roy P. 1980. *Loyalty and Leadership in an Early Islamic Community*. Princeton: Princeton University Press.

Muñoz Camargo, Diego. [1584] 1984. "Descripción de la ciudad y provincia de Tlaxcala." In *Relaciones Geográficas del siglo XVI*, vol. 1, *Tlaxcala*, ed. René Acuña, pp. 23–286. Mexico City: Universidad Nacional Autónoma de México.

Munster, Anna Manis. 2000. "Functionen des dames et damoiselles d'honneur im Gefolge franzosischer Koniginnen und Herzoginnen (14.–15. Jahrhundert)." In *Das Frauenzimmer: Die Frau bei Hofe in Spatmittelalter und fruher Neuzeit*, ed. Jan Hirschbiegel and Werner Paravicini, pp. 336–54. Stuttgart: Jan Thorbecke.

Muntakhab-ut-Tavarikh, by ʿAbd al-Qadir Badauni. [1925] 1989. Trans. and ed. George S. A. Ranking [vol. 1], W. H. Lowe [vol. 2], and Sir Wolseley Haig [vol. 3]. 3 vols. Delhi: Idarah-i Adabiyat-i Delli.

Nagashima Konshirō, Ōta Takeo. [1892] 1971. *Chiyodajō ōoku*. 2 vols. Tokyo: Hara Shobō.

Nagtegaal, Luc. 1996. *Riding the Dutch Tiger: The Dutch East Indies Company and the Northeast Coast of Java, 1680–1743*. Leiden: KITLV Press.

Naima, Mustafa. 1863–64 (A.H. 1280). *Tarih-i Naima*. 6 vols. Istanbul: Matbaa-yi Amire.

Nasonov, A. N. 1969. *Istoriia russkogo letopisaniia XI-nachala XVIII veka: Ocherki i issledovaniia*. Moscow: Nauka.

Nast, Heidi J. 2005. *Concubines and Power: Five Hundred Years in a Northern Nigeria Palace.* Minneapolis: University of Minnesota Press.

Newton, William Ritchey. 2000. *L'espace du roi: La court de France au chateau de Versailles 1682–1789.* Paris: Fayard.

Nguyen Ngoc Huy and Ta Van Tai, with the cooperation of Tran Van Liem. 1987. *The Lê Code: Law in Traditional Vietnam. A Comparative Sino-Vietnamese Legal Study with Historical Juridical Analysis and Annotations.* 3 vols. Athens: Ohio University Press.

Nguyen The Anh. 1995. "The Vietnamization of the Cham Deity Po Nagar." In *Essays into Vietnamese Pasts*, ed. Keith Taylor and John K. Whitmore, pp. 43–50. Ithaca, N.Y.: Southeast Asia Program, Cornell University.

Nicholl, Robert, ed. 1975. *European Sources for the History of the Sultanate of Brunei in the Sixteenth Century.* Brunei: Brunei Museum.

Nigun-Han, Emma. "The Socio-Political Roles of Women in Japan and Burma." Ph.D. diss., University of Colorado, 1972.

Nishikawa Kazuko. 2003. *Kyōjoō Fuana: Supein ōka no densetsu wo tazunete.* Tokyo: Sairyūsha.

Nizam al-Din Ahmad. [1929–39] 1992. *Tabaqat-i Akbari of Khwajah Nizammudin Ahmad.* Trans. Brajendranath De and Baini Prasad. 3 vols. Delhi: Low Price Publications.

Norberg, Kathryn. 2004. "Incorporating Women/Gender in French History Courses, 1429–1789: Did Women of the Old Regime Have a Political History?" *French Historical Studies* 27.2 (Spring): 243–66.

Novikov, N. I., ed. [1788–91] 1970. *Drevniaia rossiiskaia vivliofika.* 2nd ed. 20 vols. Slavistic Printings and Reprintings 250. The Hague: Mouton. Cited as DRV.

Orband, R. 1916. "Les Funérailles de Thieu-Tri d'Après les Documents Officiels." *Bulletin des Amis du Vieux Hué* 3.1 (January–March): 104–15.

Ouyang Xiu. 1974. *Xin Wudai shi* (New history of the Five Dynasties). Peking: Zhong hua shu ju.

Palisot de Beauvois, A. M. F. J. 1801. "Notice sur le peuple de Bénin." *Décadé Philosophique*, no. 12.

Papanek, Hanna, and Gail Minault, eds. 1982. *Separate Worlds: Studies of Purdah in South Asia.* Delhi: Chanakya Publications.

Paravacini, Joannes Andries. 1862. "Eerbiedigst Rapport . . . over de Zaken en Belangen van Timor, Rotty, Solor, Sacoe, Sumba en Borneo," *Bijdragen tot de Taal-, Land en Volkenkunde van Nederlandsch-Indië* 8: 227–54.

Paris, Isabelle, comtesse de. 1998. *La reine Marie-Amélie, grand-mère de l'Europe*. Paris: Perrin.

Parsons, John Carmi, and Bonnie Wheeler, eds. 1996. *Medieval Mothering*. New York: Garland.

Peirce, Leslie P. 1993. *The Imperial Harem: Women and Sovereignty in the Ottoman Empire*. New York: Oxford University Press.

Perrot, Michelle, ed. 1990. *A History of Private Life*, ed. Philippe Ariès and Georges Duby, vol. 4, *From the Fires of the Revolution to the Great War*. Trans. Arthur Goldhammer. Cambridge, Mass.: Harvard University Press.

Persian Aˁin. See Abu al-Fazl 1872–77.

Petitfils, Jean-Christian. 1989. *Madame de Montespan*. Paris: Fayard.

Petrey, Sandy. 2005. *In the Court of the Pear King: French Culture and the Rise of Realism*. Ithaca, N.Y.: Cornell University Press.

Philostratus, Flavius. 1912–50. *The Life of Apollonius of Tyana, the Epistles of Apollonius and the Treatise of Eusebius*. Trans. F. C. Conybeare. 2 vols. Cambridge, Mass.: Harvard University Press.

Phongsawadan lawaek chabap plae chò sò 1170. [1808] 1969. Trans. Sara Banchong. In *Prachum Phongsawadan phak thi 71* (History series, part 71), Khurusapha reprint series, 44:243–88, 45:1–58. Bangkok: Khurusapha Press.

Pinkney, David. 1972. *The French Revolution of 1830*. Princeton: Princeton University Press.

Pis'ma russkikh gosudarei. See Arkheograficheskaia kommissiia 1848.

Plumer, Cheryl. 1971. *African Textiles; An Outline of Handcrafted Sub-Saharan Fabrics*. [East Lansing]: African Studies Center, Michigan State University.

Poignant, Simone. 1970. *Les filles de Louis XV: L'Aile des Princes*. Paris: Editions Arthaud.

Polnoe sobranie russkikh letopisei. 1846–1995. 41 vols. to date. St. Petersburg–Moscow: n.p. Cited as *PSRL*.

Pomar, Juan Bautista. [1582] 1941. *Relación de Tezcoco*. In *Relaciones de Texcoco y de la Nueva España*, by Pomar-Zurita, pp. 1–64. Mexico City: Editorial Salvador Chavez Hayhoe.

Possevino, Antonio. 1977. *The Moscovia of Antonio Possevino, S.J.* Trans. Hugh F. Graham. Pittsburgh: University Center for International Studies, University of Pittsburgh.

Prime Ministry Archives. Istanbul. Ali Emiri Series, Register Kanuni 24.

———. Kamil Kepeci Series, Register 7098.

———. Maliyeden Müdevver Series, Registers 397, 774, 1509, 1692.

Primi Visconti, Giovanni Battista. 1908. *Mémoires sur la cour de Louis XIV*. Trans. Jean Lemoine. Paris: Calmann-Lévy.

Procopius. 1962–64. *Procopii Caesariensis Opera Omnia*. Ed. Jacobus Haury and Gerhard Wirth. 4 vols. Leipzig: B. G. Teubner.

PSRL. See *Polnoe sobranie russkikh letopisei* 1846–1995.

Purchas, Samuel, ed. [1625] 1905. *Hakluytus Posthumus or Purchas His Pilgrimes*. Vols. 2–3. Glasgow: James Maclehose and Sons.

(Qinding) *Baqi tongzhi* (Imperial commissioned general history of the eight banners). [1739] 1986. Ed. Ortai. Changchun: Dongbei shifandaxue chu ban she.

(Qinding) *Baqi tongzhi xubian* (Imperially commissioned sequel to the general history of the eight banners). [1799] 1986. Ed. Tiebao. Taipei: Xuesheng shuju.

(Qinding) *Zongrenfu zeli* (Imperially commissioned regulations of the Imperial Clan Court). [1908] 2004. 31 vols. Hong Kong: Fuchi shuyuan chuban youxian gongsi.

Rawski, Evelyn S. 1991. "Ch'ing Imperial Marriage and Problems of Rulership." In *Marriage and Inequality in Chinese Society*, ed. Rubie S. Watson and Patricia Buckley Ebrey, pp. 170–203. Berkeley: University of California Press.

———. 1998. *The Last Emperors: A Social History of Qing Imperial Institutions*. Berkeley: University of California Press.

Reddy, William M. 1997. *The Invisible Code: Honor and Sentiment in Postrevolutionary France, 1814–1848*. Berkeley: University of California Press.

Reents-Budet, Dorie. 1994. *Painting the Maya Universe: Royal Ceramics of the Classic Period*. Durham, N.C.: Duke University Press.

Reid, Anthony. 2004. "Global and Local in Southeast Asian History." *International Journal of Asian Studies* 1.1: 5–21.

Renne, Elisha P. 1995. *Cloth That Does Not Die: The Meaning of Cloth in Bùnú Social Life*. Seattle: University of Washington Press.

Restall, Matthew. 1997. *The Maya World: Yucatec Culture and Society, 1550–1850*. Stanford: Stanford University Press.

RIB. See Arkheograficheskaia kommissiia 1872–1927.

Richards, John F. [1993] 1998. *The Mughal Empire*. Cambridge: Cambridge University Press.

Ricklefs, M. C. 1974. *Jogjakarta under Sultan Mangkubumi, 1749–92: A History of the Division of Java*. London: Oxford University Press.

———. 1993. *War, Culture and Economy in Java 1677–1726: Asian and European Imperialism in the Early Kartasura Period*. Sydney: Allen and Unwin.

———. 1998. *The Seen and Unseen Worlds in Java, 1726–1749: History Literature and Islam in the Court of Pakubuwana II*. Honolulu: University of Hawai'i Press.

Ringle, William M., and George J. Bey III. 2001. "Post-Classic and Terminal Classic Courts of the Northern Maya Lowlands." In *Royal Courts of the Ancient*

Maya, vol. 2, *Data and Case Study*, ed. Takeshi Inomata and Stephen D. Houston, pp. 266–307. Boulder, Colo.: Westview Press.

Ringrose, Kathryn M. 2003. *The Perfect Servant, Eunuchs and the Social Construction of Gender in the Byzantine Empire*. Chicago: University of Chicago Press.

Robin, Cynthia. 2002. "Gender and Maya Farming: Chan Nòohol, Belize." In *Ancient Maya Women*, ed. Traci Ardren, pp. 12–31. Walnut Creek, Calif.: AltaMira Press.

Roche, Daniel, ed. 1998. *Les écuries royales: du XVIe siècle au XVIIIe siècle*. Paris: Editions de Versailles.

Rogister, John. 2004. "Queen Marie Leszczyńska and Faction at the French Court, 1725–1768." In *Queenship in Europe, 1660–1815*, ed. Clarissa Campell Orr, pp. 186–220. Cambridge: Cambridge University Press.

Roth, H. Ling. [1903] 1968. *Great Benin: Its Customs, Art and Horrors*. New York: Barnes and Noble.

The Royal Chronicles of Ayutthaya. 2000. Trans. Richard Cushman. Ed. David K. Wyatt. Bangkok: Siam Society.

The Royal Orders of Burma, A.D. 1598–1885. 1983. Ed. Than Tun. Vol. 1. Kyoto: Center for Southeast Asian Studies, Kyoto University.

Rutnin, Mattani Mojdara. 1993. *Dance, Drama and Theatre in Thailand: The Process of Development and Modernization*. Tokyo: Centre for East Asian Cultural Studies for UNESCO.

Rutt, Richard, and Kim Chong-un, trans. 1974. *The True History of Queen Inhyŏn*. In *Virtuous Women: Three Classic Korean Novels*, pp. 179–233. Seoul: Royal Asiatic Society, Korea Branch.

Sahagún, Bernardino de. 1959. *The Merchants*. Trans. with notes by C. E. Dibble and A. J. O. Anderson. Book 9 of the Florentine Codex. Santa Fe: School of American Research; Salt Lake City: University of Utah. (Originally written in Spanish and Nahuatl in 1569.)

———. 1961. *The People*. Trans. with notes by C. E. Dibble and A. J. O. Anderson. Book 10 of the Florentine Codex. Sante Fe: School of American Research; Salt Lake City: University of Utah. (Originally written in Spanish and Nahuatl in 1569.)

———. 1969. *Rhetoric and Moral Philosophy*. Trans. and ed. C. E. Dibble and A. J. O. Anderson. Book 6 of the Florentine Codex. Santa Fe: School of American Research; Salt Lake City: University of Utah. (Originally written in Spanish and Nahuatl in 1569.)

———. 1993. *Psalmodia Christiana*. Trans. and intro. A. J. O. Anderson. Salt Lake City: University of Utah Press. (Originally written in Nahuatl in 1583.)

Saint-Amand, Imbert de. 1891. *La jeunesse de la reine Marie-Amélie*. Paris: Dentu.

———. 1892. *Marie-Amélie au Palais Royal*. Paris: Dentu.

———. 1893a. *Marie-Amélie et la Cour des Tuileries*. Paris: Dentu.

———. 1893b. *Marie-Amélie et la duchesse d'Orléans* Paris: Dentu.

———. 1894a. *Marie-Amélie et l'apogée de Louis Philippe*. Paris: Dentu.

———. 1894b. *Marie-Amélie et la société française en 1847*. Paris: Dentu.

Saint-Simon, Louis de Rouvoy, duc de. 1983. *Mémoires*. Ed. Yves Coirault. 8 vols. Paris: Gallimard, Collection de la Pléiade.

Salvadori, Philippe. 1996. *La chasse sous l'ancien régime*. Paris: Fayard.

Sanchez, Julia L. 1997. "Royal Strategies and Audience: An Analysis of Classic Maya Monumental Art." Ph.D. diss., University of California, Los Angeles.

Sanders, William T. 1992. "Ecology and Cultural Syncretism in 16th-Century Mesoamerica." *Antiquity* 66: 172–90.

Sanders, William T., and David Webster. 1988. "Mesoamerican Urban Tradition." *American Anthropologist* 90.3: 521–46.

Schacht, Joseph. *Introduction to Islamic Law*. Oxford: Clarendon Press, 1964.

Schele, Linda, and David A. Freidel. 1990. *A Forest of Kings: The Untold Story of the Ancient Maya*. New York: Morrow.

Schele, Linda, and Mary Ellen Miller. 1986. *The Blood of Kings: Dynasty and Ritual in Maya Art*. Fort Worth, Tex.: Kimbell Art Museum.

Scheper-Hughes, Nancy. 1993. *Death without Weeping: The Violence of Everyday Life in Brazil*. Berkeley: University of California Press.

Schroeder, Susan. 1991. *Chimalpahin and the Kingdoms of Chalco*. Tucson: University of Arizona Press.

SGGD. See Malinovskii 1813–94.

Shan Shiyuan. 1960. "Guanyu Qing gong de xiunu he gongnu" (*Xiunu and gongnu* in the Qing palace). *Gugong bowuyuan yuankan* 2: 97–102.

Shea, Philip James. 1975. "The Development of an Export Oriented Dyed Cloth Industry in Kano Emirate in the Nineteenth Century." Ph.D. diss., University of Wisconsin.

Sheng Yu. *Baqi wenjing* (Collected works of Eight Banners). 1901. Wuchang: n.p.

SHY. See Xu 1976.

Sima Guang (1019–1086). 1997. *Su shui ji wen*. Ed. Tang Song shi liao bi ji cong kan. Beijing: Zhong hua shu ju.

Skinner, Neil. 1996. *Hausa Comparative Dictionary*. Cologne: Koppe.

Skrynnikov, R. G. 1975. *Ivan Groznyi*. Moscow: Nauka.

Skylitzes, John. 1973. *Ioannis Scylitzae Synopsis historiarum*. Ed. Hans Thurn. Berlin: De Gruyter.

Slater, Mariam K. 1996. "Taboo." In *The Encyclopedia of Cultural Anthropology*, ed. David Levinson and Melvin Ember, 4:1279–85. New York: Henry Holt.

Smith, A. Ledyard. 1950. *Uaxactun, Guatemala: Excavations of 1931–1937*. Carnegie Institution of Washington Publication 588. Washington, D.C.: Carnegie Institution of Washington.

Solnon, Jean-François. 1987. *La cour de France*. Paris: Fayard.

SS. See Tuotuo et al. 1977.

Steingass, F. [1892] 1981. *A Comprehensive Persian-English Dictionary*. New Delhi: Oriental Books Reprint.

Stoler, Ann. 1989. "Making Empire Respectable: The Politics of Race and Sexual Morality in 20th-Century Colonial Cultures." *American Ethnologist* 16.4 (November): 634–60.

Strong, Roy. 1973. *Splendor at Court: Renaissance Spectacle and Illusion*. London: Weidenfeld and Nicolson.

Stuart, David. 1998. " 'The Fire Enters His House': Architecture and Ritual in Classic Maya Text." In *Function and Meaning in Classic Maya Architecture*, ed. Stephen D. Houston, pp. 373–426. Washington, D.C.: Dumbarton Oaks Research Library and Collection.

Subrahmanyam, Sanjay. 1992. "The Mughal State—Structure or Process? Reflections on Recent Western Historiography." *Indian Economic and Social History Review* 29.3: 291–321.

Tambiah, Stanley Jeyaraja. 1976. *World Conqueror and World Renouncer: A Study of Buddhism and Polity in Thailand against a Historical Background*. Cambridge: Cambridge University Press.

Tang, Bangzhi. 1985. *Qing huangshi si pu* (Qing imperial genealogy). Taipei: Mingwen shuju.

Tapper, Nancy. 1980. "Matrons and Mistresses: Women and Boundaries in Two Middle Eastern Tribal Societies." *Archives Européennes de Sociologie* 21: 59–79.

Tate, Carolyn E. 1992. *Yaxchilan: The Design of a Maya Ceremonial City*. Austin: University of Texas Press.

Taube, Karl. 1985. "Classic Maya Maize God: A Reappraisal." In *Fifth Palenque Round Table, 1983*, ed. Virginia M. Fields, pp. 171–81. San Francisco: Pre-Columbian Art Research Institute.

———. 1989. "Ritual Humor in Classic Maya Religion." In *Word and Image in Maya Culture: Explorations in Language, Writing, and Representation*, ed. William F. Hanks and Don S. Rice, pp. 351–82. Salt Lake City: University of Utah Press.

Tavernier, J[ean] B[aptiste]. 1681. *Nouvelle relation de l'interieur du Serrail de Grand Seigneur*. [Amsterdam.]

Taylor, Craig. 2006. "The Salic Law, French Queenship, and the Defense of Women in the Late Middle Ages." *French Historical Studies* 29.4: 543–64.

Theophanes the Confessor. 1997. *The Chronicle of Theophanes Confessor: Byzantine and Near Eastern History, A.D. 284–813*. Ed. and trans. Cyril Mango and Roger Scott. Oxford: Clarendon Press; New York: Oxford University Press.

Thomas, Mary A. 1980. "Managerial Roles in the Suzdal'skii Pokrovskii Convent during the Seventeenth Century." *Russian History* 7.1–2: 92–112.

———. 1983. "Muscovite Convents in the Seventeenth Century." *Russian History* 10.2: 230–42.

Three Worlds According to King Ruang: A Thai Buddhist Cosmology. 1982. Trans. with intro. and notes by Frank E. Reynolds and Mani B. Reynolds. Berkeley: Center for South and Southeast Asian Studies, University of California.

Thyrêt, Isolde. 2001. *Between God and Tsar: Religious Symbolism and the Royal Women of Muscovite Russia*. Dekalb: Northern Illinois University Press.

Tikhomirov, M. N. 1979. *Russkoe letopisanie*. Moscow: Nauka.

Tirmizi, S. A. I. 1979. *Edicts from the Mughal Harem*. Delhi: Idarah-i Adabiyat-i Delli.

Titley, Norah M. 1977. *Miniatures from Persian Manuscripts: A Catalogue and Subject Index of Paintings from Persia, India, and Turkey in the British Library and the British Museum*. London: British Museum Publications.

Tokmakov, I. F., and G. P. Smirnov-Platonov, eds. 1885. *Istoricheskoe opisanie Moskovskago Novodevich'iago monastyria*. Moscow: Tipografiia L. F. Snegireva.

Topkapï Palace Archives, Istanbul. Evrak: 2457/2

Torbert, Preston. 1977. *The Ch'ing Imperial Household Department: A Study of Its Organization and Principal Functions, 1661–1796*. Cambridge, Mass.: Harvard University Press.

Tozzer, Alfred M., ed. 1941. *Landa's "Relación de las cosas de Yucatan": A Translation*. Papers of the Peabody Museum of American Archaeology and Ethnology 18. Cambridge, Mass.: Peabody Museum of American Archaeology and Ethnology.

Tuotuo et al., comps. 1977. *Song shi* (Song history). Peking: Zhong hua shu ju. Cited as SS.

Uluçay, Çagatay. 1980. *Padişahlarïn Kadïnlarï ve Kïzlarï*. Ankara: Türk Tarih Kurumu Basïmevi.

Vail, Gabrielle, and Andrea Stone. 2002. "Representations of Women in Postclassic and Colonial Maya Literature and Art." In *Ancient Maya Women*, ed. Traci Ardren, pp. 203–29. Walnut Creek, Calif.: AltaMira Press.

Valdés, Juan Antonio, and Federico Fahsen. 1995. "The Reigning Dynasty of Uaxactun during the Early Classic: The Rulers and the Ruled." *Ancient Mesoamerica* 6: 197–220.

Vasenko, P. G. 1912. *Nachalo dinastii Romanovykh*. St. Petersburg: Izdanie Ia. Bashmakova.

Vilinskii, S. G., ed. 1911. "Zhitie sv. Vasiliia Novago v russkoi literature." *Zapiski Imperatorskago novorossiiskago universiteta* 7: 5–346.

"Vita of Euphrosyna." 1910. *Acta Sanctorum* 3 (November): 861–77.

Wall, L. Lewis. 1988. *Hausa Medicine: Illness and Well-being in a West African Culture*. Durham, N.C.: Duke University Press.

Wang Anzhong (1076–1134). 1983. *Chu liao ji*. In Wen yuan ge, Si ku quan shu, vol. 1127. Taipei: Commercial Press.

Wang Daocheng. 1985. "Cong Xue Pan song mei daixuan tanqi—guanyu Qingdaide xiunu zhidu" (Discussing Xue Pan dispatching his sister to await selection—the Qing xiunu system). *Beijing shiyuan* 3: 303–16.

Wang Gui (1019–85). 1983. *Hua yang ji*. In Wen yuan ge, Si ku quan shu, vol. 1131. Taipei: Commercial Press.

Wang Peihuan. 1993. *Qinggong houfei* (Empresses and concubines in the Qing palace). Shenyang: Liaoning daxue chu ban she.

Wang, Shuo. 2004. "The Selection of Women for the Qing Imperial Harem." *Chinese Historical Review* 11 (Fall): 212–22.

Wang Shuqing. 1980. "Qingdai houfei zhidu zhong de jige wenti" (Some questions about the system of imperial consorts in the Qing dynasty). *Gugong bowuyuan yuankan* 1: 38–46.

———. 1982. "Qingdai de gongzhu" (Qing princesses). *Gugong bowuyuan yuankan* 3: 31–38.

Wang Zhonghan. 1993. *Qingshi xukao* (Sequel to the studies of Qing history). Taipei: Huashi chu ban she.

Ward Price, H. L. 1939. *Dark Subjects*. London: Jarrolds.

Watson, Rubie S. 1991. "Afterword: Marriage and Gender Inequality." In *Marriage and Inequality in Chinese Society*, ed. Rubie S. Watson and Patricia Buckley Ebrey, pp. 347–68. Berkeley: University of California Press.

Webster, David. 2001. "Spatial Dimensions of Maya Courtly Life: Problems and Issues." In Inomata and Houston 2001b, pp. 130–67.

Wei Jing (1159–1226). 1983. *Hou le ji*. In Wen yuan ge, Si ku quan shu, vol. 1169. Taipei: Commercial Press.

Wei Qi. 1984. "Qingdai diyici xuan xiunu" (The first xiunu selection in the Qing). *Zijincheng* 26: 20.

Wessing, Robert. 1991. "An Enclosure in the Garden of Love." *Journal of Southeast Asian Studies* 22.1 (March): 1–15.

West, Robert C., and John P. Augelli. 1989. *Middle America: Its Land and Peoples*. 3rd ed. Englewood Cliffs, N.J.: Prentice Hall.

Whitmore, John. 2000. "Gender, State and History: The Literati Voice in Early Modern Vietnam." In *Other Pasts: Women, Gender and History in Early Modern Southeast Asia*, ed. Barbara Watson Andaya, pp. 215–30. Honolulu: Center for Southeast Asian Studies, University of Hawai'i at Mânoa.

Whitmore, Thomas M. 1992. *Disease and Death in Early Colonial Mexico: Simulating Amerindian Depopulation*. Dellplain Latin American Studies, No. 28. Boulder, Colo.: Westview Press.

Withers, Robert. 1905. "The Grand Signiors Serraglio." (Translation of Ottaviano Bon, "Descrizione del Serraglio del Gran Signore," in *Le relazioni degli stati Europei*, ed. Nicoló Barozzi and Giglielmo Berchet, ser. 5 [Venice: P. Naratovich, 1871], 1:59–124.) In *Hakluytus Posthumus or Purchas His Pilgrimes*, ed. Samuel Purchas, 9:322–406. Glasgow: James Maclehose and Sons.

Wolters, O. W. 1999. *History, Culture and Region in Southeast Asian Perspectives*. Rev. ed. Ithaca, N.Y.: Southeast Asia Program Publications, Southeast Asia Program, Cornell University.

Woodward, Jennifer. 1997. *The Theatre of Death: The Ritual Management of Royal Funerals in Renaissance England, 1570–1625*. Woodbury, Suffolk: Boydell Press.

Wu, Pei-Yi. 1990. *The Confucian Progress: Autobiographical Writings in Traditional China*. Princeton: Princeton University Press.

Wu Zhenyu (1792–1870). 1985. *Yangjizhai cong lu* (Notes from the Yangji studio). Hangzhou: Zhejiang guji chu ban she.

Wyatt, David K. 1982. *Thailand: A Short History*. New Haven: Yale University Press.

———. 2004. *Reading Thai Murals*. Chiang Mai: Silkworm Books.

Xu Song, comp. 1976. *Song hui yao ji gao*. Taipei: Xinwenfeng chu ban gong si. Cited as SHY.

Ye Shaoweng. [1989] 1997. *Si chao wen jian lu*. Ed. Tang Song shi liao bi ji cong kan. Peking: Zhonghua.

Yi Pyŏnggi and Paek Chŏl. 1990. *Kungmunhak chŏnsa*. 2nd ed. Seoul: Sin'gu munhwasa. (First edition published in 1957.)

Yŏnhaengnok sŏnjip. [1832] 1960–62. 2 vols. Trans. Gari Ledyard. Seoul: Songyungwan Taehakkyo Taedong Munhwa Yonguwon.

Yu Jing (1000–1064). 1983. *Wu xi ji*. In Wen yuan ge, Si ku quan shu, vol. 1089. Taipei: Commercial Press.

Yu Zhuoyun, comp. 1984. *Palaces of the Forbidden City*. Trans. Ng Mau-Sang, Chan Sinwai, and Puwen Lee. Ed. Graham Hutt. New York: Viking Press.

Zanger, Abby. 1997. *Scenes from the Marriage of Louis XIV: Nuptial Fictions and the Making of Absolutist Power*. Stanford: Stanford University Press.

Zeitlin, Judith T. 2003. "Disappearing Verses: Writing on Walls and Anxieties of Loss." In *Writing and Materiality in China: Essays in Honor of Patrick Hanan*, ed.

Judith T. Zeitlin and Lydia H. Liu, pp. 73–132. Cambridge, Mass.: Harvard University Asia Center for the Harvard-Yenching Institute, distributed by Harvard University Press.

Zhang Naiwei. 1990. *Qinggong shuwen* (Jottings in Qing palace). Beijing: Zijincheng chu ban she.

Zhao Erxun. 1976–77. *Qingshi gao* (Draft history of the Qing). Beijing: Zhonghua shuju.

Zhao Yuntian. 1984. "Qingdai de 'beizhi efu' zhidu" (The institution for "selecting imperial sons-in-law" in the Qing). *Gugong bowuyuan yuankan* 4: 28–37.

Zhou Mi. [1983] 1997. *Qi dong ye yu*. Ed. Tang Song shi liao bi ji cong kan. Peking: Zhonghua.

Zito, Angela. 1997. *Of Body and Brush: Grand Sacrifice as Text/Performance in Eighteenth-Century China*. Chicago: University of Chicago Press.

CONTRIBUTORS

BARBARA WATSON ANDAYA is a professor of Asian studies at the University of Hawai'i at Mânoa and past president of the Association for Asian Studies. She is the author of numerous studies on the Malay world and Southeast Asia, including *Perak, the Abode of Grace: A Study of an Eighteenth-Century Malay State* (1979), *To Live as Brothers: Southeast Sumatra in the Seventeenth and Eighteenth Centuries* (1993), and *The Flaming Womb: Repositioning Women in Early Modern Southeast Asia* (2006).

BEVERLY BOSSLER is a professor of history at University of California, Davis. She specializes in China's High Imperial period (Tang-Song-Yuan, 618–1368) and is the author of *Powerful Relations: Kinship, Status, and the State in Song China (960–1279)* (1998).

SUSAN TOBY EVANS is a professor in the Department of Anthropology at Pennsylvania State University. She has written extensively on the archaeology of Mesoamerica, with an emphasis on Aztec culture. Her recent books include *Ancient Mexico and Central America* (2004, winner of the 2005 Society of American Archaeology Book Award) and *Palaces of the Ancient New World* (2004, co-edited with Joanne Pillsbury).

JAHYUN KIM HABOUSH is King Sejong Professor of Korean Studies at Columbia University. Her publications include *The Confucian Kingship in Korea: Yongjo and the Politics of Sagacity* (2001) and *The Memoirs of Lady Hyegyŏng: The Autobiographical Writings of a Crown Princess of Eighteenth-Century Korea* (1996).

HATA HISAKO is a curator at the Edo-Tokyo Museum and author of *Edo oku jochū monogatari* (A tale of maids in Edo's inner quarters, 2001).

TAKESHI INOMATA is an associate professor of anthropology at the University of Arizona and director of the Ceibal-Petexbatun Archaeological Project located in the southwestern Peten region of Guatemala. He is co-editor of *Royal Courts of the Ancient Maya* (2001) and of *The Archaeology of Performance: Theaters of Power, Community, and Politics* (2006).

FLORA EDOUWAYE S. KAPLAN is an anthropologist, founder and former director of graduate museum studies, and professor emerita, Faculty of Arts and Science, New York University, with many publications to her credit on gender, museums, politics, and art in Mexico and Nigeria. Her books include *A Mexican Folk Pottery Tradition: Cognition and Style in Material Culture in the Valley of Puebla* (1994), *Museums and the Making of "Ourselves": The Role of Objects in National Identity* (1994, 1996, 1998), and the edited volume *Queens, Queen Mothers, Priestesses, and Power: Case Studies in African Gender* (1997, 1998). She is currently finishing *Benin Art and Culture*.

RUBY LAL is an associate professor in the Department of Middle Eastern and South Asian Studies at Emory University. She recently published *Domesticity and Power in the Early Mughal World* (2005).

JO BURR MARGADANT, Lee and Seymour Graff Professor at Santa Clara University, is former co-editor of *French Historical Studies*, author of *Madame le Professeur: Women Educators in the Third Republic* (1990), and editor of *The New Biography: Performing Femininity in Nineteenth-Century France* (2000). For *Madame le Professeur* she was in 1991 co-recipient of the David Pinkney Prize, Best Book in French History from the Society for French Historical Studies, and the Best Book Award from the Berkshire Conference on Women's History and recipient of the Best Book Award from the History of Education Society and from Phi Sigma Nu, the Jesuit Honor Society.

HEIDI J. NAST, a professor of international studies at DePaul University, is the author of *Pet-i-filia: Love and Alienation in the 21st Century* (forthcoming) and *Concubines and Power: Five Hundred Years in a Northern Nigerian Palace* (2005), which won the African Studies Association's Aidoo-Snyder Book Prize in 2005. She co-edited *Places through the Body* (1998) and *Thresholds in Feminist Geography* (1997), and publishes extensively on the political and cultural economies of sexuality, fertility, and reproduction.

KATHRYN NORBERG, an associate professor of history at University of California, Los Angeles, was co-editor of *Signs: Journal of Women in Culture and Society* between 2000 and 2005. She co-edited *From Royal to Republican Body: Incorporating the Political in Seventeenth and Eighteenth Century France* (1989) and *Furnishing the Eighteenth Century: What Furniture Can Tell Us about the European and American Past*

(2006). She is the author of *Rich and Poor in Grenoble, 1600–1814* (1985) and is currently completing a study of prostitution in seventeenth-century France and an edited volume on fashion during the reign of Louis XIV.

LESLIE P. PEIRCE, Silver Professor of History at New York University, is the author of *The Imperial Harem: Women and Sovereignty in the Ottoman Empire* (1993), winner of 1993–94 Köprülü Prize of the Turkish Studies Association for best book, and *Morality Tales: Law and Gender in the Ottoman Court of Aintab* (2003), awarded the Albert Hourani Prize of the Middle East Studies Association and the Köprülü Prize of the Turkish Studies Association for best book in 2003.

KATHRYN M. RINGROSE, a lecturer in history at University of California, San Diego, is the author of *Eunuchs and the Social Construction of Gender in Byzantium* (2003).

ISOLDE THYRÊT, an associate professor of history at Kent State University, is the author of *Between God and Tsar: Religious Symbolism and the Royal Women of Muscovite Russia* (2001) and recipient of the Barbara Heldt Prize for best book in Slavic/East European/Eurasian women's studies in 2002.

ANNE WALTHALL is a professor of history at University of California, Irvine, and author of *The Weak Body of a Useless Woman: Matsuo Taseko and the Meiji Restoration* (1998).

SHUO WANG, an associate professor of history at California State University at Stanislaus, is currently working on a book titled *Acculturation and Gender: Changes in Manchu Power in Late Imperial China.*

INDEX

Note: page numbers in **bold** indicate authors' contributions to this volume.

Benin City, 117, 118; archaeological excavations, 119–20; palace compound, 118–19

Benin cloth, 244

Benin Punitive Expedition, 125

Benin royal harem, 115–16, 119–36; activities and visitors, 121–22, 123; administration of, 12, 125, 127, 137; births in, 11, 130–31; chief wife (Eson), 12, 123, 125, 126fig, 127, 129fig, 130; escapes from, 134; harem recruitment and politics, 15, 117, 131–35; physical space and setting, 118–19, 121; as place of seclusion, 7, 116, 119–21, 135; power sources and networks, 10, 115, 122, 127, 134–35; queen mothers (Iyobas), 9, 116, 118, 128–31, 129fig, 135n6; servants, 16–17, 123, 127–28, 133; slaves in, 123, 133; wives of current Oba, 126fig, 132fig; wives' status and influence, 116, 117, 122–25, 127, 134–35; women's groups and, 121–22, 136n10

Berry, duc de, 309fig

Berry, Marie-Caroline, duchesse de, 315–17

Beveridge, Henry, 114n66

Bhopal begums, 9

Bibi Fatimeh, 109, 110

Bird Jaguar, 57, 60

births. *See* pregnancies and births

Bogdanov, Stepan, 166

Bonampak murals and stelae, 50, 52, 57, 62

Book of Ceremonies, 68–69, 75–76

Bossler, Beverly, 15, **261–79**

Bourbon Restoration, 302, 303, 304, 308, 325n12. *See also* July monarchy; Louis-Philippe; Marie-Amélie

bourgeoisie, postrevolutionary French notions of, 305–7, 315, 322–23

Bourgogne, duchesse de, 194, 198, 201, 211n21

Brazzaville textile production, 244

breast-feeding, 102–3, 103–4, 112n35, 113n41. *See also* wet nurses

British East India Company, 25

Brunei, Magellan's crew received in, 30

Bryant, Mark, 205

Buddhism, 11–12, 23, 27, 28

Buddhist monks and nuns, 17

Bunu people, 241–42

burials, Classic Maya, 55

Burma, 27, 30–31, 33, 36

Burton, Sir Richard, 127–28

Byzantine court, 65–81; ceremony and ritual, 7, 68–74, 79; space use patterns, 66, 67–68, 70–71, 72, 78–79; succession and legitimacy, 67

Byzantine empresses, 9, 66, 67, 77–79; in court ceremonial, 69, 70–74, 79; powerful empresses, 66, 76–78; staff eunuchs and imperial power, 75, 76–78, 79; "women's court" attendants, 69, 70–71, 72–73, 79

Byzantine eunuchs, 74–77, 78, 79, 80n22; chief eunuchs, 68, 70, 72, 73, 75–76, 80nn4,21; in court ceremonial, 16, 68, 70, 71, 72, 73, 74; imperial power and, 75, 76, 78, 79; as mediators, 16, 66, 68, 73, 74–75, 78, 79

Caligula, 67

Cambodia, 25, 27, 28, 30, 37

Campan, Madame, 199

Campbell, Peter, 213n76

Campo, Juan, 98

La Caricature, 317, 318fig, 320fig

carrousels, 208

Catherine de' Medici, 194, 211n34

Catherine the Great, 9

Catholicism: imposition on Aztecs, 215–16, 226–28; at Versailles, 204. *See also* Christianity

ceremony and ritual, 4, 7–8; Byzantine court, 7, 68–74, 79; Chosŏn Korea, 284, 289–91, 294; Classic Maya courts, 7, 47–51, 52–53, 60–61, 62, 63; cosmological elements, 7, 28, 41; deaths and funerals, 37, 120; emphasizing divide between ruler

305–7, 317, 319, 320–23; postrevolutionary politics and society, 299–305; postrevolutionary views of family, 299–300, 301–2, 306–7, 324–25. *See also* French kings; French queens; French royal children; July Monarchy; Orléans family; *entries beginning with Versailles; specific individuals*

French kings, 207–8, 301–2; attendants and retainers, 195, 196, 199; royal governess and, 196–97, 203; virility/fertility of, 207–8, 214n92. *See also specific kings by name*

French queens, 206, 300–301, 302; attendants and retainers, 193–94, 195–96, 198–99, 203, 210n9, 212n60; barred from rule, 9, 206, 300; as regents, 206, 211n34, 213n82, 300–301. *See also* Versailles women; *specific queens by name*

French royal children: children's household at Versailles, 196–97, 198, 203, 204, 207, 211nn24,26,27, 212n40; finances of Orléans children, 315; Louis-Philippe and Marie-Amélie as parents, 303, 307–8; Orléans family caricatured, 317, 319fig; Orléans family in popular prints, 307–14, 310fig, 311fig, 312fig, 313fig. *See also specific individuals*

Fujinami, 172, 173, 176, 178–80, 182, 185–86, 189

Fukai Masaumi, 17

Fulani jihad and reforms, Hausaland, 16, 232, 234, 250–53, 254, 256

Fulin (Shunzhi), 139table, 140–41, 155n14

funerals, Southeast Asian courts, 37, 40

Gagarin, Daniel Grigor'evich, 165, 167

Gagarin, Grigorii, 167

Galdan, 150

Gaozong, 267, 268

gardens of love, 33

Ghazi, 103

Geertz, Clifford: "theater state" concept, 24, 44

gendered spaces. *See* harems; seclusion; segregation; space use patterns

gender relations, Aztec Mexico, 228, 230

General History of the Things of New Spain (Sahagún), 222–23, 224fig, 225fig

Godunov, Boris, 160, 161–62, 163

Godunova, Irina, 160–61, 162

Goens, Rijklof van, 22–23, 26, 31, 34

Gong Mei, 272, 275

Gosse, Nicholas: Marie-Amélie painted by, 315

governesses, at Versailles, 196–97, 198, 203, 207

Grandville, Jean Ignace, 318fig

Great Interior: occupants and positions, 174–77; physical setting, 5, 6fig, 172, 173–74, 177–78

Great Interior women, 172–90; board games for, 181, 183, 184fig; concubines, 14, 173, 175; daily lives, 176–78, 179–80; education and training, 16, 18, 181, 182, 187, 189; Fujinami, 172, 173, 176, 178–80, 182, 185–86, 189; historical background, 173; marital status, 181–82; name changes, 183; number of, 177; physical setting, 5, 6fig, 172, 173–74, 177–78; positions and duties, 17, 175–76, 176table, 178–79, 183, 185, 190n5; princesses' staffs, 175, 177, 185; promotion opportunities, 183, 185; recruitment and social backgrounds, 172, 180–83; retirement/resignation, 181, 183, 187–89; seclusion of, 173–74; shogun's mother, 12, 174, 175, 190n6; shogun's wives, 12, 173, 174, 181, 186–87; status outside the castle, 186; vacations and excursions, 185–87

Great Skull, Lady, 57

Great Statutes for the Governance of the State, 282–83

Gregory VII, 67

Guangxu (Zaitian), 139table

Guangzong, 269

queen mothers. *See* dowager queens and empresses; mothers (of monarchs)

queens: *iloi* of Benin, 12, 116, 117, 122–25, 124fig, 126fig; inauguration ceremonies, 37, 70–72; Maya, depictions of, 57. *See also* female monarchs; female regents; French queens; *specific queens by name*

Quentin, Marie, 199, 200

Rama I, 36

Ratu Kidul, 33

Ravenna: San Vitale mosaics, 76–77, 77fig

Rawski, Evelyn, 143, 148, 152

Record of Private and Public Anecdotes of the Court Seen and Heard, 292, 298n26

The Record of the Event of 1613, 280–81, 282, 284, 285–88, 292; possible authorship, 281, 296, 297n2

The Records of the Historian, 287

Reddy, William, 306

regents. *See* female regents

regicide, 40

religion: Catholicism imposed on Aztecs, 215–16, 226–28; Christianity in Southeast Asia, 24; religious constraints on polygyny, 26–27, 66–67, 94n3, 215–16, 226–27; role at Versailles, 204. *See also* Buddhism; Islam; *specific gods and goddesses*

Richards, John F., 114n71

Ringrose, Kathryn M., 9, 16, **65–81**

River Jambo indigo dyeing site, 233, 246–47, 247fig

"rocking the womb" ceremony, 35

Romanos I, 67, 72

Romanos II, 72

Romanos III, 78

Romanov, Aleksei Mikhailovich, 162

Romanov, Michael Fedorovich, 162, 163–64, 165–66, 167–68

Romanov dynasty, 10, 164, 166, 167–68

Roth, Felix N., 125

Rousseau, Jean-Jacques, 302–3, 306

royal children: Benin, 123, 125, 130–31; Chosŏn Korea, 13, 283;

dangers of two sons by same mother, 11, 130–31; Kano, 235, 254, 257n4; Mughal India, 100–101, 102–4; Tokugawa Japan, 174, 175, 177. *See also* French royal children; pregnancies and births; Qing imperial daughters; *specific individuals*

royal status/authority: ceremonial iterations of, 4, 24; Mughal *haram* as symbol of, 97, 98; polygyny as demonstration of, 29, 41

rulers. *See* female monarchs; monarchs

Rumfa, Muhammadu, 235

Ruqayya-Sultan Begum, 113n52

Rurikide dynasty, 159–60, 161

Russian monarchs: female, 9; legitimacy concerns, 10, 164, 167–68

Russian tsaritsa-nuns, 10, 159–71; Aleksandra (Evdokiia Saburova), 161–62, 168, 168n2, 169n15, 171n49; Dar'ia (Anna Alekseevna Koltovskaia), 161, 163–68; forced tonsure as elimination mechanism, 159, 163; historical background, 159–61; infertility, 160–61, 168; Leonida (Elena Ivanovna Sheremeteva), 162–63, 168n2; social and political ties, 162–63, 164, 165–68; status of, 160–61, 163, 166, 168; tsars' economic support and obligations, 161–62, 163–65, 167

Saburova, Evdokiia Bogdanovna (Aleksandra), 161–62, 168, 168n2, 169n15, 171n49

Saburova, Solomoniia, 160, 161

Sadiya Bayero Sanusi, 239, 246

Sado, 292

Safiye Sultan, 90, 91, 93

Sahagún, Bernardino de, 222–23, 227

Saint-Simon, Louis de Rouvroy, duc de, 191–92, 202, 205, 209, 213n73

Sak B'iyaan, 57

Sakineh Banu Begum, 107

Salic Law, 9, 206, 300

Salim, Shaikh, 100

Theodora (empress, wife of
Theophilos), 66, 78
Theodosius II, 76
Theoktistos, 78
Theophano, 72
Thierry, Augustin, 305
Three Feudatories, 140–41, 148
Thyrêt, Isolde, 10, **159–71**
Tiancong. *See* Hongtaiji
Tianming (Nurhaci), 139–40, 139table,
148, 149, 151, 156n45
Tikal, 48
Time of Troubles, 160, 162, 163, 168
Tokugawa Ieharu, 177, 188–89
Tokugawa Iemitsu, 175
Tokugawa Iemochi, 20n10, 175, 178
Tokugawa Ienari, 174, 177, 178, 186,
187
Tokugawa Iesada, 177, 178, 179–80
Tokugawa Ieyoshi, 177, 178
Tokugawa shoguns, 14, 189; staff's op-
tions at death of, 187–89; succession
struggles, 10, 20n10. *See also* Great In-
terior; Great Interior women; *specific
shoguns by name*
Tokugawa Yoshimune, 12, 20n10, 175
Tokugawa Yoshinobu, 190n6
Tongzhi (Zaichun), 139table
tonsured women, 10, 17, 188–89. *See
also* Russian tsaritsa-nuns
Topkapi Palace, 5–6, 7–8, 8fig. *See also
entries beginning with* Ottoman
The True History of Queen Inhyŏn, 285
Tsereng, 150
Turhan Sultan, 87, 91

Uaxactun murals, 51fig, 62
Uaxactun palace, 55–56, 56fig
Umetani, 186, 187Usman dan Fodio,
251
Ustiug Zhelezopol'skii Monastery of the
Resurrection, 165
Usuanlele, 124fig
Uyiekpen, 124fig

Vali Ni'mat Begum, 101
Vasil'chikova, Anna, 161

Vasilii III, 160
Ventadour, Madame de, 202, 203
The Veritable Records of Kwanghae's Reign,
287
Versailles, 4–5, 41, 192–95; ceremony
and amusements at, 201, 207–8,
214nn95,97; king's attendants
and retainers, 195, 196; male ser-
vants at, 194–95, 211n24; male
vs. female status and influence
at, 206–7, 213n88; presentation at
court, 197–98; role of religion at,
204
Versailles women, 191–214; benefits of
service, 199–202, 203–4, 209,
212n54; contributions and influence,
201–2, 205, 208–9, 213n88; duties
and positions, 195–97, 201, 203–6;
vs. male courtiers, 206–7; number of,
192–95; queen's power and influ-
ence, 206; recruitment and inherited
positions, 197–99; royal childrens'
attendants, 196–97, 198, 203, 207,
212n40; royal mistresses, 202,
203–5; royal relatives, 193, 210n5;
scholarship on, 191–92, 214n89. *See
also* French queens; *specific women by
name*
Viennese court, 5
Vietnam, 23, 25, 27, 28, 39; ceremony
and entertainments, 34, 36; servants/
slaves, 31
Villars, duchesse de, 201
Visconti, Primi, 202, 203
VOC (Dutch East India Company), 22,
26, 28, 31, 34

Wak Jalam Chan Ajaw, Lady, 57
Wak Tuun, 57
Walthall, Anne, **1–21,** 46
Wang, Shuo, 14, **137–58**
Wang Gui, 269
Wang Guozheng, 141
Watson, Rubie S., 153
wedding ceremonies: Byzantine, 7,
70–72; Chosŏn court, 289, 290,
291, 298n17; Kano, 239, 257n10;

Text:	10/13 Joanna
Display:	Joanna, Syntax
Cartographer/Illustrator:	Bill Nelson
Indexer:	Thérèse Shere
Compositor:	Binghamton Valley Composition, LLC
Printer and binder:	Sheridan Books, Inc.